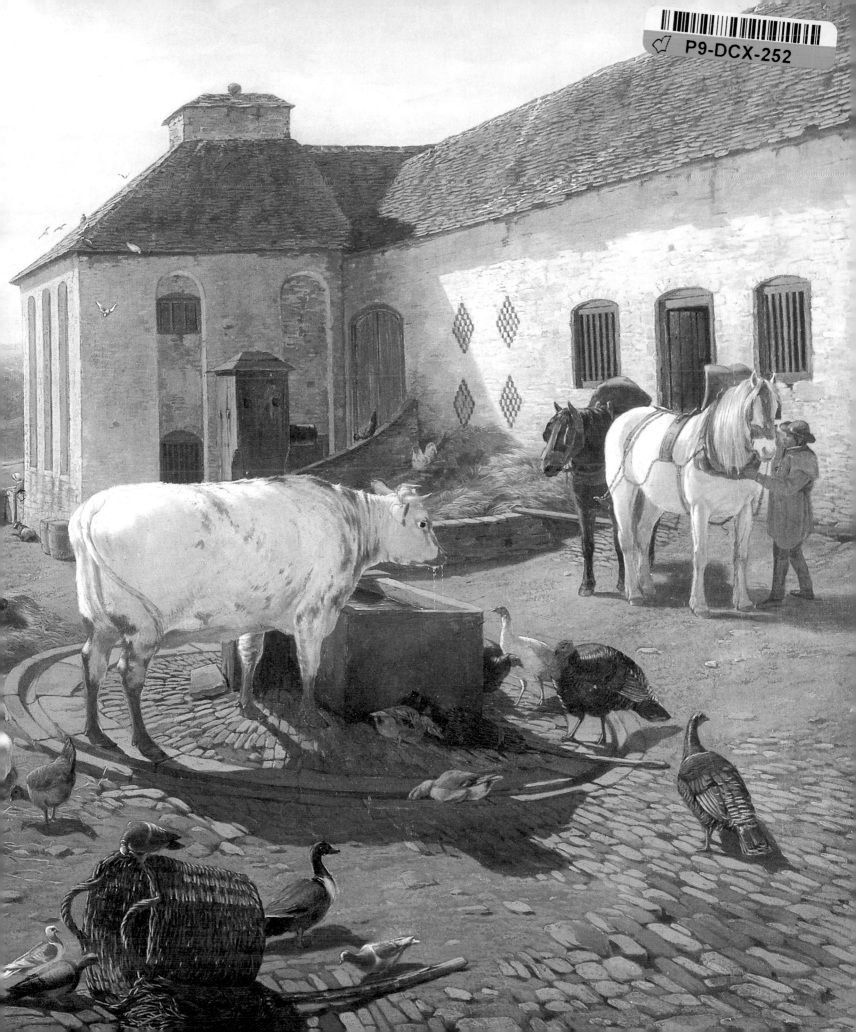

FARM ANIMAL PORTRAITS

In Memory

Of

William V. Totman

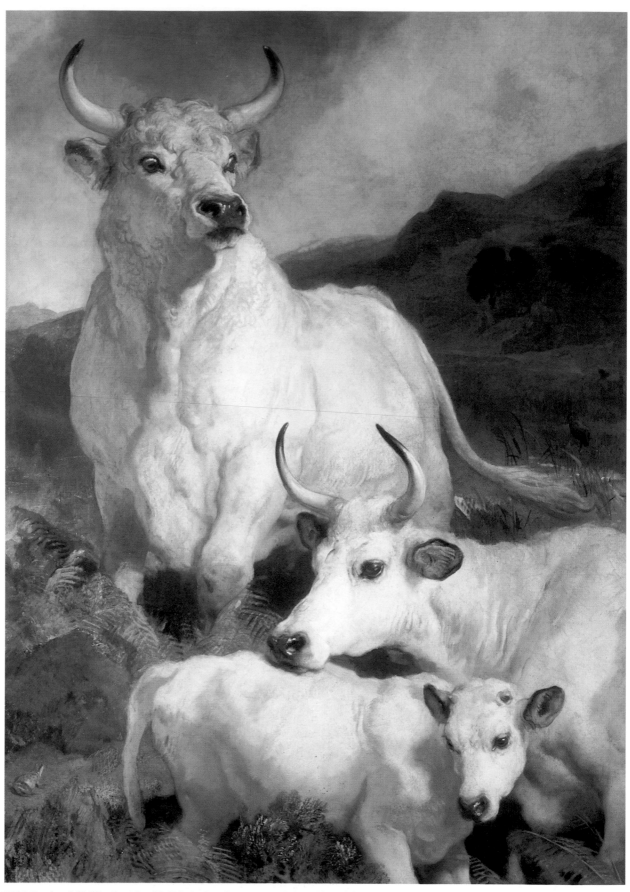

Wild Cattle of Chillingham by Sir Edwin Landseer – see Colour Plate 305

FARM ANIMAL PORTRAITS

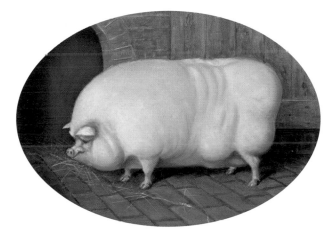

Elspeth Moncrieff

with

Stephen and Iona Joseph

Antique Collectors' Club

ISBN 1 85149 239 9

British Library Cataloguing-in-Publication Data
A catalogue record for this book is available from the British Library

Printed in England
by the Antique Collectors' Club Ltd., Woodbridge, Suffolk
on Consort Royal Satin paper
supplied by the Donside Paper Company, Aberdeen, Scotland

Antique Collectors' Club

The Antique Collectors' Club was formed in 1966 and quickly grew to a five figure membership spread throughout the world. It publishes the only independently run monthly antiques magazine, *Antique Collecting*, which caters for those collectors who are interested in widening their knowledge of antiques, both by greater awareness of quality and by discussion of the factors which influence the price that is likely to be asked. The Antique Collectors' Club pioneered the provision of information on prices for collectors and the magazine still leads in the provision of detailed articles on a variety of subjects.

It was in response to the enormous demand for information on 'what to pay' that the price guide series was introduced in 1968 with the first edition of *The Price Guide to Antique Furniture* (completely revised 1978 and 1989), a book which broke new ground by illustrating the more common types of antique furniture, the sort that collectors could buy in shops and at auctions rather than the rare museum pieces which had previously been used (and still to a large extent are used) to make up the limited amount of illustrations in books published by commercial publishers. Many other price guides have followed, all copiously illustrated, and greatly appreciated by collectors for the valuable information they contain, quite apart from prices. The Price Guide Series heralded the publication of many standard works of reference on art and antiques. *The Dictionary of British Art* (now in six volumes), *The Pictorial Dictionary of British 19th Century Furniture Design, Oak Furniture* and *Early English Clocks* were followed by many deeply researched reference works such as *The Directory of Gold and Silversmiths,* providing new information. Many of these books are now accepted as the standard work of reference on their subject.

The Antique Collectors' Club has widened its list to include books on gardens and architecture. All the Club's publications are available through bookshops world wide and a full catalogue of all these titles is available free of charge from the addresses below.

Club membership, open to all collectors, costs little. Members receive free of charge *Antique Collecting*, the Club's magazine (published ten times a year), which contains well-illustrated articles dealing with the practical aspects of collecting not normally dealt with by magazines. Prices, features of value, investment potential, fakes and forgeries are all given prominence in the magazine.

Among other facilities available to members are private buying and selling facilities, the longest list of 'For Sales' of any antiques magazine, an annual ceramics conference and the opportunity to meet other collectors at their local antique collectors' clubs. There are over eighty in Britain and more than a dozen overseas. Members may also buy the Club's publications at special pre-publication prices.

As its motto implies, the Club is an organisation designed to help collectors get the most out of their hobby: it is informal and friendly and gives enormous enjoyment to all concerned.

For Collectors —By Collectors —About Collecting

ANTIQUE COLLECTORS' CLUB

5 Church Street, Woodbridge, Suffolk IP12 1DS, UK Tel: 01394 385501 Fax: 01394 384434

or

Market Street Industrial Park, Wappingers' Falls, NY 12590, USA Tel: 914 297 0003 Fax: 914 297 0068

For Charlie

Contents

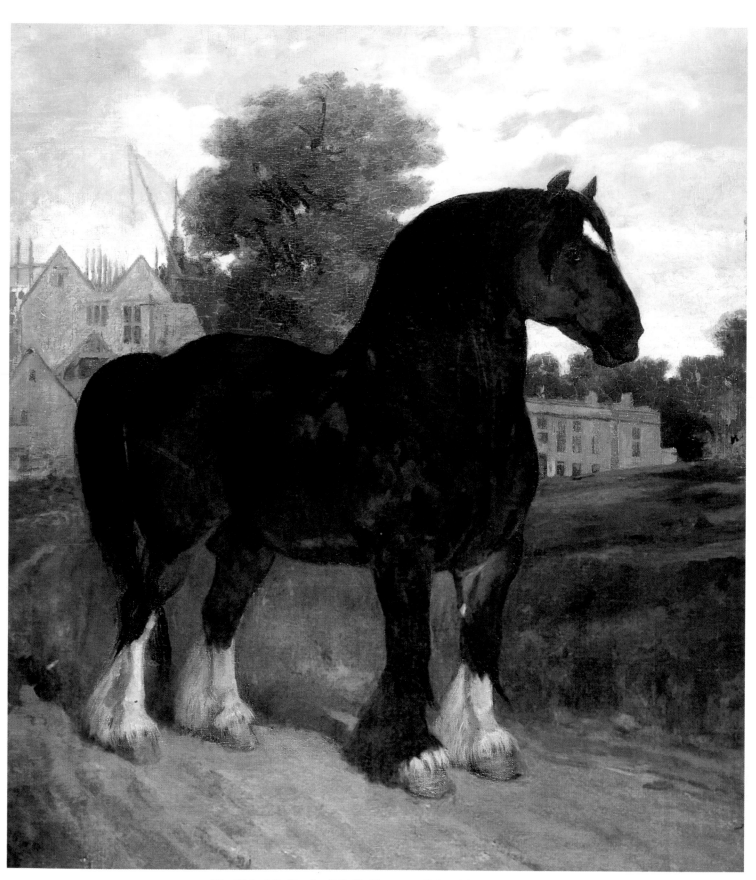

The Mitford Stallion by E.S. Sheldon – see Colour Plate 305

Foreword
by the Duchess of Devonshire

I am delighted to have been asked to write a foreword to *Farm Animal Portraits.* I have long admired, and been fascinated by, the old paintings of English domestic farm animals, so much more interesting to me than the wild creatures and big game of far away continents.

This book fills a gap in both history of art and of the beasts portrayed and described. Until lately such animal portraits were scorned and thrown out of the big houses for which they were commissioned in the first place. Now the pendulum has swung and the interest in them, and their value, has escalated into high fashion.

Nostalgia plays a part. It is not so long ago that the horse was the source of power on the farm and there are still people alive, myself among them, who remember the days when Shires, Clydesdales and Suffolk Punches were an essential to ploughing, sowing and harvesting. The portraits of them, often by artists who no one has ever heard of, please me as much as those of famous thoroughbred racehorses by Stubbs. Their honest faces and solid bodies are as reassuring as those of the horsemen and carters at their heads.

Agriculture was then the premier industry and the biggest employer in the land. Landowners, farmers and workers depended on its prosperity for their own incomes, either directly or via their tenants and, in the case of farm workers, for their very existence. Their livestock was a vital part of their business and the breeders competed with each other to follow fashion and produce the biggest and fattest beasts.

The enthusiasm came from the top. Queen Victoria and Prince Albert were deeply interested in their farms at Windsor and Osborne and some of the animals were named by the Queen after members of her family. The portrait of a Shorthorn heifer called Princess Helena is a model of femininity. Three Fat Pigs at Windsor Castle are not named after any royal personages but the picture has a grand background of the castle. Other farmers boldly called their bulls Duke of Northumberland and Earl of Derby, which are portrayed with their proud owners. The monster pigs were not given aristocratic names, their titles being more descriptive like The Spherical Pig and Jumbo. Their charm oozes through many inches of fat.

The pictures in this book are more than likenesses of the animals, they are historic documents in that they show farm buildings and landscapes of a vanished age. Distinguished architects designed cowsheds and pigsties as well as stables. A glance at the fencing made of lengths of timber which was not sawn, but riven by axe, takes you back a hundred years. Neatly thatched haystacks, stooks of corn in the fields and farmyards with ducks, geese and chickens at large are still remembered by living people who will delight in being reminded of their country childhood.

One beast is close to home for me. The Craven Heifer occupied a loose-box which still stands at Bolton Abbey in Yorkshire. It has a door which is twice the width of its

neighbours to allow her great bulk to get in and out. Nearly two hundred years after her demise she is still part of folklore in Yorkshire and several pubs are named after her.

We have seen the trend of fatstock do an about turn and now the meat in the shops is all lean and you have to add fat. Once again I think fashion has gone too far and I watch with interest how keen people are becoming on our traditional breeds, some of them on the 'endangered species' list, which have enough fat to cook well and taste delicious.

Meanwhile we can enjoy the illustrations and the well-researched text of this book which will bring a great deal of pleasure to a great many people.

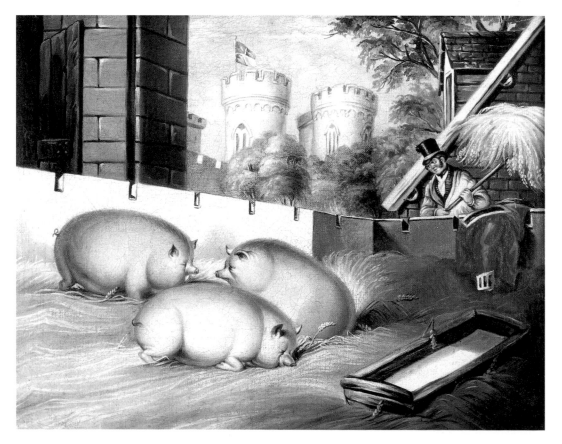

Suffolk and Bedfordshire Pigs belonging to the Prince Consort – detail of Colour Plate 264

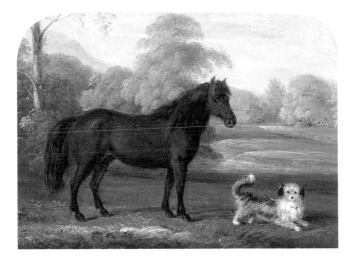

Acknowledgements

Stephen and Iona Joseph conceived the idea for this book. Without their confidence, enthusiasm and enormous practical help it would never have been written.

Of the many individuals who have contributed I would like to thank in particular John Gall, Lawrence Alderson, Pat Stanley, Christopher Davenport Jones, Andrew Sheldon, Hugh Scantlebury, Norman Comben, Colin Graham Stewart, Richard Garne, Christopher Belby, Ian Fleming, Brian Tench, Gordon Edington, Michael Russell and Demelza Spargo, all of whom so generously shared their specialist knowledge with me and passed on the fruits of many years' research. I am also very grateful to Michael Weaver and Sir Toby Weaver for pointing me in the direction of Thomas Weaver's manuscripts.

A special thanks are due to all those who have allowed us to illustrate their paintings. The illustrations are credited individually but I am particularly grateful to Her Majesty the Queen, The Duchess of Devonshire, The Marquess of Tavistock, The Earl of Leicester, The Earl Spencer, The Lord Egremont, Sir Richard Hanbury-Tenison, Mr Anthony Cullen, Clifford Ellison, the Royal Highland and Agricultural Society of Scotland, Rothamsted Experimental Station and the National Trust. Many of the private collectors have preferred to remain anonymous but their co-operation from all over the world has been deeply appreciated.

Several art dealers have been extremely generous in providing help with the illustrations: Richard Green, Christopher Bibby, Andrew Thomas, Christopher Foley, William Marler, Ray O'Shea, Peter Johnson and Vicky de Rin.

I am extremely grateful to the many curators and custodians who have kindly given up their precious time to show me round collections normally hidden from public view: Lavinia Wellicome, John Gusterson, Roger Pegg, Hugh Cheape, Group Captain Carson, Marion Ramsay, Julia Collieu, Roy Brigden, Liz Allsopp, Chris Copp, Diane Perkins and Kai Kim.

Also thank you to the many people who found the answer to my queries through recourse to their archives or specialist knowledge: Ann Mitchell, Charles Noble, Jim Lawson, Jean Evans, Sally Ball, Albert Baer, Lyn Gibbings, Mike Clarke, Phillip Sheppy, Christine Jackson, Philip Ryder-Davies, Keith Chivers, Lewis Thomas and Judith Phillips.

Finally a special thank you to Primrose Elliott who so patiently edited the manuscript and incorporated dozens of alterations, my father who read the text and found it 'surprisingly interesting' and my nanny Melanie Brown who entertained Alastair and Oliver with unfailing cheerfulness through the long winter days.

Introduction

Surely these hideously misformed creatures could never have existed? Why then were farm animals of elephantine proportions bulging with rolls of fat and apparently incapable of supporting their weight on absurd and spindly legs painted in their thousands? It was my determination to answer this question which led me to embark on this book.

It has been a fascinating progress through a neglected aspect of British social history, revealing a way of life and a farming community long since vanished. In the mid-nineteenth century a shepherd's wages were £30 a year, yet a prize ram could sell for over 200 guineas such was the value attached to British pedigree livestock. Breeders and farmers were prepared to go to any lengths to secure the coveted prizes that conferred championship status on their animals. They resorted to stealth, creeping into their neighbours' folds and cowsheds to learn their secrets. They stooped to deception; animals were groomed and sheared into artificial shapes and their teeth filed to make them appear younger.

Today very few of us know our Shorthorn from our Hereford, our Cotswold from our Southdown, our Gloucester Old Spot from our Tamworth. For urban children, a cow is something black and white glimpsed from the window of a speeding car, but it was not always so. In the years covered by this book livestock breeding swept the country with the urgency of any newly created fashion. Thousands of people attended agricultural shows up and down the country. Debates were waged in the national press over the relative merits of one breed versus another. Animals of extraordinary dimensions were toured in horse- drawn caravans over impassable roads to entertain the crowds who flocked to see them.

Breeders had one thing in common; to impress their friends, clients and the world at large with the quality of the improved breeds. The paintings were commissioned to celebrate their show ring triumphs. Alongside silver trophies they decorated the farmhouse parlour and the Lord's estate office. In order to win, animals had to be bred to type. Small heads, legs and feet were desirable; the back of an animal had to be as long as possible and straight as an arrow. All the value of the beast was in the back quarter which consequently was painted as large as possible without stretching the bounds of belief too far. Fat was a prized commodity; as a much valued source of carbohydrate and for making tallow and a dozen other household uses. In the late eighteenth century fat animals were a delightful novelty. With the agricultural revolution had come both the resources and the genetic understanding to breed such animals and farmers were universally proud of their monstrous creations.

Only a few of the works illustrated here have come from public collections and one of the greatest challenges was tracking down a sufficient number of paintings. They have turned up in homes up and down the country from the stately mansions of Althorp and Woburn Abbey to humble cottages. Nothing has given me more pleasure than finding a painting still treasured by the descendants of the stocky yeoman farmer who commissioned it.

As the book developed it became clear that the paintings could not be treated in conventional art historical terms. They are painted to a formula, some badly, others with

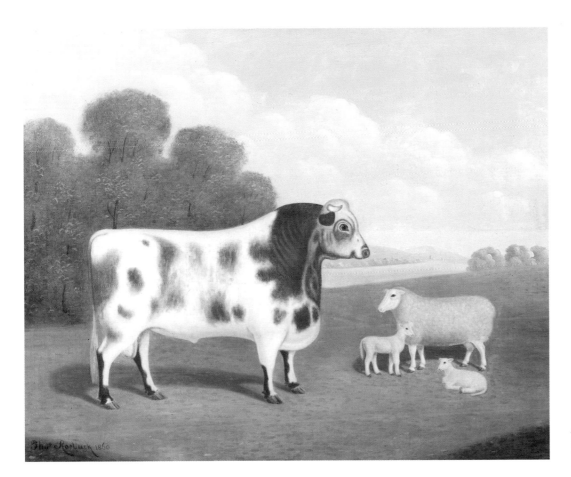

extraordinary charm, humour and skill, but there is no real artistic development within the genre. They are ciphers which come alive once their social and art historical context is understood. I have therefore tried to explain the unique conditions which gave rise to such an extraordinary school of painting and to chart the lives and outputs of those artists for whom we have any documentary evidence. In the second section of the book I have examined the development of our native breeds of livestock, providing in the illustrations a unique record of the now rare or extinct animals which once grazed these lands.

As trends in agriculture changed these paintings fell from fashion. The consumer wanted only lean meat, and the farmer standard shaped animals which conformed to modern retail requirements. Many animal paintings were neglected, thrown on bonfires or in the case of the Royal Collection sent to the Vicar of Windsor's rummage sale. When Stephen and Iona Joseph began collecting them some twenty-five years ago they were regarded with incredulity. Did you paint them yourselves was the question they were most frequently asked? In 1983 they took these painting to the Grosvenor House Antiques Fair, one of the most prestigious events in the international arts calendar, for the first time. In addition to their picture dealing business they have put together the finest private collection of farm animal painting in the world and thankfully they are no longer alone in their appreciation of these works. This book is above all a tribute to the Josephs' twenty-five years of dedicated collecting.

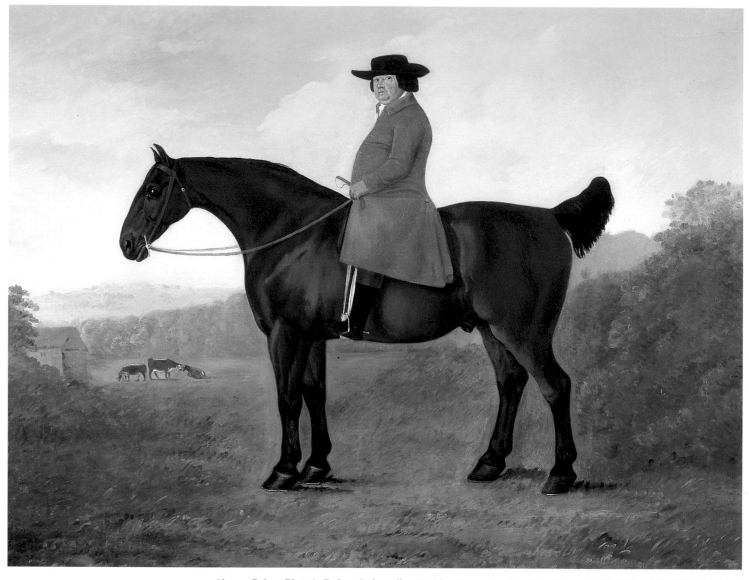

Above. Colour Plate 1. *Robert Bakewell at Dishley Grange* by John Boultbee, c.1785. 27½ x 36in. (70 x 91.5cm). Mounted on his bay cob with a group of Longhorns in the distance, Bakewell is portrayed as a sturdy yeoman farmer. At least three other versions of this portrait are known, one in the National Portrait Gallery and two in private collections. *Leicestershire Museums, Arts and Records Service*

Right. Colour Plate 2. *Longhorns and New Leicester Sheep with Dishley Grange* in the background by Thomas Weaver, 1802. Oil on canvas, 28 x 36in. (71 x 91.5cm).
Bakewell concentrated on improving two types of animal in particular, Longhorn cattle and Leicester sheep. He altered the appearance of both breeds into a more compact animal with small bones and heads, long straight backs, swelling rumps and the most weight in the valuable joints. This painting by Weaver is very similar in composition to an earlier painting by John Boultbee at Petworth House (Plate 20). *Private Collection*

CHAPTER 1
The Agricultural and Artistic Background

As the eighteenth century opened, farming in Britain had altered little since the Middle Ages. Over the next hundred years both agriculture and the nature of the countryside underwent sudden and dramatic changes. More than half the country was still open common, heath and moorland. A growing population and increasing demand for food made it worth while for landowners to enclose them. The Enclosure Acts, begun in the early eighteenth century, became even more drastic in the 1760s and made the transition from medieval to modern farming possible. Large areas of land could now be cultivated by a single landowner who therefore concentrated his energies on achieving higher and better yields to feed the rapidly expanding population. Between them Jethro Tull (1674-1741) and Charles Townshend (1674-1738) popularised the seed-drill, horse hoe and the principle of crop rotation. The resulting improved fodder crops meant that more animals could survive the winter, producing extra manure to fertilise the fields and ensure a better crop the following year.

Higher grain yields were not enough. Over the course of the century the population almost doubled to just under ten million. Forced off the land and evicted from their homes, people were moving from the country to the towns in their thousands. If they were not to starve something had to be done to feed them. Robert Bakewell (1725-1795), a Leicestershire farmer (Colour Plate 1), came up with a revolutionary concept. By experimenting with selective breeding he was able to develop new breeds of livestock which could produce double the amount of meat on less feed in half the amount of time (Colour Plate 2). His aim was to put meat on the table of every family in the country and his new philosophy encouraged the breeding of animals of the most extraordinary size and dimensions. Weights at this period were not standardised. Several systems existed side by side. Not only could the number of pounds to a stone vary from eight to fourteen, but ounces and pounds varied according to the system being used. This makes any accurate evaluation of the animals' weights extremely difficult and effective comparisons between one animal and another impossible. The outbreak of war with France in 1803 lent greater urgency to the agricultural situation as the country was now entirely dependent on home production. British farming enjoyed a massive expansion until the defeat of Napoleon in 1815.

Bakewell's experiments in animal breeding and crop management revolutionised British

Plate 1. *John, Sixth Duke of Bedford (1766-1839)* by George Garrard, engraved by George Garrard, 1806. 11 x 7in. (28 x 18cm).
Inscribed: *His Excellency John Duke of Bedford. Vice Roy of Ireland. View Woburn Abbey. From the original picture in the possession of Lord Somerville.*
Francis 5th Duke of Bedford was the first President of the Smithfield Club. On his death in 1802 his brother John became Duke. The 6th Duke continued as president until 1813, the year he also discontinued the Woburn sheep-shearings. Lawes Agricultural Trust, Rothamsted Experimental Station

Plate 2. *Portrait of Lord Somerville* after Samuel Woodforde. 10¾ x 7in. (27.5 x 18cm).
Inscribed: *John Fifteenth Lord Somerville. President of the Board of Agriculture.*
Somerville (1765-1817) was one of the largest breeders of Merino sheep and was also interested in agricultural machines. His improved plough is seen in the background. University of Reading, Rural History Centre

farming and profoundly influenced the agricultural revolution. His experiments represent one of the earliest forms of genetic engineering. He awakened the country to the concept that certain characteristics could be selected in individual livestock and perpetuated and fixed in their progeny so that after several generations a new breed was established. Before this there had been almost no attempt to improve the quality of livestock. Breeds were local, varying from one county to another. The fortunes of the British landowners had been based on wool and arable crops and meat had always been a tertiary consideration. The fashion for livestock breeding swept the country. From George III downwards, everyone wanted to share in the modern agricultural improvements. 'We are all farmers now', wrote the journalist, Arthur Young, 'from the Duke to the apprentice'. The King set up model farms at Windsor, Kew and Mortlake, stocking them with the new breeds of sheep and cattle. He even contributed a series of articles to *The Annals of Agriculture* under the pseudonym of Ralph Richardson. Farming was a great social leveller; the Duke of Bedford (Plate 1), Lord Somerville (Plate 2), Lord Egremont and Thomas Coke (Colour Plate 11), later Lord Leicester, were the key political figures in the agricultural movement. They competed on equal terms with yeoman farmers to develop the finest examples of the new emerging breeds of livestock.

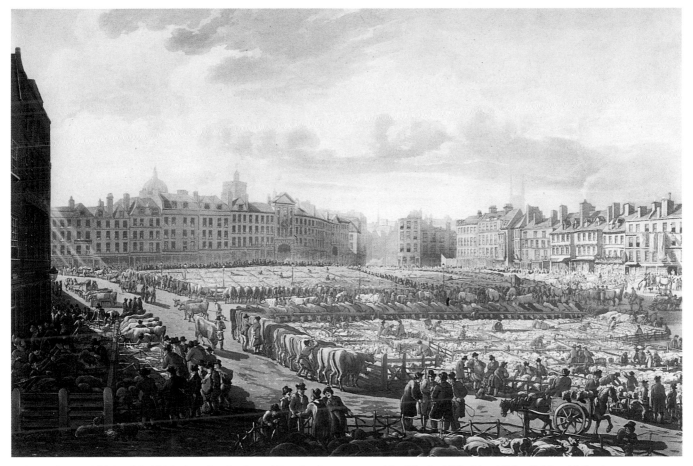

Colour Plate 3. *Old Smithfield Market* after Pugin and Rowlandson, engraved by Bluck, 1811. 14 x 19½in. (35.5 x 49.5cm).
Inscribed: *A bird's eye view of Smithfield market (taken from the Bear and Ragged Staff).*
London's meat market was crammed into squalid, inadequate premises in Smithfield until the increased volume of cattle finally forced its removal to larger premises in Islington (Colour Plate 89). Lawes Agricultural Trust. Rothamsted Experimental Station

The widespread availability of new foods such as fodder crops and oil cake for fattening animals, combined with Bakewell's experiments, dramatically improved the size of British cattle. At Smithfield in 1710 the average weight for beeves was 370lb., for calves 50lb., for sheep 28lb. and for lambs 18lb. In 1795 these figures had risen to 800lb. for beeves, 148lb. for calves, 80lb. for sheep and 50lb. for lambs. In the early 19th century London's meat market remained in the old medieval market of Smithfield which lay in the angle formed by the Thames and Fleet rivers (Colour Plate 3). Before the invention of the railways and refrigeration meat was sold 'on the hoof' to the butchers who removed the animals for slaughtering. Roads with stops for resting the stock overnight led to Smithfield from all parts of the country and inns with stockyards where the animals could be housed overnight sprang up all over the area. It was at the Dolphin Yard at Wooton's Livery Stables adjacent to Smithfield that the Smithfield Society's first cattle show was held. The number of cattle received at Smithfield rose from 76,210 in 1734 to 109,064 in 1794. By the mid-nineteenth century it was unable to cope with the volume of animals and moved to new premises in Islington (Colour Plate 89)

Bakewell long remained a favourite toast at agricultural dinners. At the Holkham Sheep-shearing in 1813 Thomas Coke proposed a toast to 'The Memory of Mr Bakewell' stating 'on the authority of the London butchers, that there was more than double the quantity of meat upon the same quantity of bone to what there was 15 years ago.'

It was a period of extraordinary experimentation. Steamed potatoes, carrots, cabbages, seaweed, Scots pine shoots, clover and oil cake were all fed to cattle to see which was the most

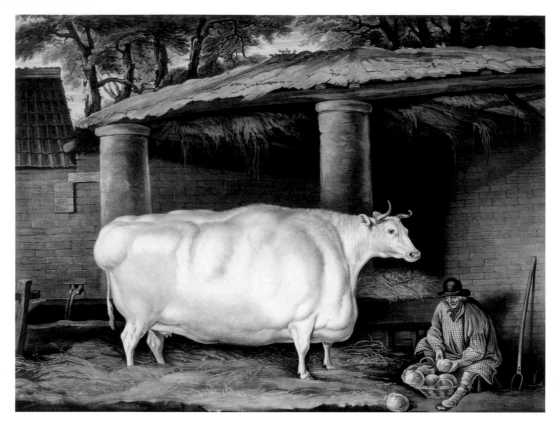

Colour Plate 4. *A Shorthorned Heifer, Seven Years*, unknown artist after Thomas Weaver, c.1840. Oil on canvas, 20 x 26 in. (51 x 66cm).
One of Robert Colling's most famous animals, the White Heifer toured England as an exhibition animal. She is shown here outside a byre with a man slicing turnips to show she was reared in the 'improved' way.
From the Collection of Mrs George Riley

suitable. Animals were fed on a carefully regulated diet and the results of how each had performed were compared. 'Mark' and 'Spot', two of the Duke of Bedford's cattle, were wintered on turnips and hay and kept on short rations to make them take the oil cake which was introduced in March before they went into the pasture in April. Long before the formation of the Royal Agricultural Society of England with its annual national show in 1838 (as the English Agricultural Society), farmers had begun organising themselves into local agricultural societies to promote the new farming techniques and encourage breeds and practices unknown to that locality. The forerunners to the agricultural shows were the lavish private shows held by the nobility. Thomas Coke and the Duke of Bedford held their annual Sheep-shearings in June each year, the one at Holkham following on a few days after that at Woburn. Lord Somerville held a private show in London for two days during March at Sadlers Yard in Goswell Street, the site of the Smithfield Show where livestock from all over the country competed in different classes. Lord Somerville presented all the prizes and entertained two to three hundred for dinner. Lord Egremont gave the Petworth Fair the character of an agricultural show, presenting prizes to farmers for improved livestock.

Celebrated animals were also exhibited at these shows. Writing to the artist Thomas Weaver on 5 November 1811, the Shorthorn breeder Robert Colling describes how the White Heifer (Colour Plate 4) will be in London for the Christmas Smithfield show and goes on to say, 'I lately had a good deal of conversation respecting her with Lord Somervil, who was so very obliging as express his particular wishes that she might also be exhibited at his show, which I suppose be about another six weeks after the other...his Lordship said how his was more numerously attended than the one at Smithfield.' This would seem to contradict Lord Somerville's statement that 'his reasons for admitting the famous Craven and Durham Heifers to be seperately shewn for money in the yard, contrary to his custom, to be at the earnest request of the land-owners, the Duke of Devonshire and Mr Robert Collings'. The White Heifer was one of the Collings' most famous animals. She was fattened as an exhibition animal rather than being used for breeding. She was said to weigh 164 stone and travelled to all the

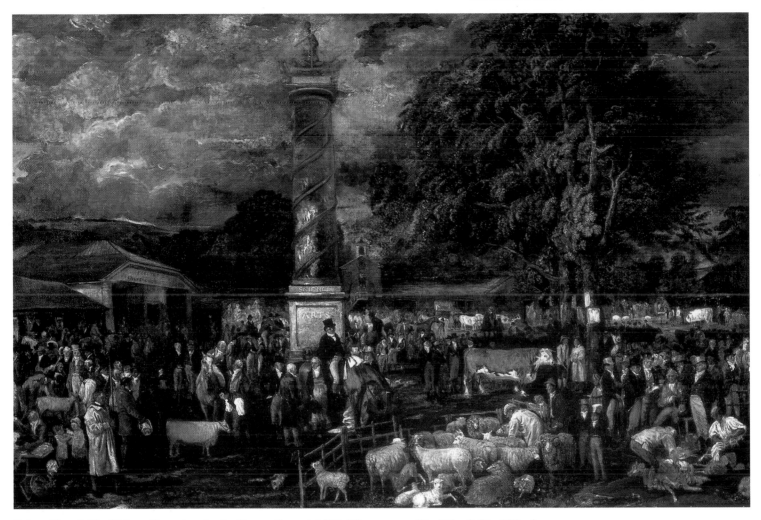

Colour Plate 5. *The Woburn Sheepshearing* by George Garrard, 1804. Oil on canvas, 52 x 78in. (132 x 198cm). Garrard's painting is a composite view of many of the activities which would have taken place at separate times. John, 6th Duke of Bedford, is seated on horseback in the centre of the composition, a sheepshearing competition takes place in the foreground, to the left the Duke's sheep are being led out for inspection and elsewhere other breeds of livestock and agricultural implements are being displayed. The artist is depicted in the bottom right-hand corner presenting models of his cattle to the Duke's children.

By kind permission of the Marquess of Tavistock and the Trustees of the Bedford Estates

major agricultural shows all over the country for exhibition.

By 1803 at least thirty-two local agricultural societies had been formed, all of which had their own annual shows which included classes for the exhibition and judging of livestock. The first agricultural show to be held was that of the Bath and West of England Society in 1797 under the auspices of its chairman Lord Somerville. The Duke of Bedford was one of the judges and several members of the nobility as well as two hundred farmers attended. The Sussex Agricultural Society held its first show at Lewes the following year and in 1799 the newly formed Smithfield Club held the first of its annual Christmas shows dedicated almost entirely to the judging of livestock. Soon Christmas fatstock shows and markets were being held all over the country. Animals could now be judged and compared with one another and details of feeding, breeding and carcass weight exchanged. Gaining a prize was not only a matter of pride; it added considerable value to one's stock.

Garrard's painting of *The Woburn Sheepshearing* (Colour Plate 5) provides a perfect introduction to the agricultural world at the turn of the century. Little is known about the commission, but it was painted after the 5th Duke's death when his brother John had assumed the Dukedom.

6

7

8

9

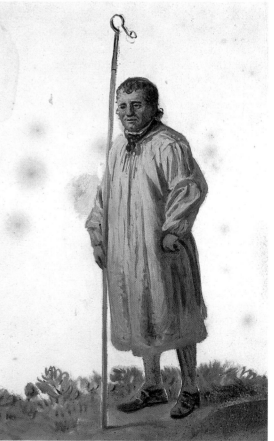

10

Colour Plates 6, 7, 8, 9, 10. *Sketches for the Woburn Sheepshearing* by George Garrard. 11 x 7in. (28 x 18cm). Arthur Young. Lord Winchelsea. Samuel Whitbread. Sir Joseph Banks. Holland the Shepherd.

Garrard executed portrait sketches of many of the figures for his ambitious composition of the Woburn Sheep-shearing. The one of Samuel Whitbread is of particular interest as the figure was later painted out possibly after his suicide.

The blurred edges of the images are due to the oil medium of the paint staining the paper.

By kind permission of the Marquess of Tavistock and the Trustees of the Bedford Estates

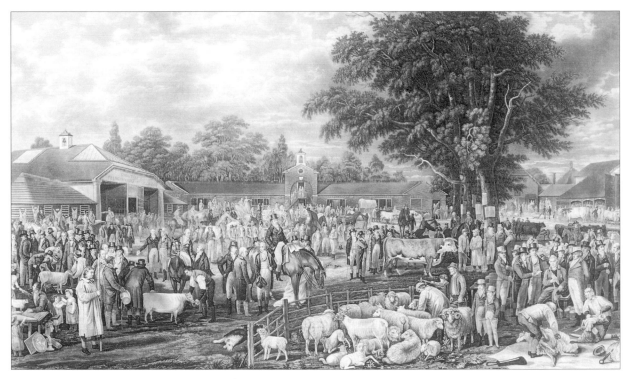

Plate 3. *Woburn Sheepshearing* after George Garrard, engraved by M.N. Bate, J.C. Stadler, T. Morris, G. Garrard, 1811. 18 x 29¼in. (46 x 74.5cm). Inscribed: *Wobourn* [sic] *sheepshearing. Dedicated by permission to his Grace the Duke of Bedford, by His Grace's most obedient and very humble servant, George Garrard.*

The description begins at the left-hand corner. 1st the Shepherd (1) leaning on his crook, a Southdown tup, led out by a Shepherds boy (2). Portraits, Sir Andrew Corbett (3), H. Hanmer (4), Messrs. Reeves (5), Honnibone (6), Stubbins (7), Dr. Cartwright (8), Sir Thos. Hanmer (9), Mr. Smith (10), Lord Dundas (11), the Revd. Bate Dudley (12), Rt. Honble. John Foster (13), Marquis of Tavistock (14), Ld. Ludlow (15), Ld. Thanet (16), Conyers (17), Towers (18), & Rt. Bing (19), Esqrs. Messrs. Wilson (20), Buckley (21), Walton (22), Stone (23), & Runciman (24). Sir Thos. Miller (25), Mr Fary (26), Sectry to the Smithfield Club. Dr Yates (37) of Bedford. The Revd. Mr Smernhove, Envoy from Russia (27). To commemorate the encouragement given by the late and present Dukes of Bedford, to the art of modelling cattle, an artist is represented in the foreground distributing models to the four infant sons of his Grace, Lord Wriothorsley (28), Lds Edward (29), Charles (30), and Ld Francis John (31), this compartment is releived [sic] by the Exhibition Room, on which the prize carcases are hung.

2nd In the centre of the picture a portrait of his Grace the Duke of Bedford (32), mounted on his favourite Irish mare, inspecting a piece of broad cloth, presented by Mr. George Tollet (33) of his own Merino growth. Ld. Somerville (34), Mr. Chas. Gordon Grey (35) and Mr. Curwen M.P. (36), form the principal group, a shepherd (38) leading out a new Leicester tup. Portraits of Ld. Winchelsea (39), Sir Watkin William Wynne (40), H.R.H. the duke of Clarence (41), and Mr. Elman (42). In the background, Mr. Northey M.P. (43) on horseback inspecting some Swedish turnips, presented by Mr Thos. Gibbs, M Astley (44), Lord William Russell (45) – Charles Callis Westurn Esqr. M.P. (46), Sir Charles Bunbury (47), Hugh Hoare (48) and Lee Antony Esqrs. M.P. (49), Ld. Sheffield (50) and Mr. Sitwell (51), Mr Marshall (52) author of agricultural works, and Sir Thos. Carr with other gentlemen inspecting a pair of Scotch oxen – also portraits Sir Harry Fetherstone (91), Major Battin (90), Ld. Egremont (89), and an extended group of carriages and horsemen.

3rd The Duke of Bedfords second and third sons painted in 1805, Ld William (54) and Ld John (55) Russell, in the foreground Samuel Whitbread (56) and William Adam (57) Esqrs. M.P. speaking to a herdsman, Mr. Isted (58) and

Coll. Cunningham (59) inspecting cattle, also Messrs. Lechmere (60), Westcar (61), Wakefield (62), and Crook (63), the late Godfrey Thornton (64) and Mr. Higgins (65), Ld. Ossory (66), the Duke of Manchester (67), Lord Bridgewater (68), and an extended group of Noblemen and Gentlemen. – In this part of the composition the principal animals consist of a group of sheep of various breeds. In the foreground Southdown (A), Leicester (B), Welch (C) and Spanish (D). The Oakley Hereford Bull (E) under the trees, the Wobourn Ox feeder at the head of the bull talking to Mr.Westcar's herdsman who fed all the beautiful oxen that have been sent from Creslow. In the distance before the carthorse stable, a Suffolk Punch (F), yokes of oxen, & c. & c.

4th Arthur Young (69) Esqr. Sectry to the board of Agriculture, conversing with Sir John Sinclair (70), Presd. B.A., Sir Joseph Banks K.B. (71), and Thos. Willm. Coke (72), Esqr. M.P., Messrs. Overman (73) and Monyhill (74), Davy (75), the celebrated chemist, Messrs. Pickford (76), Moore (77), Reynelle (78), and Oakley (79), Sir George Osborne (80), Sir John Sebright (81), Coll. Beaumont (82), Mr. Praed Jnr. (83), Mr Waters (84) and Mr. George Baker (85) of Durham., in the distance the Revd. Mr. Hutton (86) Mr. Salmon (87) Resident Surveyor, leaning on a plough conversing with Mr.Leicester (88) implement maker. In this compartment of the picture the Durham or Teeswater (G) fat ox & Scotch (H) bulls are seen, in front of the great barn, the fat pigs in the distance, a Devon heifer, with other cattle and sheep under the trees. Two men shearing for a prize in the foreground, in the presence of the leading members of the Board of Agriculture above mentioned.

The numbers over the names refer to numbers on or near each of the portraits which are readily seen with a glass. Stipled and outline etched by M.N. Bate figures and landscape by J. C. Stadler lined by T. Morris, pupil to the late celebrated Mr. Woollet the whole touched and arranged by the original painter. Painted and published by G. Garrard A.R.A. 4 Queens Buildings, Knightsbridge, May 31, 1811. London.

The engraving is much clearer to read than the original painting and the inclusion of a key has made it possible to identify all the characters, although the numbers can only be read under a microscope. Garrard's detailed prospectus for the print was published in the *Agricultural Magazine* vol.V111, no.XLIV, February, 1811, pp.87-90. This is reprinted in the Mall Galleries Exhibition Catalogue, *This Land is Our Land*, p.54.

Courtesy of the O'Shea Gallery

Plate 4. *Viewing the Prize Beasts – Sketch'd at Hotham*, unknown artist, 1810. Coloured engraving. 8¼ x 12¾in. (21 x 32.5cm).
Beamish. The North of England Open Air Museum

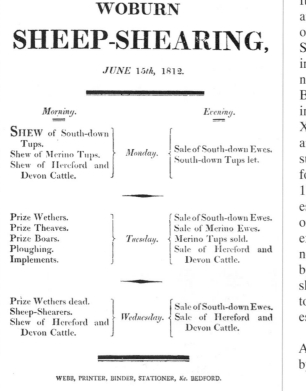

John, 6th Duke of Bedford, continued his brother's interest in agricultural reform. Garrard was an ambitious artist and a good self-publicist and he may have suggested the subject as a way of ingratiating himself with the most eminent agriculturalists and thus gaining further commissions. Copies of the engraving (Plate 3) were circulated at the annual dinners held at Smithfield and similar events and Garrard made a point of appearing at the Woburn Sheep-shearing and Lord Somerville's and the Smithfield Show in London to advertise the print. Eighty-eight characters are included in the painting which would have guaranteed sales. Royalty and nobility are present along with farmers, stock breeders and humble shepherds. By 1800 the Woburn sheep-shearing (begun in 1797) was attracting an international audience; the Tsar of Russia sent his representative and Louis XVIII attended while in exile in England. The Duke entertained between two and three hundred to dinner at the Abbey on three consecutive days. The surrounding roads were choked with traffic and many were forced to walk. It followed a very similar format to the Sheep-shearings begun at Holkham in 1778. Those assembled could view the enlightened farming practices on the estates. All sorts of events took place: ram letting for the next season, the sale of livestock from the estate, sheep-shearing and ploughing competitions, the exhibition of agricultural implements and the judging of livestock which was not confined to animals bred on the estate. The event was further enlivened by a competitive sweepstake on who would carry off the prizes. The Woburn shearings were finally discontinued in 1813 when the Duke of Bedford went to live abroad. The expense may also have become too great for a private estate to maintain.

The scene takes place in the range of model farm buildings laid out at Woburn Abbey by Henry Holland and Robert Salmon in about 1780 and now occupied by Lady Tavistock's Bloomsbury Stud. The Duke of Bedford occupies the

Plate 5. Schedule for Woburn Sheep-shearing. Beamish. The North of England Open Air Museum

Plate 6. *Arthur Young* (1741-1820) by John Russell, 1794. Pastel on paper, 24 x 17¾in. (61 x 45.5 cm). Young was the most influential journalist of his day and an admirer of Robert Bakewell whose new techniques he did a great deal to promote. He published a journal, the *Annals of Agriculture,* between 1784 and 1815 and was disappointed that it was not more widely read. He was appointed first secretary to the Board of Agriculture, and served on the committee of the Smithfield Club. Young was fascinated by agricultural experiments and is reputed to have conducted over 3,000 experiments by his death. Ironically he always lost money at farming. He travelled more than 20,000 miles on his blind white horse, recording the state of agriculture as he went.

By courtesy of the National Portrait Gallery, London

central position of the picture seated on his favourite Irish mare; he is being handed a piece of cloth woven from his own Merino sheep. Interestingly the second most prominent person in the picture is Holland, the chief shepherd, placed closest to the picture plane on the right of the painting and distinguished by his white smock and shepherd's crook. His faithful dog lies watching the sheep in the fold. Just some of the other nobility present in the painting include H.R.H the Duke of Clarence, Lord Somerville, The Earl of Egremont, Lord Winchelsea, Lord Bridgewater and the Duke of Manchester. Sir Joseph Banks is seated on the far left together with the journalist, Arthur Young, notebook in hand and Sir John Sinclair, President of the Board of Agriculture. Samuel Whitbread, the brewer and agricultural reformer, was originally standing under the tree on the right-hand side but for some reason, possibly after his suicide, was painted out. Garrard has identified every breeder in the painting and they include Mr Honeyborn, Bakewell's nephew, Mr Ellman, the Southdown breeder, Mr Westcar, the Hereford breeder and many others.

In the foreground, two men are shearing for a prize watched by leading members of the Board of Agriculture. On the right a Southdown tup has just been led out for inspection. In the far distance on the right-hand side can just be made out the Durham Ox and opposite him the fat Devon Heifer which gained a prize at Smithfield in 1802. Behind the Devon heifer fat pigs are exhibited and to the right of the Duke of Bedford Mr Westcar's Oakley Hereford bull is on display. A sketchbook survives for the painting with studies of many of the principal characters. They have a liveliness and fluidity missing from the rather laboured finished painting which suggests Garrard had to sketch them rapidly rather than from formal sittings. On the far left-hand side Garrard includes a portrait of himself seated at a table piled with his prints and models of cattle. Lord Edward, one of the Duke's sons, has just been given a model sheep while Lord Charles, the baby, is receiving a model lamb. Several of Garrard's models still survive at Woburn. In 1811 Garrard published a print (Plate 3) with a detailed legend which has made it possible to identify all the different characters for posterity.

Livestock painting developed against this background of experiment and competition. Agricultural journalists like William Marshall (1745-1820) and Arthur Young (1741-1820, Plate 6), who published his *Annals of Agriculture* from 1784-1815, did much to disseminate information. Young was secretary to the Board of Agriculture established by William Pitt in 1793 where he was responsible for organising the publication of a series of county agricultural surveys. Other farming periodicals to serve the general interest in improvements followed; *Bells Weekly Messenger* was begun in 1796, the Edinburgh *Farmer's Magazine* in 1800 and *Evans and Ruffy's Farmers Journal* in 1807. In the Victorian period the number of agricultural journals increased dramatically; they took on a more scientific aspect with specialist publications on dairying, stock breeding and poultry. The two most influential were the London based *Farmer's Magazine* begun in 1834, edited by J.C. Morton, and the *Mark Lane Express* edited initially by Henry Shaw and later by Henry Corbett. The *Farmer's Magazine*

published a series of engravings of cattle, sheep, pigs and horses in every volume until the last in 1881. However, in an age where much of the population was illiterate, the best way in which information on the new breeds could be circulated was through exhibiting the animals up and down the country and commissioning paintings and prints of them.

Many of the early paintings and prints were commissioned by farmers, to advertise their new improved herds. By the 1790s knowledge of Bakewell's experiments had percolated beyond the circle of eminent agriculturists to a more popular level. Exhibiting cattle of immense proportions was not new; Yorkshire, Lincolnshire and Durham had long been famous for large cattle and in 1724-27 Defoe comments on their large size adding that from Sir Edward Blackett's park near Ripon on two or three occasions an ox had been 'led as far as Newcastle and Scotland, for the Country for a Sight and shewed the biggest Bullock in England'. There is however a distinction between 'fat' animals and the so-called 'improved' breeds which Bakewell's experiments had made possible. Farmers were now interested in the pedigree and conformation of an animal. The first herd book to be established was that of the Shorthorn in 1822 and the breed can trace its ancestry as far back as the animals bred by the Collings near Darlington in the 1780s.

It is important to understand the distinction between the travelling exhibition animals of massive proportions and the valuable pedigree animals used for breeding. The former were oxen (castrated bulls) or heifers (a cow which has not been mated) which were fattened for seven years or more to see how large they could grow. Today, with the fashion for lean, tender meat, the majority of cattle, unless they are dairy cattle, are slaughtered by about eighteen months. Young castrated males are known as steers or bullocks and today oxen and heifers are not bred to such ages or amazing dimensions which partly explains why many nineteenth-century cattle paintings appear so extraordinary.

The most famous animal of all was the 'Durham Ox'. At least five different versions of prints of him are known and his image recurs throughout nineteenth-century agricultural literature. The most popular print, executed in 1802 when the ox was first exhibited, sold more than 2,000 copies in its first year of publication. Prints of prize animals were found in inns and coaching houses throughout the country publicising the most celebrated beasts in the locality. Prize animals were also used to decorate ceramics. The Durham Ox appears on an entire blue and white Staffordshire dinner service, and a Coalport cup in the Ironbridge Gorge Museum is decorated with a heifer and inscribed: 'Peach the Broughton Prize Heifer bred and fed by Sir Chas R Tempest Bart 1843'. The Durham Ox toured the country in a specially constructed carriage which was drawn by four horses; if the going was tough six horses had to be resorted to.

The breeding details of the animal are given in Chapter 4 (page 176). The animal was famous not only for its extremely large size but for its perfect shape and configuration. John Day, the owner of the animal, wrote a pamphlet entitled an 'Account of the Late Extraordinary Durham Ox'. He described the perfect characteristics for an ox to which the Durham Ox conformed in every respect:

> Head rather long, and muzzle fine–eyes bright and prominent–ears long and thin–neck gently arching from the shoulders, and small close to the head–breast broad, and projecting before the legs–fore thighs muscular, and tapering to the knee–legs clean, and fine boned–back broad, straight, and flat–hips wide placed, round, and rather higher than the back–carcase, on the whole, nearly round.

The animal was also praised for its ability to fatten quickly on a modest amount of food and for the excellent cut and quality of its carcass. Day gives conflicting information for his

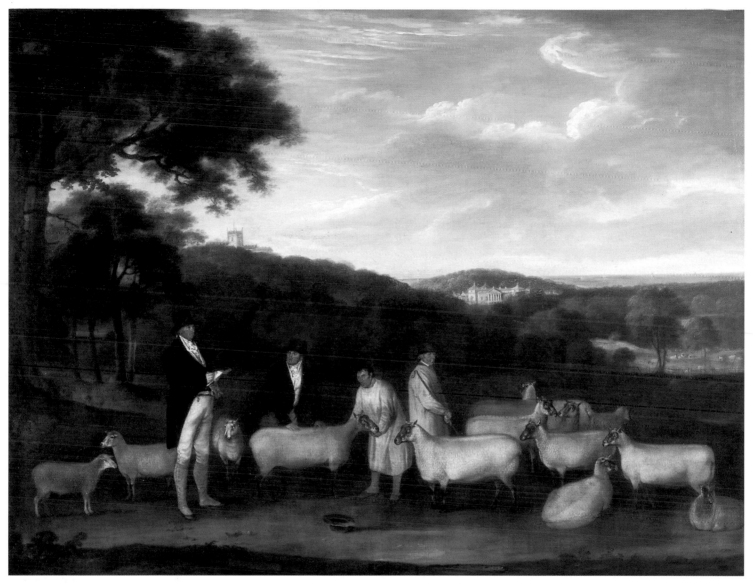

Colour Plate 11. *Thomas Coke and his Southdown Sheep* by Thomas Weaver, 1807. Oil on canvas, 47 x 78in. (119.5 x 198cm).

Thomas William Coke (1752-1842), created first Earl of Leicester, 1837, was one of the great figures of the agricultural revolution. His uncle the first Thomas Coke (1697-1759) built Holkham Hall, seen in the distance, and enclosed the estate with hedges. Thomas William Coke carried on his improvements building a model farm designed by Samuel Wyatt. He was a noted breeder of Southdown and Merino sheep and Devon and Hereford cattle. In 1778 he turned his annual sheep-shearings into a public gathering which heralded the formal agricultural shows. Farmers could meet, display their livestock, discuss contemporary ideas and learn from Coke's exemplary methods. He is depicted here inspecting his Southdown sheep, notebook in hand, demonstrating the meticulous records he kept. An entry in Weaver's diary identifies the other figures as Mr. Walton and two shepherds, Old Leonard and son. Weaver was paid 63 guineas for this painting.

By kind permission of the Earl of Leicester and the Trustees of the Holkham Estate

weight. In the print he commissioned in 1802 he tells us he 'weighs according to the computation of the best judges 30 score pr Quarter, which is 300 Stone 8lb to the Stone or 171 Stone 14 lb to the Stone'. In his pamphlet, however, he records the weight of the animal as 27 cwt or 216 stone at 14 lb to the stone when he purchased him in 1801 aged five years old, rising to 34 cwt or 272 stone five years later. (A hundredweight equals 112lb.) Portraits of the ox were also painted by George Garrard and Thomas Weaver. The publicity print commissioned

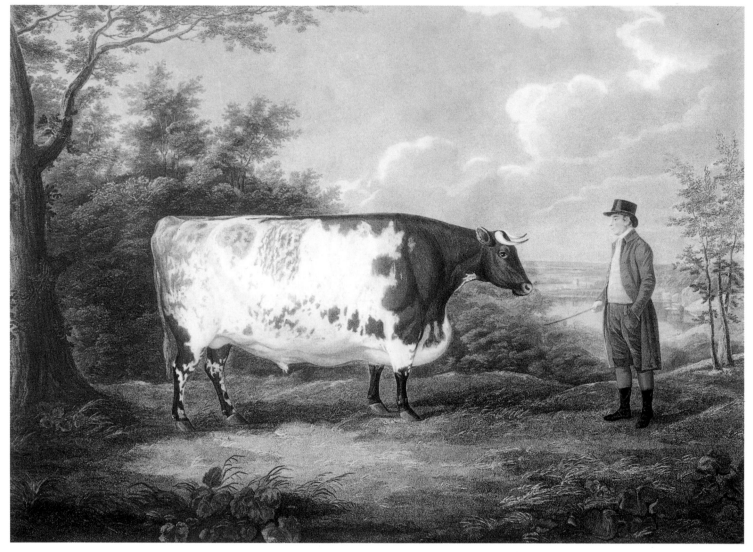

Colour Plate 12. *The Durham Ox* after J. Boultbee, engraved by I. Whessel. 1802. 17¾ x 23½in. (45 x 59.5cm). (See Colour Plate 54 for Boultbee's original version.)

Inscribed: *The Durham ox. To the Right Honourable Lord Somerville this print is with great respect humbly dedicated by his Lordship's most obedt. servant John Day. This wonderful animal is now the property of Mr. John Day of Harmston, near Lincoln, and was, March 20, 1802, six years old. Dimensions: Height at the shoulders, 5'6"; Length from the nose to the setting on the tail, 11'0"; Girth, 11'1"; Breadth across the back in three places: across the hips 3'1", across the middle of the back 3'1", across the shoulders squared on each side, 3'1"; Breadth of the first rib, 9¼"; Girth of the fore leg below the knee, 9¼"; From the breast to the ground, 1'6"; Breadth between the fore legs, 1'5".*

Subscriptions taken for this print in the first year, amounted to two thousand upwards, from whence the Public opinion of this beautiful animal may well be ascertained. This Ox is still in a growing and improving state, and weighs according to the computation of the best judges 30 score pr quarter, which is 300 Stone 8lb to the Stone, or 171 Stone 14 lb to the Stone.

Courtesy of the O'Shea Gallery

by John Day (Colour Plate 12) makes an interesting comparison with Garrard's print, which we know to be accurate (Colour Plate 13). According to Garrard's measurements in 1800, his height at the shoulders was 5ft.5in. Two years later in Day's print the animal has grown by an inch to 5ft.6in.

From May 1801 to February 1807 the Ox criss-crossed the country from Southern Scotland to Wales and was exhibited at two hundred venues. In 1802 he spent nearly a year in London where takings on one day alone amounted to £97. Otherwise the length of a stay in one place varied from a day to three months spent in Edinburgh in the winter of 1803-04. In his wake

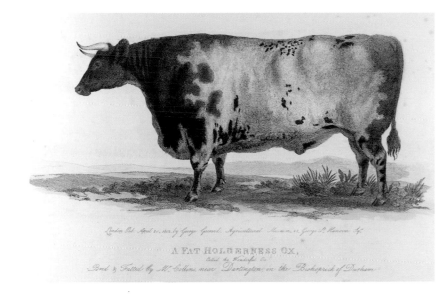

Colour Plate 13. *A Fat Holderness Ox called the Wonderful Ox* ('The Durham Ox') by George Garrard, 1802. 13 x 17in. (33 x 43cm).
Inscribed: *Bred & Fatted by Mr Collins near Darlington in the Bishoprick of Durham.*

Height of:	Ft.	In.	Q.
Hind quarters	5.	5.	½
Shoulder	5.	5.	0
Knee	1.	2.	0
Hock	1.	11.	0
Round the chest	10.	1	

By kind permission of the Marquess of Tavistock and the Trustees of the Bedford Estates

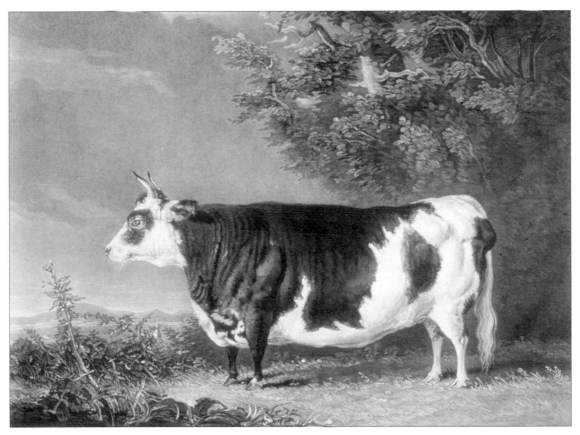

Plate 7. *West Highland Heifer Kyloe* after T. Bewick, engraved by C. Turner, 1823. 15½ x 20¾in. (39.5 x 52.5cm).
Inscribed: *This print of the West Highland heifer Kyloe. Is dedicated with permission to the Right Honourable Lord Redesdale & c. & c. by his much obliged and obedient humble servant Hilton Middleton. This extraordinary animal, 5 years old, bred in the Isle of Skye, fed by Mr. H. Middleton of Newton near Darlington in the county of Durham, measures only 3'5" in height, and weighs upwards of 105 stone 8lb to the stone. This breed of cattle stands unrivalled as the first in the kingdom for quickness of grazing and superior quality of beef, and at all markets one third more is given for them unfed (according to their weight) than any other breed whatever. The Newton heifer was fed with the view of bringing the breed into more general notice, and is allowed by the first judges to be the fattest ever seen, with the least coarse beef to its weight.*

With its small horns and black and white colouring this ugly looking animal is not typical of the majority of Highland cattle of the period. It was common practice for animals bred in the Highlands to be sold to specialist graziers in England for fattening. They fell from favour as people demanded beef obtained from younger animals fed on fodder crops closer to the London market. This print was commissioned to publicise a breed already losing out to the Shorthorn and the Hereford.

Lawes Agricultural Trust. Rothamsted Experimental Station

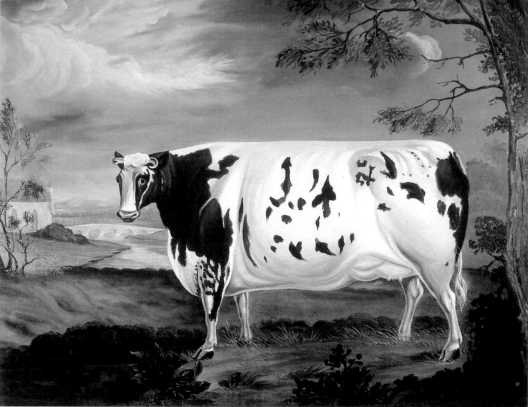

Colour Plate 14. *The Craven Heifer*, unknown artist. 21 x 25in. (53.5 x 63.5 cm).

Bred in 1807 by the Rev W. Carr on the Duke of Devonshire's estate, this animal was so large a special door twice the width of its neighbours had to be built to enable her to enter her loose-box. She weighed 312 stone (8lb. to the stone) or 176 stone 4lb. (14lb. to the stone) and measured 11ft.4in. from her nose to the tip of her tail. Most of the enormous cattle in the early 19th century came from Yorkshire, Lincolnshire and Durham. Like many of her contemporaries, she was sent to London to be exhibited at the Smithfield Show; the journey from Wakefield to London lasted seventy-three days and she was exhibited at many of the towns and cities along the route. Several versions of this painting are known, each varying slightly in the background detail. The heifer met an ignominious end when she was competed for in a cockfight.

Collection of J.H.G. Garnett

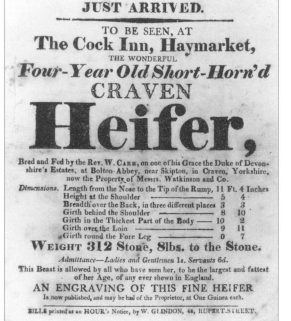

dozens of pubs were named after him; there is even a Durham Ox Inn in a remote corner of Victoria, Australia. Despite his large size and dreadfully idle life, Day tells us that he was capable of 'leaping over a water-trough, two feet high' and Day's 'wife, who rode with him in the carriage, found him harmless as a fawn, and familar as a lap-dog'. Apart from an annual fit of the 'yellows', which we can surmise to be jaundice brought on by his unnaturally confined lifestyle, the animal enjoyed good health. He was slaughtered at Oxford on 15 April 1807 when 'by an unfortunate accident, he dislocated his hip-bone' and nothing could be done to save him.

There seems to have been a vogue for exhibiting 'improved' animals early in the century when public interest in the new breeding was at its height. They were transported either in specially constructed machines which were drawn by horses as was the 'Durham Ox' or they walked often hundreds of miles resting at regular intervals to eat and ensure they did not lose too much weight and condition. As well as advertising the animal, prints provided an additional source of income. Subscription to a print appears to have guaranteed free entry to the exhibition (see page 59) and provided an attractive souvenir. After about 1845 the number of prints published tails off dramatically. Photography of farm animals was not yet developed and engravings were still made but usually in book form or for illustration in journals and periodicals. The majority of the large cattle prints which were published before 1845 were issued privately, either by the breeder or the artist, and one must assume that after this date there was no longer sufficient popular interest to make publication financially

Plate 8. Poster advertising the Craven heifer. Acounts relating to her journey detail the amount spent on the heifer's food, bills for stabling and horses for conveying the animal on various stages of her journey.

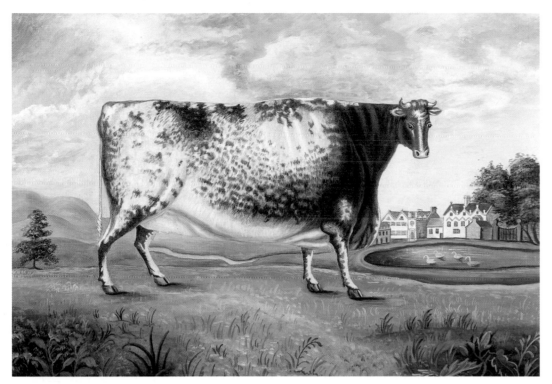

Colour Plate 15. *The Airedale Heifer.* unknown artist, c.1840. Oil on canvas. 21½in. x 26½in. (54.5 x 67.5cm). Bred by Mr William Slingsby at Carlton in Craven and fed at Riddlesden Hall, near Keighley in Yorkshire, the heifer was one of the biggest cows to come out of Yorkshire. Her dimensions were roughly equivalent to the Lincolnshire ox weighing nearly 24 cwt. dead weight.
Private Collection

Colour Plate 16. *The Durham White Ox* after George Garrard, engraved by William Ward, 1813. 18 x 23¾in. (46 x 60.5 cm).
Inscribed: *The Durham White ox. Of the improved Tees Water breed. Bred and fed by John Nesham Esqr. of Houghton le Spring, Durham. Weight 233 stone of 14 lb; Through shoulder point, 4'0"; Height of shoulder, 5'4"; do. Rump, 5'5"; From tail to pole, 8'6"; Round shin bone, 8½"; Across huggins, 3'6"; Day light under brisket, 1'3"; Girth at brisket, 10'10"; do. of Chest, 10'8"; do. huggens, 10'6". Aged 7 years.*
Garrard also included the Durham White Ox in his *Description of Oxen* and another painting of this animal by T.F. Wilson is in the Beamish Museum.
Courtesy of the O'Shea Gallery

attractive. Other famous animals which toured the country and were immortalised in prints were the Duke of Devonshire's 'Craven Heifer' (Colour Plate 14) and the 'Wonderful White Ox of Houghton-le-Spring' (Colour Plate 16) who, having travelled the length and breadth of the country, 'by something unaccountable, fell ill and languished for three weeks' in Rochester before being slaughtered; his dead weight was 168 stone. Even more famous was the 'White

Colour Plate 17. *The Famous Lincolnshire Ox* after J. Barenger, unknown engraver, 1823. 16 x 20¾in. (41 x 52.5cm).
Inscribed: *The famous Lincolnshire ox, fed by the Right Honble. Lord Yarborough Brikelsby* [sic, for Brocklesby] *under the direction of the Honble. Chas. A. Pelham, M.P, to whom this plate is dedicated by their most obdt. and truly humble servants Marshall, Lovitt & Armitage the present owners. The Lincolnshire ox was got by Young Fortune, the property of Phillip Skipworth, Esqr. Young Fortune was got by Young Favourite, & Young Favourite by Comet, out of Countess. Comet was sold for 1,000 guineas at Mr. Charles Collings sale & Countess sold at the same time for 420 when nine years old. The Lincolnshire ox was out of a favorite cow of R. Goultons Esqr. Bonby, which was got by Coddlenob and Coddlenob by Patriot. Live weight 464 stone. Dimensions: 5'6" in height of the shoulders, 11'10" from the nose to the setting of the tail, 11'1" in girth, 3'3" across the back in three places, viz. the hips, shoulders, and middle of the back, 1'2" from the breast to the ground, 9" in girth of the fore leg, and 1'10" between the fore legs.*
Lawes Agricultural Trust. Rothamsted Experimental Station

Plate 9. *Durham Prize Pig* engraved by Robert Pollard, 1805. 12 x 15in. (30.5 x 38cm).
Inscribed: *Bred by Mr Luke Seymour of Woodhouse Close & Fed by Mr William Reed of Durham. Age 17 months. Weight when alive 36 Stone 4lb and when dead 32 stone 11 lb. offall 3 Stone 11 lb.*
Breed types for pigs were not fixed until the late 19th century. This pig was probably engraved because of its large size and is very early for a pig print.
Collection of Andrew Thomas

Heifer that Travelled' (Colour Plate 4), bred and fed by Robert Colling, whose portrait was painted by Weaver and engraved by William Ward in 1811. Like the 'Durham Ox' she was sired by 'Favourite' and sent to all the major agricultural fairs and shows for exhibition and was said to weigh 2,300lb. or 164 stone. Weaver painted her in a byre with a man slicing turnips, implying that she had been reared in the 'improved' way. She is a very unattractive animal with her monstrously obese body, tiny head and spindly legs which look incapable of bearing her weight. The 'Famous Lincolnshire Ox' (Colour Plate 17) was descended from Colling's most famous bull 'Comet' and weighed considerably more than the 'Durham Ox' An undated advertisement described the Lincolnshire Ox as 'the property of Mr Young, at the Horse Bazaar, King Street, Portman-square, London. Live weight, 464 stone!' It continued, 'The above ox has been seen by the Lincolnshire and Leicestershire Graziers, and by the best judges is allowed to be 40 stone heavier than the Durham Ox. – It has also been inspected by the principal Graziers in the neighbourhood of Warwick and Leamington, and is by them considered to be the largest, and to have the greatest proportion of meat upon the least bone of any Ox that has ever been submitted to public inspection.' The enormous detail in which the animal's pedigree has been described shows how much value is now attributed to breeding.

The fashion for farm livestock portraiture lasted well over one hundred years from 1780 to about 1900, by which time it was becoming superseded by photography. While some of the early images were executed to promote and circulate information on the new breeds, the fashion could not have lasted for so long or been so widespread throughout society if this was

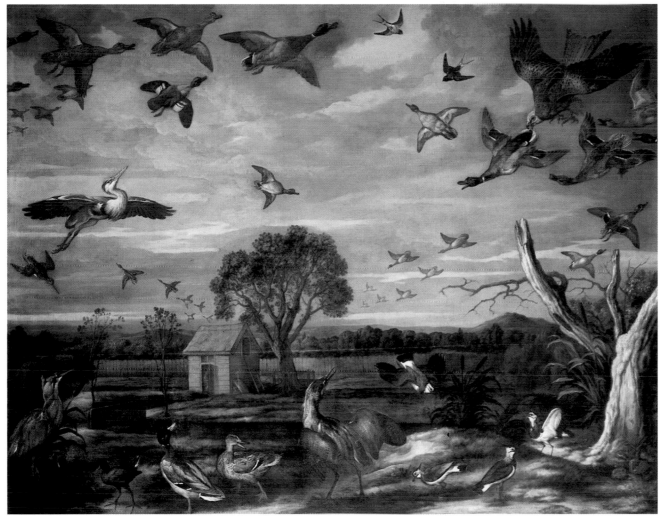

Colour Plate 18. *The Decoy* by Francis Barlow. 43½ x 62½in. (110 x 159cm).
Francis Barlow (c.1626-1704) was the first British painter to specialise in animal painting. His work was strongly influenced by Flemish painting but these paintings show the beginnings of a native appreciation and observation of the British countryside and its birds and animals.
The Onslow Collection, Clandon Park (The National Trust)

their only *raison d'être*. By the late eighteenth century, Britain had already established a unique school of animal painting and many livestock paintings were commissioned out of pride of ownership, or local rivalry, in the same spirit as the horse and dog pictures still hanging in so many country houses today.

Before the eighteenth century there were no native animal painters in England, but, transplanted from the Low Countries, the genre began to enjoy an increasing popularity from the mid-seventeenth century. Abraham Hondius (c.1638-1695) arrived in London from Rotterdam in 1666. His work shows a sound knowledge of anatomy and a frank realism. In his paintings of bull-baiting and boar hunting, the animals are wild and savage as they tear each other, limb from limb. Francis Barlow was the first British born artist to show a real interest in animal painting. His large scale *Farmyard* (not illustrated) at Clandon Park, Surrey, is a glorious invention as rich and detailed as a Flemish tapestry. A crumbling classical column and a fanciful house with birds roosting in the belfry combine with an old English pig in his cottage sty. A peacock with its glorious tail holds pride of place, while a mêlée of ducks, geese and hens strut and squawk about the yard. *The Decoy* (Colour Plate 18) shows the artist developing a more genuine feeling for the English landscape and its inhabitants. Barlow's patron, Denzil Onslow, constructed a decoy at nearby Pyrford and Barlow's painting shows such a scene at

Plate 10. *The Common Boar* from *A General History of Quadrupeds* by Thomas Bewick, 1790. Woodcut, 1⅞ x 3⅛in. (5 x 7.73cm).
The British Library

Plate 11. *The Ram* from *Historie of Four-Footed Beasts,* by Edward Topsell, 1607.
This was the first major natural history book to be printed in English. The illustrations are crude and generalised but it demonstrates an awakening of interest in the classification of the animal world. The British Library

dusk as wild geese settle on the water. Among Barlow's many etchings, sheep, oxen and pigs appear and, according to Shaw Sparrow, 1922, he made an etching of a giant German ox which stood 9½ft. high and was exhibited at Ipswich and also in London.

An interest in natural history illustration had been growing throughout the seventeenth and eighteenth centuries. Edward Topsell's *Historie of Four-Footed Beasts* (Plate 11) published in 1607 was the first major book on animals to be printed in English. Based on an earlier work by Conrad Gesner, The *Histori Animalium* of 1551-54, the illustrations are crude and rudimentary and have no understanding of proportion or anatomy. In 1790 Thomas Bewick published *A General History of Quadrupeds*. Here the detailed woodcut engravings are

Plate 12. *The Chillingham Wild Bull* drawn and engraved by Thomas Bewick. Wood engraving, c.1789. 7½ x 9½in. (19 x 24cm).
Inscribed: *The wild bull, of the ancient Caledonian breed, now in the park at Chillingham-Castle, Northumberland. 1789.*
Bewick considered this woodcut to be his masterpiece. Best known for his book illustrations, he executed several livestock portraits for patrons in the Newcastle area. Bewick's memoirs include the well-known quote on page 54 which accuses the Colling brothers of asking him to exaggerate the proportions of their animals.
Lawes Agricultural Trust. Rothamsted Experimental Station

Colour Plate 19. *A Leicester Wether* after J. Barwick, lithographed by J.W. Giles, c.1840. 14½ x 20in. (37 x 51cm).
Inscribed: *Portrait of a Leicester wether, bred and fed by Messrs. Brown of Denver in Norfolk from the flock of Bakewell without a cross. This sheep was four years old,– Height 2'6½'.– Girt 5'2".– Length 2'10½".– and extreme length 4'2½'.– Dead weight 236 lbs.*
While prints of Shorthorns were by far the most numerous, many of the other new breeds of animals were also depicted. There were no established pedigrees for sheep until much later than cattle. Here the breeder points out his animals are descended from Bakewell's stock fifty years later.
Lawes Agricultural Trust. Rothamsted Experimental Station

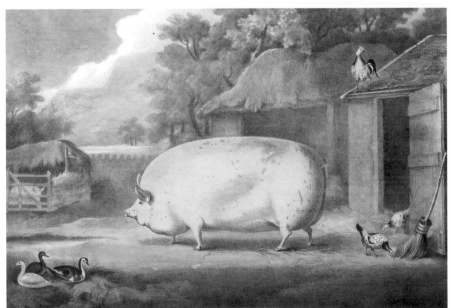

Colour Plate 20. *A Leicester Sow* by W.H. Davis, 1843. Lithograph, 14 x 20⅓in. (35.5 x 52cm).
Inscribed: *Two Years old. Bred by Mr. Wiley of Brondsby nr York. Painted from life, Drawn on stone and Published by W.H. Davis, Animal painter to the Queen Dowager, Church Street, Chelsea.*
Although pigs were fattened to very large sizes they did not receive the same attention from livestock breeders as sheep and cattle until much later in the 19th century.
Collection of Christopher Davenport Jones

exquisitely drawn with a firm grasp of anatomy and detail (Plate 10, also Plates 87, 88, 106 and 107). Bewick's accurate woodcuts are in a different league from any previous attempt to illustrate the different breeds of animals. He was a highly perceptive observer of the English countryside and its way of life and followed his *General History of Quadrupeds* with a *History of British Birds* published in two volumes in 1797 and 1804. In the background to the animal studies are anecdotal scenes of farming life, a figure being chased by a bull, a woman returning home with a milk pail or piglets racing towards the trough. In the tailpieces and vignettes interspersed throughout the text, often only 2 x 3in. (5 x 7.5cm), Bewick captures the essence of the English rural scene with his studies of scenes like a partridge shoot, an angler resting or a horse with its dung bag.

It was a naturalist, Marmaduke Tunstall (1743-1790), who commissioned Bewick at a cost of seven guineas to execute his woodcut of *The Wild Bull of Chillingham* to illustrate a treatise he was preparing on the now rare herd of wild white cattle (Plate 12). Bewick's *Memoirs*

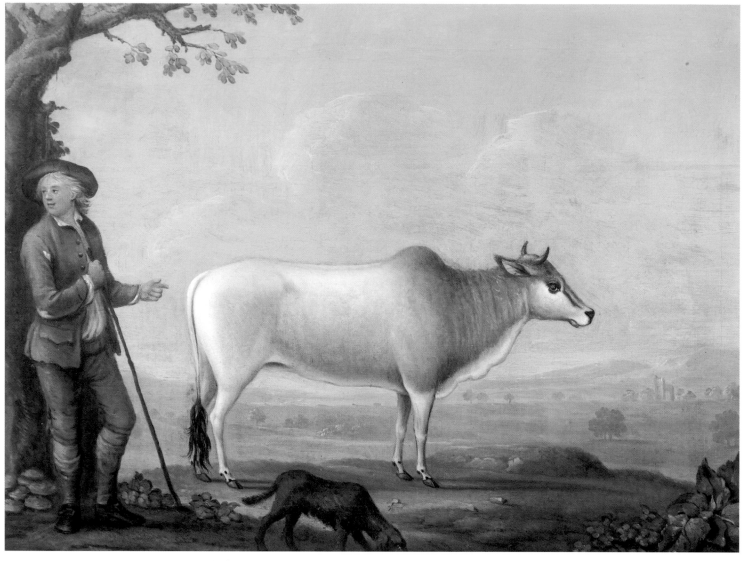

Colour Plate 21. *A Brahma Cow with a Herdsman and Dog,* unknown artist, c.1770. Oil on canvas, 19 x 26⅛in. (48 x 66.5cm).

Brahma cows were imported into England in the late 17th century. Lord Rockingham had a herd of Indian cattle at Wentworth Park in the late 1770s presented to him by the Governor of Bengal. This painting is very early for a cattle study, predating the earliest livestock paintings by ten years. The cow was recorded because it was such an unusual species, probably one of the first of its kind to enter Britain. Private Collection

recount the difficulties he had getting close enough to sketch the wild animals. The resulting image is considered one of his best works; dripping foam from its mouth, the wild creature emerges from the forest, turning a wary eye on the spectator as he paws the ground. It is in striking contrast to contemporary images of docile domestic cattle.

Artists had always been on hand to record exotic species as soon as they set foot in the country. In the eighteenth century, painters like George Stubbs and Jacques-Laurent Agasse frequented the menageries such as those kept by Queen Charlotte at Richmond and Buckingham Gate where Stubbs painted his famous zebra now in the Mellon Collection. The Brahma Cow (Colour Plate 21) was probably painted because it was one of the first of its kind to be imported to England. When Agasse painted the quagga (Colour Plate 22) and various generations of its offspring, achieved by crossing with Arab mares, he chose a formal, profile pose since the paintings were regarded as scientific records. In 1788 the Linnean Society was formed with its precise approach to the recording of the natural world with the development

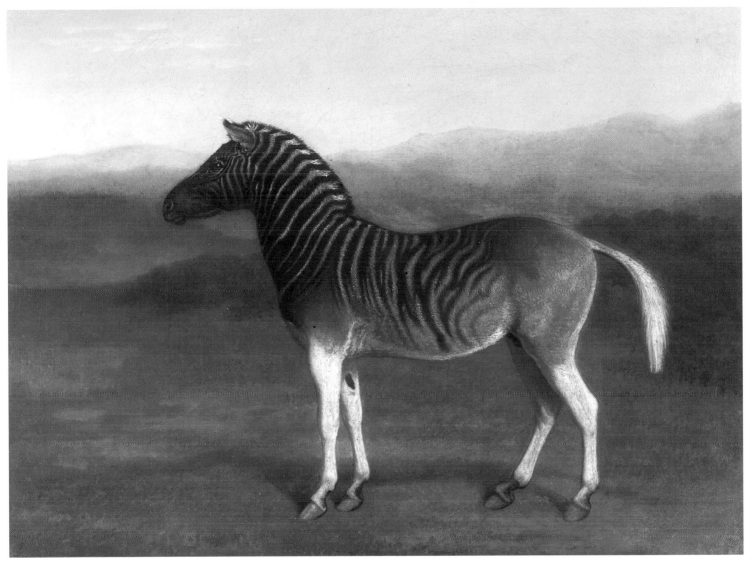

Colour Plate 22. *A Male Quagga from Africa: the First Sire,* by J.L.Agasse, 1821. Oil on canvas, 19 x 23in. (48 x 58.5cm).
Agasse has not revealed his versatility as an animal painter. The portrait was commissioned as a part of a scientific breeding record and, like contemporary livestock portraits, the animal is shown in profile giving the maximum amount of information about its appearance.
Reproduced by kind permission of the President and Council of the Royal College of Surgeons of England

of a universal system of nomenclature for both plants and animals. It was not, however, a desire to record the natural world which led to the burgeoning of animal painting in Britain, but a more prosaic reason – the British passion for horse-racing and fox hunting.

Out of a population of six million, less than one and a half million lived in towns in the early eighteenth century. The British love of the countryside was deep and ingrained. People were much closer to the land and enormous social status was associated with the country estate and the horses, dogs, hunting, shooting and racing that were so much a part of it. Communications were poor and for those who lived in isolated farming communities field sports were a much valued recreation. The Enclosure Acts, combined with the clearance of woodland, opened up the English countryside and the changes in the landscape meant that hare and stag-hunting were superseded by the much speedier and more exhilarating foxhunt. Leicestershire and its neighbouring counties had become almost entirely grassland divided by big fences by the 1780s and was the best hunting country in England. Stronger, heavier horses were needed to

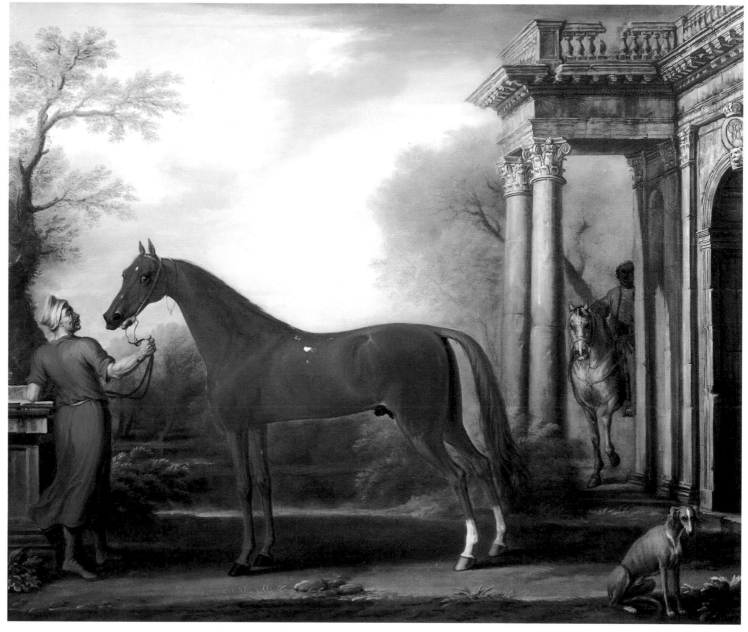

Colour Plate 23. *The Hampton Court Chestnut Arabian* by John Wootton. Oil on canvas, 51 x 60⅓in. (129.5 x 153.5cm).
The horse is probably 'Horn' who belonged to George I. There are several versions of this painting including one in the Royal Collection at Windsor Castle. They all combine different Arabian motifs in the background to illustrate the horse's origins.

Courtesy Richard Green

gallop the long distances and take the big fences. Side by side with the development of hunting went the rise of the English thoroughbred developed from imported stallions like the 'Byerley Turk', the 'Godolphin Arabian' and the 'Darley Arabian'. It was from the principles of inbreeding first used in the development of thoroughbred racehorses that Robert Bakewell drew his ideas for improving farm livestock. As a scientific approach to the breeding of racehorses developed, the sport progressed from a local and haphazard affair to a professionally organised activity. In 1752 the Jockey Club was formed and by 1809 the three classic races, the St Leger, the Oaks and the Derby were all established.

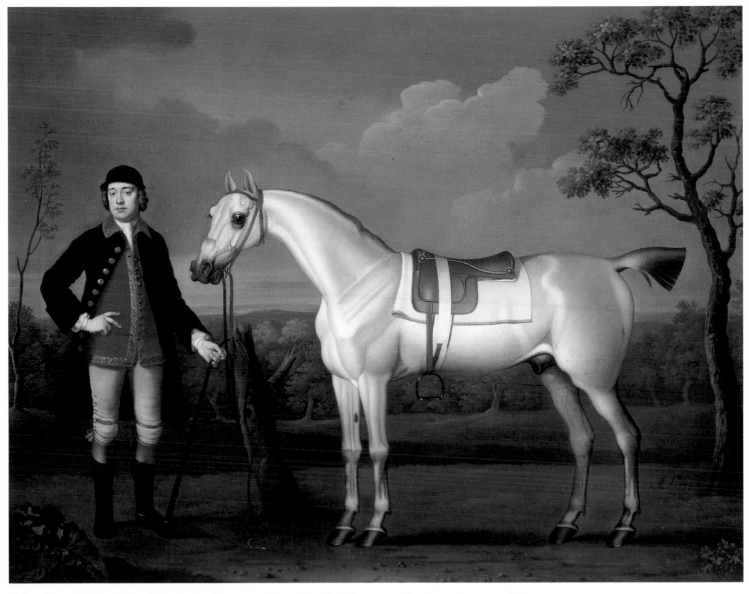

Colour Plate 24. *The Duke of Cumberland's grey racehorse Crab held by a groom* by James Seymour. Oil on canvas, 36 x 54in. (91.5 x 137cm).
This pose of a horse in profile and groom against a distant landscape is typical of horse portraiture in the mid-18th century. It was taken up by livestock painters and continued throughout the 19th century.

Courtesy Richard Green

A flood of horse and sporting commissions resulted. Many of England's large country houses still have their quota of eighteenth-century horse paintings by artists like John Wootton (Colour Plate 23), James Seymour (Colour Plate 24), Peter Tillemans, John Nost Sartorius and Ben Marshall. For the first half of the century the animals appear stilted and wooden looking, as the artists had little understanding of anatomy. The arrival of George Stubbs (Colour Plate 28) and Sawrey Gilpin on the scene changed the genre of horse painting for ever. In 1766 Stubbs published his ground-breaking *Anatomy of the Horse*, revolutionising the approach to horse painting. Gilpin also broke away from the formalised, static, compositions of his predecessors. In his painting *Death of a Fox* in the Tate Gallery, he broke new ground by investing the fox with the feelings of a trapped and hunted creature and drawing in the emotions of the spectator.

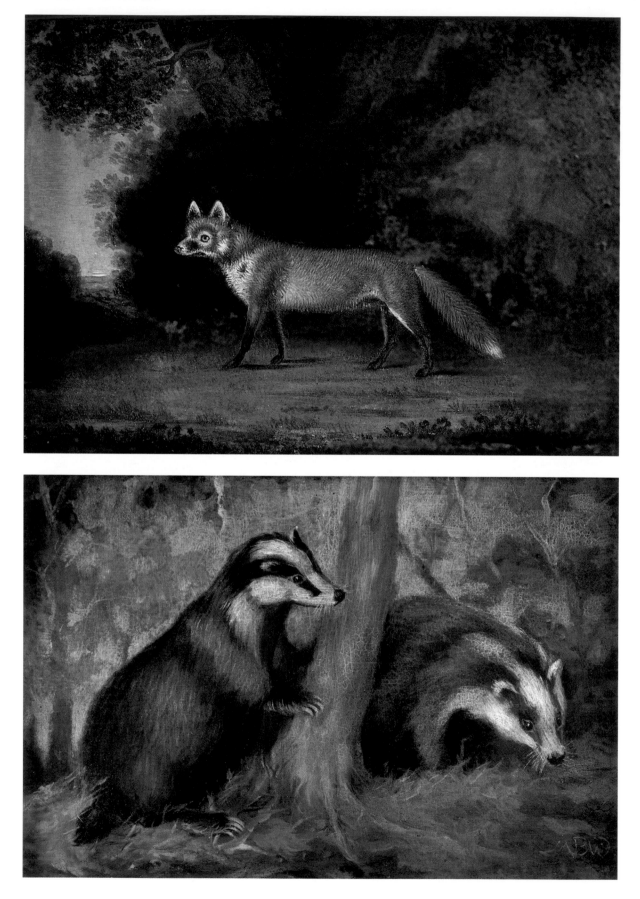

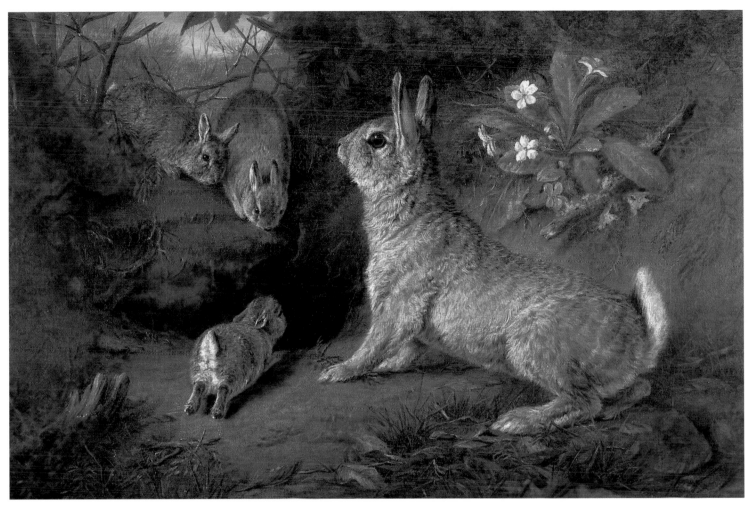

Opposite above. Colour Plate 25. *A Study of a Fox in a Wooded Landscape* by B. Killingbeck, 1787. 6 x 8in. (15 x 20cm).
The fashion for hunting and scenes of the countryside even extended to the portrayal of foxes and other wild animals such as badgers and rabbits. From the Collection of John M Davis

Opposite below. Colour Plate 26. *Badgers at Play,* unknown artist, c.1860. Oil on canvas, 6 x 9in. (15 x 23cm).
 Private Collection

Colour Plate 27. *Rabbits in a Wooded Landscape* by W. Luker, 1878. Oil on canvas, 16½ x 24in. (42 x 61 cm)
 Private Collection

Animal painting had become an alternative to 'face' painting for an artist as a means of earning a respectable living. These sporting artists tended to be outside the mainstream of artistic fashion and uninfluenced by current artistic trends. They were fulfilling the demands of their patrons, providing a record of their favourite animals, or of themselves engaged in sporting activities, and there was little room for invention. Racehorses or favourite hunters are depicted in profile against a generalised landscape. The angle of vision is chosen to exaggerate the length of the animal's legs, their cannon bones are impossibly long and weak and they tower over their grooms and jockeys. In fact these early thoroughbreds were a good deal smaller than racehorses today, generally not more than fifteen hands high (Colour Plate 28). Often there is some reference to the animal's origins, such as the colours of the groom or the inclusion of the owner's house in the distance, but seldom the owner himself. The country gentleman still preferred to be portrayed riding to hounds or out shooting with his favourite dogs. It was against this well-established tradition of horse portraiture that the demand for

Colour Plate 28. *Molly Longlegs* by George Stubbs, c.1761. 39½ x 49½in. (100 x 126cm).
Stubbs revolutionised horse painting by introducing an exacting anatomical approach. He has exaggerated the height of Molly Longlegs by taking a low viewpoint and painting her towering over the groom. These were exactly the techniques adopted by livestock painters to emphasise the size of cattle.
The Board of Trustees of the National Museums and Galleries on Merseyside (Walker Art Gallery, Liverpool)

Colour Plate 29. *The Sorby Family* by John F. Herring, Senior, 1828. Oil on canvas, 28½ x 40¼in. (72.5 x 102.5cm).
John Sorby (1755-1829), shown here with his son and grandson, lived at Spital Hill, Sheffield and was a manufacturer of edged tools. He was a member of the newly emerging middle classes who had made his wealth in manufacturing. Typically, he chose to have himself portrayed as a country gentleman enjoying rural pursuits with his family.
Courtesy Richard Green

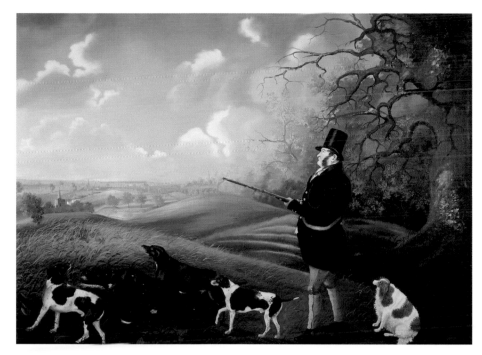

Colour Plate 30. *A Gentleman Out Shooting,* unknown artist, c.1830. Oil on canvas, 29 x 36in. (74 x 91.5cm). Provincial artists must have been influenced by the compositions of more accomplished artists. This portrait is strikingly similar to Boultbee's painting of Squire Thornton of Brockhall (Plate 19).

Collection of Johnny Mengers

Colour Plate 31. *A Huntsman with his Hounds,* unknown artist, c.1850. Oil on canvas, 30 x 36in. (76 x 91.5cm).

This may well be a member of the Crisp family of the Manor House, Saxmundham, Suffolk. The enclosures in the mid-18th century opened up the countryside for magnificent hunting. Hunting scenes became enormously popular and not only with the aristocracy. This portrait of a sturdy yeoman with his ridiculously small hounds is typical of English provincial art.

From the Collection of John M. Davis

Colour Plate 32. *The Blackwell Ox* after George Cuitt, engraved by J. Bailey, 1780. 11½ x 16in. (29 x 40.5cm).
Inscribed: *The Blackwell ox (rising 6 years old) bred and fed by Christr. Hill. Esq: of Blackwell in the county*
of Durham. Killed at Darlington 17 Dec: 1779 by Mr Geo: Coates who sold him for £109.11.6. Weight: Two
fore quarters, 75 st. 7 lb; Hind do., 76 st. 3 lb; Tallow, 11 st.; Total, 162 st. 10 lb. NB: 14 lb to the stone.
Dimensions: Height at the crop, 6'0"; – Shoulder 5'9¼"; – Loins, 5'8"; – From breast to ground, 2'1";
Length from horns to rump, 9'5½"; Breadth over the shoulders, 2'10¼"; – From hip to hip, 2'10½"; Girt
before the shoulder, 9'7½"; – Behind do., 10'6"; – At the loins, 9'6¾".
This is the earliest true livestock portrait. It shows a Teeswater ox of the old, unimproved breed but it is a
portrait of a specific animal rather than a generalised image and contains the animal's exact dimensions and
breeding history. Cuitt employed many of the techniques familiar to horse painters. The animal is recorded in
profile from a low viewpoint against a distant landscape to emphasise his size.

Lawes Agricultural Trust. Rothamsted Experimental Station

livestock painting developed. It became as fashionable to be painted with your cattle or sheep,
perhaps with your country seat in the background, as to be painted with your favourite hunter.

The first cattle painters adopted the iconography of horse portraiture, placing the beasts in
profile in the foreground of the paintings against a distant landscape. This composition
remained popular for the next 120 years. The earliest dated cattle portrait is a print of *The
Blackwell Ox* of 1780 (Colour Plate 32), engraved by John Bailey after a painting by George
Cuitt. Bailey was an animal painter and engraver who became Steward to the Earl of
Tankerville at Chillingham. He is responsible for several of the early cattle prints in the
Northumberland area. The painting itself has not been located and may have pre-dated the print
by a few years. For the first time in livestock portraiture the breeding, history and vital
statistics of the animal are recorded which demonstrates an entirely new and scientific
approach to animal painting. There was now a desire to compare breed with breed as well as
the way similar animals fared on different fodder in an effort to produce the most productive
and efficient animal for food. The painting and the print were presumably commissioned by
the breeder, Christopher Hill of Blackwell, County Durham, who turned to a local painter,
George Cuitt, who lived a few miles away at Richmond in Yorkshire. Cuitt was not an animal
painter. He had spent several years in Italy, before returning to his native Yorkshire where he
established a flourishing practice as a detailed and accurate painter of topographical
landscapes, townscapes and country seats. He was therefore an obvious choice for a local
farmer requiring an accurate record of his prized ox. It is an impressive image with which to

Colour Plate 33. *Woodcutter Courting a Milkmaid* by Thomas Gainsborough, 1755. Oil on canvas, 42 x 50in. (107 x 127cm).
In Gainsborough's work the countryside is still seen as a rustic idyll. His peasants are not working the land but dallying at their tasks. The cattle in this painting are scraggy looking with hollow backs, typical of the old unimproved breeds. By kind permission of the Marquess of Tavistock and the Trustees of the Bedford Estates

begin the history of livestock portraiture. The animal is shown with his head down grazing, a posture which is seldom adopted again. He is a Teeswater of the old, unimproved Shorthorn breed. He weighed 162 stone which compares well with the massive improved animals of the next generation. He is a magnificent beast standing against a distant landscape of a river estuary with hills beyond. Living in the heart of the Shorthorn country, Cuitt received several other commissions from local breeders including Charles Colling for whom he painted the 'Ketton' or 'Durham Ox' in 1801 (Colour Plate 168).

Alongside the fashion for animal portraits came an interest in agricultural landscapes and rural scenes. While the country was caught up in a fervour of agricultural improvement, scenes of the countryside where peasants are industriously employed working the land to its maximum potential were popular. Gainsborough had dotted his landscapes with peasants who dallied over their tasks in a rural idyll as in *Woodcutter courting a Milkmaid* (Colour Plate 33). The cattle in his paintings are thin with hollow backs and long, scraggy legs and epitomise the

Colour Plate 34. *Haymakers* by George Stubbs, 1785. Oil on canvas, 35¼ x 53¼in. (89.5 x 135.3cm).

The Tate Gallery, London

Opposite above. Colour Plate 35. *Harvesting Scene,* unknown artist, c.1840. Oil on canvas, 14 x 18in. (35.5x 46cm).
The same methods are being used as in Stubbs' earlier painting. The horsedrawn waggon is being piled high with hay and carted to the rick in the distance.
Collection of Mr & Mrs Henry Sweetbaum

Opposite below. Colour Plate 36. *Bargaining for Sheep* by George Morland, 1794. Oil on canvas, 55 x 78in. (139.5 x 198cm).
Morland's rustic scenes are rooted in the reality of the countryside in contrast to many of the idealised farmyard scenes so popular with the Victorian middle classes. Here the country butcher mounted on horseback is negotiating the price of a sheep from a smallholder whose rustic surroundings typify Morland's subject matter.
Leicestershire Museums, Arts and Record Service

old unimproved breeds. By contrast, the villagers in Stubbs' *Haymakers* (Colour Plate 34), although rather too immaculately dressed, are industriously employed cultivating the land. Fuelled by a nostalgia for the countryside, which was seen as providing a better way of life than the growing and overcrowded towns, English landscape painters began to abandon the search for picturesque and sublime subjects. Artists concentrated more and more on naturalistic representation and everyday agricultural scenes. George Morland (1763-1804), who produced rustic farmyard scenes without the sentimentality of the Victorians, typifies this genre (Colour Plate 36). His cottages are crumbling and his peasants drunk and dishevelled, while his pigs wallow in mud. He was a prolific painter turning out canvases to pay off his drinking debts and, although generalised, his compositions have a degree of reality absent in Victorian painting. John Frederick Herring Senior (1795-1865), by contrast, in his later farmyard paintings always presents a neat and orderly scene, spread with fresh straw and shining, clean animals (Colour Plate 37). Thomas Sidney Cooper (1803-1902) was one of the

Colour Plate 37. *A Winter Farmyard Scene* by John F. Herring, Senior, 1857. Oil on canvas, 24 x 36in. (61 x 91.5 cm). In 1853 Herring leased a home at Meopham Park near Tonbridge which included a large farm. He painted primarily nostalgic, idealised versions of rural and farmyard scenes which sold to the Victorian middle classes as fast as he could finish them.

Courtesy Richard Green

Colour Plate 38. *Returning to the Farm* by Thomas Sidney Cooper, 1869. Oil on panel, 20 x 30in. (51 x 76cm). The most popular and prolific Victorian painter of cattle, Cooper was strongly influenced by the Dutch tradition. He was just one of dozens of artists who specialised in idealised landscape scenes of sheep and cattle which contrasted strongly with the detailed formal portraits demanded by livestock breeders. Courtesy Richard Green

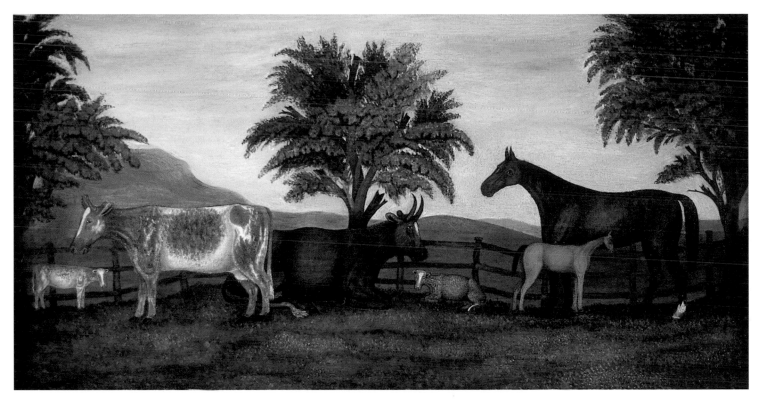

Colour Plate 39. *Cattle and Horses in a Landscape* by P. Bell – K (Kelso), 1855. Oil on panel, 11¼ x 21¾ in. (28.5 x 55.5cm).
Despite their lack of artistic conventions, such as space and perspective, naïve paintings with their meticulous recording of detail give us far more information about the 19th century farm than many of the more idealised academic paintings. Private Collection

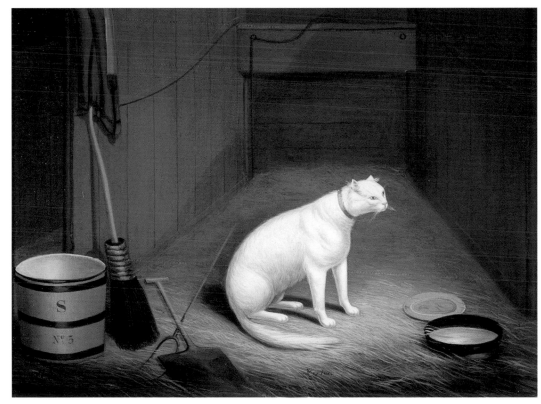

Colour Plate 40. *A Farmyard Cat in a Stable,* initialled HS, 1830. Oil on canvas, 14 x 18in. (35.5 x 45.5cm).
Cats and 'ratters' were vital for keeping rats at bay and protecting the stores in the badly insulated farm buildings. Private Collection

most popular Victorian artists (Colour Plates 38 and 104 and Plates 50 and 51); his cattle always look immaculate and well mannered, standing conveniently in picturesque groups. These were the images middle class Victorians wanted to hang in their urban villas, a romanticised and nostalgic vision of the rural life they had left behind.

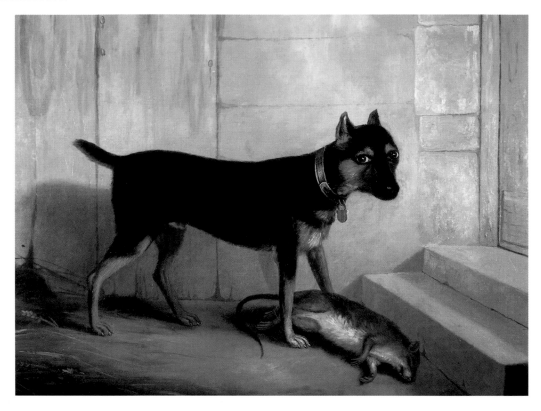

Colour Plate 41. *A Ratter*. Signed with a monogram, 1845. Oil on canvas, 22 x 28in. (56 x 71cm).
Collection of Mr and Mrs O.S. Blodget

Colour Plate 42. *Joseph Lawson's Prize Pig*. Oil on canvas, 26½ x 42in. (67.5 x 107cm) Pigs took very much longer than sheep or cattle to become established as pedigree breeding animals. Consequently they come in every shape and colour rather than conforming to breed type. Private Collection

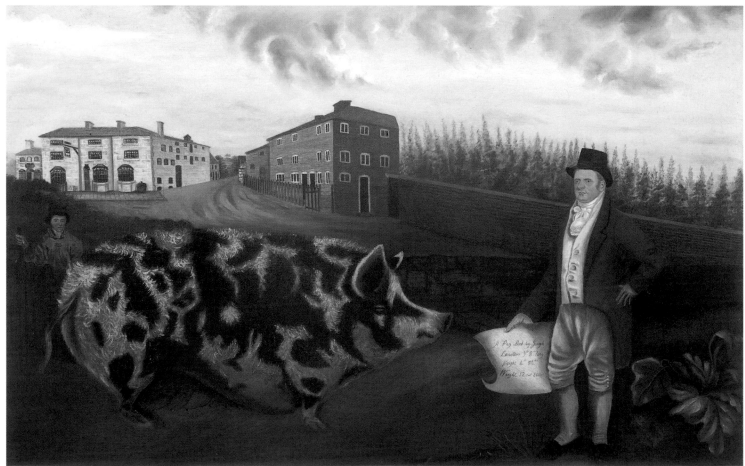

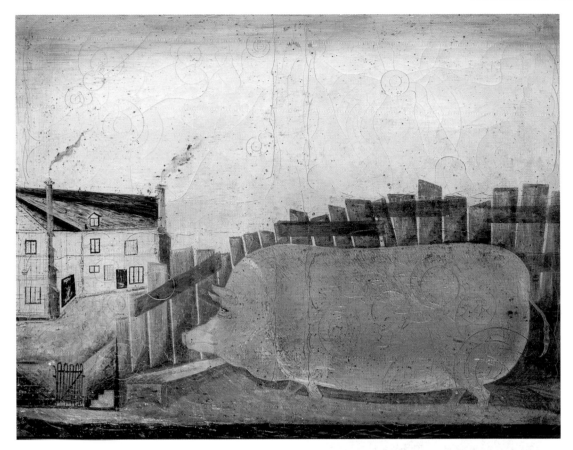

Colour Plate 43. *A Fat Hog in a Cottage Garden*. Oil on canvas, 13 x 17¼in. (33 x 44cm).
Inscribed: *Head by Chas Herd, Hill Farm, Hanbury. Drawn by Thoʼ Hughes, painter and glazier, Droitwich.*
Throughout the 19th century pigs were kept in cottage gardens in towns and villages. Fed on scraps they were referred to as 'the gentleman that pays the rent'. Thomas Hughes who painted this picture describes himself as a painter and glazier showing how painting was regarded like any other trade among the working classes.
Photograph courtesy of Sotheby's

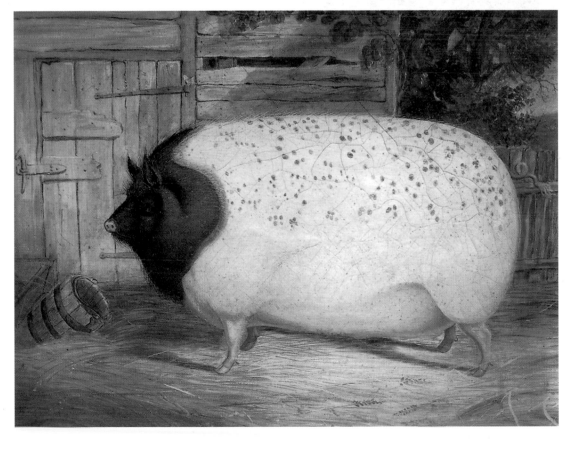

Colour Plate 44. *A Fat Hog* by T. Glasscock, 1842. 19¾ x 24½in. (50 x 62cm).
Inscribed: *This Hog was Fatted by Miss Eliza Newton of Stortford Hall in the County of Herts. Killed May 14th 1842.*
After years of neglect naïve painting became fashionable again in the 1970s and '80s. This picture sold at the top of the market in June 1988 and still holds a world record of £33, 000 for an image of this type.
Photograph courtesy of Sotheby's

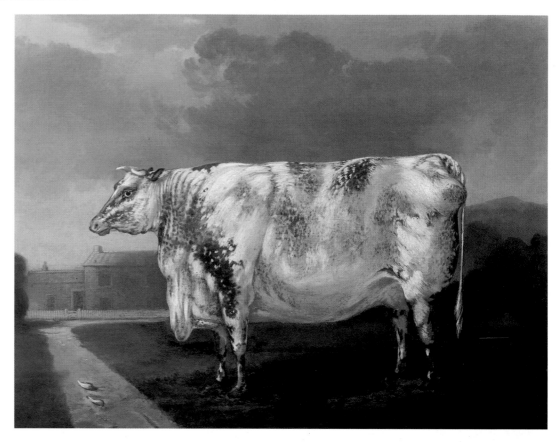

Colour Plate 45. *Joseph Hutchinson's Old Cow*, unknown artist, c.1830. 16½ x 20in. (42 x 51cm).
Maximilian Von Hoote

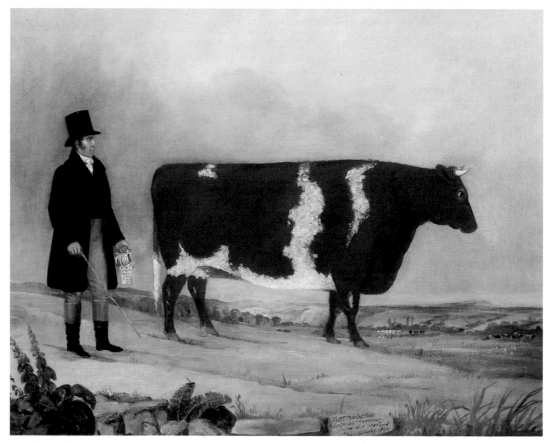

Colour Plate 46. *A Prize Heifer with her proud owner carrying a trophy*, unknown artist, 1846. 15½ x 19in. (39 x 48cm).
Inscribed: *To Mr Charles Hale for the best yearling heifer, one year & ten months.* The silver trophies presented at agricultural shows were competed for with intense rivalry and displayed with enormous pride. The device of including the trophy in the painting makes it doubly clear that this is a prize-winning animal.
From the collection of Jon Antony

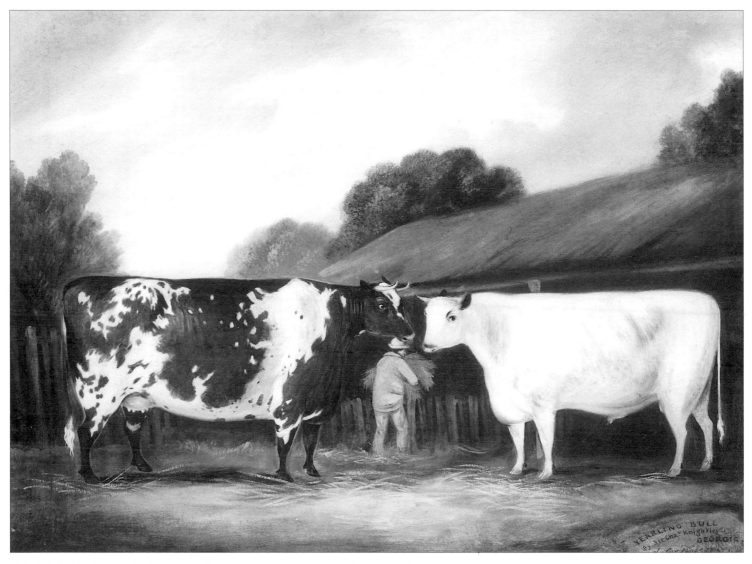

Plate 13. *A Bull, Cow and a Farmer* by J. Cox. Oil on canvas, 1847. 22 x 29in. (56 x 74cm).
This and Colour Plate 46 typify the naïve tradition of livestock portraiture. The artists were not concerned with conventional realism but have recorded the appearance of the animals with meticulous care and detail. Together with the cow the yearling bull 'Georgie' towers over the diminutive cowhand. Paintings such as these were commissioned by ordinary country folk to record their prize-winning animals. They do not record the documented pedigree herds but tell us about the ambitions and aspirations of more ordinary farmers.
Private Collection

A love of country scenes was not restricted to the middle and upper classes. The less sophisticated landowners, farmers and labourers who played such an important role in country life, worked the land and husbanded the cattle also wanted images of animals and the countryside. Before the advent of mass-produced images through colour printing and photography, popular taste did not require paintings that fulfilled all the academic traditions of space, proportion, depth and light. Painting was seen like any other job of craftsmanship and the intention was to set down an accurate likeness. An untrained or primitive artist was quite prepared to distort reality in order to achieve this. He depended as much on his knowledge of what he was painting as what he could actually see of it. These painters were often itinerant house-painters and sign writers, or craftsmen such as plumbers and carpenters who painted as a sideline. They followed their own instincts and painted the scenes and objects around them with a reality, intensity and humour derived from first-hand experience. Naïve portraits of farm

Colour Plate 47. *Model of a Butcher's Shop,* 19th century, painted wood and plaster.

The different cuts of meat are made with great care and accuracy and they may have been used for instructing butchers or as a window display to demonstrate the type of cuts available to the public. Many of the primitive painters were also sign painters and use the same bold colours and outlines.

British Folk Collection, Peter Moores Foundation

Colour Plate 48. *Butcher's Model of a Hereford Bull,* c.1880. Painted wood, height 17in., width 29in. (43 x 73.5cm). Models and signs like this advertising a particular trade or product were common in every high street. Naïve paintings were intended to convey a direct message, regardless of conventional reality, and have much in common with sign painting.

Iona Antiques

animals also served a practical purpose. A small farmer was as proud of an animal which had carried off first prize at the local agricultural show as Lord Spencer was of his famous herd of pedigree Shorthorns. He too needed a statement recording his success and pride.

This type of painting is part of the British craft tradition which would have enlivened every ordinary household. Similar decoration is found on furniture such as the box for shepherd's crooks (Colour Plate 49), needlework and ceramics. They are simple images not far removed from the signs and models used to advertise shops and craftsmen's trades or fairground exhibitions. A reference from a contemporary journal quoted in full on page 105 refers to animals which are 'stuffed out to a size unparalleled except on the external paintings of penny shows'. This type of art has never been properly studied in this country and the vast majority of it has been destroyed. Such images would have confronted the public in shops, inns, fairs, markets and on the sides of coaches at every opportunity. The easiest contemporary comparison is with the advertising posters with which we are daily bombarded. Freed from the sophisticated conventions demanded by academic painting, the artist could simplify and distort reality as much as posters do today. Their intention was to convey a message as directly as possible through the use of bold shapes and outlines, simplified compositions and often bright primary colours which took no account of the subtleties of shading and perspective. Neglected for the first half of this century, these naïve images are now extremely popular. Unfortunately the plethora of kitsch reproductions on table mats, waste paper baskets and cheap prints means that they are now being undervalued for a different set of reasons. It is important to approach the nineteenth century naïve paintings with fresh eyes and an open mind. They convey a striking message with a clarity of purpose and an artistic integrity which is utterly refreshing in its humour and ingenuity.

Colour Plate 49. *Shepherd's Chest.* 13½ x 66½in. (34 x 169cm).
This was used for storing crooks. It is painted on the front with sheep in a landscape. Primitive painting was part of a widespread craft tradition used to decorate furniture, textiles and ceramics
Collection of John Gall and Rosy Allan

Chapter 2
Livestock Painting 1780-1830

Animal painting was considered one of the more inferior branches of the arts, in the nineteenth century, only just above still-life and way below history painting or portraiture. Yet, in direct contrast to the prevailing academic opinion, animal painting was immensely popular. Writing in his *Treasures of Art in Great Britain*, published 1854-57, Dr Waagen points out, 'In no country is so much attention paid to the races of different animals as in England, and, although a mercenary reason may be assigned in the cases of horses, oxen, and sheep, yet a feeling for the beauty of these animals is also very general'. Even Dr Johnson (1709-84) 'would rather see a portrait of a dog I know than all the allegories you can show me'. Reviewers of the Royal Academy's Summer Exhibition frequently criticise it for the high proportion of animal painting. It was, however, a type of painting that the English public really enjoyed and like portraiture were happy to commission. For as the immigrant artist Henry Fuseli (1741-1825) commented, there is 'little hope of poetical painting finding encouragement in England. The people are not prepared for it. Portraits with them are everything, their tastes and feelings go to realities'.

Although it attracted only a few artists of the very top league, animal portraiture was well paid. Ben Marshall's often quoted quip to Abraham Cooper bears this out: 'many a man will pay me fifty guineas for painting his horse who thinks ten guineas too much for painting his wife'. John Ferneley's account books show that he charged from £10 for a small horse portrait up to £70 for a group portrait and occasionally £100 for a very large hunting scene. Thomas Weaver, a Shropshire artist, charged comparable but slightly lower prices at the outset of his career. A small animal portrait was £5, rising considerably as soon as more than one animal was involved. Ferneley earned on average about £380 a year, although some years the sum was substantially higher, in 1833 being as much as £1,254. An average labourer's wage was £1 a week; it is now £200 so these annual figures multiplied by £200 come out at £76,000 and £250,000 respectively. At the height of his success, a fashionable London artist like James Ward was earning over £1,000 a year almost entirely from animal painting and was charging 50 guineas for a very small canvas only 10in. x 12in. He charged Lord Chesterfield an extra 125 guineas to include a pet fawn in the portrait of his two daughters, the entire portrait costing 500 guineas. An artist specialising in this genre could expect a constant supply of work and a steady income. Once the fashion for farm animal portraiture became established in the 1780s and '90s, it was an obvious addition to artists whose portfolios had so far been limited to sporting and horse and dog painting.

The question which has most intrigued the public ever since these pictures were first painted is how accurate are they? Could such animals really ever have existed? They are often dismissed as exaggerated publicity portraits with Thomas Bewick's protestation on being sent to Robert Colling's farm at Barmpton to record some animals for one of the Board of Agriculture's Surveys quoted in support of this argument:

> After I had made my drawings from the fat sheep, I soon saw that they were not approved, but that they were to be made like certain paintings shown to me. I observed to my employer that the paintings bore no resemblance to the animals whose figures I had made my drawings from; and that

I would not alter mine to suit the paintings that were shown to me; but if it were wished that I should make engravings from these paintings, I had not the slightest objection to do so, and I would also endeavour to make facsimiles of them.

This proposal would not do; and my journey, as far as concerned these fat cattle makers, ended in nothing. I objected to put lumps of fat here and there where I could not see it, at least, not in so exaggerated a way as on the paintings before me; so 'I got my labour for my trouble.' Many of the animals were during this rage for fat cattle, fed up to as great a weight and bulk as it was possible for feeding to make them; but this was not enough; they were to be figured monstrously fat before the owners of them could be pleased. Painters were found who were quite subservient to this guidance, and nothing else would satisfy. Many of these paintings will mark the times, and, by the exaggerated productions of the artist, serve to be laughed at when the folly and the self-interested motives which gave birth to them are done away.

There is an element of truth in these accusations. Breeders had gone to great pains to produce 'improved' animals with small heads and legs, long straight backs, large hind quarters and as much fat as possible. They were commissioning an expensive portrait and would have encouraged the artist to emphasise such points. If anyone was prepared to distort the appearance of their cattle, it was the commercial minded Colling brothers. However, Bewick is the only artist who is recorded making such a comment. To a Victorian artist like Thomas Sidney Cooper the problem was that he was expected to be too accurate. When asked to paint a Devon and a Hereford he complains: 'The outline and general form of these animals were only fit for portraits, and not at all calculated to make good or effective pictures, *as* pictures'. James Ward's cattle portraits do not have the nobility and beauty of his more imaginative compositions, they appear warts and all. Artistic licence played no part in these paintings and there would have been no point in commissioning paintings which were not reasonably accurate. They had no other function than as records and the patrons had very specific ideas about how the animals were to be depicted. They wanted them shown in profile in a static and almost schematic manner so that carcass size, distribution of fat and proportions could be properly appreciated. Of course many of the artists who undertook such work were not of the highest calibre and these naïve images are among the most delightful and striking animal paintings ever executed. When painted by competent artists, however, they are fairly accurate records of the animals then being bred. We have the detailed measurements of their accompanying inscriptions and Garrard's scale models to prove it (Plates 28 and 29). Livestock breeding follows fashion; enormous fat animals are not required today when the consumer wants lean and tender meat but those who specialise in rare breeds can confirm that animals similar to these shapes could be bred again.

In a letter to the artist Thomas Weaver, dated 5 November 1811, the Shorthorn breeder Robert Colling confesses that, 'you will know I am no judge of paintings, indeed I do not consider myself so.' Colling was a hard-hearted businessman; even on his death he left no legacies to the loyal servants who had looked after him for so long. There is little doubt that he regarded Weaver's paintings of his animals as important promotional material. The paintings would have been displayed in his farmhouse as other paintings were at Bakewell's Dishley Grange to impress visiting farmers and agriculturalists. In the same letter to Weaver he says, 'the whole of the paintings of Comet may be directed either single or in one package to any of the proprietors at Mr Scotts Kings Head Darlington, if in one chest, I should direct them so as to have them understood who each of them are for.' At least five versions of this painting are known and Colling had obviously been astute enough to convince several of his farming acquaintances that they should have an expensive portrait of 'Comet' (Colour Plate

169). Such purely mercenary motives account for only a proportion of the livestock paintings which were undertaken. There is a distinction between the publicity portraits commissioned to promote the top breeding animals and paintings which were commissioned by the owners for their own pride and pleasure, or out of rivalry with their neighbouring farmers.

Writing in 1820 Major Bartholomew Rudd tells Weaver, 'You have already adorned my dining room with some fine specimens of your art and I do not think that I have at present any animals in that state of condition which I should wish to have as paintings'. He goes on to explain how his animals are at present in a low condition and that he has 'no fat ox or cow or bull for such a purpose.' Weaver's clients often asked him to come on a particular day before the animals are sold, so they will have a record of the animal to keep. Writing from Babworth on 6 July 1818, Mr Holland tells Weaver that the purchaser of Mr Simpson's ox 'requested me to let him have the painting of the animal which I could not well refuse as he promised to pay for another in lieu of it, which I beg you will as a particular favour make for me as soon as possible'. Writing from Wighton on 27 June 1814, John Reeves declares himself 'sorry you could not come last ————— as my bull and cows were then in high feather. I should still like

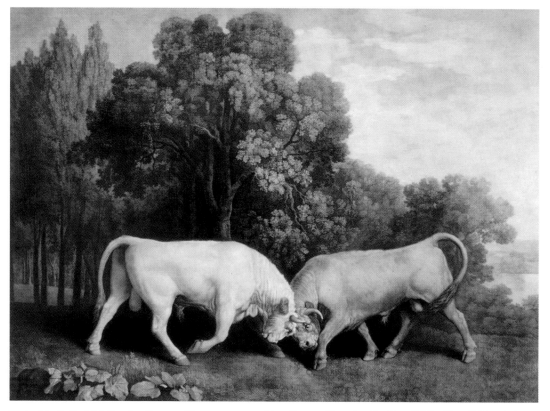

Plate 14. *Bulls Fighting* by George Stubbs, engraved by George Townley Stubbs, 1788. 19 x 23¾in. (48.2 x 60.5cm).
Inscribed: *To Robert Bakewell Esqr. this plate of bulls fighting is respectfully inscribed by his most obedt. servt Benjn. Beale Evans.*
This portrayal of two bulls locked in combat demonstrates Stubbs' ability to portray the wild aspect of animals as well as their more docile domesticated nature. The publisher has dedicated the print to Robert Bakewell although the animals depicted are not of the Longhorn breed.
British Museum

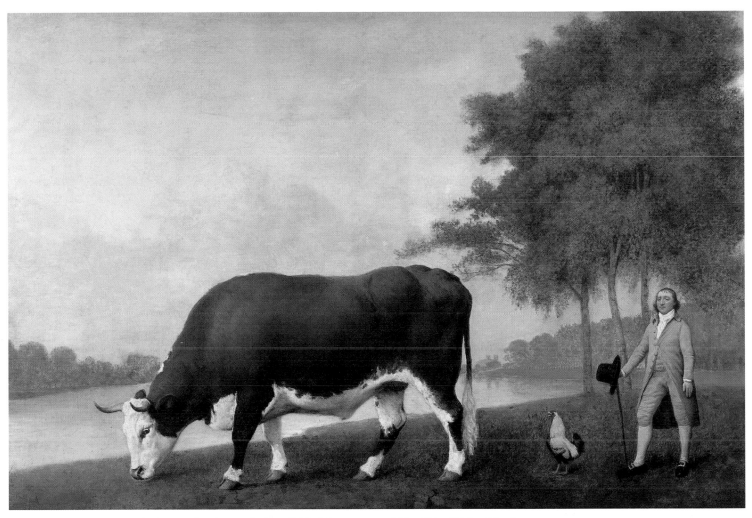

Colour Plate 50. *The Lincolnshire Ox* by George Stubbs, 1791. Oil on canvas, 26¾ x 39in. (67.9 x 99cm). One of the earliest surviving animal paintings, it was commissioned from George Stubbs, the country's leading animal painter. This painting was engraved and sold as a souvenir where the animal was exhibited. (See also Plate 78.)

The Board of Trustees of the National Museums & Galleries on Merseyside (Walker Art Gallery, Liverpool)

to have the bull taken he is now six years old and got to his shape'.

Care is taken that the animals are painted when in their fattest and best condition. It was only the most exceptional animals and not the average ones which were painted which of course distorts the picture further. Weaver's correspondence contains accurate measurements in his own handwriting which he had taken both for 'The White Heifer' and 'Mr Jellicoe's Heifer' and another client, Mr Dorrien, writes in 1801, 'The Portrait of the ram is very good, I remember the original perfectly, I like the whole picture very much; as well as that of the Hereford bull, – which for the size of the figure & the price is best suited to my purpose, which is to make a collection of the different breeds of cattle and sheep.'

One of the earliest of the exhibition animals to be painted is the *Lincolnshire Ox* (Colour Plate 50) in 1791. Stubbs here copied the stance of Cuitt's *Blackwell Ox* (Colour Plate 32), one of the few existing prototypes. Stubbs had devoted himself to studying the anatomy of the horse, introducing a new naturalistic approach to horse painting. He was probably the best qualified artist alive to undertake accurate portraits of livestock. We have only to turn to his mezzotint of *Two Bulls Fighting* (Plate 14) to see what he was capable of as an animal painter. The Lincolnshire Ox' was massive; it stood 6ft.4in. high and weighed 360 stone at 8lb. to the stone; that is 2,880 lb. or 205 stone 7lb. at 14lb. to the stone. It was an unimproved Shorthorn,

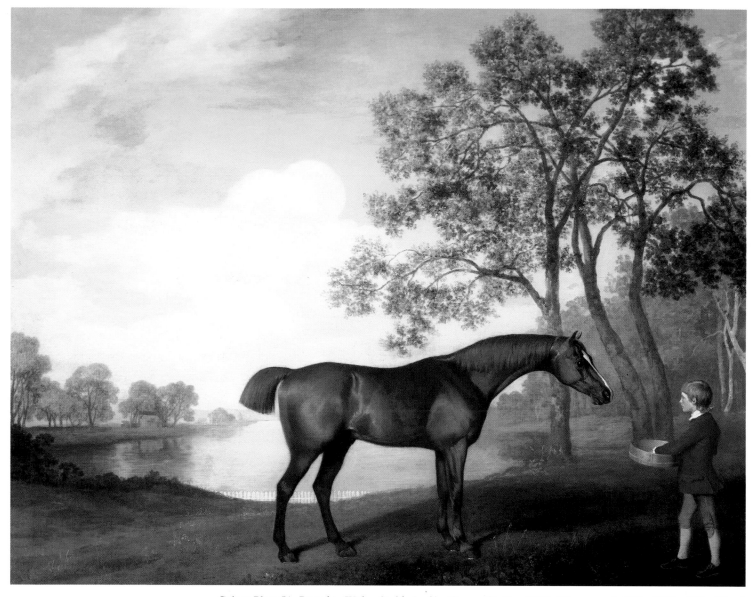

Colour Plate 51. *Pumpkin With a Stable Lad* by George Stubbs, 1774. Oil on panel, 32¾ x 39⅛in. (83 x 99cm) Stubbs' Lincolnshire Ox employs the same compositional devices as this earlier painting. The horse is silhouetted against a distant lake and contrasted with a small figure to emphasise its size.

Paul Mellon Collection, Upperville, Virginia

still with fairly long legs and heavy forequarters, similar in appearance to *The Blackwell Ox* which, although it was 6ft. tall, weighed only 162 stone 10lb. when slaughtered. Stubbs has not distorted the animal's appearance but has placed the owner John Gibbon very ambiguously in the picture plane so that the ox appears to dwarf him. Stubbs used a very similar composition in his painting of *Pumpkin with a Stable Lad* (Colour Plate 51), silhouetting the animal against a lake and emphasising his size by juxtaposition with the stable lad. Sir Joseph Banks, President of the Royal Society and a great Lincolnshire landowner, advised Gibbon on the choice of artist. Both the painting and the engraving after it by George Townley Stubbs were made in 1790 and the painting was exhibited at the Royal Academy that year as *Portrait of the Lincolnshire Ox now to be seen at the Lyceum, Strand*. It appears to be the only cattle portrait undertaken by Stubbs.

Several documents relating to this painting and the print of it survive in the Walker Art Gallery, Liverpool. Stubbs was paid £64.12s.6d. for the painting. The ox was transported to

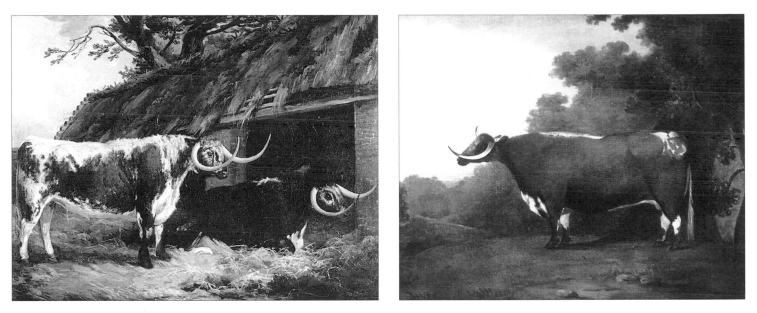

Plate 15. *Two Longhorn Steers* by James Ward, 1796. Oil on canvas, 20 x 26in. (51 x 66cm).
Ward exhibited this painting as 'Staffordshire Cow and a Staffordshire Bull belonging to Mr Thomas Princep
of Croxhall, Derbyshire' at the Royal Academy in 1797. Princep was an influential breeder (see Plate 35 and
Colour Plate 167) and the work established Ward as a livestock painter. Private Collection

Plate 16. *Longhorn* by John Best, 1782. Oil on canvas, 25 x 30in. (63.5 x 76.2cm). One of the earliest dated
oil paintings of a Longhorn, this may be the painting exhibited by Best at the Royal Academy in 1782 as
'Portrait of a large ox belonging to Mr Bakewell'. Private Collection

London in a 'Machine' drawn by eight horses and exhibited in its machine in Park Lane
opposite Grosvenor Gate until it was moved to the Royal Riding House in Hyde Park. The
town subscription opened on 11 February 1790 and continued until 22 May. Subscribers to the
print were given a free entry to the exhibition, others were charged – 1s. for an adult and 6d.
for children and servants. Gibbon sold the ox at Tattersall's on 25 May 1790 for 185 guineas
to a Mr Turk of Newport Street who exhibited it at the Lyceum in the Strand along with a
rhinoceros which Stubbs also painted and 'three Stupendous Ostriches'. The exhibition
continued until April the following year. It had been intended to butcher the ox on 4 June to
celebrate the King's birthday but unfortunately the poor beast began to decline. His legs went
numb and swelled and he refused to stand up. The exhibition therefore closed on 19 April 1791
and he was slaughtered the next day. Even then, public interest in the animal did not subside,
for 'a conspicuous part of him' remained on display in London until 4 May and then in
Lincolnshire. The meat was recorded as 'exceedingly fat & rich; insomuch that it did not
stiffen; …it took salt very well' (Burt, 1791).

Paintings of cattle were regularly exhibited at the Royal Academy, showing they were held
in the same esteem as horse portraits. Sawrey Gilpin, John Nost Sartorius, George Stubbs and
James Ward (Plate 15) all exhibited cattle paintings in the Summer Exhibitions during the
1780s and '90s. John Best, an established London horse painter who is perhaps best known for
his copies after Stubbs, exhibited a 'Portrait of a large ox, belonging to Mr Bakewell' in 1782
which may well be the animal in Plate 16. Best's painting of a Longhorn is very similar in style
to John Boultbee who also executed commissions for Bakewell and whose work was much
influenced by Stubbs.

Boultbee was the first artist to specialise in cattle painting. Together with his twin brother,
Thomas, he studied at the Royal Academy Schools, entering in 1775. He was born into a
Leicestershire family of some standing, living at Stordon Grange, a moated manor house at
Osgathorpe. Boultbee was one of eleven children and his parents evidently lived beyond their
means for he did not receive an inheritance and, with a wife and eight children to support,

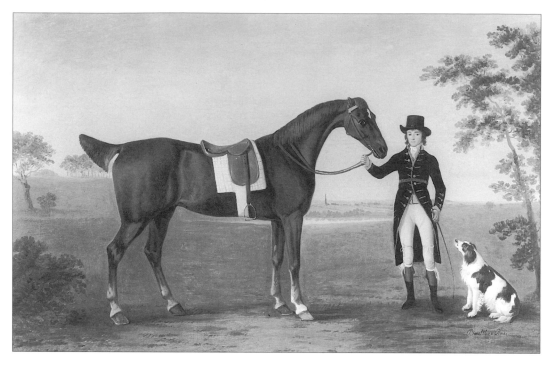

Plate 17. *Horse and Rider with a Spaniel* by John Boultbee. Oil on canvas, 17½ x 27½in. (44.5 x 70cm). Boultbee's debt to Stubbs is clear in the frieze-like arrangement of the figures against the background.

Private Collection. Photograph Courtauld Institute of Art

horse and cattle portraiture would have provided him with a reasonable living. His brother Thomas married well and painted only as an amateur. Boultbee is an underrated artist. While some of his more ordinary animal portraits tend towards the dull and repetitious, his best work comes close to Stubbs and has been confused with it. By the 1780s, Boultbee had returned to his home territory and was working in the Loughborough area painting horse, sporting and dog portraits. His clients, while including much of the local gentry, extended well beyond his locality. A *Portrait of horse and rider with a Spaniel* (Plate 17) shows his debt to Stubbs in the treatment of the horses and the hounds and the frieze-like arrangement of the participants against a distant landscape. Boultbee's drawing of a horse shows him struggling to understand anatomy (Plate 18). He did not, however, have much feeling for landscape. The backgrounds to his paintings are often generalised with a strong diagonal of foliage forming a screen in the middle distance. In his painting of *Squire Thornton of Brockhall* (Plate 19) he has attempted a distant perspective which he has brought off far more successfully than the background to the painting of a *Horse and Rider* (Plate 17) where the two halves of the landscape do not relate to one another.

Loughborough was conveniently close to Robert Bakewell's farm at Dishley Grange and it may well have been an introduction to Bakewell which gave Boultbee the opportunity to add cattle painting to his commissions. He painted a portrait of Bakewell on his bay cob, with the great barn at Dishley and Longhorn cattle in the background, several versions of which exist (Colour Plate 1). In 1788 Boultbee exhibited a horse picture at the Academy described as 'a favourite horse of Mr Bakewell'. This is unlikely to be the painting in Colour Plate 297, since this is inscribed 'The Celebrated Carthorse Property of Mr Bakewell of Dishley, 1790'. The buildings of Dishley Grange can be clearly seen in the background. Boultbee himself published a print after his painting of Bakewell's cart-horse entitled *The Black Shire Horse*, engraved by F. Jukes in 1791 (illustrated *Walker's Quarterly*, 1932). Dishley Grange and its adjacent church where Robert Bakewell is buried appear in the background of a painting by Boultbee of a Longhorn at Calke Abbey (Plate 76). The animal has developed huge deposits of fat about his tail, a characteristic of Bakewell's animals. The painting may well have been acquired by Sir John Harpur Crewe (1844-1886) who owned a prize herd of Longhorns and was an ardent admirer of Robert Bakewell. Boultbee was also patronised by Bakewell's heir Mr Honeyborn, executing a portrait of a two year old ram which he published as an engraving in 1802 (Colour Plate 211).

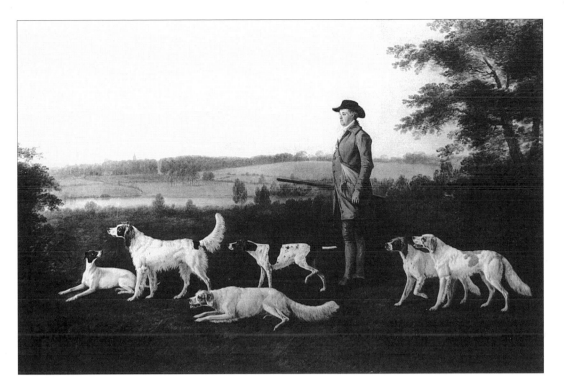

Plate 19. *Squire Thornton of Brockhall* by John Boultbee. 59 x 85in. (150 x 216cm).
Boultbee was well established as a horse and sporting painter for the aristocracy and landed gentry before turning to farm animal painting. Squire Thornton has been painted out shooting with his favourite dogs in a manner typical of the English gentry of this period.
Whereabouts unknown. Private Collection.
Photograph Courtauld Institute of Art

Through Bakewell, Boultbee could have earned an introduction to many of the most eminent cattle breeders although the marriage of his relation Charles Boultbee (1783-1833) to Julia Wyndham, sister of Lord Egremont, would also have been useful. Shaw Sparrow (*Connoisseur,* March 1933) records eleven portraits of sheep and cattle belonging to Lord Egremont. Only five of these have survived at Petworth, none of which is signed. However, *Goats and Sheep* signed J. Bolteby. Pinx 1797 appears in the catalogue of paintings at Petworth House in 1926 and was also recorded by Shaw Sparrow. These paintings appear to be by Boultbee and Shaw Sparrow suggests he may have reverted to the medieval spelling of his name after a talk with Lord Egremont.

Alastair Laing of the National Trust has kindly pointed out a reference to Boultbee painting at Petworth in the diaries of the sculptor Thomas Alphonso Hayley and his father the poet William Hayley. William Hayley and his son Thomas were part of the artistic and intellectual world surrounding Lord Egremont. Despite being 'only a painter of four-footed animals', Boultbee was on intimate terms with the Hayleys; he is described as 'this good and very *ingenious* man'. He goes out riding with them and dines at their home at Eartham near Petworth. Hayley first met Boultbee at Petworth on 9 February 1797. He refers to him as 'Mr Boltby' which is interesting in the light of the signature on the Petworth painting, and describes him as 'of a good northern family' with 'a wife and several children, in Leicestershire, whom he is much attached to, but has been obliged to quit them for several months in the pursuit of his profession'. Boultbee has 'many works in hand' at Petworth. Through Lord Egremont, Boultbee obtained an

Plate 18. *Royalist* by John Boultbee. Pen, ink and watercolour on paper, 6 x 7¾in. (15.5 x 19.4cm).
Inscribed: *Royalist late the property of H R Highness Prince of Wales.*
Boultbee was very influenced by the work of Stubbs which had such a dramatic impact on animal painting in the later 18th century. This drawing shows him trying to master the anatomy of the horse.
Private Collection. Photograph Courtauld Institute of Art

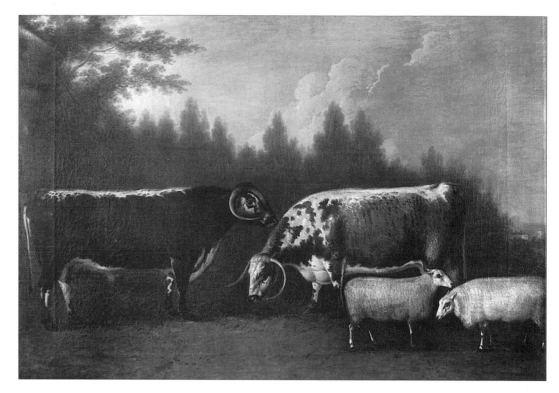

Plate 20. *Longhorns and Leicester Sheep with Dishley Grange in the Background* by John Boultbee. Oil on canvas, 27½ x 36in. (70 x 91.5cm).
This is one of a series of paintings by Boultbee executed for Lord Egremont showing different breeds of cattle with the owners' houses in the background. The animals illustrated here are particularly good examples of their breeds. As in other paintings by Boultbee of Robert Bakewell's animals, Dishley Grange can be seen in the distance. Thomas Weaver executed a painting very similar in composition (Colour Plate 2).

By kind permission of Lord Egremont

introduction to George III. Hayley described him as 'already engaged to paint several favourite animals of the Royal Farmer George' and he 'will set out in a few days for Windsor'. Unfortunately no record of any paintings by Boultbee in the Royal Collection has yet come to light.

The surviving paintings at Petworth are very interesting for each shows a different house in the background. A painting of two Longhorns and two New Leicester sheep has Dishley Grange and the church in the background (Plate 20) and is very similar in composition to a painting by Thomas Weaver dated 1802, after Bakewell's death, which also shows Dishley Grange in the background (Colour Plate 2). The painting of *Sussex Bull and Cow, South Down Ram and Ewes*, has Petworth House in the distance which is consistent with the animals bred by Lord Egremont. There is still a fine herd of Sussex cattle at Petworth. Two paintings of Shorthorns have views of Windsor Castle in the background (one of which is illustrated in *Walker's Quarterly*, 1932), suggesting they are from the Royal Herd of George III. A fifth painting of sheep has a classical looking house in the distance. The entries in the 1926 catalogue are too brief to give us much information on the missing pictures and Shaw Sparrow did not record them commenting, 'Only four of the eleven can be seen at all well, as the others have fared badly during a Long life.' The series at Petworth confirms that livestock portraits were not commissioned just by their owners but also as standards of excellence by other breeders which explains why there is often more than one version of a painting.

Bakewell may have introduced Boultbee to another important patron, Thomas Coke of Norfolk. In 1783 he exhibited two portraits of horses belonging to Coke at the Royal Academy. The group of paintings of Longhorns by Boultbee at Shugborough are believed to have been commissioned by Coke when he purchased the animals after the dispersal of the Rollright herd in 1791 (Colour Plates 161 to 164). According to an unproven tradition they may have come to Shugborough together with the animals when Thomas Anson married Coke's daughter Margaret in 1794. Viscount Anson was in the forefront of current agricultural theory and much influenced by Thomas Coke. He built a model farm designed by Wyatt in emulation of the one he had designed at Holkham. The Rollright Longhorns at Shugborough are 'Broken Horned Beauty' who sold for 44 guineas, 'Garrick', the highest priced bull at 205 guineas, 'Garrick's Sister', 'Brindled Beauty', the star of the sale who fetched 206 guineas and 'Spotted Nancy'

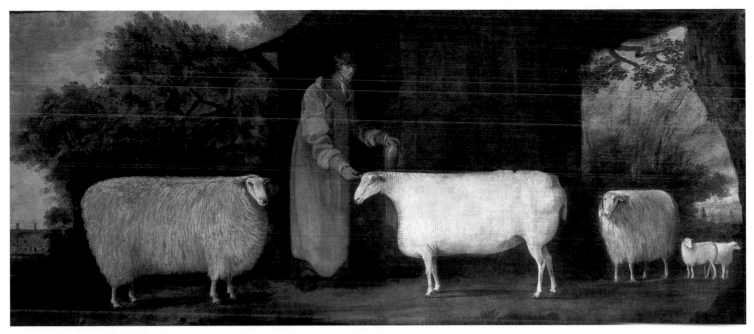

Colour Plate 52. *A Shepherd with his Flock* by J. Digby Curtis. Oil on canvas, 24½ x 56¾in. (62 x144cm).
The artist painted Bakewell's famous ram 'Two Pounder' which belongs to the Unit of Agricultural
Economics, Oxford, in 1790. A contemporary of Boultbee's, his style was more naïve and his work is
extremely rare. Bonhams: Bridgeman Art Library, London

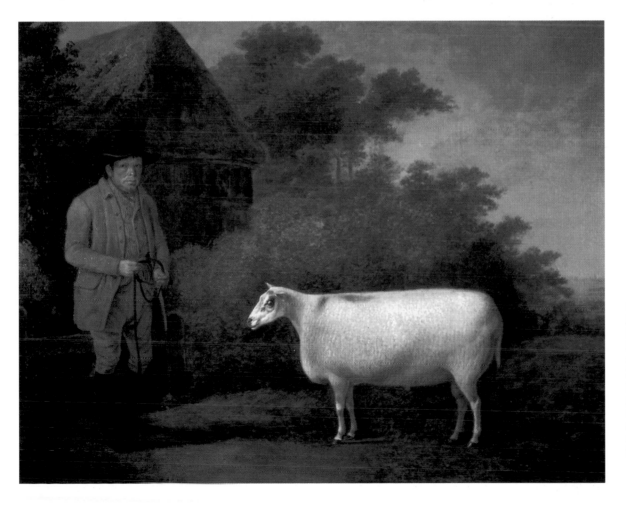

Colour Plate 53. *Richard Meek of Dunstall Hall with his prize Leicester Ram*, by John Boultbee. Oil on canvas laid down on board, 22 x 28in. (56 x 71cm). Boultbee was a fine portrait painter. Meek appears as a ruddy faced farmer against a generalised background of foliage, typical of Boultbee's work.

Collection of Mr and Mrs
Edd Stepp

63

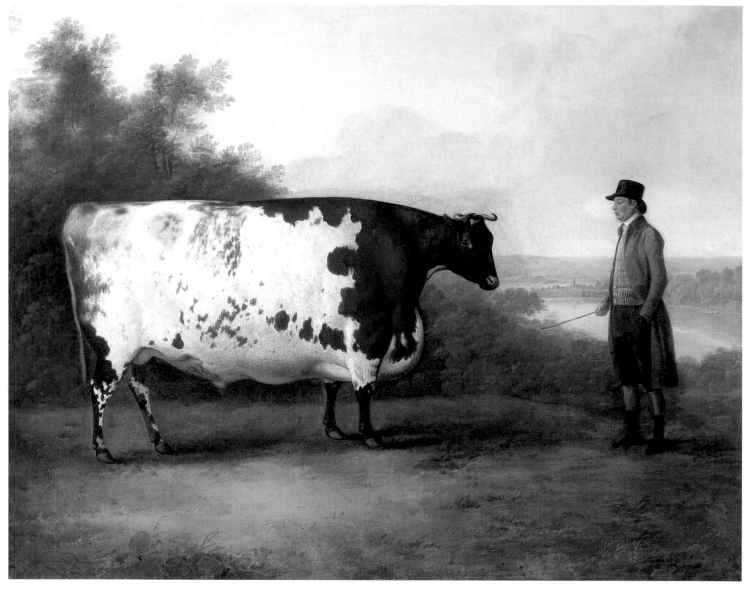

Colour Plate 54. *The Durham Ox* by John Boultbee. Oil on canvas, 1802. 40½ x 50½in. (103 x 128cm).
This is one of Boultbee's finest cattle portraits and the best known image of the Durham Ox since more than 2,000 copies of the print (Colour Plate 12) were circulated within a year of its publication

From the Collection at Althorp

who sold for 80 guineas. All are signed Boultbee but not dated. A further group of seven Longhorns from the Rollright herd, attributed to Boultbee, belong to the Unit of Agricultural Economics, Oxford. They depict 'Garrick', 'Shakespeare', 'Brindled Beauty', 'Long Horn Beauty' and an unnamed cow and a bull. Another portrait of 'Shakespeare' signed J Boultbee, 1795, is at Rothamsted experimental station.

Boultbee's most famous cattle portrait is the *Durham Ox* (Colour Plate 54). One of the earliest improved Shorthorns to be publicly exhibited, it is in the collection of Lord Spencer. It is not known when it entered the collection at Althorp but was probably acquired by the 3rd Earl Spencer (1782-1845) whose celebrated Shorthorn herd is recorded in twenty-three cattle portraits still at Althorp. The ox was painted by several different artists. Weaver's version was painted the same year as Boultbee's (Colour Plate 55), but twelve years later in 1814 he exhibited 'Portrait of the Durham Ox, bred and fed by Charles Colling, Esq' at the Liverpool Academy which may have been another version. Boultbee's portrait is easily the most superior.

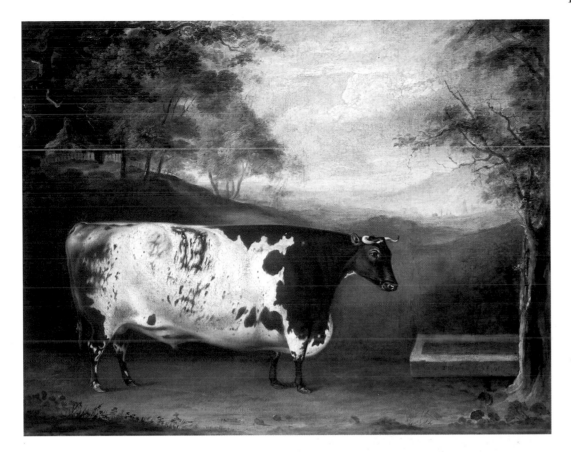

Colour Plate 55. *The Durham Ox* by Thomas Weaver, 1802. Oil on canvas, 32¼ x 39½in. (82 x 100cm).
Several artists painted the Durham Ox. This painting by Weaver is the same date as Boultbee's and closely follows his composition. Clifford Ellison

The painting was commissioned by the ox's owner, John Day, a travelling showman, so that he could produce a print for sale while he toured the animal. The ox proved to be a fine investment; Charles Colling sold him for £140 and later that year Day was offered and declined £2,000. The gentle looking ox stands facing his owner in profile against a carefully painted landscape. The ox was 5ft.6in. tall, 10in. shorter than Stubbs' Lincolnshire Ox, and weighed 272 stone at his peak. Far from attempting to exaggerate the animal's size, Boultbee has even placed Day on a slight hillock making the ox appear shorter in relation to him than he actually was. His size and proportions are very similar to Garrard's accurate engraving of the subject with its carefully recorded measurements (Colour Plate 13). Boultbee continued to paint right up to his death. In 1812 he moved from Chester to Liverpool and exhibited eight paintings in the Liverpool Academy before dying unexpectedly on 30 November that year.

Boultbee's pupil and successor was a Shropshire artist Thomas Weaver (1774-1843). A collection of letters from his patrons and other documents relating to his life and work, already quoted from above, as well as extracts from his diary survive. Born at Worthen, near Shrewsbury, his father was an officer in the Excise. Thomas was one of eleven children and was apprenticed to John Boultbee for five years in 1792 for the sum of £150 guineas. He returned to Shrewsbury in 1797 and by 1811 had married Susanna, the daughter of the Rev John Pyefinch, Rector of Westbury, Shropshire. The young couple set up house on St John's Hill, Shrewsbury and Weaver established a prosperous business as an animal painter. A passage ran up the side of his house along which horses and cattle were taken to his studio to be painted.

Two of his earliest paintings dated 1802, *The Durham Ox* (Colour Plate 55) and *Livestock at Dishley Grange* (Colour Plate 2) are very similar in composition to works by Boultbee (Colour Plate 54 and Plate 20). Weaver was a provincial artist; he spent most of his life in his native Shrewsbury, moving to Liverpool in 1833 where his son John Pyefinch Weaver, also a painter, lived and where he died in 1844. He did visit London in 1805 and again for two weeks in 1825 and exhibited four works at the Royal Academy in 1801, two in 1808 and one in 1809, as well

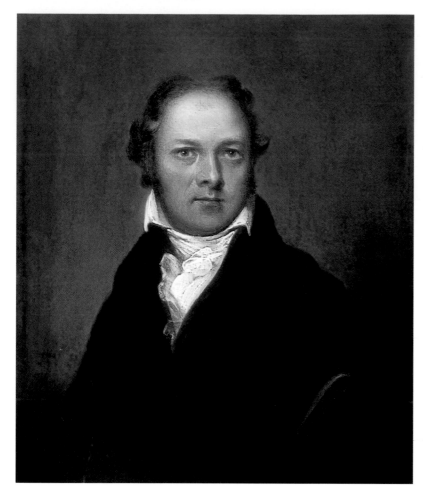

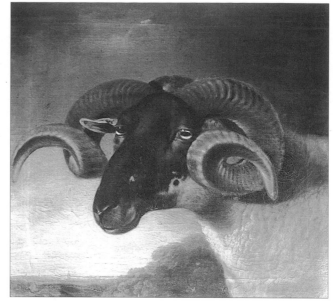

Plate 21. *Head of a Ram* by John Boultbee. Oil on canvas, 28¾ x 30in. (73 x 76.5cm).
An almost identical painting by Thomas Weaver is at Shugborough.
By kind permission of The Earl of Leicester and Trustees of the Holkham Estate. Photograph Courtauld Institute of Ar

Colour Plate 56. *Self Portrait* by Thomas Weaver. Oil on tin plate. Initialled T.W.P 6¾ x 5½in. (17.2 x 14cm).
This has the delicate handling of a miniaturist and clearly shows what an able artist Weaver was. Private Collection

as exhibiting at the Liverpool Academy. He was not however concerned with mainstream artistic developments although a painting dated 1814, *White Trotting Horse in a Storm* (Colour Plate 57), has a strong emotional content showing the animal's wild nature and suggests he had looked at the work of Stubbs and James Ward. Weaver began his career painting portraits and animal portraits for a local clientele in his native Shrewsbury. His early patrons included local tradesmen and gentry, for whom he painted horse and dog portraits, as well as established landowners like John Cotes, M.P. for Salop (Plate 27). He was also patronised by the aristocracy including Lord Warwick for whom he painted a horse portrait in 1800, the Earl of Powis and Viscount Anson at Shugborough. Weaver executed seven works for the Ansons between 1808 and 1811. Four of these were of the family's riding horses but he also painted the magnificent Longhorn bull (Colour Plate 58) and two portraits of rams' heads. There is a very similar portrait of a ram's head by Boultbee at Holkham Hall (Plate 21). Weaver established himself as a livestock painter very early in his career. In 1801 he painted twelve copies of the Hereford bull which won a wager against a Longhorn (Colour Plate 177) and the following year he worked for the Duke of Bedford, painting a Southdown ram and a racehorse, 'Dragon'. The Anson and Coke families were related by marriage (see above) which might explain why Weaver gained his important commission to paint *Thomas Coke with his Southdown Sheep* in 1807. He was paid 63 guineas for the painting, by far his most expensive commission to date. (Colour Plate 11).

Where Boultbee had painted Bakewell's animals, Weaver's most influential patrons in the livestock breeding world were Bakewell's successors, the Shorthorn breeders Charles and Robert Colling whose portraits he also painted. Already the Shorthorn was beginning to eclipse the Longhorn and Weaver immortalised many of the new improved shorthorns of the

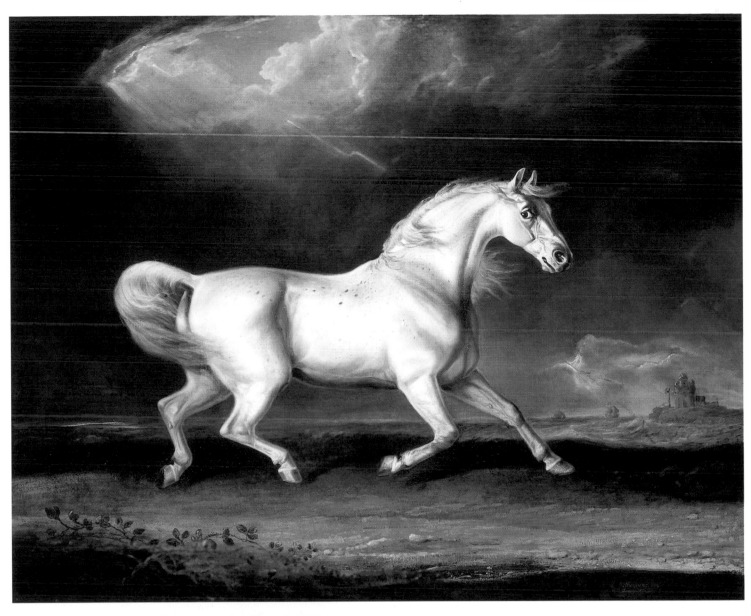

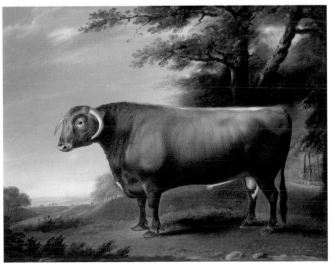

Colour Plate 57. *Mr. R Blackburn's White Trotting Horse in a Storm* by Thomas Weaver. Oil on canvas, 40 x 67¾in. (102 x 172cm).
The painting was exhibited at the Liverpool Academy in 1814. It shows Weaver coming under the influence of James Ward and George Stubbs who painted horses in similar attitudes. The treatment of the horse's head is particularly fine although the anatomy of the animal is incorrect. The horse tossing his head and flaring his nostrils against a storm-tossed sea is in marked contrast to the static poses Weaver had to adopt in most of his animal portraits. The surface of the paint is carefully built up with delicate glazes and scumbles. Private Collection

Colour Plate 58. *A Long Horn Bull Belonging to Viscount Anson* by Thomas Weaver, 1808. Oil on canvas, 19½ x 24½in. (49.5 x 62cm).
Weaver executed at least seven works for the Ansons between 1808 and 1811. He obviously remained on good terms with them for towards the end of his life, when he was ill and on hard times, Viscount Anson secured an appointment for his youngest son Harry Edward in the Liverpool Post Office. Private Collection

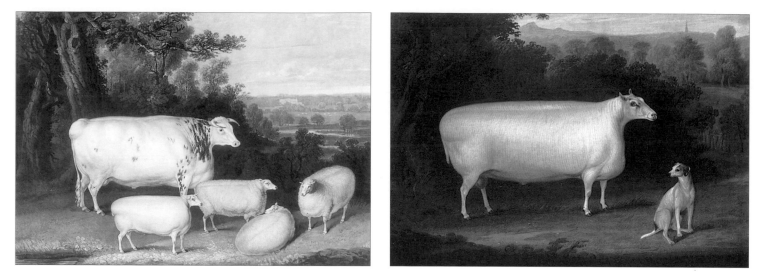

Plate 22. *The Blyth Comet Ox* after Thomas Weaver, engraved by William Ward, 1818. 21¾ x 28½in. (55.5 x 72.5cm).
Inscribed: *Portraits of the Blyth Comet ox, 2 years & 11 months old, and four wether sheep, 21 months old Bred & fed by Mr. Champion of Blyth, Notts. & exhibited by him at the London Christmas Cattle Show, Sadlers Yard, Decr. 1817. To his Grace the Duke of Bedford, this print, is by permission, most respectfully inscribed by His Grace's very obliged servant, Charles Champion. Dead weight of the Durham steer, 236 st. 7 lbs, 8lbs to the stone London weight ... The dead weights of the four sheep, 94 st. 7½ lbs.*
Charles Champion was a Shorthorn breeder and one of Weaver's friends and patrons in the Midlands.

Courtesy of the O'Shea Gallery

Plate 23. *A New Leicester Ram with a Dog*, by Thomas Weaver, 1829. Oil on canvas, 18 x 24in. (45.7 x 61cm). The ram has an extremely long back and in several of Weaver's paintings the anatomy appears exaggerated. The heads of his sheep often appear too small, but this is how they were bred at the time.

National Trust, Calke Abbey. NT Photo Library

early nineteenth century, among them 'Comet' (Colour Plate 169), Charles Colling's famous £1,000 bull 'Petrarch' (Colour Plate 59), who was sired by 'Comet', and Robert Colling's grotesque large 'White Heifer' (Colour Plate 4). He was often asked to execute copies of these famous animals for rival breeders. Other Shorthorn breeders whose animals he painted were mainly from the North and Midlands and included George Coates of Driffield (Colour Plate 60), Yorkshire, Charles Champion of Blyth (Plate 22), Sir George Harpur Crewe at Calke Abbey (Plate 23) and Major Bartholomew Rudd of Marton Lodge, Stockton-on-Tees.

Weaver's sporting and hunting scenes are among his most complicated and costly compositions. The best known of these, also produced as an engraving, is *Mr John Corbet out with his Hounds,* now at Upton House, Banbury. He was as much in demand to portray horses and dogs as cattle, but he was not such an accomplished animal painter as Boultbee. His animals can have a rather wooden two-dimensional feeling and certainly his sense of anatomy was not as good. 'Comet's' back is extraordinarily long and the 'White Heifer' could surely not have supported her enormous weight on such spindly legs. There is a fine collection of sheep and cattle portraits by Weaver at Calke Abbey, most of which date from 1830 and '31. Even at this date his sheep still have absurdly long backs (Plate 23) and while the cattle appear to be more in proportion they have tiny heads compared with their bodies. Weaver thoroughly immersed himself in the agricultural world, so much so that he was asked to contribute articles to a new agricultural periodical, the *National Advertiser,* which did not however ever get off the ground. Leading breeders wrote detailed letters to him with accounts of their sales and prize animals. Charles Champion in 1819 calls Weaver 'a staunch friend to the shorthorn' and goes on to describe a cattle sale he held recently for a further two pages. Weaver covered enormous distances in the North and Midlands travelling as far as the Scottish borders to paint animal portraits. He was a regular visitor at many of the grandest stately homes where he often

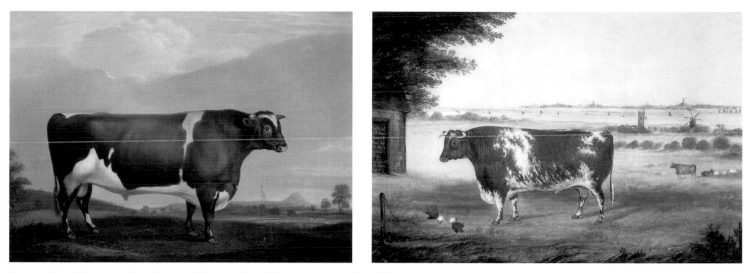

Colour Plate 59. *Petrarch* by Thomas Weaver, 1812. Oil on canvas, 24¾ x 31½in. (63 x 80cm).
The Colling brothers and Major Rudd were among the Shorthorn breeders of the Midlands who patronised Weaver. Petrarch was bought by Major Rudd at Colling's famous Ketton sale in 1810 for 365 guineas. Where Boultbee had painted the famous early Longhorns, Weaver immortalised the Shorthorns of the next generation. Photograph Christie's Images

Colour Plate 60. *Patriot* after Thomas Weaver. Oil on canvas, 18 x 26in. (46 x 66cm).
Inscribed: *Patriot at 6 yrs no.486 Bred by M G Coates, Driffield Got by Driffield 227 in the year 1804.*
George Coates was one of the most important early breeders of Shorthorns. An original version of this painting by Weaver exists in the Unit of Agricultural Economics, Oxford. Private Collection

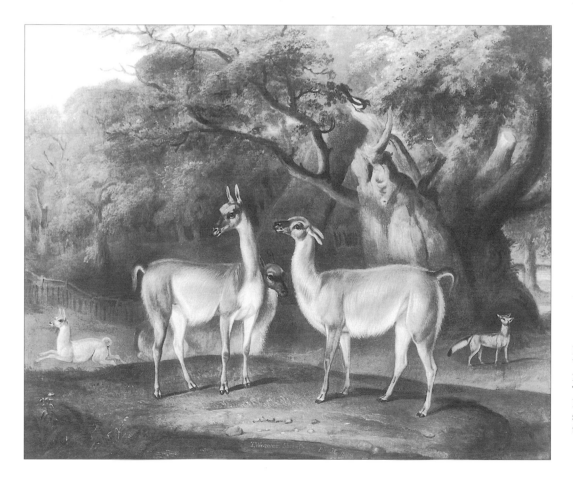

Plate 24. *Llamas and Fox* by Thomas Weaver, 1828. Oil on canvas, 24 x 29in. (60.9 x 73.5cm).
The painting was commissioned by Lord Talbot of Ingestre Park. Exotic species were a fashionable addition to the gentleman's park.
Private Collection. Photograph Courtauld Institute of Art

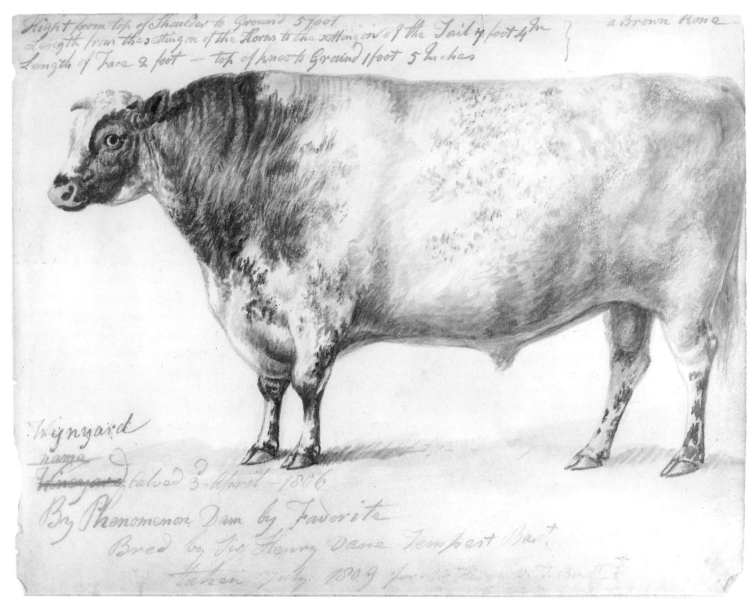

Hight from top of Shoulder to Ground 5 foot
Length from the setting on of the Horns to the setting on of the Tail 7 foot 4 in
Length of Face 2 foot — top of knee to Ground 1 foot 5 inches

a Brown Rone

Wynyard
name

Calved 3 April 1806
By Phenomenon Dam by Favorite
Bred by Sir Henry Vane Tempest Bart
taken July 1809 for Sir Henry V.T. Bart

Colour Plate 61. *Sketch of a Shorthorn Bull Wynyard* by Thomas Fairbairn Wilson, 1809. Watercolour on paper, 8¾ x 9¾in. (22.5 x 25cm).
Inscribed: *Name Wynyard Calved 3rd April 1806 By Phenomenon Dam by Favorite Bred by Sir Henry Vane Tempest Bart taken July 1809 for Sir Henry V.T. Bart.*
Hight [sic] *from top of Shoulder to Ground 5 foot Length from the setting on of the horns to the setting on of the Tail 7 foot 4 in Length of Face 2 foot – Top of knee to Ground 1 foot 5 inches. A brown Roan.*
Working sketches for finished paintings are extremely rare. These are executed with a great deal of care and detail showing Wilson to be a firm and accomplished draughtsman. No background details are included suggesting that, like many of his contemporaries, he placed the animals against a generalised landscape setting in the finished paintings. The finished painting of Wynyard is now in the collection at Rothamsted Experimental Station.
Collection of John Gall and Rosy Allan

stayed for several weeks. His regular clients included the Earl of Chesterfield, the Earl of Bradford, the Earl of Powis, Earl Talbot, Viscount Anson and Sir George Harpur Crewe. As well as painting animals and portraits of the family he was also called upon to restore the family paintings and undertake valuations.. He was well entertained on these occasions and large amounts of port were consumed which his descendants believed helped contribute to the 'chronic rheumatism' which crippled him in later life.

Weaver does not however appear to have had any clients in the South. Although he worked

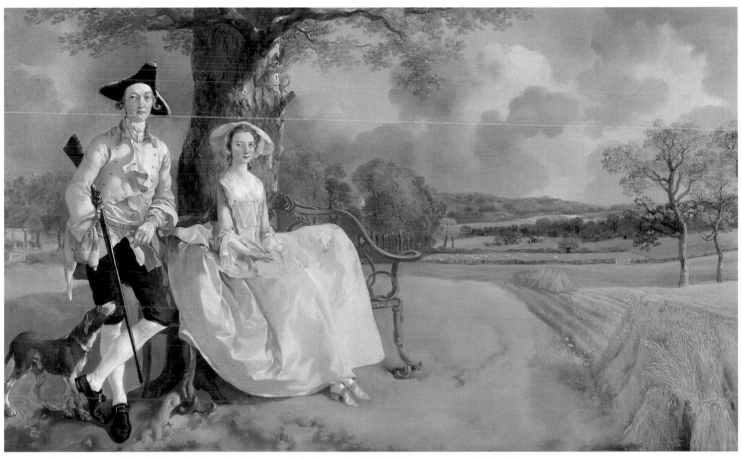

Colour Plate 62. *Mr and Mrs Robert Andrews* by Thomas Gainsborough, 1748-9. Oil on canvas, 27½ x 47in. (69.8 x 119.5cm).
This is one of the earliest paintings to place the sitter in a farming setting rather than in parkland adjacent to the house. Mr Andrews' straight furrows indicate he has adopted the use of the seed drill.

for the Duke of Bedford and Thomas Coke there is no evidence that he attended the sheep-shearings although John Reeves wrote to him from Wighton in 1814, assuring him there is 'little doubt of your meeting with employ' at the forthcoming Holkham show. Charles Champion urges him to be at Blyth for his ram show on 3 June where he 'will meet with many friends'.

Anatomy may not have been Weaver's strongest point but his paintings have an undeniable charm and he is at his best in his delightful portraits of gentlemen breeders with their prize cattle which reveal so much about contemporary attitudes to farming. These scenes are in direct contrast to the generalised rustic genre scenes of artists like George Morland for they illustrate specific farming practices and were commissioned by patrons anxious to illustrate their model breeds and farming practices. They evolve out of the eighteenth century conversation piece where artists like Arthur Devis placed their patrons either on the terrace overlooking their magnificent parklands or actually in the park. These conversation pieces were an extension of the seventeenth-century English 'Prospect' which gave a topographical view of the nobleman's estate.

When Gainsborough painted *Mr and Mrs Robert Andrews* in 1748-9 (Colour Plate 62) he broke with the tradition of the 'Prospect' by placing them in the centre of their farm near Sudbury. The immaculately straight lines of stubble and healthy golden sheaves of corn show us that Mr Andrews is a successful, progressive farmer who has introduced the seed drill. He has every reason to look satisfied. In the same way our attention is drawn to the Earl of

Plate 25. *The Earl of Chesterfield, his son Lord Stanhope, Mr Blaikie the Steward, a cowman and a fat heifer* by Thomas Weaver, 1810. Oil on canvas.

The English 'conversation piece' is here taken into the farmyard. The Earl is seeing that his son is instructed in the finer points of cattle breeding. The cowman is seen collecting up the manure, demonstrating good farming practice.

Private Collection. Photograph Courtauld Institute of Art

Plate 26. *The Countess of Chesterfield, her two daughters, General Beaudie and a cowman* by Thomas Weaver. Oil on canvas, 39½ x 47½in. (100 x 120.5cm).

A pendant to Plate 25, here the Earl's daughers are admiring a dairy cow. Weaver was paid £147 for the pair.

Private Collection. Photograph Courtauld Institute of Art

Plate 27. *John Cotes Esq. M P for Salop* by Thomas Weaver, engraved by William Ward, 1810. 22 x 28½in. (55.8 x 72.5cm).
John Cotes was one of Weaver's local patrons. He is here depicted with his improved swing plough which could be drawn even by the diminutive horses in the picture. Lawes Agricultural Trust, Rothamsted Experimental Station

Chesterfield's immaculate model farmyard and cowshed which is being kept scrupulously clean by the cowherd, pitchfork in hand, in Plate 25. The Earl's son is being instructed in the finer points of cattle breeding and management by the steward. The cow has Weaver's characteristic long back and the figures, though wooden, are painted with an exact eye for detail. In a pendant to this work (Plate 26) the Countess of Chesterfield drives in Bretby Park with her two daughters Georgiana and Elizabeth to inspect a dairy cow; beyond her spreads the river valley on a summer's day, dotted with cottages and tiny figures. The Earl of Chesterfield carried out many agricultural improvements to his farm near Derby. He commissioned Weaver to paint the Bradby Heifer, a Devon Alderney cross, and James Ward also visited him to paint various animals. Weaver depicts John Cotes (Plate 27) admiring his new improved Rotherham swing plough which could be drawn by only two horses as slight as those portrayed. It is the same improved plough in action in the ploughing competition from Weston Park (Plate 99). Weaver undertook natural history studies such as foxes and badgers and his foxgloves in the Tate Gallery shows him as an accomplished flower painter. He had an understanding of and sympathy with the English countryside which he paints with charming detail. One of Weaver's most ambitious and successful conversation pieces is his ram-letting scene in the Tate Gallery (Colour Plate 216).

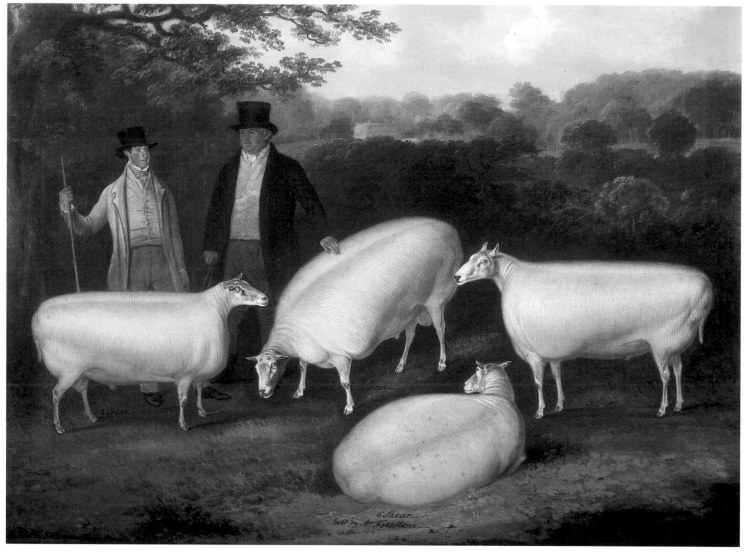

Colour Plate 63. *Mr Freestone and his Shepherd with four prize Leicester Rams* by Thomas Weaver, 1824.
28 x 36in. Oil on canvas, (71 x 91.5cm).
Inscribed: *Bred by Mr Freestone 2, 3, 4 & 6 Shear.*

Maximilian Von Hoote

Erroneously thought to portray Robert Bakewell's ram-letting at Dishley Grange, it has now been identified as depicting Thomas Morris of Barton on Humber.

A group of paintings relating to Mr Freestone and his sheep provides an interesting demonstration of the way in which copies and adaptations of paintings were made (Colour Plates 63-67). A version might be required for the farm manager as well as the owner, while other breeders required examples of prize animals as a standard of excellence. Weaver's original painting of Mr Freestone shows him talking to his shepherd who stands crook in hand (Colour Plate 63). Another version shows a fairly accurate copy of the animals but the background is different and the figures have been omitted altogether. A third version has substituted entirely different figures and a fourth, related, version has combined elements from another painting by Weaver, *A Shepherd and some Sheep in Ingestre Park, Staffordshire*, which was commissioned by the 3rd Lord Talbot, and shows the Doric rotunda on the hill in the background.

At least eleven engravings were made after Weaver's paintings by William Ward, the brother of the animal painter James Ward. While in many cases these were published by the breeders, in the case of *The Bull, Patriot*; *Thomas Coke inspecting his Southdowns* and *John Cotes Esq; M. P. for Salop* Weaver undertook the publication himself at considerable financial risk. A

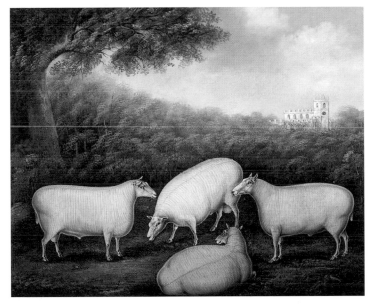

Colour Plate 64. *Four Prize Leicester Rams*, unknown artist, c.1830. Oil on canvas, 20 x 24in. (51 x 61cm).
Inscribed: *Bred by Mr Frestone, 2,3,4 & 6 Shear.*

Collection of Susie & Bob Zohlman

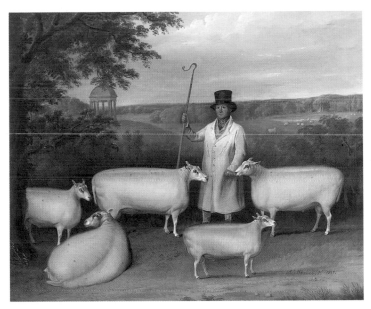

Colour Plate 65. *A Shepherd and some Sheep in Ingestre Park, Staffordshire with the Doric Rotunda in the Background* by Thomas Weaver, 1828. Oil on canvas, 25 x 31in. (63.5 x 78.7cm).

Private Collection

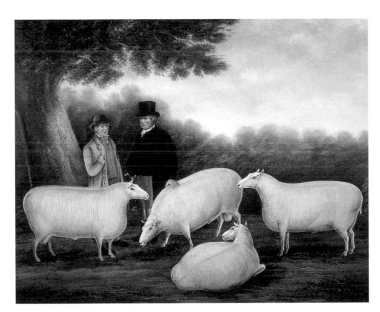

Colour Plate 66. *A Gentleman Farmer with his Farm Manager and four prize Leicester Rams,* unknown artist, c.1830. 25 x 30in. (63.5 x 76.2cm).

Private Collection

Colour Plate 67. *Five Prize Leicester Rams in Ingestre Park, Staffordshire with the Doric Rotunda in the Background* by J.B. Wood, 1831. Oil on canvas, 25 x 31½in. (63.5 x 80cm).

Iona Antiques

letter from his agent, a Mr Hills, indicates how agricultural prints were disseminated. The man was employed to travel around the country raising names for the subscription list. He recalls how he was at Norwich last week and was 'tolerably successful' but is expecting better things from the half yearly agricultural meeting to be held at King's Lynn next week. He then intends to go on to Lord Somerville's show on 1 March. Raising the subscription was only a part of the problem, for Weaver was forced to place an advertisement in a local paper relating to his print of John Cotes, M.P., requesting that those gentlemen 'who have not paid for their prints' will remit the money to his bank. The prints cost £3.3s. for a proof impression and £4.4s. coloured. Framing and varnishing cost an additional £1.16s. which 'will save the expense of

Colour Plate 68. *Two Prize Rams in a Wooded Landscape* by Thomas Weaver, 1800. Oil on canvas, 23 x 30in. (58.5 x 76cm).
The quality of Weaver's work varied according to the standard of his commission. Here he shows himself the equal of many of his academically trained contemporaries. The heads of the sheep are painted with the same care and rich modelling as Mr Blackburn's horse and the delicate background is built up by the application of rich glazes. Had Weaver decided to pursue a more academic career, works such as this suggest he could well have established himself as a leading painter.
Collection of Christopher Davenport Jones

glass'. A separate account indicates the very high cost of glass; a frame for the print of Coke, including 6s. for staining and varnishing the prints, amounts to £2.12s, while the glass alone is £2.12s.6d. This does not compare very favourably with the price of Garrard's engravings of oxen. These were a good deal smaller and less elaborate but cost only 2s.6d. plain, 5s. coloured or £6.10s. plain and £13 coloured for the whole work which contained fifty-two plates.

Weaver must have made a reasonable living. He charged 5gns. to 7gns. for a straightforward animal portrait and if two animals are included in the portrait it goes up to 10gns. He charged considerably more for elaborate compositions, 63gns. for *Thomas Coke and his Southdown sheep* (Colour Plate 11) and 85gns. for his portrait of *The Earl of Bradford with George Tollet inspecting his Southdown sheep* (Colour Plate 231). The prints he published, if successful, brought in a hefty income, that of Thomas Coke clearing £500 after expenses. In 1811 his balance at Gurney & Co.'s bank at Fakenham was £916.10s. He was clearly of some standing in the community, for he married a parson's daughter and was elected a Burger of Shrewsbury in 1825. His children were all well educated in local schools. One of his sons became a surgeon and another director

Colour Plate 69. *Four Pigs with Chickens in a Barn* by Thomas Weaver, 1810. Oil on canvas, 19 x 21½in. (48.5 x 54.5cm).

Weaver painted very few portraits of pigs. This painting shows the uneven quality of his work, the perspective is incorrect and the background very flat. The device of an open stable door giving a view of a distant landscape occurs quite frequently in his work. Iona Antiques

of a telegraph company. However, he had eight children to provide for and when illness over took him at the age of sixty in 1834 he had made no provision and fell on hard times. He painted very little after this date publishing a pathetic appeal in the *Salopian Journal* in 1840 in which he described himself as 'suffering from a wasting disease', now 'aged, infirm and a cripple'. He must have been a popular man for the nobility and gentry of Shropshire and the surrounding counties responded with a sum of nearly £350.

Gaining a successful entry into the neighbourhood was the key to acquiring several other commissions in the area. In a letter to Weaver, Robert Colling describes how another artist, George Garrard, spent several days in the Darlington area painting different livestock portraits. It appears that Garrard in this instance was not carrying out specific commissions but collecting material for his ambitious project *A Description of the Different Varieties of Oxen*

Plate 28. *Model of a Leicester Longhorn* by George Garrard, c.1800. Plaster.

The Natural History Museum, London

Plate 29. *Model of a Shorthorn Ox*, probably the 'Durham Ox', by George Garrard. Plaster.
This ox may well be a model of the 'Durham Ox' which Garrard published in his 'Description of Oxen' to accompany the models. It is very similar in shape to Boultbee's painting (Colour Plate 54) although Boultbee has exaggerated the animal's hindquarters giving it a more square appearance which has also made its hind legs look much smaller. Over-painting on Boultbee's painting shows that he had originally made the animal's neck and back several inches longer before adjusting them to more accurate proportions.

The Natural History Museum, London

Common in the British Isles which he began to publish in 1800 with plates issued up to 1815 (Colour Plates 13, 70 and 198). Garrard was a pupil of Sawrey Gilpin and married his daughter Matilda. He studied at the Royal Academy Schools and his early works included horse portraits and animal scenes, but his ambitions extended well beyond this *oeuvre* and were not entirely fulfilled. By the early 1800s he was trying hard to establish himself as a portrait sculptor. His portrait sculptures included Sir Joseph Banks, Samuel Whitbread, the younger Pitt and the Duke of Wellington. Many of his most ambitious projects, such as a colossal statue of the Duke of Wellington and a large bull in Smithfield market, failed to materialise. His former teacher Gilpin remarked that he supposed the latter would be worshipped by cleaver-tapping graziers singing, 'Glory be to thee, oh Fat!'

Garrard's engravings of oxen were sponsored by the Duke of Bedford and Lord Egremont and had the official backing of the Board of Agriculture. His preface therefore sums up the attitude of the leading agriculturalists towards the depiction of livestock. It is interesting for its emphasis on accuracy and its distinctively nationalistic overtones:

> These works are not intended merely as matters of curiosity, they exhibit, at once, the ideas of the best Judges of the times, respecting the most improved shape in the different kinds of Livestock – ideas which have seldom been obtained without great expense and the practice of many years. It is presumed that, by applying to works of this kind, the difficulty of acquiring a just knowledge upon the subject may be considerably removed; and also that distant countries where they may be sent, will be enabled to form very perfect ideas of the high state of cultivation in which the domestic animals are produced at this day in Great Britain; and should further progress be made these models will show what has already been done, and may be a sort of standard whereby to measure the improvements of future times.

Clearly, accuracy was of the highest importance; the engravings had an important documentary function as Ambassadors of British livestock improvement abroad. They are the first attempt to publish an independent record of the new improved breeds but Garrard was

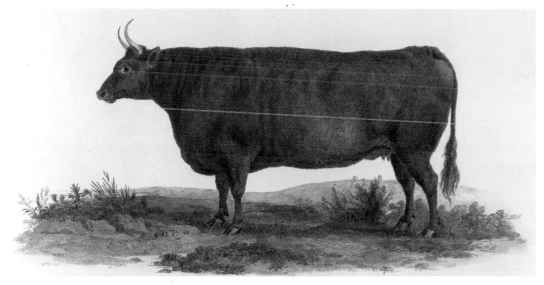

Colour Plate 70, *A Beautiful fat Devon Heifer* by George Garrard, 1805. Coloured engraving, 13 x 17in. (34 x 44cm).
Inscribed: *Which obtained a Prize at Smithfield 1802. Bred by the late Duke of Bedford and exhibited by His Grace the present Duke of Bedford.*

Dimensions	Ft.	in.	Weight	St	lb
Height of Hind Qtrs	4	5	Carcase	106	1
Round Chest	7	2	Fat	<u>19</u>	<u>4</u>
Pole to tail	6	8		125	5

highly selective in his choice, choosing twelve breeds that he later added to. They were Devon, Hereford, Leicester, Sussex, Holderness, Yorkshire Polled, Suffolk Polled, South Wales or Pembroke, North Wales or Anglesey, Scotch, Irish and Alderney. Each example has twenty-four detailed measurements as well as the history and breeding of the animal. Garrard selected the finest examples travelling the length of England painting animals drawn from Lord Egremont's stock in Sussex to the Collings up in Darlington. He did not, however, venture into Scotland or Ireland, finding examples of these breeds closer to home. There can be no doubt that Garrard's engravings are accurate, if a little dull.

The engravings were also published to accompany a group of livestock models sculpted by Garrard. As early as 1795 Garrard appears to have thought that models of cattle might be useful to landscape painters and exhibited a cow and a bull at the Academy of that year. In 1797 he secured a copyright act for the protection of sculptors. According to a notice in the *Annals of Agriculture* for 1798:

> Mr Garrard is now preparing the models from the best specimens that can be procured, under the inspection of those noblemen the Duke of Bedford and the Earl of Egremont; and he proposes to publish a set of models, to consist of a bull, a cow, and an ox, of the Devonshire, Herefordshire and Holdernesse cattle, upon a scale from nature, of two inches and a quarter to a foot. The price to subscribers two guineas each model, plain, and three guineas coloured after nature. Some observations will be published with each number, descriptive of the cattle, and the soil where they are bred in the highest perfection, with other interesting particulars, under the inspection of a nobleman of the first information, in matters relating to agriculture.

Between this date and 1810, the date incised on some of the models, Garrard executed at least twenty-three different breeds. He travelled all over the country to procure the best examples of each breed and his models were executed to a very high standard of accuracy. At least sixteen of these were cattle including Devons, Herefords, Longhorns (Plate 28), Shorthorns (the Holderness Shorthorn illustrated in Plate 29 may well be modelled on the 'Durham Ox'), Yorkshire Polleds, Alderneys and examples from Gujarat, Bengal and Ceylon. The sheep included New Leicesters (Plate 85), Southdowns, Merinos (Plate 90) and Lincolns (Plate 84)

and his pig models (Plate 93) include an early example of an Old English Siamese cross. Several of the models survive in the Natural History Museum and others are dotted around country house collections including Woburn Abbey, Southill and Burghley House. Garrard called his house in Hanover Square, London, 'The Agricultural Museum', selling the models from here. He was an able publicist and included a portrait of himself with some of his models in his *Woburn Sheepshearing* (Colour Plate 5).

Garrard was one of the first artists to put in a regular appearance at the agricultural shows, aware of the opportunities they presented for gaining future commissions. At the Smithfield Show in 1811 he made a drawing and took the dimensions of Mr Westcar's large Hereford ox. The following year he attended Lord Somerville's Show with his son and made several drawings of animals. The Woburn Sheep-shearing was a good opportunity to advertise his print of 'The Sheepshearing'. In 1813 he issued proposals for an accompanying print

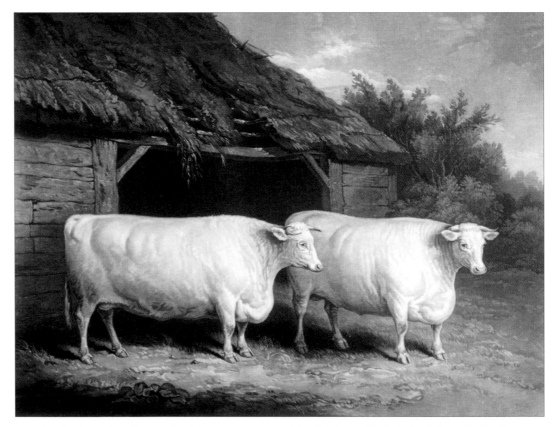

Plate 30. *Durham Twin Steers* after J. Barenger, engraved by C. Turner, 1817. 17¾ x 23in. (45 x 58.5cm). Inscribed: *Portraits of Durham twin steers supposed to weigh near 200 stone each - Bred by Mr. Thos. Arrowsmith of Ferry Hill in the county of Durham - Fed by Mr. John Wetherill of Kirby Mallory, Leicestershire. Dedicated by permission to the Right Honourable Lord Somerville.*
Barenger was a well established sporting and animal painter. A contemporary of Garrard's, he is mentioned in *Evans and Ruffy's Farmers' Journal* review of the Smithfield Show in 1811. 'Mr James Barenger, the artist exhibited most admirable portraits of a horse and a dog, belonging to Mr Westcar' and at Lord Somerville's cattle show in March 1812 'Mr Barenger also attended and took drawings of the Earl of Bridgewater's sheep, Mr James King's three oxen & c.' Lawes Agricultural Trust, Rothamsted Experimental Station

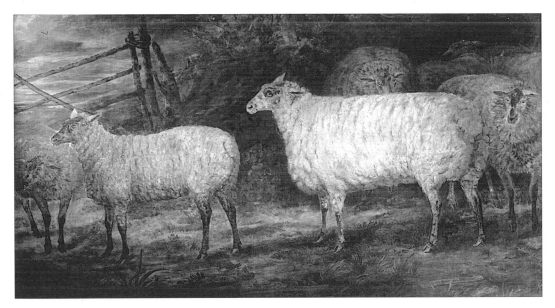

Plate 31. *South Down Sheep* by George Garrard. Oil on canvas, 59 x 107in. (150 x 272cm).
Inscribed: *Improvement of Southdown Breed of sheep at Holkham in Norfolk. Southdown Wether 1793 – Southdown Wether 1804.*
The handling of these sheep is very similar in style to the two murals in the old sheep house at Woburn.
By kind permission of the Earl of Leicester and the Trustees of the Holkham Estate.
Photograph Courtauld Institute of Art

representing the Sheep-shearing dinner in the great hall at Woburn. Obviously this venture did not receive enough support for it was never executed. One suspects the practice of artists attending the agricultural shows at this date was not nearly as common as it became later in the nineteenth century. At the Holkham Shearing in 1811 Coke's Devon heifer was exhibited on the first day and then slaughtered so her carcass could be inspected; 'her symetry [*sic*] when alive was beautiful and it was only to be lamented no artist was present to take a drawing of her'.

In addition to *The Sheepshearing,* Garrard executed several other commissions for the Duke of Bedford. An account dated 4 July 1801 survives at Woburn for work on a model of a 'Bull for the Pediment to the Greenhouse' as well as models for the sheephouse which included a 'Group of Leicester cattle' and a model of a 'Fat Heifer' whose location is not specified. These are accompanied by a letter suggesting Garrard was in financial difficulties. In 1801 he held an exhibition of work at his studio. He comments in the letter that 'the cause and the object of the exhibition having failed', he must apply to the Duke for funds. It seems very probable that Garrard also painted the life-size murals of sheep which survive in very poor condition in one of the old sheephouses at Woburn. They are similar in style to a painting by Garrard of Southdown sheep at Holkham (Plate 31). A prospectus for the engraving of the *Woburn Sheep-shearing* published in the *Agricultural Magazine,* February 1811, contains the following reference which leaves us in little doubt: 'The exhibition rooms in which the sheep are usually shewn (the front room of which is decorated with two large pictures of the Southdown and New Leicester sheep painted by Mr Garrard) forms a background to these two compartments of the picture'.

Garrard may also be the artist of *Sheepshearing in a Great Barn,* at Woburn Abbey, traditionally attributed to George Morland (Plate 32). The scene shows a sheep-shearing competition in progress watched by members of the aristocracy. Such competitions took place as part of the annual Woburn Sheep-shearings and it is probably set in the Great Barn at Woburn. The figure on the left who has his arm round the arm of another gentleman bears a close likeness to the 6th Duke of Bedford. Both the Duke of Bedford and Thomas Coke pioneered new breeds of sheep introducing Southdowns and Merinos on to their estates. Sheep-shearing

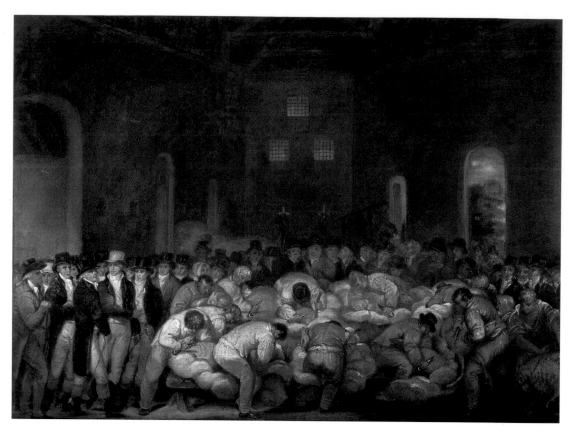

Colour Plate 71. *Sheepshearing in a Great Barn* attributed to George Garrard. Oil on canvas, 22 x 29in. (56 x 73.5cm).
By kind permission of the Earl of Leicester and the Trustees of the Holkham Estate

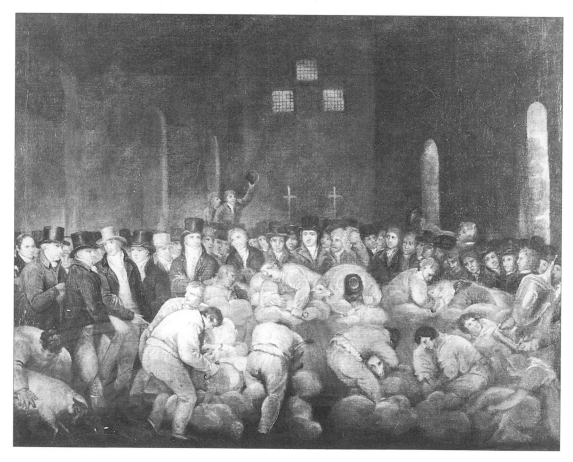

Plate 32. *Sheep-shearing in a Great Barn*, attributed to George Garrard. Oil on canvas, 40½ x 49in. (103 x 124.5cm).
A very similar version of this painting exists at Holkham in Norfolk (Colour Plate 71). These paintings give a lively impression of the frenzied activities of sheep-shearing competitions, the shearers urged on by a crowd of onlookers.
By kind permission of the Marquess of Tavistock and the Trustees of the Bedford Estates

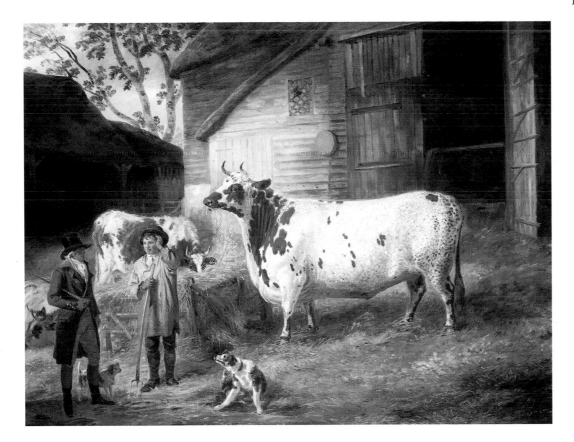

Colour Plate 72. *A Holderness Cow* by George Garrard, 1798. Oil on canvas, 40¼ x 52in. (102 x 132cm).
Garrard has combined his portrait of this magnificent stocky Shorthorn cow with the detail of a genre scene by an artist such as Morland. The gentleman in the foreground may well be the owner, Mr Taylor. He was obviously pleased with the finished work, subsequently publishing it as a print dedicated to his patron Lord Somerville at his own expense.
Courtesy Richard Green

competitions took place at the annual Woburn and Holkham sheep-shearings which followed one another in June and there is another version of this painting at Holkham Hall (Colour Plate 71). The scene takes place in the same setting, but the figures of the shearers and spectators have been altered and the large silver cup, which presumably would have been presented to the winner, is absent. It is quite conceivable that Thomas Coke could have asked Garrard to paint him an alternative version.

Garrard appears to have been an erratic character, prone to bouts of temper, and in 1812 the Duke of Bedford burnt two of his letters because they were so impolite. Garrard's early career showed promise, his portrait of Whitbread's *Brewhouse Yard* was purchased by Reynolds at the 1784 exhibition, 'to encourage the rising merit of the artist'; in 1800 he became an Associate member of the RA and in 1801 Farington recommended him as horse painter to Daniel Wakefield, thinking that 'Stubbs wd. be too expensive' and that Gilpin had 'declined painting portraits of animals'. However, Garrard failed to realise his ambition of becoming a full member of the Academy and his painting is very varied in quality. After completing his *Description of Oxen* he did not do a great deal more in the field of livestock portraiture, his ambitions tending in other directions. Garrard's most loyal patron was Samuel Whitbread at Southill for whom he executed landscapes with views of Southill, horse and dog portraits and numerous sculptures. Whitbread also owned a painting of *Holkham Sheep*, no longer at Southill, as well as some twenty-five models of livestock which were displayed in glass-fronted cases in the billiard room.

Garrard had scarcely finished his *Description of Oxen* before James Ward was embarking on an even more ambitious project sponsored by the Board of Agriculture. He was commissioned to make two hundred paintings of all the breeds of domestic livestock in the British Isles. They were to be done as accurately as possible and drawn to a precise scale of measurement and proportion. The project was to be financed by the Boydell printing firm which was to pay Ward's expenses and fifteen guineas for each picture delivered from which they would publish their engravings. The project was the most ambitious yet undertaken and, like Garrard's engravings, had nationalistic overtones. The need for agricultural reform was pressing since

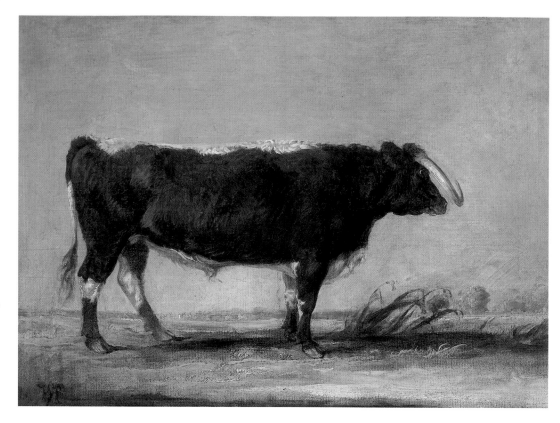

Colour Plate 73. *Longhorn* by James Ward. Oil on canvas, 12½ x 16¾in. (31.75 x 42.5cm).
Ward followed the traditional format for his livestock paintings. His work is distinguished from many of his contemporaries by his technique of applying thin transparent glazes over a white ground in the Flemish manner. He thus imparts a vigour and luminosity to the most static compositions.

Leicestershire Museums, Arts and Records Service

the outbreak of war with the French. As well as reflecting the widespread philosophical and scientific interest in this area, the project was a way of proselytising the benefits of improved livestock through selective breeding.

Ward entered into the scheme with enthusiasm, a list of subjects was drawn up by Lord Somerville, President of the Board of Agriculture, assisted by the Duke of Bedford, and in 1801 Ward set out to visit John Ellman at Glynde near Lewes, the noted sheep and cattle breeder (Plate 36 and Colour Plate 188). From here he went to Windsor and painted two of the king's sheep before undertaking a two month tour of the south-west through Dorset, Devon, Cornwall, Somerset, Wiltshire and Berkshire. The following year he spent seven months travelling through the wilds of Wales, Hereford and Shropshire in a rickety gig which finally broke down and was abandoned in Anglesey. Ward was armed with a circular letter of introduction from the Duke of Bedford and, as well as sketches of livestock, he made innumerable studies of scenes and local people, those done on the Welsh trip alone reputedly numbering over five hundred. Ward recounts the hardships he had to endure on these trips as well as the extremely difficult circumstances in which he was forced to paint prize livestock which had been sent to London. He frequently painted all night by candlelight as the animals were due to be slaughtered the next day.

Sadly the Boydell project never materialised. Ward was expecting to be paid fifteen guineas per picture; he would deliver one a week and be paid immediately. Boydell, however, maintained he could publish them when he chose and no payment was due until publication. Ward also produced far more paintings than the firm, no longer at the peak of its success, could ever have published and many of the scenes and events were well outside the scope of the original contract. In 1805 he appears to have fallen out irreparably with Boydell. Only eight prints were ever published by Boydell; these were engraved by Thomas Tagg in 1807. Ward completed over one hundred paintings and his paintings and sketches are now spread far and wide and appear from time to time in the salerooms. They range from small pencil studies through oil studies to more finished works where he includes farming vignettes in the background similar to those found in Bewick's *History of Quadrupeds*. His commission

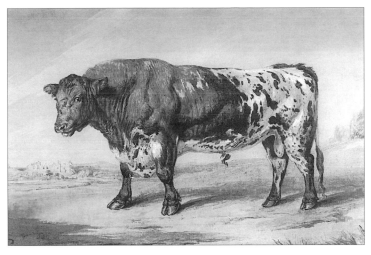

Plate 33. *The Durham Bull* by James Ward (detail), 1798. Watercolour on paper, 12½ x 18¼in. (31.75 x 46.5cm).
This study predates Ward's work on the Boydell project but is similar in style and composition. The animal is set against a very low horizon, a ruined castle is included to add interest.
City of Nottingham Museums: Castle Museum and Art Gallery

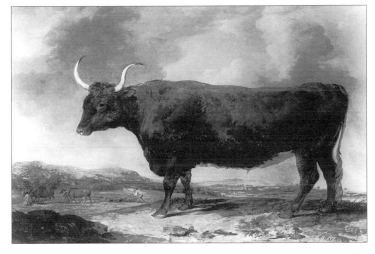

Plate 34. *A Devonshire Ox* by James Ward, 1801. Oil on canvas, 17 x 23½in. (43.2 x 59.7cm).
This is typical of Ward's finished work for the Boydell project. The composition derives from Bewick's *History of Quadrupeds*. The ox is placed right in the foreground to emphasise its size while a team of oxen yoked to a plough in the distance adds an anecdotal detail.
Private Collection. Photograph Courtauld Institute of Art

Plate 35. *Mr Princeps Berkshire Boar* by James Ward. Pencil on paper, 4½ x 6¾in. (11.5 x 17cm).
Thomas Princep, the Staffordshire farmer, was one of Ward's early patrons (see Plate 15). This sketch would have been done on one of Ward's trips to record Princep's important herd of Longhorns. The heavy curly, coated boar must have caught his eye and its vigorous and hasty execution is in contrast to the carefully worked sketch of Ellman's Sussex cow which he recorded as part of the Boydell project (Plate 36).
Mrs Margaret Marshall. Photograph Courtauld Institute of Art

Plate 36. *Mr Elman's Sussex Cow* by James Ward. Pencil on paper, 7¼ x 10¾in. (18.5 x 27.5cm).
Inscribed: *Mr Elman's Sussex Cow … Diner.*
Mr Ellman was Ward's first stop as he began collecting material for the Boydell project. This carefully executed drawing indicates his working approach when asked to record a breed with as much accuracy as possible.
Courtesy of Sotheby's. Photograph Courtauld Institute of Art

included sheep and pigs as well as cattle and the failure of the project has deprived us of the most important record of British livestock ever undertaken.

Ward no doubt landed the commission as a result of his early success as an animal painter and his introduction to Lord Somerville. Originally apprenticed to an engraver, Ward's early work was very much in the rustic style of George Morland whose influence he came under and who subsequently became his brother-in-law. He attended John Brooke's school of anatomy in Blenheim Street where he dissected animals, birds and humans. He exhibited his first paintings

Colour Plate 74. *Gordale Scar* by James Ward, c.1814. Oil on canvas, 131 x 166in. (332.7 x 421.6cm).
Here Ward has employed all his artistic powers to create a spectacular painting. The animals are wild and
untamed set against the dramatic natural forces of the thundering cataract. It forms a striking contrast with his
images of domestic cattle. The Tate Gallery, London

at the Royal Academy in 1792 and in 1794 was appointed painter and engraver in mezzotint
to the Prince of Wales. His *Staffordshire Cow and a Staffordshire Bull belonging to Mr Thomas
Princep of Croxhall, Derbyshire,* appeared at the Academy in 1797 (Plate 15) and established
his reputation as a livestock painter. While staying on the Isle of Thanet in 1788 or '89 he met
Lord Somerville who commissioned him to paint a cow. Some time before 1800 he also
painted a *Ewe of the new Leicester Stock* for the Duke of Bedford which he engraved in 1800.

Although the Boydell project was a disaster, the experience and the contacts Ward gained
through the trip set him up as the country's leading animal painter. In the collapse of the
project, a flood of other commissions ensured he was constantly on the move about the
countryside. Ward was an independent character, a good shot and excellent horseman,
perfectly at home in the company of nobility. He accompanied Lord Somerville on a trip to his
Scottish seat at Melrose and in 1801 stayed with the Duke of Bedford at Woburn. One of his

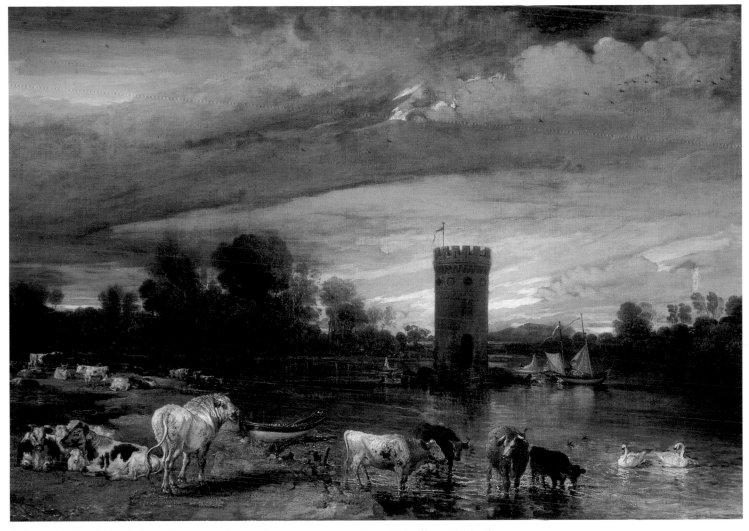

Colour Plate 75. *Tabley Lake and Tower* by James Ward. Oil on canvas, 37 x 53½in. (94 x 135.9cm).
Ward was a frequent visitor to Tabley Park. Sir John Leicester was a leading patron of British artists and commissioned several works from him. This work shows the influence of the Flemish school on Ward's painting.
The Tate Gallery, London

most loyal patrons was Sir John Fleming Leicester of Tabley House. In 1811 he stayed with Lord Ribblesdale at Gisburn in Yorkshire where he spent days sketching the famous Gisburn herd of white cattle before painting his magnificent *Gordale Scar*, now in the Tate Gallery (Colour Plate 74). On the way to and from Gisburn he visited Tabley where he painted Tabley Lake and Tower (Colour Plate 75) which shows cattle standing in the foreground. In 1818 he was engaged by the Duke of Northumberland to paint cattle and horses at Alnwick and took the opportunity of visiting the elderly Thomas Bewick. On one occasion Ward seems to have overstepped the mark. While staying with the Earl of Chesterfield in Derbyshire, he entertained hopes of a match between the Earl's nephew, Lieutenant Stanhope, and his own daughter. The Earl was clearly appalled at the suggestion and Ward departed in high dudgeon.

Ward's reputation as a horse painter was established by his painting of *Grandilla, a Broodmare and Skyscraper, a Colt* in 1809 (whereabouts unknown). He is reputed to have painted this as a result of a stinging comment from his brother-in law and rival, Henry Chalon, who commented that, 'Ward can no more paint blood horses than my boot'. In fact Ward was probably the most successful horse painter of his generation. His patrons included George III and George IV, Lord Londonderry, Earl Powis, Sir William Watkins Wynne and the Duke of

Plate 37. *Landscape With Cattle* by James Ward, 1822. Oil on canvas, 129½ x 191in. (328.9 x 485.1cm).
Ward had been compared to the Dutch painter Paulus Potter since the 1790s. Here he attempts to outshine him. He originally named the painting 'Protection', investing the animals with noble emotions.

The Tate Gallery, London

Northumberland. The years up to 1815 were ones of enormous prosperity for Ward. His annual income exceeded £1,000 and he was charging 250 guineas for a full-length portrait, fifty guineas for a small animal painting. His wife kept a luxurious household complete with a footman in silver-trimmed livery and the Wards entertained lavishly. Contemporary reviews rave about his qualities as an animal painter. In 1809 the *Sporting Magazine* confirms that he was 'generally allowed to be the first among animal painters now living' and Lord Ribblesdale, writing to his son in June 1811, says of the Summer Exhibition, 'Turner was not inferior to Claude – Ward was allowed to beat Paul Potter out and out'. *The Times* of 6 May 1815 commented that 'Mr Ward has no equal in the present day as a painter of quadrupeds'.

Ward's best animal paintings set him way above most livestock painters. In the tradition established by Stubbs and Sawrey Gilpin, he captures the fierce, wild characteristics of animals in conflict or at bay as in his *Bulls fighting with a View of St Donat's Castle*, 1803, in the Victoria and Albert Museum. His rich technique of applying thin translucent glazes was derived from Flemish painting and imparts life and vigour to even the most static poses. Even when he is painting cattle at rest, as in his *Landscape with Cattle* (Plate 37), now in the Tate Gallery, Ward invests his animals with noble emotions. As he explains in the Catalogue to his exhibition of 1822, 'the bull glances around a look of defiance, with an expression of protection to his mate, whose maternal solicitude and tenderness towards her young are evident in her gesture and attitude'. Paul Potter's *Young Bull* in the Hague was the inspiration behind this work. Ward had been compared with Potter since the 1790s and in this work Ward has taken on his mentor and attempted to outshine him. Ward may also have been motivated by his rivalry with Abraham Cooper, since the cattle depicted are the property of John Alnutt Esq., and Cooper had exhibited a work, *Alderney Bull and Cows, the property of J.Alnutt, Esq*, at the Academy in 1818.

In his livestock portraits Ward obviously has to conform to a static hierarchical arrangement where the display of information takes precedence over any artistic concern. He follows the by now established precedent of placing the animals in profile against a low horizon so their size is emphasised by a distortion of the spatial distances. Sometimes farming vignettes are seen beyond the animal, reminiscent of Bewick's woodcuts (Plate 34). It is interesting to compare a work such as his *Longhorn* (Colour Plate 73) with the way the cattle are drawn in *Landscape with Cattle* (Plate 37). In the former, Ward's object is to describe the exact shape of the carcass

and the disposition of the fat rather than the grace or nobility of the animal. None the less the picture still has life and movement as a result of the sleek glistening texture of the animal's coat and the delicate glazes of the background. Again in his portrait of two oxen painted for the Earl of Powis he makes the painting more interesting by placing the animals in a dramatic architectural setting. One is tempted to conclude that Ward's livestock portraits were factually accurate even though his Durham Bull (Plate 33) looks misshapen and unattractive with its long back and lumpy neck. The question of which should dominate, factual or aesthetic considerations, must have been important to him.

In his more elaborate compositions, Ward employs both artistic theory and artistic licence liberally. *Gordale Scar* (Colour Plate 74) is a highly contrived composition which evolved out of dozens of sketches. The red deer emerging from the cave were in fact kept in the park at Gisburn and would never have been present in the scene, nor too would the white bull who stares out of the picture. The animals combine with the thundering cataract and stormy sky to emphasise the wild, primordial nature of the scene. Any such considerations formed no part of livestock portraiture where Ward's job was to record the animals as accurately as possible. Ward's training as an engraver would have given him an excellent grounding for he needed to be a meticulous copyist, capable of transferring the information before him on a reduced scale to the copper plate. He was able to depict the minutiae of the breeds with extreme care. Although he met Thomas Bewick, he makes no mention of ever having been asked to exaggerate his portraits as the latter complained.

Ward continued to paint livestock portraits all his life. His experience as a result of the Boydell project left him pre-eminently qualified. The exhibition of paintings he held at his house in Newman Street in 1822 included six cattle portraits, among them, 'A prize Ox, of the Hereford breed, fed by Charles Westcar, Esq.' and 'A bull of the Old English Wild breed – the property of Lord Ribblesdale'. 'This is the original English species and is only preserved in two or three places in the kingdom'. There were also several pig portraits in the exhibition including, 'Peggy, Nine years old, 34 inches in height from Bengal. She was found wild 600 miles up the country: brought to England by Captain Holden of the Surrey East Indiaman'. These and many other portraits must surely have been painted by Ward to satisfy his own curiosity rather than for a particular patron. He had a strongly developed interest in the bizarre and unusual and his fascination with the curious and atypical was very common in his time. He was friendly with a Dr Woodey who kept a private asylum at Tamworth which he visited and his 1822 exhibition included such curiosities as the head of a native of New South Wales pickled at the Royal College of Surgeons and a portrait of Luke and Kate Kenny who lived in a moveable hut in the form of a cone.

Ward had aspirations well beyond that of animal painting, evidenced in particular by his *Allegory of Waterloo*, completed in 1821 to critical failure. Farington records how he did not wish to be admitted to the Academy as an animal painter, sending as his probationary picture 'two naked Bacchanalian Children' which in Farington's opinion was 'a performance much inferior in merit to his pictures of horses'. However he never appears to have felt livestock painting was beneath him. As late as 1833, now in financial difficulties following the failure of the *Waterloo Allegory*, Ward went on a tour of East Anglia where he planned to attend the Annual Dinner of the Suffolk Agricultural Society in order to secure livestock painting commissions. The trip was not a success and Ward wrote an irritated letter in December 1833 saying, 'I am too old to run about the country districts plying my works to innkeepers and farmers, who after all would be better pleased with the works of a Suffolk pot-house Cooper than a Ward.' Although Ward had aspirations beyond animal painting these were his most

Colour Plate 76. *Portrait of Valentine Barford* by Henry Barraud, 40 x 67½in. (102 x 172cm).
Valentine's father established his celebrated flock of New Leicester sheep on his farm at Foscote, South West Northamptonshire, in 1789 with stock descended from Robert Bakewell's. His son Valentine continued his work, becoming a champion breeder in his own right. Henry and his brother William were well-known sporting artists who also executed some fine livestock portraits.

Published by permission of Northampton Museums and Art Gallery

successful compositions. During his life he was hailed as the greatest living animal painter and his finest works raise him far above many of his contemporaries who contented themselves with straightforward animal portraiture.

Abraham Cooper was just one of many horse and cattle painters with whom Ward would have come into competition in the tightly knit circle of artists and patrons at that time. Others included Charles Towne, Henry Chalon, John Ferneley, William and Henry Barraud, whose fine portrait of Valentine Barford is seen in Colour Plate 76, Daniel Clowes, John and David Dalby of York and the slightly older Benjamin Marshall. All of these artists earned a respectable living as animal painters, while never aspiring to a position in the mainstream of English art as Ward had done. They typify the animal and sporting art painters unique to the English School. While none of them specialised in cattle painting all were eminently qualified to fulfil the demand when it arose. In his portrait of *The Celebrated Bull Alexander* (Colour Plate 77), Ben Marshall has managed to turn a straightforward livestock painting into a composition in which cattle and landscape unite in harmony. Alexander is placed in profile in the traditional pose but the composition is both softened and enlivened by the addition of

Colour Plate 77. *The Celebrated Bull Alexander* by Benjamin Marshall. Oil on canvas, 40 x 50in. (101.5 x 127cm).

Ben Marshall was one of the many horse and sporting painters who dabbled in livestock painting. A print after this work is inscribed: *This print of the celebrated bull Alexander & the rest of the cattle, the property of Mr. J. Wilkinson of Lenton, near Nottingham, is respectfully inscribed to Genl. The Honble. Francis Needham.* According to tradition, George III commissioned Marshall to paint cattle from the Royal herds.

The Tate Gallery, London. Bequeathed by Mrs F Ambrose Clark through the British Sporting Art Trust, 1982

several cows and a young calf. We know from the inscription on the print after this work that Alexander was the property of Mr J. Wilkinson of Lenton, near Nottingham, but Marshall's distant landscape is almost Italianate in feeling. Marshall was also commissioned, early in his career, to paint cattle for George III.

The Leicestershire artist, John Ferneley, was a pupil of Ben Marshall with whom he spent a three year apprenticeship in London. Ferneley spent most of his artistic life in Melton Mowbray, the heart of the hunting scene where three packs, the Quorn, the Belvoir and the Cottesmore, provided six days of hunting a week and enough commissions to keep him as busy as he desired. Cattle paintings are only a tiny part of his output but are painted with the same acute observation, accuracy and attention to detail as his horse and hunting portraits. His cattle have gleaming coats, glossy muzzles and bright eyes with a degree of characterisation also found in his horse portraits. He executed two fine portraits for Sir John Palmer. One of them

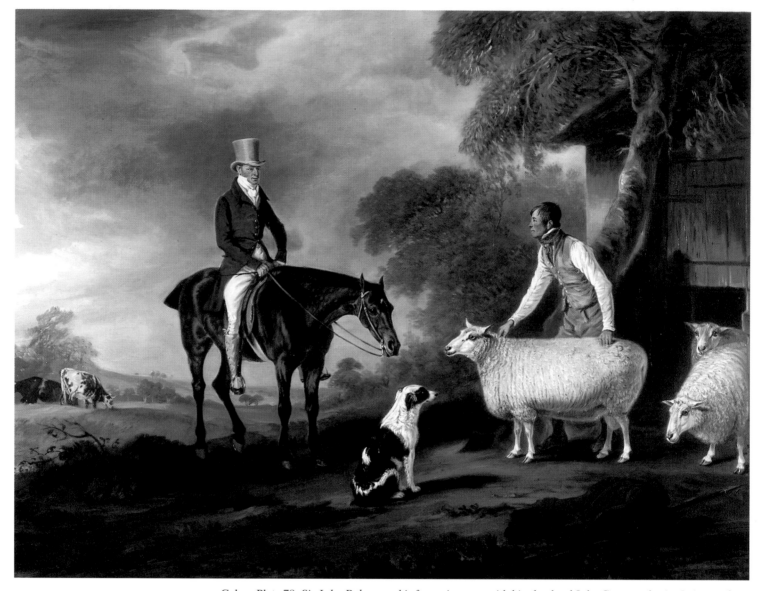

Colour Plate 78. *Sir John Palmer on his favourite mare with his shepherd John Green and prize Leicester long wool sheep* by John Ferneley, 1823. Oil on canvas, 33½ x 43in. (85 x 109cm).
When asked to paint livestock portraits, Ferneley could not resist including a horse and rider. He undertook only a few livestock commissions but executed them with the same feeling for anatomy and meticulous attention to detail as his horse portraits. Sir John Palmer, 5th Bart, was M.P. for Leicester. He is here portrayed as a country gentleman surveying his lands and holdings having retired from public service.
Leicestershire Museums, Arts and Records Service

shows Sir John on his favourite mare with his shepherd, John Green, and Prize Leicester Longwool sheep (Colour Plate 78); the other is a more typical cattle portrait of his prize Durham ox but includes the interesting detail of his groom John Mentham on his favourite grey horse to enliven the subject (Colour Plate 79). The latter is mentioned in the artist's account book as, 'Sir John Palmer, Portrait of the Fat Ox, Hack and Trees, 1826, £26.5s', which would appear to be comparable in price to Ferneley's horse portraits. Abraham Cooper was another of Ben Marshall's pupils. As a boy of thirteen he had worked at Astley's circus which specialised in equestrian displays and developed a talent for drawing animals. He continued to take an interest in exotic species throughout his life. Among his paintings are an Indian bull and cow, an Australian dingo and a Wapiti deer which had been captured in the Upper Missouri Country and was exhibited at the King's Mews in Charing Cross. Cooper was

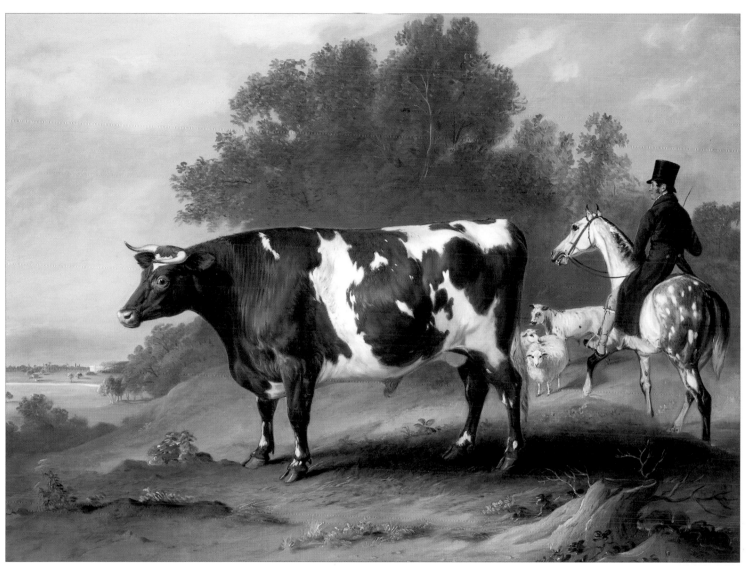

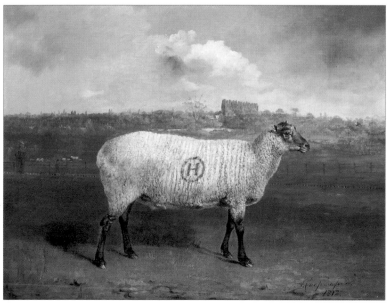

Colour Plate 79. *Sir John Palmer's prize Durham ox, with the groom John Mentham on his favourite grey horse* by John Ferneley, 1826. Oil on canvas, 33½ x 43in. (85 x 109cm).
The ox won first prize of 10 guineas and sweepstake of 6 guineas for animals fed on grass, hay and vegetables at Brampton Show. Aged 5 and weighing 1,280 lb, it sold for £45. Courtesy Richard Green

Colour Plate 80. *Mr J A Houblon's Prize Suffolk* by Abraham Cooper, 1812. Oil on canvas, 14 x 18in. (35.6 x 45.7cm).
Hallingbury Place, Essex, the family seat of the Houblon family, appears in the background. It has since been demolished.
 Courtesy of Arthur Ackermann and Peter Johnson Ltd.

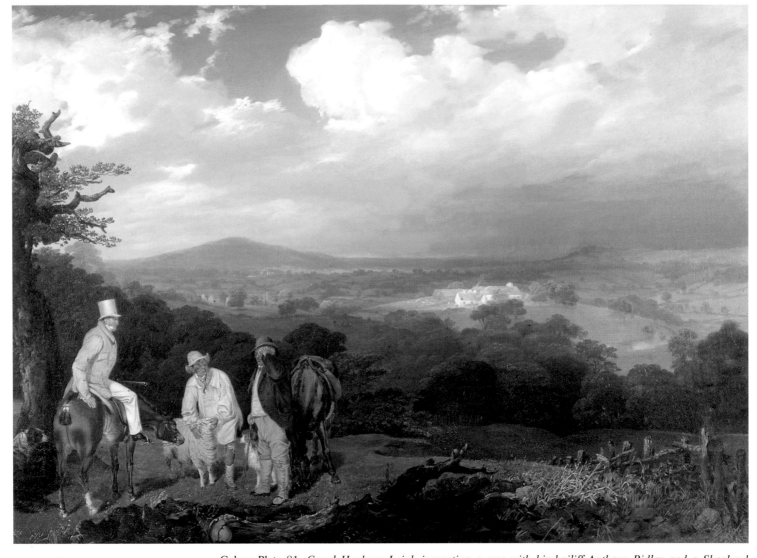

Colour Plate 81. *Capel Hanbury Leigh inspecting a ewe with his bailiff Anthony Ridley and a Shepherd* attributed to Abraham Cooper. Oil on canvas. 26¾ x 37in. (68 x 94cm).
The scene is painted from the top of Pontypool Park looking over the Home Farm towards Clytha Hill. The Brecon canal can be seen in the middle distance. Capel Hanbury Leigh (1776-1861) was a leading member of the South Wales Agricultural Community. He improved and extended the Home Farm and presented several cups to the annual Tredegar show where his animals were frequent prize winners. (See Colour Plate 135.)
Sir Richard Hanbury-Tenison

a very competent horse and cattle painter and Ward's disparaging remark seems quite unjustified.

Henry Chalon too appears to have been no friend of Ward's. He married Ward's sister Sarah but abandoned her in 1810 to live with his mistress Sarah Williams. It was Chalon who goaded Ward that he was unfit to paint thoroughbred horses and Ward did all he could to block his career, including impeding his election to the Royal Academy. Chalon was much influenced by Stubbs and established himself as a leading horse painter. His book, *Studies from Nature*, contained twenty plates, three of them on the anatomy of the horse showing his debt to Stubbs. He also published *Chalon's Drawing book of Animals and Birds of Every Description*. His portrait of the Bradwell Ox (Colour Plate 83) is a very convincing portrait of one of the largest animals ever bred. Chalon's knowledge of anatomy has stood him in good stead and he has managed to convey the animal's enormous bulk without losing all sense of proportion. By

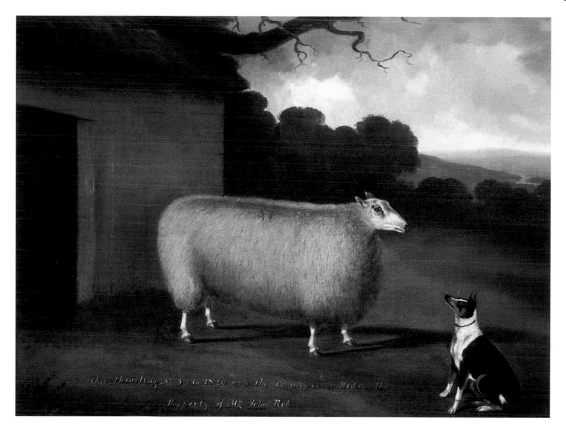

Colour Plate 82. A prize sheep and Dog by D. Dalby of York, c.1820. Oil on canvas, 16 x 21in. (40.5 x 53.5cm). Inscribed: This shearling No. 52 in 1820 won the Premium at Bedale the property of Mr John Rob.

Collection of Susie and Robert Zohlman

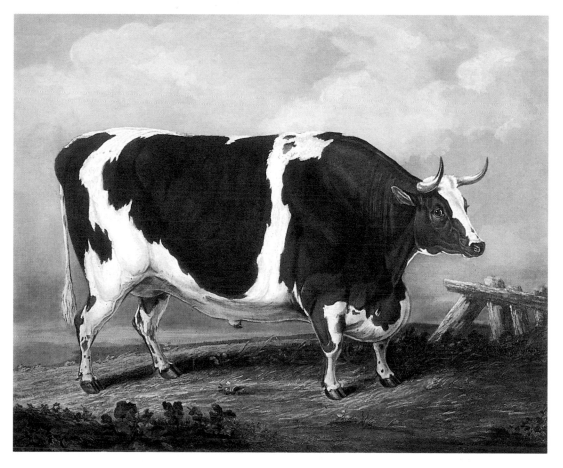

Colour Plate 83. *The Bradwell Ox* by Henry Chalon, engraver unknown, 1830. 17 x 21in. (43 x 53.3cm). Inscribed: *The Bradwell ox. This engraving is by permission most respectfully dedicated to the Right Honorable Lord Viscount Althorpe, & c. &c. & c. by his Lordship's most obliged and obedient servant, William Spurgin. This animal, the greatest phenomenon of his species belongs to William Spurgin, Esqr. of Bradwell, Essex. It is supposed to be half Lincolnshire and half Durham breed. The live weight of the ox is 560 stone, being more than 60 stone heavier than the famous Lincolnshire ox, & 160 stone heavier than the Durham ox. Admeasurement as follows. From the end of the nose to the tip of the tail 180". To the top of the shoulders 70". Across the hips 33". Across the shoulders 33". Between the fore legs 18". From the breast to the ground 20". And in the girth 132". Age of the animal, six years.* Chalon was a highly esteemed horse painter. Married to Ward's sister Sarah, he later abandoned her and the two artists became bitter rivals.

Lawes Agricultural Trust, Rothamsted Experimental Station

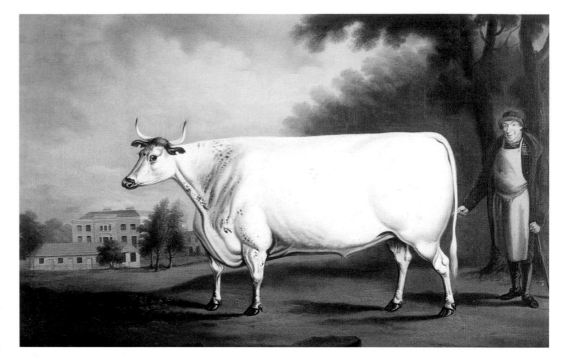

Colour Plate 84. *The White Ox* by Daniel Clowes, 1824. Oil on canvas, 23½ x 33½in. (59.7 x 85.1cm).
Over 200 people were entertained in the marquee which can be seen attached to the front of the house.
Private Collection

Detail of Colour Plate 84.

placing the ox's head at an angle to the picture plane, he emphasises his massive head and brisket.

Working in the Chester area, Daniel Clowes may well have been influenced by Boultbee who moved to Chester in about 1800. He built up a highly successful practice in the Chester area, principally as a sporting and equestrian artist and, although he travelled long distances within his locality, never exhibited in London, presumably because he had a constant supply of work. Clowes' more important patrons included the Grey-Egertons of Oulton Hall and the Stanleys of Hooton Hall and the 2nd Earl of Grosvenor at Eaton Hall for whom he executed equestrian paintings over a period of several years which would have provided him with a reasonably steady income. Clowes' known works number approximately ninety, but the following extract from *The Annals of Sporting and Fancy Gazette*, London 1824, indicates that he was a prolific artist:

> of the artist Mr. Clowes and the production of his easel, it becomes us to say a few words; and more so, as the opportunity of bestowing the due meed of praise on retiring merit heightens the feeling of doing justice. As an animal painter, few artists have done more justice to their subjects, and of these Mr. Clowes has executed a good number for the nobility and gentry in the neighbourhood of Chester. Sir Thomas Stanley's collection is enriched with a good number and the orders Mr Clowes still has in hand would occupy some of our artists a good potion [*sic*] of their lives; but he performs his task with remarkable celerity, we are given to understand -a faculty we are loathe to recommend him to revise, uncertain as we are whether he works more for money or fame – that which has spoiled the style of many a promising artist.

The status of his reputation, at least in his native area, is demonstrated by an article in the *Chester Courant* of 25 April 1826:

> Mr Clowes of this city has just finished an exquisitely painted portrait of His Majesty for the Black Dog Coffee Room which was put up for the first time yesterday evening. The native talent of this excellent artist is highly creditable to the City of Chester. He has long been much esteemed as an animal painter and judging from some specimens we have lately seen of his style in portraits and landscape, he is no less master of these lines in the art. Why does not Mr. Clowes send some specimens to the exhibition in London?

Clowes' cattle paintings are among the most delightful of this period. He uses very strong contrasts of light and shade and gives his animals an almost cartoon quality of characterisation. In his *Shorthorn Ox and Heifer* (Plate 38) the huge animal towers over the diminutive man while the calf looks on in puzzlement. His three Sussex oxen (Colour Plate 187) look rather

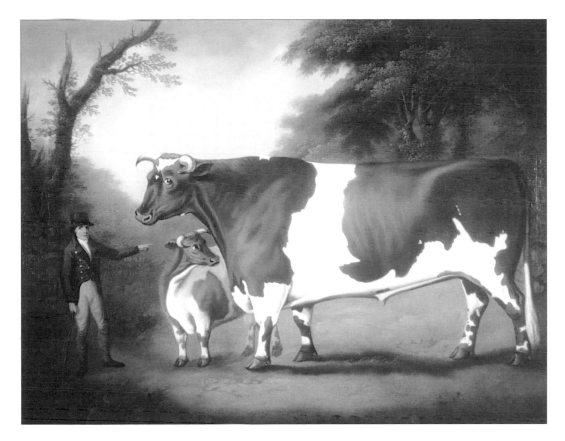

Plate 38. *Shorthorn Ox and Heifer* by Daniel Clowes, June 1804. Oil on canvas, 26½ x 33¼in. (67.3 x 84.4cm) The 5 year old ox was 6ft.5in. high, 12ft. in girth, 12ft. long from nose to tail and weighed 546 stone. Clowes was a very well respected provincial artist but in this painting he has made the bull appear ridiculously tall; it stands at least five feet higher than its owner.

Beamish, The North of England Open Air Museum

like carved animals from a toy farm. Clowes worked principally in the Chester area but undertook long journeys into remote areas of Wales. His best documented cattle paintings were undertaken for Sir Robert Vaughan, M.P. for Merioneth who lived at Nannau, an inaccessible estate in North Wales. Clowes painted *The White Ox* to celebrate the coming of age of Sir Robert Vaughan's son (Colour Plate 84). The animal, the last of the white cattle of Nannau, was eaten as part of the birthday festivities and the high point of the feast came when the 'baron of beef' was brought into the room in a procession led by the herdsman Sian Dafydd who had fed the beast and is depicted in the painting. There were over two hundred guests and copies of the print were doubtless presented to them. The painting bears two contradictory inscriptions, suggesting Clowes became confused. One on a tablet reads, 'The BARON weighing 165 lbs was roasted at NANNAU June 25 1824', and the other in the centre of the painting, 'weight per quarter 246 lbs'. The '165 lbs' probably refers to the actual weight of that part of the ox referred to as the 'Baron', which was served at the feast. The horns and forefeet of the ox were mounted into a silver candelabrum bearing a commemorative inscription. While at Nannau Clowes painted four portraits of the family's favourite dogs and horses and the two Welsh cattle, *Bethnal and Bran* (Colour Plate 194). The solid, hardy cattle with their glistening coats have horns tipped with brass finials. Like the White Ox their ears are clipped with a V, the brand mark of the Vaughans.

Clowes passed on his artistic talent to his son Henry whose work is very similar in style and subject matter. *The Ferry at Eccleston* (Colour Plate 85) shows a similar treatment of the cattle, although Henry's handling of the background is less sophisticated than his father's more accomplished treatment. The painting depicts the hand-operated ferry crossing the River Dee at Eccleston, two miles south of Chester. A local farmer escorts a Shorthorn cow and her calf, the chief dairy breed in the region, while a gentleman travels on horseback. It reminds us of the slow pace of life during this period and the difficulties of travel and communications.

Charles Towne of Liverpool was another successful horse painter working in the north-west. He acquired some knowledge of landscape from the painter John Rathbone and worked for a coach painter in Liverpool. Towne is reputed to have copied Stubbs' *Harvesters* and *Reapers*

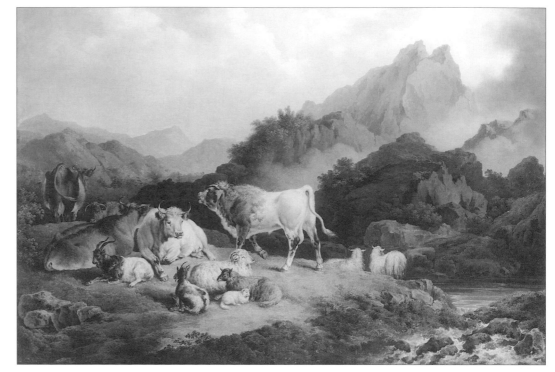

Plate 39. *The Monarch of the Glen* by Charles Towne, 1821. Oil on canvas. 35.6 x 44in. (91.5 x 112cm).
This work is typical of Towne's cattle paintings which were heavily imbued with the romantic tradition of Dutch 17th century painting. His livestock portraits look rather incongruous as realistic animals contrast so strongly with their stylised settings.
The Board of Trustees of the National Museums and Galleries on Merseyside
(Walker Art Gallery, Liverpool)

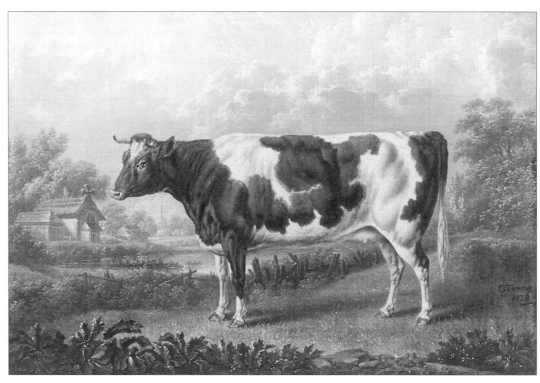

Plate 40. *Monarch of the Pastureland* by Charles Towne, 1797. Oil on canvas 35½ x 41¾in. (90.5 x 106cm).
The Board of Trustees of the National Museums and Galleries on Merseyside
(Walker Art Gallery, Liverpool)

when they were exhibited at the Liverpool Society in 1787. He established himself as a successful animal painter in the realistic manner of Stubbs. However, he came more and more under the influence of the Dutch Old Masters and developed a romantic landscape style with cattle in the foreground in the manner of Aelbert Cuyp (1620-1691) and Nicolaes Berchem (1620-1683). Towne even copied two paintings by Berchem and Cuyp which were sold by a dealer for £30 each. He lived with an Essex breeder and butcher for a while so had ample opportunity to study cattle at close quarters. His subjects include bull-baiting scenes and *Bulls*

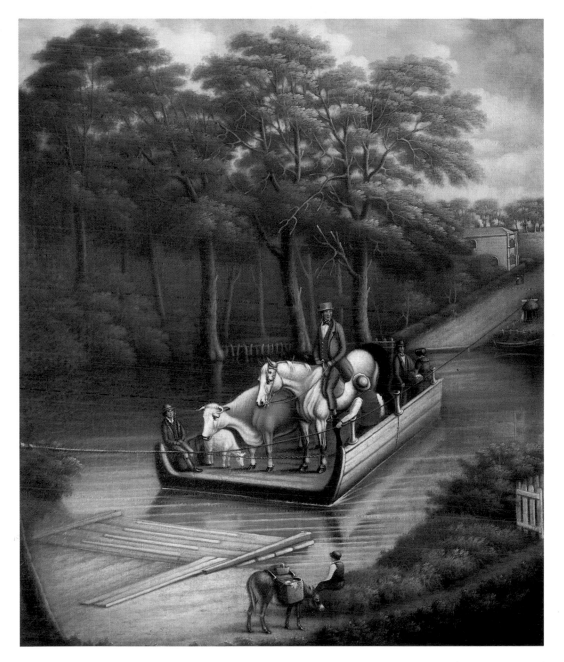

Colour Plate 85. *View of Eccleston Ferry* by Henry Clowes, 1853. Oil on canvas, 30 x 37in. (76 x 94cm).
The son of Daniel, Henry continued his father's work but adopted a more naïve manner in his pictures. The background to this picture is handled very simplistically but the country folk on the ferry are depicted with warmth and detail. Chester Museums

Plate 41. *Cattle Study* by Robert Hills. Pencil on paper, approx. 10¼ x 7¾in. (26 x 19.5cm).
Hills' spontaneous cattle sketches capture the idiosyncrasies of cattle whether still at pasture, in the process of standing or stretching on a hot summer's day.
City of Birmingham Museums and
Art Gallery

Fighting of 1809 which is clearly influenced by Stubbs and shows his well-developed sense of anatomy. Towne executed many fine livestock paintings (Plates 39 and 40) which are distinguished from his contemporaries by their beautifully painted landscape backgrounds. These imaginative panoramic landscapes with their picturesque ruins seem strangely at odds with the rather prosaic realism of the animals depicted.

Another landscape painter who specialised in cattle was Robert Hills. Despite his acute observation of farmyard animals he never undertook any livestock paintings but published two volumes of etchings of studies of various animals including cattle, swine, horses and sheep 'for the embellishment of landscape' between 1798 and 1817. He worked in watercolour and his finished exhibition pictures are dull and laboured comprising elaborately worked farmyard scenes and landscapes with sheep and cattle. His sketches, however, are a different story. The largest collection of them in the Birmingham Museum and Art Gallery show sheet after sheet of spontaneous studies of cattle which capture all their nuances of movement (Plate 41). They could not provide a greater contrast to the formal hierarchical poses demanded by livestock owners.

CHAPTER 3
The Victorian Painters and their Aftermath 1830-1900

The plump cattle and prosperous owners depicted in the last chapter give no indication of the deep crisis which overtook British agriculture following the defeat of Napoleon in 1815. Over-production, renewed competition from overseas markets and a surplus of labour, with British servicemen returning from the war, plunged the country into an agricultural depression. Coupled with this was an increasing unrest over the corn laws which prevented the establishment of a free market; violent riots also took place aimed at smashing the new agricultural machines which threatened the livelihood of the labourer. Many farmers were forced out of business and there was real hardship and poverty among the labouring classes. This letter written in 1822 to Sir Charles Morgan, organiser of the Tredegar cattle show, from a pamphleteer, John Frost, expresses concern that the agricultural policy of the improvers was misguided and out of touch with the real needs of small farmers:

> …what an absurd thing to offer a silver cup to farmers, to put flesh on the bones of their cattle when they cannot put any on their own. Go over the whole of your estate, reduce the rent. Let every farmer have a small portion of the good things of this life. Take off taxes. Instead of taking the money out of the pockets of your farmers, to put it in those of placemen and pensioners, let it remain in the pockets of your tenants; you will then see, that every farmer will for his own interest, improve his stock to his best advantage.

From the late 1830s, however, things began to improve and until the 1870s Britain enjoyed a golden era of agriculture. The population was still rising and demand for meat was high. Farmers started to adopt a more scientific approach, they were beginning to use fertilisers, the value of manufactured foods was being assessed and increasing mechanisation made cultivation of the land easier. They had both the resources and the incentive to concentrate on refining and improving their pedigree herds and livestock portraiture therefore continued to flourish. The mood of optimism is aptly expressed in the speech made by the Chairman of the Devon Agricultural Society at the Society's annual dinner in 1837. After quoting the growing numbers and weights of beasts at Smithfield market he points out that the population is increasing by 248,000 a year, '– with such an increase then in the number of consumers – with such a number of mouths that must be fed – with such a market for all produce before them, what could undermine the agricultural interests.'

From the 1830s a much greater range of breeds, in particular sheep and pigs, were depicted; this reflects the expansion of breed classes at the agricultural shows which were promoting new breeds at a national level. In the 1860s and '70s horses came to greater prominence with classes for Agricultural (shires) Clydesdales and Suffolks. Breed types were now becoming firmly established and the development of pedigree herd books with illustrations, the first being the Shorthorn in 1822, meant that there was now a formalised literature on the subject. The establishment of the Royal Agricultural Society of England in 1838 put the showing of livestock on a national footing.

Both the Queen and Prince Albert were extremely interested in agricultural reform, setting

Plate 42. *A Hereford Steer* by A.M. Gauci, 1884. 20 x 27in. (50.8 x 68.6cm).
The steer, three years and eight months old, won 1st prize in his class and the £50 cup, as the best steer in any class, at the Smithfield Club Show, 1883. The Royal Collection © 1996 Her Majesty The Queen

up a model farm on their new estate at Osborne and enlarging and improving the farms at Windsor and Balmoral. Their involvement lent further momentum to the national agricultural movement. The Queen was patron of the RASE and Prince Albert a life governor; he was also a member of the Smithfield Club showing animals continually from 1843 until his death in 1861. The Queen and Prince Albert won the Championship of the Smithfield Show on four occasions with their Hereford and Shorthorn cattle and in July 1851 the Royal Agricultural Society Cattle Show was held at Windsor Home Park. The Queen named her favourite farm animals after members of her family and employed several artists to paint them. At least thirty-three animal portraits were hung at Shaw Farm and five, all by the artist Gauci, at the Norfolk Farm. Little is known about Gauci. He painted another portrait for Queen Victoria in 1883, 'Cherry-Blossom', a shorthorn heifer and prize-winner at Smithfield in 1883. Five further portraits were painted earlier in 1863 and hung at the Norfolk Farm, Windsor. These were a bull 'Prince Alfred'; 'Maximus', a Hereford Bull; a Hereford Bull, 'Adela'; Hereford Ox and 'Crown Prince', a Devon bull. The Hereford illustrated in Plate 42 is the only one to survive.

Shaw Farm, where the Queen had her own suite of apartments adjacent to Mr. Tait, the

Colour Plate 86. *Two Shorthorn Ox in a stable* by Henry Calvert, 1845 Oil on canvas, 21½ x 30in. (54.6 x 76.2cm).
This was one of the paintings commissioned by Queen Victoria to hang at Shaw Farm, Windsor. Private Collection

Plate 43. *The First RASE Show at Oxford* after W.A. Delamotte, lithographed by T. Picken, 1839. 7¾ x 11¾in. (19.7 x 29.8cm).
Inscribed: *English Agricultural Society's show yard, First meeting at Oxford, July 17th. 1839. To the Right Honble. John Charles, Earl Spencer, President, the trustees, vice presidents, committee of management, and members, this print is most respectfully dedicated*
Lawes Agricultural Trust, Rothamsted Experimental Station

Colour Plate 87. *Among the Southdowns* by Friedrich Wilhelm Keyl. Oil on canvas, 12 x 22½ in.
(30.5 x 57cm).
The Southdowns are shown in their native habitat; the village of Rottingdean, near Brighton, is in the distance.
Keyl was one of Queen Victoria's favourite animal painters. This oil shows his deep rich colouring and
meticulous technique which resembled the Pre-Raphaelites.

bailiff's house, was laid out with inspection passages so that the Queen and Prince Albert could
see all the different breeds of animals. Special restrooms were provided where the oils were hung.
A note in the Queen's diary for 11 December 1867 mentions how she went to have tea at Shaw
Farm with Princess Louise, 'where we arranged, where Keyl's pictures of the prize beasts should
be hung up'. Most of the paintings of royal farm animals have been dispersed or destroyed, many
found their way to the Vicar of Windsor's rummage sale in 1936, but fortunately photographs of
several of them survive in the Royal Collection inventories. They were executed in the 1850s and
'60s. As well as A.M. Gauci, the Queen commissioned several works from W.H. Davis, Richard
Whitford and Friedrich William Keyl. Henry Calvert painted one portrait (Colour Plate 86) and
an artist called H. or A. Prescott two Herefords. Later in the 1880s Reuben Cole and Charles
Burton Barber recorded the Queen's Spanish oxen. More sophisticated farm animal paintings
which were not straightforward records, such as Keyl's *Among the Southdowns* (Colour Plate 87)
or Thomas Sidney Cooper's *Jersey Cow* (Colour Plate 104), were hung inside the Royal Palaces.

Gifts of prize animals were regularly exchanged amongst the international royal families and
British travellers or officials stationed abroad returned with animals from all corners of the
Empire. The Queen established an interesting collection of exotic and foreign species. In 1855
she sent the Emperor Napoleon a cow from 'one of her best breeds' for his model farm near
St Cloud. He wrote to thank her saying that the inhabitants of the farm would 'die of jealousy'
when the newcomer arrived. In 1862 she received some Zebu cattle from the Maharajah of
Mysore (Colour Plate 203) and at various times gifts of antelopes, gazelles, harness deer,
Indian goats, Zulu cattle and Tibetan sheep, some of which, including 'Flora', a Spanish sheep,
were kept in the gardens of Buckingham Palace.

The royal couple regularly attended the annual RASE (Plates 43 and 44) and Smithfield

Colour Plate 88. *The New Agricultural Hall in Islington* after Aston Bragg, lithographed by Frederick Tallis, c.1862. 23 x 17in. (58.5 x 43cm). Inscribed: *Agricultural Hall. Principal front, Liverpool Road, Islington, London. Architect, Mr Frederick Peck.* The Club held its first show in the Agricultural Hall in 1862. It had come a long way from its first humble event of 1799 held in Wooton's livery stables in the Dolphin Yard. The hall now used as a venue for trade shows is a masterpiece of Victorian architecture. Constructed in cast iron it covers two acres its curved glass room has a span of 125ft, 75ft above the ground.

Lawes Agricultural Trust. Rothamsted Experimental Station

shows. By the mid-nineteenth century the latter was attracting over 130,000 visitors (Colour Plate 88). Attendance at the RASE shows were more erratic. These were deliberately held in a different area of the country each year. The chosen location was a fine balance between bringing a knowledge of the new improvements to a rural or semi-isolated area while ensuring a high enough attendance to make the show a success. The development of the railways made the transportation of cattle much easier. Prior to this animals had to make the long journeys either by steamer or on foot. The animals sent to Smithfield were primarily fatstock bred for the butcher and most were sent to the market the following day. Now, however, it was possible for the top breeding animals to be exhibited all over the country. 'Bellville', a champion Shorthorn bull, was shown at the RASE show at Wakefield, the Agricultural Improvement Society of Ireland at Limerick and the Highland and Agricultural Society at Inverness all in the same year. The agricultural shows were a high point of the Victorian calendar and were widely reported on in general as well as specialist publications; the *Illustrated London News* carried several pages of engravings of the prize-winning animals. Livestock painters like W.H. Davis, John Vine and Richard Whitford travelled all over the country to attend the agricultural shows, sketching the animals in their pens. British pedigree livestock began to be exported all over the world. Paintings of prize-winning animals were commissioned by prosperous owners to impress the visiting stockmen. George Garne a Cotswold Shorthorn breeder, had a large drawing room added on to his farm at Churchill Heath to display his collection of sixty-eight trophies and animal portraits. For the sheep farmers, the annual ram sale was the most important event of the year and portraits of prize-winning sheep, often with their shepherds, were commissioned for display at these events.

Plate 44. *Country Meeting of the Royal Agricultural Society at Bristol, June 30 1842* by Richard Ansdell. Oil on canvas, 84 x 216in. (213.4 x 548.6cm).
More than 130 members of the society are portrayed including many of the leading farmers of the period. Sketches for many of the portraits also hang in the RAS. The figures are shown against a background of agricultural implements. By this date more space was given over to the implement section than to livestock at the annual RASE shows. Courtesy of the Royal Agricultural Society of England

By the 1830s, a reaction to extremely fat animals had begun to set in. The emphasis at Smithfield on the most effective feeding and fattening of animals encouraged the production of over fat beasts prompting J. French Burke to comment in his *British Husbandry* of 1834 that such animals were 'too dear to buy and too fat to eat'. A few years later *Cruickshank's Year Book* published an article, 'The Philosophy of Cattle Shows', lampooning the fashion for enormous animals at the recent Smithfield show:

> …sixty thousand people went to Baker-street bazaar to see the cattle-show – to feast their eyes on panting porkers, asthmatic sheep, and apoplectic oxen. We should doubt whether the meat is better because the animals are stuffed out to a size hitherto unparalleled except on the external paintings of penny shows, where the living monsters are represented about twice the height and breadth of the caravan where the public are invited to visit them. The present, however is the age of enlargement… Perhaps the remains of gigantic animals that geologists have occasionally lighted on, may be traced to some antediluvian cattle-show, and our ancestors may have rushed to an exhibition of prize mammoths with the same eagerness we of the present day evince in running after overgrown beeves and alarmingly blown out mutton.

Criticism gathered momentum over the next decade but had little effect on the breeders who continued to produce overfat animals. In 1852 several animals died in the extreme heat of the Lewes show, so in 1853, at Gloucester, a jury was set up to disqualify any animals found in an overfed state. Those disqualified included pigs that 'could not stand', sheep which found some 'difficulty in respiration', and rams which, 'like the Romans of old, preferred taking their meals in a reclining position.' The jury's findings were met with enormous opposition from the breeders and the system was abandoned the following year. The Society was only too aware of the damage caused by overfeeding, both to the animals' welfare and to their ability to reproduce effectively, but could do little to prevent it. The condition of show animals was often quite unrelated to their practical use on a farm and the butchers too were demanding leaner carcasses. The appearance of animals was manipulated in other ways for the showroom: the teeth of pigs and sheep were filed to give a false idea of their age, sheep were artificially sheared to accentuate symmetry and hide defects and animals were specially prepared by feeding with cod liver oil, milk and sugar, rum, brandy and treacle.

The culture of the show ring was probably the single biggest impetus to livestock portraiture in the Victorian period. The initial excitement which had greeted the new breeds in the early

Colour Plate 89. *The New Metropolitan Cattle Market* after Wagner, lithographed by Read and Co., 1856. 18¾ x 27¾in. (48 x 70.5cm).
Inscribed: *The new Metropolitan Cattle Market, Copenhagen Fields. This view is taken from the White Horse Inn, near the Caledonian Road. Also, now ready, same size, "Tattersall's or Quite Fresh" & "Smithfield or Used Up".*
By the middle of the 19th century the medieval market of Smithfield was quite unable to cope with the enormous volume of livestock passing through it. It had become a scene of squalor and crime. Stampeding cattle causing havoc and destruction were a common sight through the narrow alleyways which led to the market. Herds of cattle were often ambushed by gangs of thieves who would cosh the drovers and use the stampeding animals as a cover for pick-pocketing. The new larger cattle market was built further out of town in Islington fields where the livestock could be more easily accommodated. It was opened by Prince Albert on 13 June, 1855. Lawes Agricultural Trust. Rothamsted Experimental Station

years of the century had calmed down but the agricultural shows provided a focus for fiercely competitive breeders as well as popular interest and ensured that immensely fat animals continued to be bred. During these years the overseas trade in pedigree livestock developed and the award of a prize conferred a value on an animal far above its ordinary market price. Colonel Townley's 'Master Butterfly', which won the first prize for a Shorthorn at Chelmsford in 1856, created a new record when it sold for 1,200 guineas to Australia. By the 1870s buyers from the United States, Canada and Australia were regularly exceeding these prices and buying up much of the best stock of prize Shorthorns and Herefords. Butchers too would pay a premium for prize-winning animals and many of those exhibited at Smithfield found their way to the market the following day. The details of the butcher who bought the animal are often inscribed on livestock prints. James Pollard's print of a butcher's shop of 1822 suggests that some of the meat had come from the Smithfield Show (Colour Plate 90). The stand is decorated with holly showing that it is Christmas time. A large ham has a ticket saying 'first prize' and another carcass has a ticket which reads 'Duke of Bedford Grass fed'. The public were as interested in the quality of the carcass and the meat as the animals themselves. An

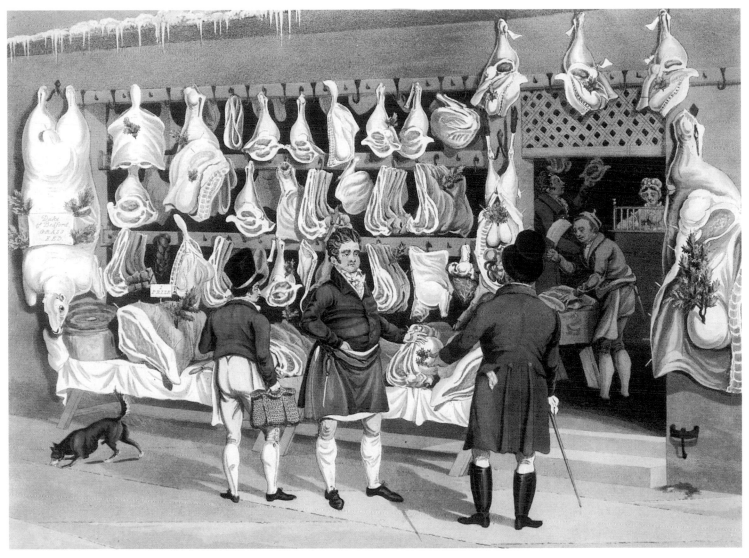

Colour Plate 90. *The Butcher's Shop* after James Pollard (1797-1867), coloured aquatint by M. Dubourg, 1822.
9 x 11¾in. (22.5 x 30 cm).
The meat hanging here includes prize-winning beasts from the Smithfield Show.

Courtesy of the O'Shea Gallery

extract from the *Mark Lane Express* for 25 December 1837 describes the Christmas display at Mr Giblett's, the royal butcher on Bond Street. It 'was the finest ever witnessed, about two thousand pounds-worth of the primest meat that could be ·obtained…crowds of people thronged his shop on the day of exhibition (Thursday last) entering at the front and passing out at the back, as if it had been a fair'.

While the new breeds were being promoted and brought to prominence, many of the less productive local breeds were dwindling into insignificance and even extinction. David Low, Professor of Agriculture at Edinburgh University, was enlightened enough to understand that it was as important to preserve the old breeds as it was to establish the new ones. In 1832 he commissioned a Scottish artist, William Shiels to begin a series of paintings, fifty-six of which were published as lithographs in a two volume book, *The Breeds of the Domestic Animals of the British Islands,* in 1842. It took Shiels a decade to complete his task; he travelled all over the country painting the animals which had previously been selected by Low on the basis of conformation and pedigree. The paintings were the most comprehensive survey of British livestock yet to be produced. Low intended the paintings for a university museum of

Colour Plate 91. *Berkshire Pig* by William Shiels, c.1835. Oil on canvas, 49¼ x 64in. (125 x 163cm).
This shows the mottled red and black appearance of the old Berkshire before it became a black pig with white points.

agriculture as an aid to teaching. Although he received a small grant for setting up the museum, he personally funded a large proportion of Shiels' work and eventually one hundred paintings went on display in the University's Department of Agriculture.

The portraits of the sheep, pigs and goats were executed life-size and the cattle and horses half life-size. Shiels, a well-established artist of equestrian and sporting works as well as domestic genre scenes, was a founding member of the Scottish Academy which was formed in 1826. He was a good choice, producing accurate, if dull, portraits which are unusual for being so large (Colour Plates 91, 190 and 207). Shiels was only paid between £14 and £20 for each work so he would not have felt encouraged to linger over the canvases. Painted against a very generalised background, they have a rather two-dimensional quality to them. Sadly the collection fell into neglect and only forty-three of the paintings survive, most of them in dreadful condition. The majority are now in the collection of the National Museum and Galleries of Scotland and a handful have recently been restored. Shiels' enormous undertaking is best known from William Nicholson's drawings of his work from which the lithographs were executed by Thomas Fairland (1804-52), a noted London printmaker (Colour Plates 215, 237, 243 and 250). They form a unique record of the range of livestock of the time. Contrary to most contemporary agricultural commentators, Low recognised the genetic importance of the traditional breeds. He placed the old alongside the new, giving equal emphasis to their characteristics. He was keenly aware of the dangers of losing qualities such as hardiness and quality of wool in some of the mountain breeds of sheep through crossbreeding. Several breeds of sheep already unfashionable and almost extinct are included: the Old Wiltshire, Old Norfolk, Ryeland, the Orkney and the Devonshire Nott, as well as the Glamorgan and Fife breeds of cattle which by this time were dwindling fast.

Scotland had formed a national agricultural society long before the RASE became formalised in England. The Highland Society was formed in 1785 with wide ranging objectives of which the improvement of agriculture formed an important part. On being granted a second royal charter in 1834, the Society altered its title to The Highland and Agricultural Society of Scotland and became primarily concerned with agriculture. It held its first fatstock show in 1822 which soon grew to become a major event rivalling that of the RASE (Colour Plate 92). When the society moved to new premises at number 3 George IV Bridge, Gourlay Steell was appointed their official animal painter to record the best examples of the different breeds. Steell's work for the Queen included *Highland Cattle in the Pass of*

Colour Plate 92. John Hall Maxwell at the Edinburgh Showground by Gourlay Steell, 1866. Oil on canvas. 46½ x 62¾in. (118 x 159.4cm). Secretary of the Society from 1846-1866 he is shown at the Edinburgh Showground on Bruntsfield Links.
Royal Highland and Agricultural Society of Scotland

Colour Plate 93. *Alpacas,* unknown artist, 1840. Oil on canvas, 24½ x 29½in. (62.2 x 75cm).
These animals aroused great curiosity when they were exhibited at the Association for the Promotion of Science in Glasgow in 1840.
Royal Highland and Agricultural Society of Scotland

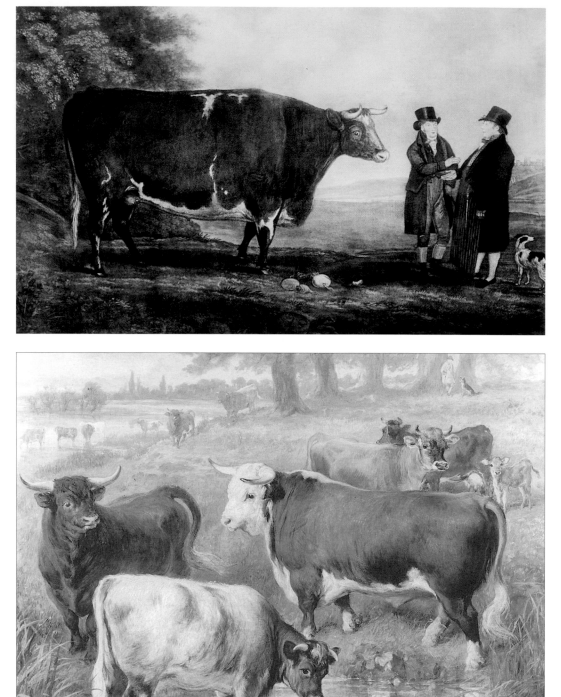

Colour Plate 94. *The Northumberland Ox* after J. Howe by R. Scott c.1830. 17 x 22¾in. (43 x 57.8cm).
Inscribed: *To Sir John Sinclair of Ulbster [sic] Bart M.P. & President of the Board of Agriculture, this print of the Northumberland ox, Bred and Fed by Thos Jobbing Esqr. of Styford in the County of Northumberland Is Humbly Dedicated by his most obedient servant, Thomas Bennet. This remarkable Animal was fed without tasting Oil-cake. His length was, from the Nose to the seting on of the Tail, 11ft 2 in. Height at Shoulder 5ft 6 in - Round the Girth 9 ft 11 in – Round the Breast and Shoulder 11 ft 3 in – and cross the Hucks 3 ft 1 in– His fore Quarters weighed 133 st 11 lb 9½ oz – His Tallow 20 st 11 lb 11½ oz- and His Hide 7 st 12 lb – being in all 162 st 7 lb 5 oz – at 14 pound to the Stone– The Quality of his Beef was so Fine that it was sold in the Edinburgh Market by Thomas Bennet, the Proprietor at 1s 6d pr pound weight, who purchased the Animal, from Mr. Thomas Hibbert of Glasgow, for 120 Guineas.*
University of Reading. Rural History Centre

Plate 45. *Favourite Cattle at Windsor* by Gourlay Steell, 1776. Oil on canvas, 27½ x 36 in (31 x 68 cm).
This painting includes Shorthorn, Hereford and Jersey cattle.
The Royal Collection © 1996 Her Majesty the Queen

Leny and the above, for which he was paid £78.15s. Both works were hung at Osborne and subsequently moved to Barton, the Osborne Home Farm.

Gourlay Steell was the pre-eminent Scottish animal painter who had had long connections with the Society and was therefore a natural choice for such an appointment. His paintings, in particular his scenes of life in the Highlands, were much admired by Queen Victoria who appointed him as her animal painter in Scotland on the death of Landseer in 1878. Steell's work was extremely competent and included large scale sporting and genre subjects as well as history painting. In some of his larger livestock paintings, such as the *Guisachan Aberdeen*

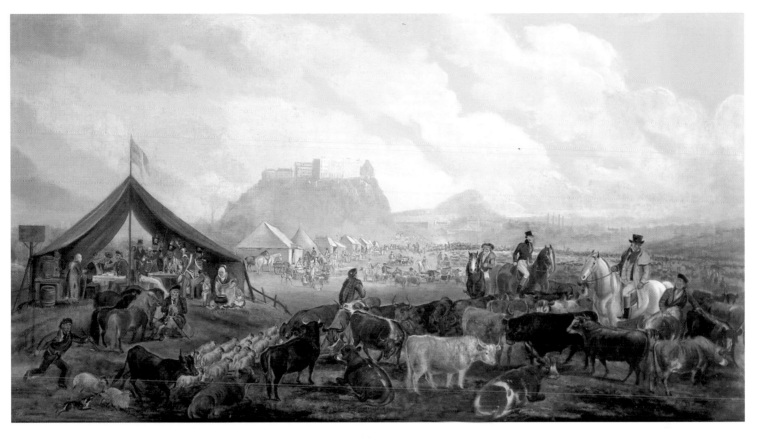

Colour Plate 95. *All Hallows Fair* by James Howe. Oil on canvas. Set on the outskirts of Edinburgh. Gentlemen farmers can be seen inspecting the livestock driven in from the surrounding areas. The cattle with their shaggy coats and long horns appear to be mainly of the Highland type.

City of Edinburgh Museums and Art Galleries. Bridgeman Art Library, London

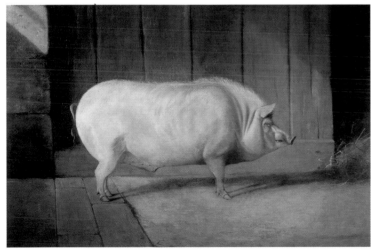

Colour Plate 96. *A Prize Large White Boar* by John Sheriff, 1844. Oil on canvas, 28 x 56in. (71.1 x 91cm).

Inscribed: *This boar bred by the Marquis of Tweedale was exhibited by the Duke of Buccleuch at the Society's General Show at Aberdeen in 1840 where he gained first prize for the best boar of any breed.*

An Edinburgh artist, Sheriff painted livestock and sporting commissions. Several of his works belong to the Royal Highland and Agricultural Society of Scotland.

Private Collection

Angus Cattle (Colour Plate 175), he breaks away from the standard schematic livestock pose, but his work lacks the originality of Landseer. James Howe (Colour Plates 94 and 95) depicted rural life, in particular scenes of horse fairs and country folk with a humorous anecdotal style. He was a skilled horse painter from the village of Skirling in Peeblesshire executing cattle and horse portraits in Northumberland and the borders. He painted farm animals for two publishing projects which are little known and predate David Low's publication by a decade. The first *Breeds of Domesticated Animals,* 1828-30 consisted of fourteen plates of horses and cattle. The second *Portraits of Horses and Prize Cattle* was published by Ballantyne and Co. in 1832 with the support of the Royal Highland Society. It ran to some fifty lithographs portraying animals belonging to leading members of the Scottish agricultural community including The Duke of Buccleuch, the Earl of Hopetoun and Hugh Watson of Keillor. Other Scottish artists

Plate 46. Interior of the Atelier, Craigmill by M.F. Struthers, c.1900. Pencil on paper, 6 x 10in. (15 x 25.5cm). Struthers was a pupil at Adam's country atelier. The skeleton of a cow can be seen on the left-hand side.
Smith Art Gallery and Museum, Stirling

who regularly painted livestock portraits include John Sheriff (Colour Plate 96), William Grant Stevenson, Alexander Forbes and Joseph Denovan Adam (Colour Plate 97).

Adam was unique in establishing a school of animal painting at Craigmill outside Stirling. Here students from all over the United Kingdom came to stay at the 'country atelier' and were instructed in the techniques of animal painting. He constructed a studio mainly of glass so that if the weather was poor the students could continue their studies from inside and designed various moveable platforms on which the animals could be placed and drawn from different angles. He insisted on a thorough grounding in anatomy and kept a complete skeleton of a cow in the studio as well as several cattle heads. Students were obliged to study the skeleton as well as to make studies of the animals' muscles from books before they were allowed to study the various live models in the park. These included Highland cattle, numerous sheep, horses, goats, poultry and dogs.

Livestock portraits provided Adam with his bread and butter work but of more interest are his ambitious Scottish landscapes in which Highland cattle play such a major role. Cattle are herded down a hillside which shines a glorious crimson in the autumn sunlight or raise their heads to a winter storm-tossed sky. His later work shows the influence of the *plein-air* movement through the work of the Scottish 'Glasgow Boys' and the colourist Samuel Peploe. His *Cattle in a Cabbage Field* in Glasgow Museum and Art Gallery makes an interesting comparison with Sir James Guthrie's well-known *A Hind's Daughter* which shows a young girl standing in a field of cabbages. Like Guthrie's painting the cabbages are really the main subject of the picture spilling out of the foreground of the canvas in an exuberant riot of greens.

Adam enjoyed great critical success and has recently been the subject of an exhibition at Stirling Art Gallery which has revaluated his importance as one of Scotland's foremost animal painters. He was a member of the Royal Scottish Academy and exhibited at the Dowdeswell Galleries in Bond Street where his work was compared favourably to both Landseer and Rosa Bonheur. He was particularly praised for his ability to integrate animals into their surroundings in harmony with both the scenery and the weather and the way he captured the individual nuances of each beast.

The British love of animal painting remained as strong as ever in the Victorian period. Under

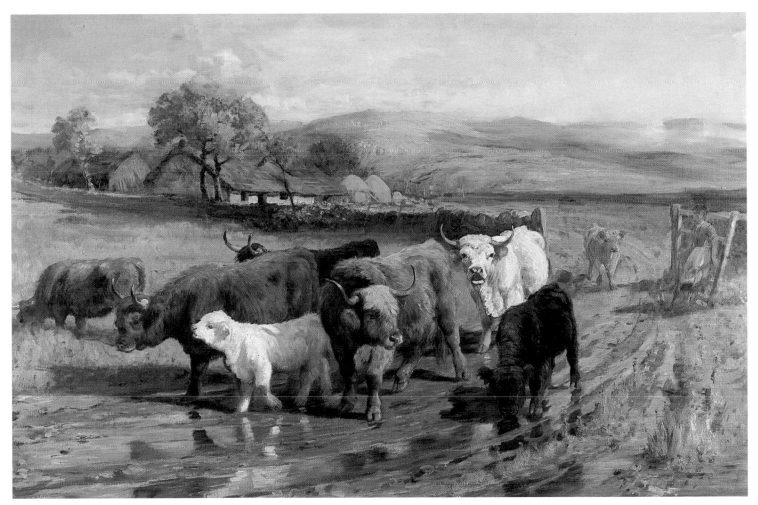

Colour Plate 97. *Going to Pasture* by Joseph Denovan Adam. Oil on canvas, 25 x 39in. (63.5 x 99cm).
Smith Art Gallery and Museum, Stirling

the dominating influence of Sir Edwin Landseer, who was much patronised by Queen Victoria and knighted for his services, it gained additional respectability. It was still regarded as inferior to other branches of the arts, but within the field there was a definite pecking order. Certain artists, by virtue of their technical ability and enlarged subject matter, had a status above the more straightforward sporting and animal painters, as this extract from the *Art Journal* of 1860 demonstrates:

> Animal painting, for example, compared with historical pictures, may be considered low Art, but it is not so in itself. Who would be bold enough to designate the works of Cuyp, of Wouvermans, Berghem, and Snyders, of Sir Edwin Landseer, Sidney Cooper and Ansdell, or of Mdlle. Rosa Bonheur, as low art? The productions of these painters are the highest art, of its kind only; for we willingly admit that, measured by the standard which should guide our decision in everything of an intellectual nature, they must take secondary rank, just in the same way as we acknowledge in literature one class order of works having precedence of others.

Livestock portraiture tends to play a very small part in the work of the most successful and ambitious artists like Sir Edwin Landseer, Richard Ansdell and Thomas Sidney Cooper. All undertook such work early in their careers while establishing their reputations but abandoned it once they had developed a more academic and sophisticated style. As a boy, Landseer drew horses, cows and dogs compulsively and while still in his teens was drawing and etching farm animals for a succession of modest Essex patrons, principally W.H. Simpson and Lord Western

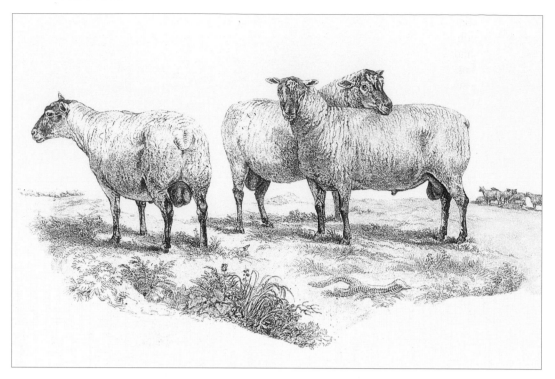

Plate 47. *South-Down Rams* after Sir Edwin Landseer by Thomas Landseer, 1814. 11¼ x 14¾in. (28.5 x 37.5cm). Inscribed: *Portraits of two aged and one shearling South-downs rams, the property of C.C. Western Esqr. M.P for the County of Essex.*
Landseer was only eleven when this drawing was etched by his brother Thomas.

Lawes Agricultural Trust. Rothamsted Experimental Station

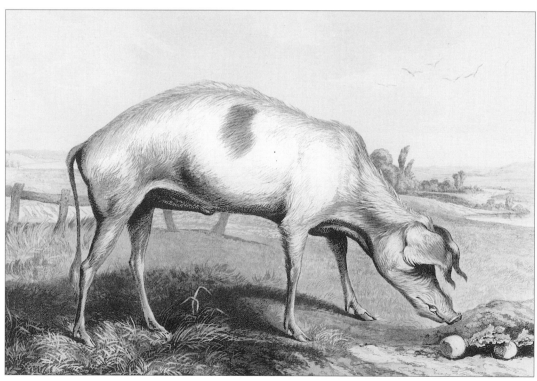

Plate 48. *A French Hog* after Sir Edwin Landseer by Thomas Landseer, 1818. 15½ x 20¼in. (39.3 x 51.3cm) Executed very early in his career, both the *British Boar* (Colour Plate 98), several versions of which exist, and the *French Hog* were engraved and show a satirical approach to national characteristics. The British Museum

(Colour Plate 98 and Plates 47 and 48). His early works exhibited at the Royal Academy between 1815 and 1825 were straightforward horse and livestock portraits and included a 'Portrait of a mule, the property of W H Simpson, Esq., of Beleigh Grange, Essex' and 'Merino sheep and dog' exhibited in 1819 which were probably bred by Lord Western. Graves lists a painting by Landseer of five Merino sheep belonging to Lord Western which were etched by Thomas Landseer in 1818, the year Lord Western was awarded the Merino Society's Gold Medal for three wethers. In 1822 he exhibited a painting at the Academy entitled 'Devonshire

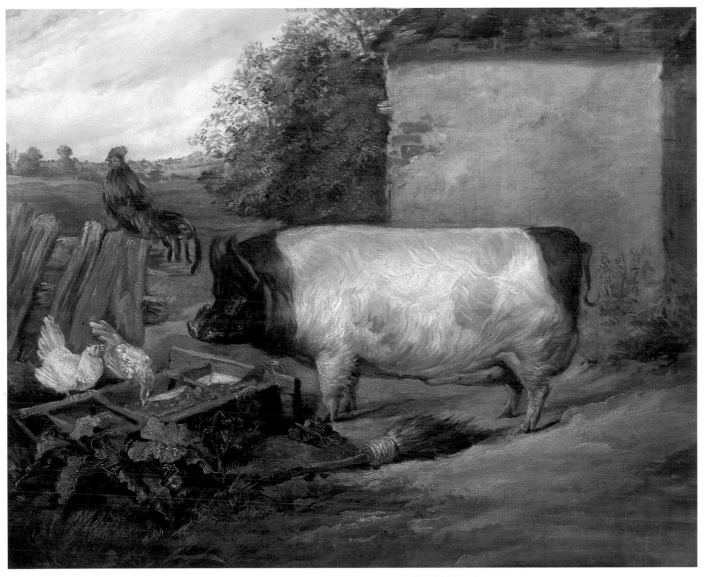

Colour Plate 98. *A British Boar* by Sir Edwin Landseer, c.1818. Oil on canvas, 21 x 24in. (53.3 x 61cm). Landseer executed many livestock paintings and sketches in his teens and early twenties, principally for a group of Essex patrons. This boar belonged to Lord Western and may be an early example of a Sheeted Essex pig.

Collection of Christopher Davenport Jones

cows'. He also drew and studied wild animals at the London menageries and from the very beginning his drawings had a superb sense of naturalism as well as an understanding of anatomy. Two early works executed in 1818, *A British Boar* and *A French Hog* (Colour Plate 98 and Plate 48), were intended as a satire of national characteristics. The model for the British boar belonged to Lord Western and may be an early example of a Sheeted Essex pig. An undated print of a Shire horse, 'Free Trade Warranted Sound', which is not listed in Graves was exhibited at the Walker Art Gallery in 1934. An extract from Dr Dixon of Witham's diary published in the *Essex Farmer's Journal* in February 1938 gives the following account of Landseer at work for Lord Western:

I did not see him [Landseer] till 1823, when he came down to paint two oxen for Mr Western, of Felix Hall. This was in December; the animals were exhibited in the London Cattle Show of that year. Mr. Western was not at home at the time. Landseer sent for me to have a talk while he was at work with his brush or pencil. It took him about four or five hours to paint them both in separate pictures. They are now hanging in the library at Felix Hall, where I saw them Yesterday (March 20 1874).

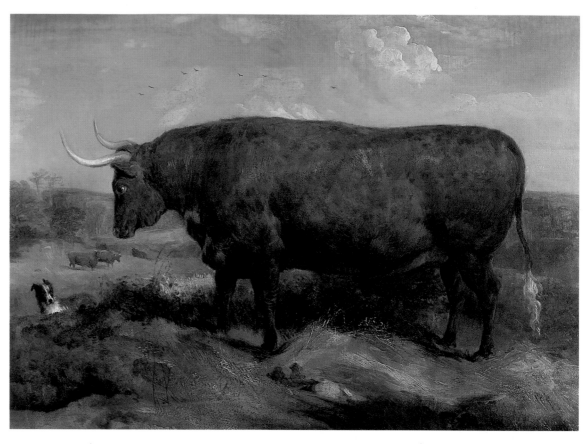

Colour Plate 99. *A North Devon Ox* by Sir Edwin Landseer, 1824. Oil on canvas, 15 x 20in. (38.1 x 50.8). Inscribed: *North Devon Ox three years and nine months bred and fed by Charles C. Western.* Mr A.L. Cullen

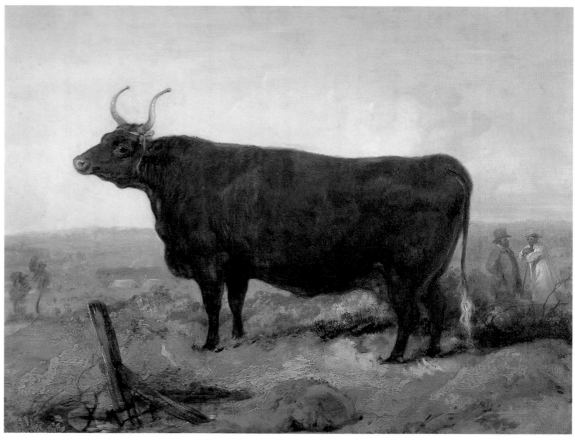

Colour Plate 100. *A North Devon Cow* by Sir Edwin Landseer, 1824. Oil on canvas, 15 x 20in. (38.1 x 50.8cm). Inscribed: *Bred and fed by Charles C Western.* Dr Dixon recorded Landseer painting cattle portraits at Felix Hall in 1823.

Mr A.L. Cullen

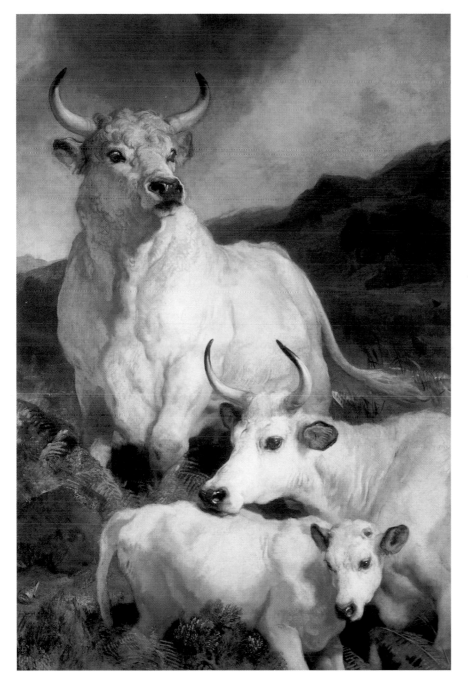

Colour Plate 101. *Wild Cattle of Chillingham* by Sir Edwin Landseer, 1867. Oil on canvas, 90 x 61½in. (228.5 x 156.3 cm).
Commissioned by the Earl of Tankerville for Chillingham Castle, this work has a companion piece, *Deer of Chillingham Park*. Landseer placed animal painting on a higher plane, investing his animals with human feelings and emotions. Here the proud male figure is set against the sky, the female and her young nestling below for protection.
Laing Art Gallery , Newcastle Upon Tyne, Tyne and Wear Museums

Colour Plates 99 and 100 show Devon cattle painted for Lord Western the following year.

Landseer, however, soon left such prosaic commissions behind him. He rose to the top of his profession and was knighted in 1850, showing the high regard in which he was held by the royal family. He was also offered the Presidency of the Royal Academy, a post which he declined due to his ill health. Perhaps it was his time spent as a student with the ambitious artist B.R Haydon that convinced Landseer that he wanted to be more than a conventional animal painter. Instead he became a story-teller, evoking in his scenes of animal life a world in which his audience could interpret their own emotions and values. Such interpretations were outside the scope and demands of conventional livestock painting.

When asked to paint the Wild Cattle of Chillingham for his patron the 6th Earl of Tankerville (Colour Plate 101), he conceived a painting which was both heroic and emblematic. The bull stands proud against the skyline while the female and her calf nestle beneath him for

Plate 49. Landseer salver. Designed by Landseer and made by Benjamin Preston, 1837. Silver, 26 x 33in. (66 x 84 cm).
The salver commemorates the agricultural achievements of the 5th and 6th Dukes of Bedford and was made from the prize medals and cups won in agricultural competitions.
By kind permission of the Marquess of Tavistock and the Trustees of the Bedford Estates

protection. *A Scene in the Grampians – The Drovers' Departure* (Colour Plate 102) demonstrates Landseer's aptitude for story-telling. The great Scottish droves where sheep and cattle from the Highlands were driven south for fattening for the London market were part of Scottish folklore. The drovers followed ancient paths through wild and remote places and experienced all kinds of difficulties and dangers including robbers who lay in wait as they returned home. The solution was to devise a safe system of transferring money and the history of banking is linked with that of droving. By the time the painting was exhibited in 1835, the traditions of the great Scottish droves were already passing away. Landseer has chosen the morning of the departure when the cattle were assembled at an appointed place under a topsman who is responsible for all the arrangements. Here the topsman is seen taking leave of his family which not only symbolises the types of Highland character but also the ages of man. For his patron the 6th Duke of Bedford Landseer executed an unusual commission, the design of a silver salver commemorating the achievements of the 5th and 6th Dukes of Bedford as agriculturalists and breeders of livestock. An inscription on the back reveals that it was made from the melted down prize medals and cups won in agricultural competitions by both Dukes. The salver (Plate 49) is an opulent, impressive piece of plate heavily chased with scenes of prize cattle, sheep, pigs and horses, scenes of harvesting and ploughing and putti bearing various agricultural implements. The centre shows a man ploughing with two oxen.

Such lavish commissions were few and far between. The demand for more mundane livestock portraiture, however, continued unabated. Thomas Sidney Cooper never tired of painting cattle and sheep grouped picturesquely in a landscape setting. His work does not contain the emotional or narrative content of Landseer or Richard Ansdell, but he was an extremely successful artist, dying a wealthy man. No private collection was considered complete without an example of his work and he was a regular exhibitor at the Royal Academy for an astonishing seventy years. In his memoirs he recounts how, on his return to England from Belgium in 1831, he was grateful for the opportunity to establish his reputation as an animal painter through livestock painting:

A good deal of my work began at this period (as I have before observed) to consist of commission pictures, mostly portraits of stock, etc., for my reputation as an animal-painter was steadily gaining ground, and I was constantly sent for by gentlemen in the country for this purpose. Indeed, as each December came round I could almost reckon upon having some prize cattle to paint, either before they came up to the great Smithfield Show, or after they returned from it to their country homes.

His writings include many amusing anecdotes. On one occasion, as he returned home from the market with the head of a magnificent Hereford bull he was intending to sketch, he was arrested by a policeman who had seen blood dripping from the hamper in the Hackney cab. On another, he was sketching a drowsy looking ox when suddenly the animal, startled by a dog, turned into a ferocious beast, charging him and trampling his drawing underfoot. When called to Norwich to paint an ox which had won first prize at the local cattle show the weather was so cold that the only way to achieve a likeness was to have the animal installed on the drawing room verandah so Cooper could remain inside in the warmth.

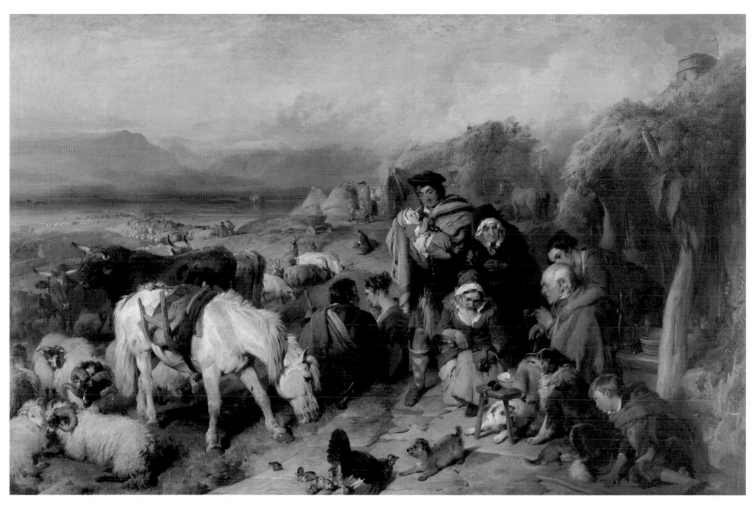

Colour Plate 102. *A Scene in the Grampians, The Drovers Departure* by Sir Edwin Landseer, 1835. Oil on canvas, 49½ x 75¼in. (125.8 x 191.2cm).
Landseer has here captured the romance and drama of the situation as the animals and men assemble before departure.
The Trustees of the Victoria and Albert Museum

Colour Plate 103. *The Bellman* by Samuel Palmer, c.1881. Watercolour and body-colour on paper, 20 x 27½in. (51 x 70cm). Palmer's painting illustrates a passage from Milton's *Il Penseroso*. It shows however a very English looking rural village with a herd of Longhorns folded in for the night. Palmer may well have chosen to illustrate Longhorns as they evoked a more nostalgic image.
The Duke of Devonshire and the Trustees of the Chatsworth Settlement

Colour Plate 104. *The Victoria Cow 'Buffie'* by Thomas Sidney Cooper, 1848. Oil on canvas, 17¾ x 24in. (45.1 x 61cm).
Cooper was the most prolific Victorian animal painter exhibiting at the Academy for seventy years. The public never appeared to tire of his paintings which reworked the same theme of sheep and cattle in a landscape over and over again.

Cooper was summoned to Osborne to paint Queen Victoria's Jersey Cow 'Buffie' (Colour Plate 104) which had been presented to her by the Island of Jersey; the Queen was patron of the Royal Jersey Agricultural and Horticultural Society. Cooper had to paint the portrait close to a haystack and seeds and particles of hay kept blowing on to his canvas, there was a very trying east wind and 'everything combined to make the poor animal very fidgety'. The commission presented more than practical difficulties and underlines the dilemma which livestock painting presented to artists who had received an academic training. They were caught between the demands of their patrons to produce an accurate portrait and their own desire to form an aesthetically pleasing composition. On inspecting the painting of 'Buffie', Prince Albert commented:

'How about those dock-leaves that you are introducing into the foreground, Mr Cooper?' I answered: 'The privilege of my branch of art, your Royal Highness, is to take advantage of objects of still-life, to assist the composition of a work, and for pictorial combination; and such accessories as dock leaves are considered allowable to avoid the monotony, as much as possible of grass and earth.'
'Well,' said the Prince jocosely, 'they are beautifully painted, and doubtless assist the composition, but they do not give evidence of good farming.'

Plate 50. *Two White oxen in a Barn* by Thomas Sidney Cooper, 1837. Oil on canvas laid on board, 23½ x 36¼in (59.6 x 92.1cm).
On his return to England in 1831 Cooper was grateful for the opportunity to build up his reputation by executing cattle portraits.
<div align="right">Private Collection. Photograph Christie's Images</div>

Plate 51. *Early from Smithfield* by Thomas Sidney Cooper, 1827. Oil on canvas, 72 x 60in (182.7 x 152.4cm).
Cooper's paintings show cattle being driven down the narrow lanes surrounding Old Smithfield Market. Private Collection. Photograph Christie's Images

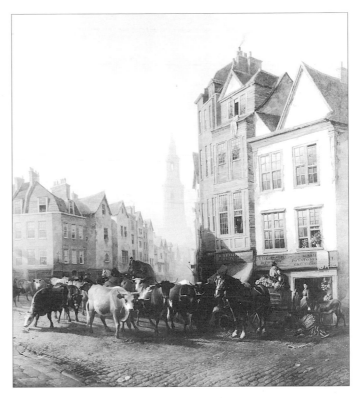

Her majesty smiled appreciatively, and, shaking her finger at the Prince, said: 'How about the little pool of water in which the heifer's hind-legs are standing?'
'Oh,' said his Royal Highness, laughing, 'I think it is a beautiful artistic idea, and gives a stamp of nature to the scene.'
'Yes, Albert,' said the Queen, 'and I like its introduction much; but it does not give evidence of good draining.'

In many other commissions Cooper complains that he was required to paint fat prize cattle which were remarkable agricultural specimens but entirely unsuitable from an artistic point of view. His study of the Dutch Old Masters and his feeling for the romantic and picturesque meant he was a great deal happier producing his idealised, light-flooded landscapes with the sheep and cattle arranged in an artistic manner.

Cooper painted only one other animal portrait for the Queen, a picture of 'Milly', Princess Alice's pet lamb. The Queen's preferred artist was Friedrich Wilhelm Keyl, a native of Frankfurt-on-Main, who like Cooper had studied under Verboeckhoven in Brussels. Keyl became friendly with Landseer who introduced him to the Queen. He painted several dog portraits for the Queen from as early as 1847. Between 1867 and 1869 he executed at least nine paintings of prize-winning farm animals. Most of these, including a portrait of 'Henry Tait, bailiff at Shaw Farm with animals' (Plate 52) and

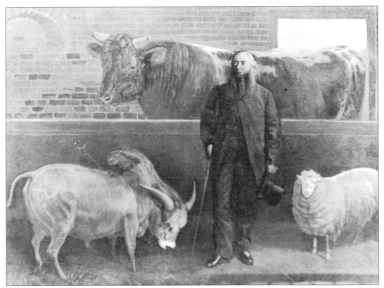

Plate 52. *Mr Henry Tait, bailiff at Shaw Farm,* the original by Friedrich Wilhelm Keyl, c.1867. Oil on canvas, 20 x 27in. (50.8 x 68.5cm).
Henry Tait is shown with a Brahma bull from Mysore, a cross-bred lamb and a shorthorn bull 'England's Glory' behind him. Other paintings by Keyl formerly in the Royal Collection and now dispersed are: a Devon bullock, 1867; 'Prince Christian', a Hereford bull, 1867; a group of pigs, 1867; 'Alexandra', a shorthorn heifer, 1869 and a cow, 'Alix' and calf. The Royal Collection © 1996 Her Majesty the Queen

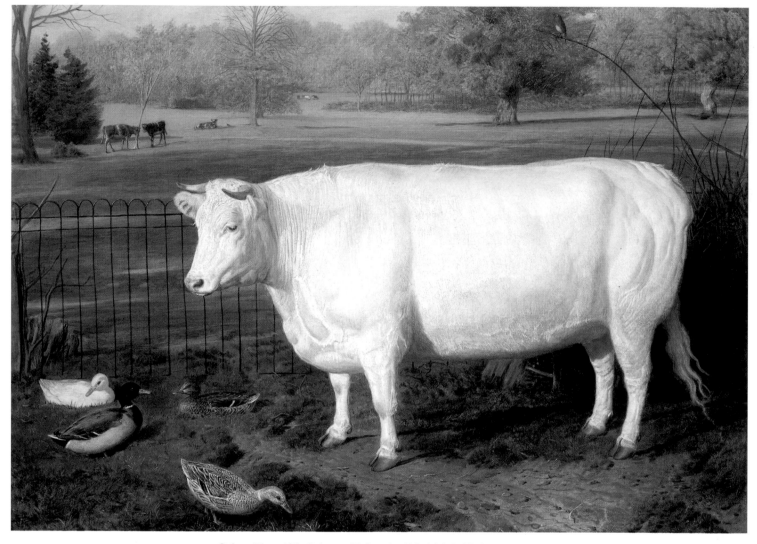

Colour Plate 105. *Princess Helena* by Friedrich Wilhelm Keyl. Oil on canvas, 21 x 27¼in. (53.3 x 69.2cm). The Shorthorn heifer is shown in an enclosure at Shaw Farm, Windsor. It shows Keyl's vibrant colour tones and highly detailed technique. The painting took him seven days to complete.

The Royal Collection © 1996 Her Majesty The Queen

various portraits of pigs, Herefords and Shorthorns, have disappeared. The surviving paintings include *Princess Helena*, a Shorthorn heifer, three and a half years old, in an enclosure at Shaw Farm (Colour Plate 105), and a Hereford bullock which had gained first prize at the Smithfield Show in 1866 as well as a painting of *Spring lambs in the Home Park at Windsor*. Entries in the royal accounts relating to *Princess Helena* reveal a little of Keyl's working practice. Over two days on 18 and 19 August 1868 he 'Worked on Heifer Chalk Study' at Shaw Farm. Between 1 and 4 January 1869 he 'traced over, and arranged and painted in heifer; Painted in Sky and landscape; Painted on heifer'. On 4 March he 'Repainted Sky and background of Heifer'. At three guineas a day, the total sum involved was twenty-one guineas. This is in striking contrast to the audacious Landseer who had tossed off two livestock portraits in five hours. Keyl's highly detailed and rather laboured technique no doubt appealed to Queen Victoria who recorded and catalogued all her possessions with such care and precision. Unlike many of his contemporaries he painted a background as precise and accurate as the animal itself. Queen Victoria also kept an album containing watercolours and drawings of her livestock, cattle, dogs and horses. Most of the sketches drawn on coloured paper and mounted in the book were executed by Keyl. They begin in 1847 and include portraits of Herefords, Shorthorns, pigs, Tibetan sheep, a Black

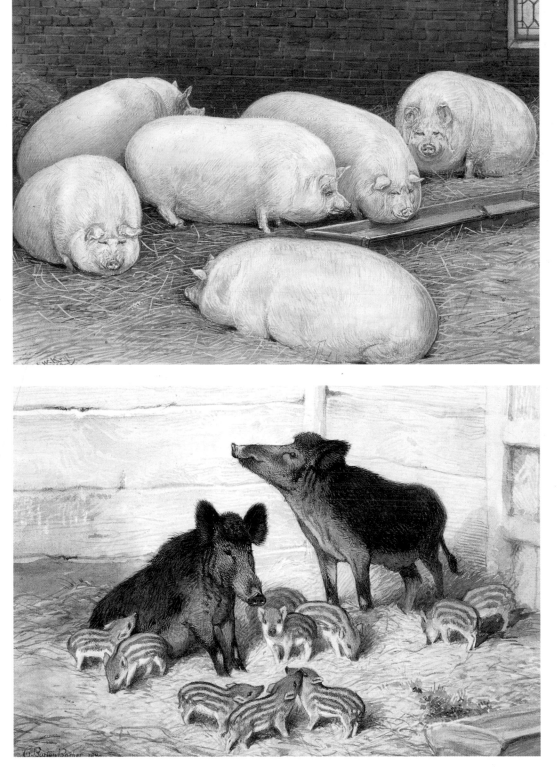

Colour Plate 106. *Pen of Pigs at Shaw Farm, Windsor* by Friedrich Wilhelm Keyl, 1858. Watercolour on paper, 8 x 10¼in (20.3 x 26cm).
The Royal Collection
© 1996 Her Majesty The Queen

Colour Plate 107. *Wild Boar* by Charles Burton Barber, 1880. Watercolour on paper, 7¼ x 9¾in. (18.3 x 24 cm).
Included in Queen Victoria's watercolour album of animal paintings the painting shows two boar with what appear to be cross-bred piglets. The Queen wrote in her journal for 7 March 1880, 'To the Shaw Farm, where we saw the wild boar, which Bertie had sent from Sandringham, & which are placed temporarily at the farm.' On 22 March she visited them again and noticed that 'the little ones, are most curious'.
The Royal Collection
© 1996 Her Majesty the Queen

Aberdeenshire polled ox, Clydesdales from the Barton homestead and Alderney cattle from Osborne. Keyl also recorded many of the Queen's exotic species. The drawings are mostly excuted in Keyl's highly detailed technique. Tiny brushstrokes emphasise the surface texture of bristle or fur. The colouring is Pre-Raphaelite in its intensiveness and richness and the placing of a cat in a stable, a robin on a drinking trough, lends a narrative element.

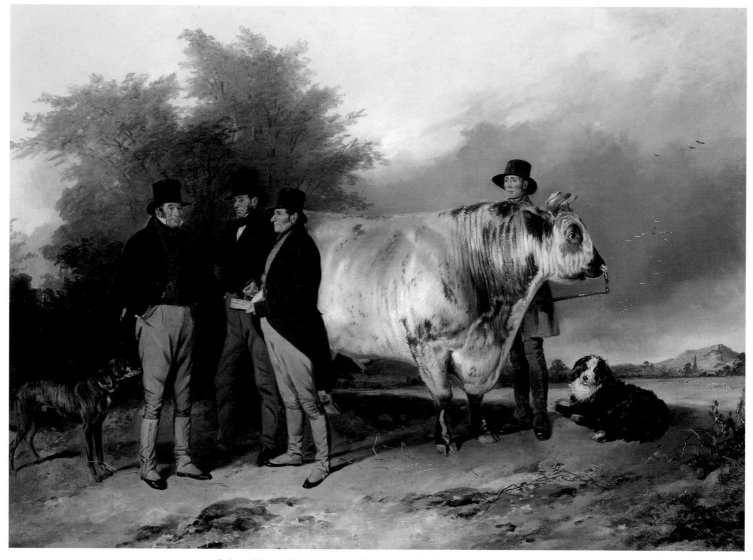

Colour Plate 108. *A Scene at Wiseton* by Richard Ansdell, c.1844. Oil on canvas, 22½ x 29½in (57.2 x 75cm). Ansdell was Landseer's nearest competitor and like him executed livestock paintings early in his career. This painting shows his skill at painting out of doors portrait groups. From the Collection at Althorp

Of all the Victorian sporting and animal painters, Richard Ansdell came closest to Landseer in the variety of his subject matter and the quality of his technique. Like Landseer, he specialised in large scale paintings of sporting and genre scenes in the Highlands and was adept at large scale outdoor figure scenes such as his painting of the RASE's meeting at Bristol in 1842. Born in Liverpool, he began by painting sporting and animal paintings for a largely local clientele. An important early patron was the 3rd Earl Spencer for whom he executed the marvellous painting *A Scene at Wiseton* (Colour Plate 108) as well as two of his prize bulls, 'Orantes' and 'Ranunculus' (Plate 53). Although Earl Spencer pursued an active political career, serving his country as Chancellor of the Exchequer, he was always more at home on his farm at Wiseton in Northamptonshire, the estate he inherited from his wife. When Chancellor of the Exchequer, the first letters he opened were those from his bailiff at Wiseton. He became President of the Smithfield Club in 1825 and was also instrumental in the foundation of the Royal Agricultural Society of England. The famous Wiseton herd of Shorthorns had been founded in 1818 with stock bought from the Colling sale at Barmpton and developed into one of the finest in the country with over 150 head. On his succession to the Earldom Lord Spencer retired from public life and concentrated on his farming. He inherited

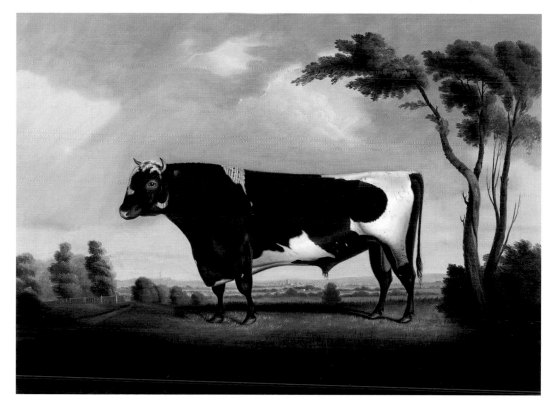

Colour Plate 109. *Ivanhoe, a Shorthorn bull from Lord Spencer's herd* by G. Bailey. Oil on canvas, 24½ x 32in. (62.2 x 81.3cm).
Lord Spencer commissioned at least twenty-six paintings of cattle. He was a shy man, passionately interested in his farm at Wiseton. Bailey was born at Bawtrey near Doncaster. He was a sporting artist but also a prize fighter and racehorse trainer.

From the Collection at Althorp

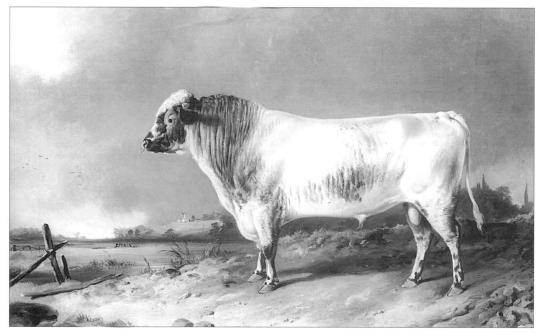

Plate 53. *Ranunculus, a Shorthorn bull from Lord Spencer's herd* by Richard Ansdell. Oil on canvas, 20½ x 29½in. (52 x 75cm).
Ansdell has created a magnificent potent image; the bull stands fierce and alert.

From the Collection at Althorp.
Photograph Courtauld Institute of Art

large debts and effected a policy of retrenchment on most of his estates; however, at Wiseton no expense was spared. He regularly farmed at an annual loss of '3,000 l'.

In *A Scene at Wiseton,* c.1844, Ansdell has shown Lord Spencer's prize bull 'Wiseton' dwarfing the humans. The 3rd Earl Spencer stands talking to his two stewards, Mr J. Elliott the steward at Althorp and Mr Hall the Steward at Wiseton while John Wagstaffe the herdsman holds 'Wiseton', one of Lord Spencer's famous shorthorns. Lord Spencer was a regular prize-winner at the local shows and commissioned at least twenty-six paintings of prize cattle by W.H. Davis, E.F. Welles (Colour Plate 139) and George Bailey (Colour Plate 109) among

others. At some stage he also acquired John Boultbee's original painting of *The Durham Ox* (see Colour Plate 54). Unlike his father, the 3rd Earl Spencer was not interested in the arts. With the exception of a few family portraits, the cattle paintings are the only artistic contribution he made to the family collection which demonstrates his passion for the subject. They have recently been restored and all hung together in Lord Spencer's private study at Althorp, forming probably the most complete visual record of a pedigree breeding herd.

It is sad that Ansdell recorded only three of Lord Spencer's prize animals for the quality of his work shines out from amongst the other cattle portraits. Although conforming to the conventions of livestock portraiture, his bulls are magnificent creatures, their muscles clearly visible under their glistening coats. They stand with proud heads, and do not seem half asleep like the animals painted by so many of his contemporaries. Ansdell was soon to leave livestock portraiture behind him. He visited Spain in 1856, executing many Spanish subjects, and was a prolific artist whose work sold immediately (with eleven children to support he needed a high income). He had a lodge on Loch Lagan in the Highlands where he painted many of his large scale Highland scenes so popular with the Victorians.

For the less ambitious, however, livestock painting could still offer a prosperous and attractive livelihood. William Henry Davis was one of the most successful and prolific livestock painters of the mid-nineteenth century. He worked for many of the most influential breeders including Lord Spencer, Thomas Coke and Lord Berwick. Davis' work varies enormously in quality but he was a good businessman. He continued working until his death at the age of eighty-one, by which time he was the owner of the leasehold on three adjacent buildings in Upper Church Street, Chelsea, as well as collecting the ground rent of three further houses. George Bryan, the Chelsea historian, writing in 1869 recalls that 'he was considered to be one of the best animal portrait painters and was constantly employed every Smithfield Cattle Show, his work being highly prized'.

It is not known who Davis studied with, although Chelsea was an area much favoured by artists. John Francis and John Nost Sartorius lived close by, as did Philip Reinagle. Davis lived most of his life in Chelsea, taking on the lease of his father's house, 8 Church Lane, in 1811. The title of two paintings exhibited in 1832 and 1833 at the British Institution, *Italian Peasant, Costume of Sora* and the *Vineyard Gate near Rome,* and another work exhibited at the Academy in 1838, *A Spanish Shepherd boy and Sheep; Study from nature,* suggest he may have visited the Continent, as did many contemporary artists.

Davis began his career as a sporting artist, exhibiting portraits of hunters, hacks and greyhounds at the London Institutions. Some of his earliest exhibited works included livestock portraiture such as *Portrait of a Merino Ram, belonging to J. Fane, Esq* exhibited in 1814 and *Portrait of a favourite cart horse belonging to Mr H. Ledger* in 1813. He appears to have built up a successful practice as a sporting artist. His earliest patrons were drawn from all over the country and included Lord Rivers, the Earl of Ilchester, Lord Lynedock, the Earl of Chesterfield and the Marquis of Anglesey who he painted out shooting, mounted on a horse as he had lost a leg at Waterloo. His painting of *Colonel Newport Charlett's favourite Greyhounds out Exercising* (Colour Plate 110) shows his work at its best. It is a marvellous evocation of English country life: the hounds gambol at the feet of the groom's horse as they stretch out across the parkland and Hanley Court can be seen in the distance. It is something of a mystery why Davis decided to restrict his output from the late 1840s almost entirely to livestock painting and after 1849 he did not bother to exhibit at the Academy. One can only assume he

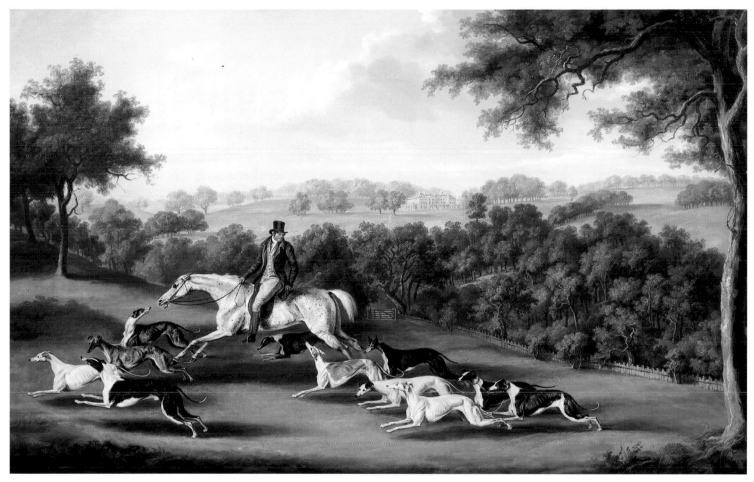

Colour Plate 110. *Colonel Newport Charlett's favourite Greyhounds at Exercise* by W.H. Davis, 1831. Oil on canvas, 47 x 72in. (119.5 x 183cm).
The greyhounds are depicted with their groom Tom Bayliss in the grounds of Hanley Court, Worcestershire. By the mid-19th century there were over 350 coursing clubs in existence; the sport had become so popular that the national Coursing Club was founded in 1858.
Courtesy of Richard Green

was so much in demand that he did not need other commissions. His reputation has suffered as a result of the many dull and mediocre but no doubt highly profitable cattle paintings he churned out.

Davis hit on a formula which clearly pleased his patrons. He placed his cattle outside against a spacious landscape, often with a farmhouse or group of buildings on the horizon and a little stream in the foreground. The animals turn very slightly towards the viewer. They are well painted but lifeless and have none of the charm of his predecessors Thomas Weaver or John Boultbee. As breeding records, however, they did their job perfectly and Davis returned to Wiscton to paint a different animal for Lord Spencer almost every year from the Earl's retirement from public life in 1834 to his death in 1845, executing eleven portraits from the Wiseton herd. An aquatint after his painting of Lord Spencer's Prize Ox which won at Smithfield in 1835 was published in 1836. He painted predominantly Shorthorns followed by Herefords which reflects the fashion of his time for these were the animals gaining most of the prizes at the Agricultural Shows. From 1851-59 he executed thirteen portraits of Lord Berwick's prize Herefords which are still at Attingham Park. The most interesting of these shows John Nash's villa Cronkhill in the distance. During the second half of the nineteenth century the estate was heavily encumbered and the Berwicks were forced to close Attingham and live at Cronkhill.

127

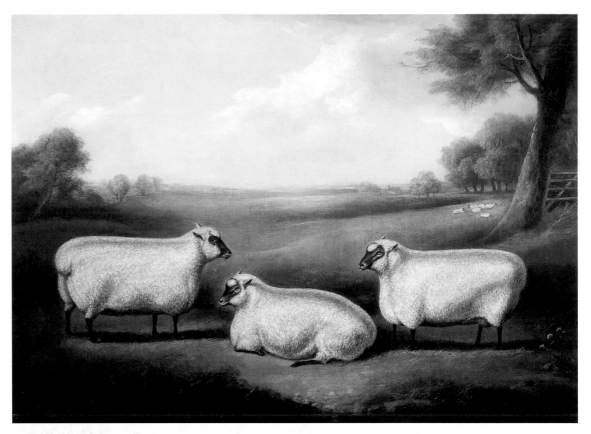

Colour Plate 111. *Three sheep in a Landscape* by W.H. Davis, 1861. Oil on canvas, 22 x 30in. (55.9 x 76.2cm).

The hazy and indistinct background is typical of Davis' livestock painting although the sheep are well observed.

Collection of
Mr and Mrs Robert Levine

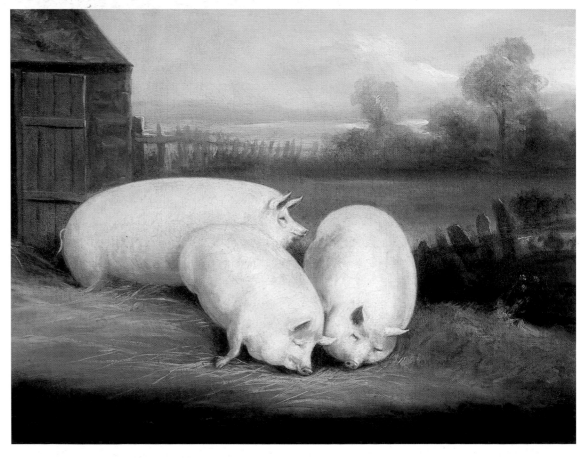

Colour Plate 112. *Three prize pigs* by W.H. Davis, 1855. Oil on canvas, 14 x 18 in (35.5 x 45.7cm).

Davis' pig portraits have far more charm than his cattle paintings. Considering what a competent artist he was he could have painted with a much greater observation and sense of place. No doubt the standard of painting reflects the level of commission and the price paid.

Private Collection

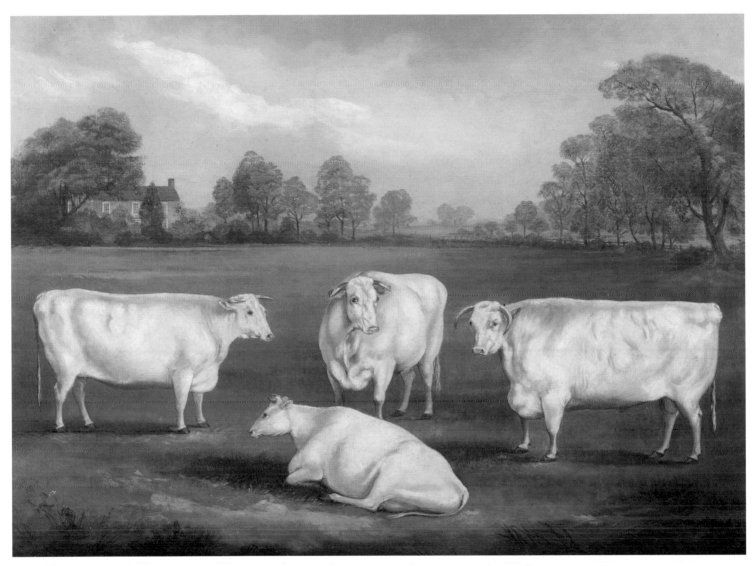

Colour Plate 113. *William Gibson's Triplet Shorthorns* by W.H. Davis, 1853. Oil on canvas, 34 x 44in. (86.5 x 112cm).
Three of the animals were produced at one birth and belonged to William Gibson of Kirkby Green, Lincolnshire. The fourth is presumably the mother. Collection Ms Madge de Wycke, Shropshire

Davis' paintings of sheep and pigs are more interesting and at times amusing. In these he took trouble to produce an interesting composition (Colour Plates 111, 112 and 220). He has some difficulty in painting pigs convincingly in a variety of poses. They never seem to lie very confidently on the ground and there is no sense of space between them, but they have a charm and decorativeness lacking in many of his cattle paintings. Davis was a competent portrait painter as his portrait of *Thomas Coke and Clerk Hilliard Esq inspecting his Devon Ox* (Plate 83) demonstrates and he portrays rural characters with considerable charm. Davis also worked in watercolour and was an accomplished lithographer. From 1827 onwards he produced lithographs, mainly of Smithfield Show winners, and engravings were also done after his work. After 1834 his prints are sometimes inscribed 'Animal Painter to his Majesty' and, after the death of William 1V, 'Animal Painter to the Queen Dowager'. He exhibited a watercolour, *Portraits of two Arab Horses, presented to his Majesty William IV, by the King of Oude*, at Suffolk Street in 1836 and executed four livestock portraits for Queen Victoria, *A Devon Bull,* 1854, *Three Fat Pigs,* 1853, *A Hereford Bull,* 1854, and *A Devon Bullock,* 1854. Prince Albert's ledger records a payment on 30 April 1855 to W.H. Davis of £16 for 'Portraits of Prize Cattle etc.'

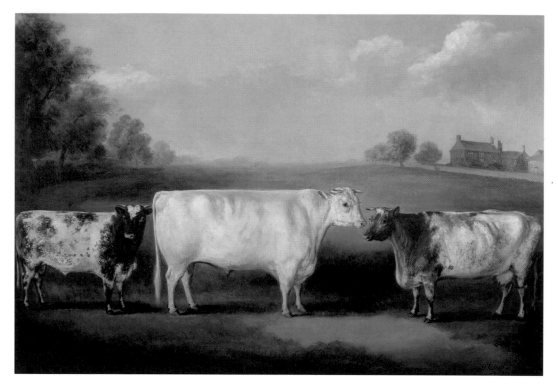

Colour Plate 114. *Two Shorthorn Bulls and a Cow* by W.H. Davis, 1857. Oil on canvas, 28 x 37in. (71 x 94cm).
From the Collection of Mr and Mrs Gary Gross

Davis must have secured a lucrative retainer from the *Farmers' Magazine* for which he recorded prize-winning animals from 1835 until his death. They are rather dull black and white engravings, the majority being of Shorthorn and Hereford cattle. Other livestock artists who produced illustrations for the magazine include Henry Strafford and E. Corbet. Several other livestock paintings and prints are known by these artists, but almost nothing about their lives. Strafford was the proprietor of *Coates' Herd Book* for Shorthorns, which was the first breed to establish official records, in 1822. Together with A.M Gauci, another animal painter best known for his prints, he executed most of the illustrations for the series although W.H. Davis also contributed a few.

Richard Whitford, a Worcestershire artist, must have known and worked alongside Davis for the first part of his career. He continued working up to the mid-1880s and was one of the most prolific livestock painters of this period. Whitford was intended for a career as a customs and excise officer but in 1848 he lost his job on charges of misappropriating 5s.3d. duty paid by a tobacco dealer. He returned to his native Evesham, where his father had been a hairdresser, with his wife and family and took up the profession of an artist. He was presumably largely self-taught, but had already gained some proficiency as a painter for he is recorded as executing a portrait of George Hudson on his hunter 'Swop', in which he collaborated with Thomas Woodward who painted the animal's head and 'some other parts of him'. An undated painting also exists signed R Whitford and W Widgery in which Widgery, the Exeter animal and landscape artist (Colour Plate 115), had painted the landscape and Whitford the sheep. Whitford clearly found it difficult to make ends meet. Before receiving his share of his father's estate in 1859 he was asked to account for an advance of £30 and any other sums of money paid on his behalf. He spent the last years of his life in lodgings, indicating he had no capital.

Almost all of Whitford's extant work is of livestock portraiture, although a sale held at Hampton House in Evesham which belonged to Henry Workman, the local solicitor in 1889, records seven paintings by Whitford including *Girl at the Spring, Keeper's Daughter (after Frith and Ansdell), Highland Shepherd boy and dog* and *Deer Stalking*. His descendant Andrew Sheldon has catalogued and recorded 174 of his paintings. Based in the Cotswolds, the great sheep breeding area of England, sheep figure prominently in his work, especially the Shropshire, Cotswold and Oxford Down breeds. He also painted many Herefords which

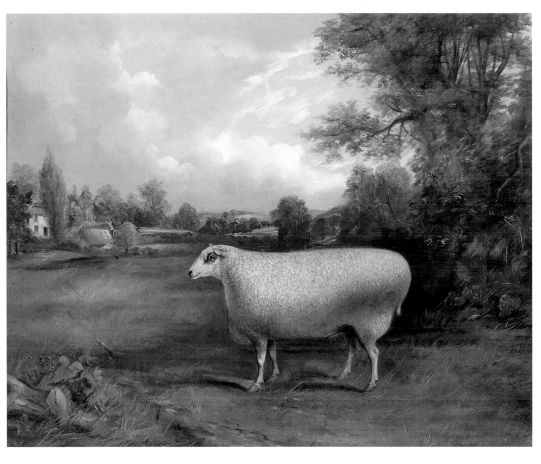

Colour Plate 115. *'Symmetry' – A prize Ram* by W. Widgery, 1858. Oil on canvas, 25 x 30in. (63 x 76cm).
Inscribed: Symmetry – *Winner of the Bath and West of England Society's 1st Prize at Cardiff June 1858.*
Theo Onisforou, K.O. Angus Stud, Australia

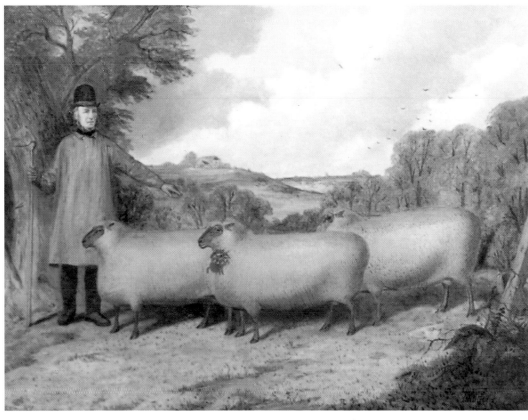

Colour Plate 116. *A Shepherd William Parker and Prize Winning sheep* by Richard Whitford. Oil on canvas, 21 x 27in. (53.3 x 68.6cm).
William Parker was the shepherd at Crabbe Hall, Burnham Market, Norfolk. He had fifty-four lambing seasons on the farm where John Overman and his son John Robert Overman were tenant farmers. It is part of the Holkham Estate. The shepherd was the key man on these farms. He brought out the shearling rams at the annual sales and those attending were expected to drop a shilling in his purse. Private Collection

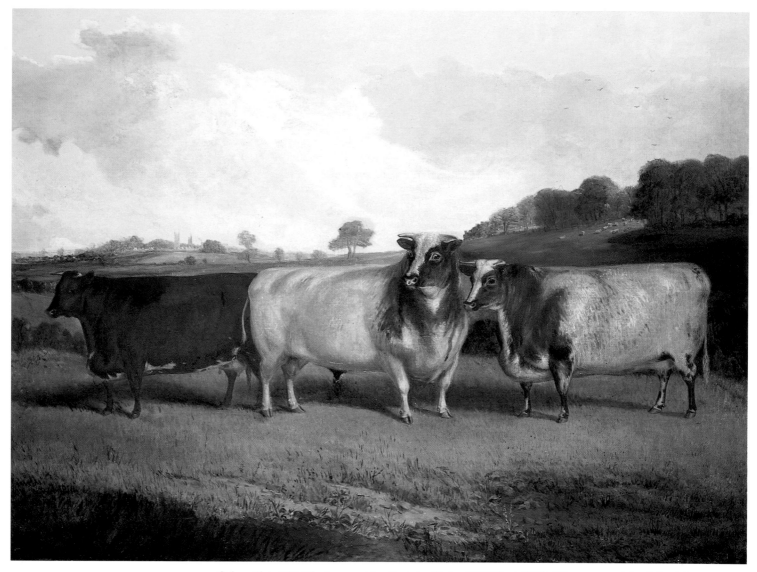

Colour Plate 117. *The Approaching Train* by Richard Whitford, 1870. Oil on canvas, 35 x 46in. (89 x 116.8cm) George Garne's prize Shorthorn bull 'Butterfly 9th' is shown in the centre with two cows, 'Duchess of Townley' and 'Pride of the Heath'. Churchill church is seen on the hill on the left and Churchill Heath Farm with a flock of Cotswold sheep on the hill on the right. In 1848 the Great Western Railway was opened between London and Cheltenham. Churchill Heath was situated close to Kingham Station. As the bull heard the engine's whistle he would look up to see the train coming round the corner. Thanks to his proximity to the station George Garne was able to show his pedigree Shorthorns all over the country and stock breeders came from all over the world to Churchill Heath.

Richard Garne

flourished in the West of England. Whitford's earliest known dated works are two horse portraits painted in 1855 and the following year he painted a Hereford bull. A large part of his clientele were the local gentry such as Edward John Rudge, for whom he painted the *Riding Party at Evesham Manor,* and middle-class farmers such as the large Garne and Lane families (Colour Plates 117, 121 and 223) who carried off most of the top prizes for Cotswolds in the '50s and '60s, and George Fletcher of Shipton Sollars (Colour Plate 119). Whitford's business card states that he was a member of the RASE and the Smithfield Club. He was at the RASE show at Chester in 1858 and appears to have travelled to the annual shows all over the country as well as the Smithfield Christmas show until the 1880s where he would have competed with W.H. Davis and John Vine for commissions. Whitford's card also describes him as a 'Portrait and Animal Painter'. While no portraits of people on their own are known, he frequently

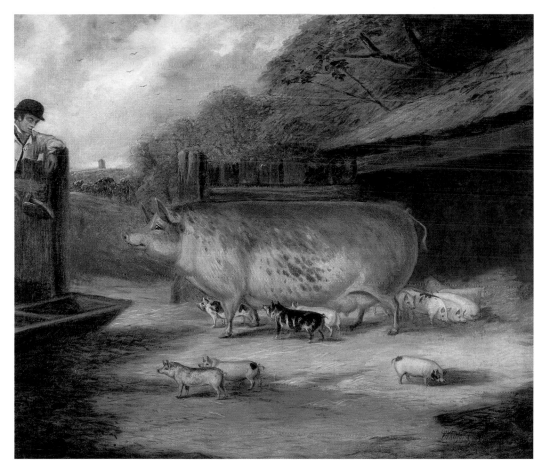

Colour Plate 118. *Salley the Sow* by Richard Whitford, c.1860. Oil on canvas, 20 x 24in. (51 x 61cm).
Inscribed: *Salley the Sow Geo. Hoddinott of Kites Nest, Worc.*
Whitford appears to have specialised almost entirely in livestock painting. His works are very thinly painted; there is often a distant spire on the horizon and his figures appear wooden. His best works are a marvellous evocation of a vanished way of life epitomised by the great farming families of the Cotswolds.
Collection of Janet Parker

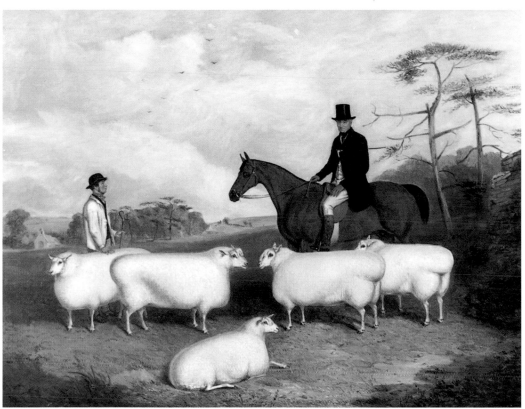

Colour Plate 119. *George Fletcher of Shipton Sollars with five Cotswold Sheep and Shepherd* by Richard Whitford, 1861. Oil on canvas, 34 x 44in. (86 x 111.5cm).
Shipton Sollars church can be seen on the left and the Manor House where George Fletcher lived is hidden behind the trees. Private Collection

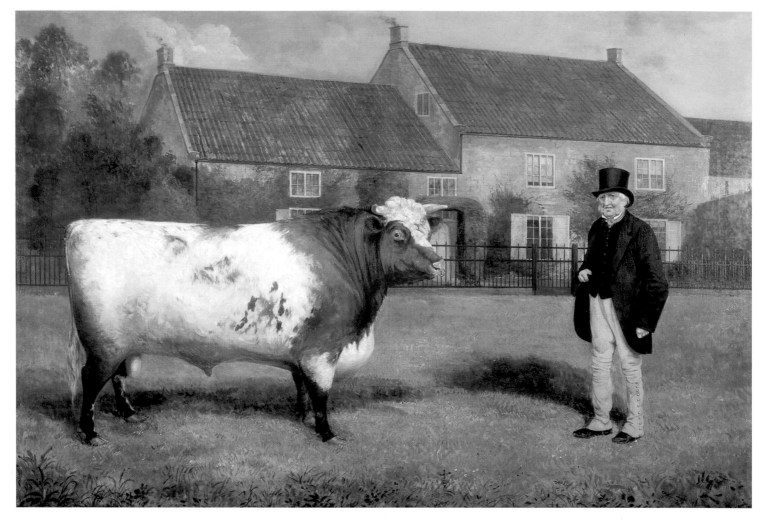

Colour Plate 120. *Earl of Derby with Samuel Wiley at Spella Park Farm* by R.D. Widdas, 1875. Oil on canvas 30 x 43½in. (76.2 x 110.5cm).
Wiley farmed at Brandsby, Yorkshire. Born in 1777 he lived into the late 1870s and was ninety-two years old when the Earl of Derby won 1st prize at the RAS in 1869.
Collection of Mr and Mrs William Pencer

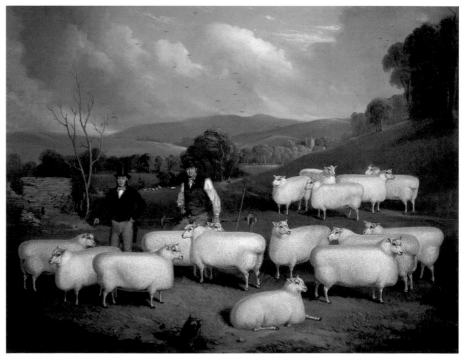

Colour Plate 121. *A Flock of Cotswold Sheep with their Owner William Lane of Broadfield Farm, Northleach* by Richard Whitford, 1861. Oil on canvas, 40 x 50in. (102 x 127cm).
William Lane was famous as a breeder of Cotswolds. His mother was Jane Garne. The Garne and Lane families were the two principal farming families in the Cotswolds and intermarried through several generations. These sheep won a prize at the Royal Show in 1861. Northleach tower can be seen in the distance. Maximilian Von Hoote

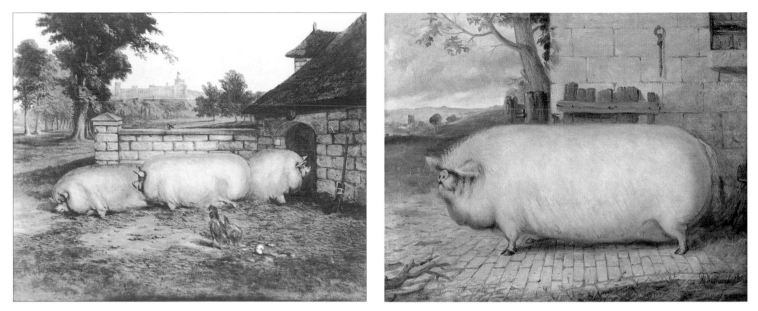

Plate 54. Photograph from Redgrave's Inventory of the Royal Collection showing *Three fat Pigs with Windsor Castle in the Background,* the original by Richard Whitford, 1864. Oil on canvas, 20 x 24in. (51 x 61cm). This is the painting referred to in the *Evesham Journal.* The pigs took first prize and silver medal at Birmingham and first prize and gold medal at the Smithfield Show, 1863. Whitford has taken a great deal of trouble over his royal commission and has included a view of Windsor Castle in the distance.

Royal Collection © 1996 Her Majesty The Queen

Colour Plate 122. *A Prize Middle White Sow in a Sty, 1882* by Richard Whitford. Oil on canvas, 14 x 18in. (35.5 x 45.7cm). Private Collection

incorporated them into his livestock paintings. These ruddy farmers and shepherds are vigorously drawn with a good degree of characterisation.

Whitford had very few aristocratic patrons, the exception being Viscount Falmouth, for whom he painted a portrait of 'Narcissus', a Devon bull, and there is only one known print of his work, *The Great Northamptonshire Short Horn,* published by Day & Son in 1866. His work turns up in the houses of farming families rather than stately homes, unlike his contemporary W.H. Davis who had many aristocratic patrons. It is therefore rather surprising that he executed several commissions for Queen Victoria and from 1862 signed himself 'Animal painter to the Queen'. None of Whitford's paintings survives in the Royal Collection, although according to records Queen Victoria owned five paintings by him of pigs, a Devon bullock, a Hereford ox, a Shorthorn heifer and 'Rose', a chestnut filly. Photographs of most of these are extant. She also owned two hand-coloured photographs after his pictures of oxen, one of which was the Tillyfour Ox, painted for Mr McCrombie of Tillyfour, Aberdeen, in 1868. Painted between 1861 and 1865, like Keyl's pictures his oil paintings all hung at Shaw Farm, Windsor.

Two of these royal commissions were recorded in the local paper, the *Evesham Journal & Four Shires Advertiser.* The pigs are illustrated in Plate 54 but there is no record of the Norfolk Polled painted for the Prince of Wales.

One of the pictures which Mr Whitford of Evesham, has been honoured with the commission to paint for the Queen may now be seen at the office of the 'Evesham Journal.' The subject of the picture is a group of pigs which took first prize and silver medal at Birmingham, and first prize and gold medal at the Smithfield Show, 1863. The picture though not quite finished, well supports Mr Whitford's high reputation as an animal painter. It will remain on view only a few days and immediately on completion will be sent to Windsor. March 12 1864.

And again:

We are pleased to observe that our townsman, Mr Whitford, amongst other commissions, had the honour to receive instructions to paint the portrait of No.171 the first prize Norfolk polled ox (exhibited at the meeting of the Smithfield Club) for his Royal Highness the Prince of Wales.

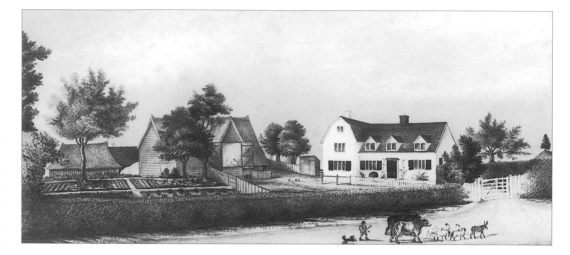

Plate 55. *An Essex Farm* by John Vine. Watercolour and pen and ink on paper laid down, 8 x 14¼in. (20.7 x 36.2cm). An example of Vine's early topographical work.

Private Collection. Photograph Courtauld Institute of Art

Whitford's paintings epitomise the late Victorian phase of livestock painting. There was still enough demand for him to earn a living, albeit a fairly paltry one, in this highly specialised trade. Though not a first-rate painter, his work is fairly consistent in quality and his animal paintings have enormous charm. He placed them against a generalised landscape setting evocative of the Cotswold countryside with its rolling hills. His work is thinly painted, especially the distant landscape which often has a windmill or church spire on the horizon. He applied thin glazes to build up the texture of the animals' coats. A pollarded tree, a stream running across the foreground, a bucket with the owners' initials on it and birds flying across the sky are all recurrent motifs.

In 1881 Whitford moved into lodgings in Cheltenham and when his landlady moved to London in 1885 Whitford moved with her, living in north London until his death in 1890. In 1885 the signature on his paintings changes to a monogram. Andrew Sheldon has suggested that the monogram is an R set in a monogram of H W for his son, Harry Sheldon Whitford, also an animal painter, and that the later paintings may have been executed by Harry or in collaboration with him.

Plate 56. *'Master Vine'*, unknown artist. 6¾ x 3¾in. (17 x 9.5cm).
As a child Vine may have been exhibited as a curiosity. This print would suggest that he executed small drawings for his audience.

British Museum

Plate 57. A photograph of John Vine taken by Ernest Mason, a Colchester photographer, who died in the 1920s.

Colchester Museum

Colour Plate 123. *Two children with cats and a kitten* (detail) by J. Vine 22 x 17½in. (55.9 x 44.5cm). This is typical of Vine's delicate watercolour portraits. Private Collection

Another important provincial livestock artist was John Vine who began by painting a variety of subject matter for a local clientele. However, the arrival of the railways coupled with his growing reputation as an animal painter meant that he was able to travel all over the country to attend the agricultural shows. Vine had to overcome considerable handicaps to become a successful artist. He was born with only very rudimentary arms and legs, similar to a Thalidomide victim, and as a child may have been exhibited as a curiosity in fairs around the country. A print of c.1820 shows him as a little boy holding a brush and a finished picture (Plate 56) which suggests that he executed small drawings for his fairground audience.

Vine was born in Bury St. Edmunds, his family moving to Colchester soon after where his father was a market gardener. Despite his disability he married a Colchester girl and used to wear a cape to hide his deformity. He was presumably self-taught and began by working in watercolour, executing charming portraits – horses, dogs and topographical scenes – all of a local nature. His earliest dated work is a watercolour of two terriers, *Prince and Vick, the property of T. Blyth of Colchester, 1834.* An undated watercolour showing an Essex farm (Plate 55) may be an earlier work since it is almost childlike in handling. A portrait of two children with their three cats (Colour Plate 123), although undated, is typical of his work at this period; he has trouble with the perspective of the table and the anatomy of the kitten. Any such

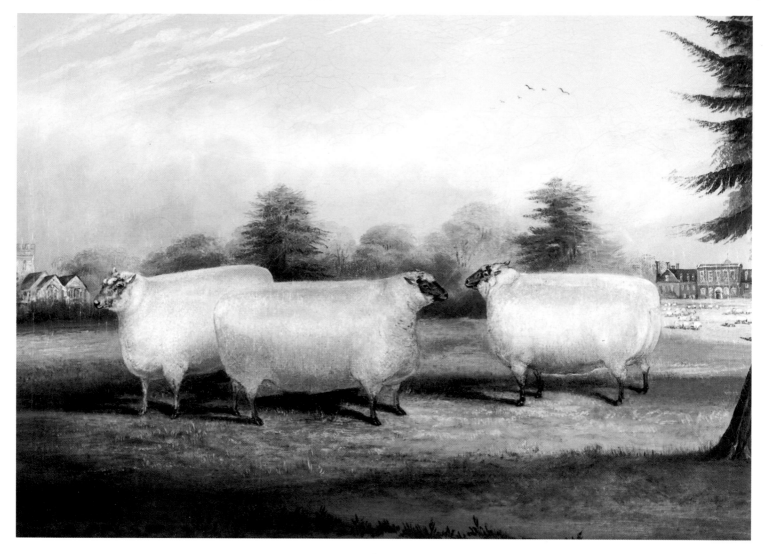

Colour Plate 125. *Three sheep in front of Gosfield Hall, Braintree, Essex* by John Vine, 1844. Oil on canvas, 20 x 24in. (51 x 61cm).
The sheep in this painting may well be Southdowns which at this date had very little white hair covering their dark faces.
Private Collection

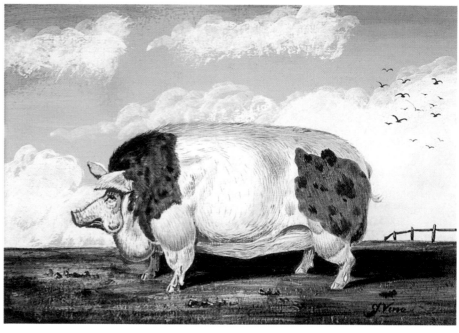

Colour Plate 124. *Prize boar in a landscape* by John Vine, 1850. Oil on board, 5 x 7½in. (12.7 x 19.2cm).
Vine's work varied in quality according to the level of the commission. Such crude examples may even have been executed as signs or advertisements.
Private Collection

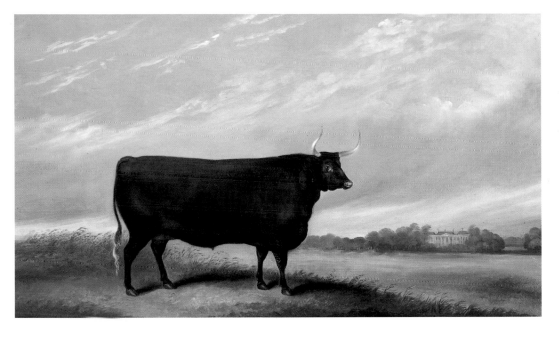

Colour Plate 126. *Devon ox bred by the Rt Hon Lord Western.* Oil on canvas, 1843. 19 x 31½in. (48.3 x 90cm). Inscribed: *painted from nature by J. Vine 1843.*

Charles Western (1767-1844) succeeded to his father's estates at Rivenhall, Essex on reaching his majority. Two years later he purchased Felix Hall, Kelvedon. He served as an M.P. from 1790-1833 becoming a mouthpiece for the agricultural movement. He kept numerous breeds including Devon cattle, Merino and Southdown sheep and Essex pigs. He was elevated to the peerage on his retirement from Parliament. Felix Hall appears in the background.

Lawes Agricultural Trust. Rothamsted Experimental Station

Plate 58. *Sketch for Lord Western's Devon Ox* by John Vine. Pencil on paper, 3½ x 6½in. (8.9 x 16.5cm).
Lane Fine Art

deficiencies are amply compensated for by the charm of the painting and the delicate sense of colour and handling of the paint.

By the 1840s Vine had an established practice in livestock and equestrian portraits in oil and watercolour as well as continuing to paint portraits and topographical scenes such as *The Phillips Children* in Colchester Museum. Vine's work varies enormously in quality which suggests the social status of those who commissioned them. *A prize boar in a Landscape* (Colour Plate 124) is extremely primitive and such paintings may have been butchers' signs or executed for cottage farmers. When he was working for the local gentry such as Lord Western of Felix Hall (Colour Plate 126), who also commissioned works from the young Landseer, or Mr Barnard of Gosfield Hall (Colour Plate 125) and Mr Fisher Hobbs of Boxted Lodge, he

Plate 59. *Sketch for for Mr Seabrook's Shorthorn* by John Vine, 1861. Pencil on paper, 3½ x 6½in. (9.9 x 16.5cm). Vine executed his finished oil paintings from a brief sketch done on the spot. He must have worked fairly quickly. His backgrounds are generalised with the same recurring motifs unless he was executing a painting such as Colour Plate 125 where the patron's seat is included.

Lane Fine Art

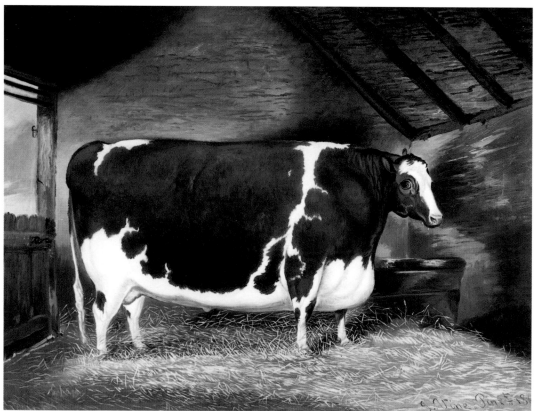

Colour Plate 127. *Shorthorn Steer* by John Vine, 1861. Oil on board, 19 x 23in. (48.3 x 58.4cm).
The animal belonged to William Seabrook of Spittals Farm, Tolleshunt D'Arcy, Maldon in Essex.

Private Collection

produced works of high quality, often including the breeder's house in the background. E.G. Barnard was typical of the local Essex gentry for whom Vine worked. He was at one time Member of Parliament for the Greenwich constituency, having made a fortune from building ships in his yards at Deptford and Greenwich. He lost a lot of money investing in railways and vowed he would never travel by rail and never did. He died insolvent at Gosfield in 1850. During his time at Gosfield Hall, he became very interested in the breeding of animals, particularly sheep. He bred Merinos and showed Southdowns at the Royal Show for most of the 1840s.

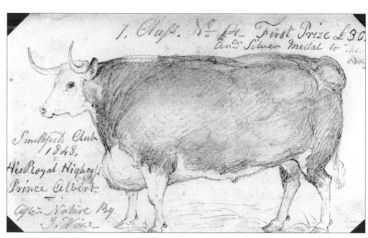

Plates 60 to 63. Pages from John Vine's sketchbook. Pencil on paper.
3½ x 6½in. (8.9 x 16.5cm). Lane Fine Art

Plate 60. *Lord Western's Neapolitan Pig.* Lane Fine Art

Plate 61. *Prince Albert's Hereford Bull* which won First Prize of £30 and
silver medal to the breeder at the 1848 Smithfield Club Show.
Lane Fine Art

Plate 62. *Mr Fisher Hobbs Improved Essex Pigs* which won first prize at
Harwich April show in 1864. Lane Fine Art

Plate 63. *A Shepherd
with his dog*, 1866.
Lane Fine Art

One of Vine's sketchbooks survives. There are a few sketches for paintings done in the 1840s
and '50s pasted into the front of the book but most of the pages date from the years 1860-64.
Some travelling expenses are also entered for the years 1865 and 1866. Over four years there
are sketches for over ninety animal paintings, many of them annotated with details of where
the animals were exhibited and the prizes they gained. This small sketchbook gives us an idea
of the huge quantity of livestock portraits which must have been produced during the Victorian
period. During the 1850s and '60s Vine attended most of the RASE and Smithfield Shows; he
was also at the Islington Horse Show in 1864 and the Great International Dog Show held in
Islington in 1863. Pasted into the book are complimentary passes issued for the Royal Shows
at Canterbury and Battersea in 1860 and 1862 respectively. More than three hundred prizes
were awarded at the RASE shows so even though he would have been competing with artists
like Whitford and Davis for clients, they offered enormous scope and enabled him to extend
the geographical range of his patronage dramatically.

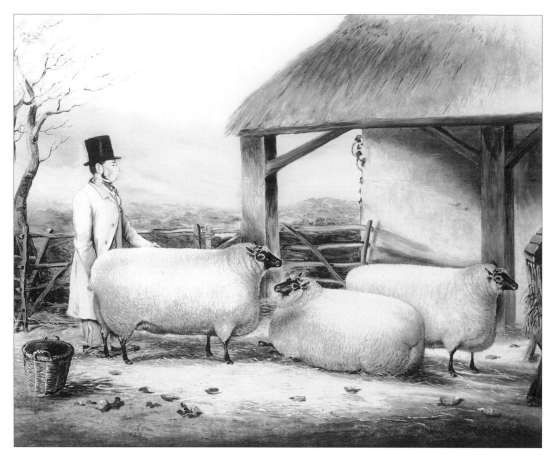

Plate 64. *A Gentleman Farmer with his sheep* by John Vine. Oil on canvas, 20 x 24in. (51 x 61 cm).
Inscribed: *Class 23, 181 RASE. 1853.*
This shows many of Vine's characteristic details. The figure is stiff but painted with great care, leaves and turnips are scattered in the foreground and the background is painted with thin glazes. Private Collection

The 1862 RASE show was held in London as part of the World's Fair and was amalgamated with the Royal Highland Society's Show normally held annually in Scotland. It also included a foreign section which made it truly international in style. Over six hundred prizes were awarded that year and one of Vine's clients was a Frederick Homeyer from Mökow, Pomerania, who won a first prize gold medal and a second prize silver medal for his Spanish Merino sheep and requested three copies of his painting. Vine occasionally adds the word Colchester to his signature since his paintings were spread far and wide and he wished potential clients to know where he could be found. During the last decade of his life he seems to have made a living almost entirely from livestock and animal painting. There are a couple of letters pasted into the sketchbook for the purpose of establishing his credentials. One from the Duke of Marlborough expresses his 'great surprise at the production of such an excellent picture by one labouring under such disadvantages'. Another fragment of a letter from an unknown client declares; 'it is the very character of a '<u>Short Horn</u>', and very like her, there is not a man in England could have made a better sketch for the purpose I am perfectly satisfied with it… You can beat Davis [the artist W.H. Davis] as far as I am able to judge so far – .' In a letter dated April 1860, Mr Fisher Hobbs declares himself 'so much pleased with the 2 portraits which you took of my Prize Boars last week that I wish you to send me another copy of each one of them as good and correct as the last.' He adds as an afterthought, 'I want them to take into Yorkshire next week, therefore let me have them on Saturday.'

Vine must have executed his paintings fairly swiftly. He made a quick sketch on the spot from which he painted the oil painting, probably in a studio. The sketches do not include any background details and unless he was painting a particular location he used a stock repertory of motifs. Swirling clouds and incidental details such as a flock of sheep in the distance, a basket of turnips, a rustic fence or shed and a few scattered leaves in the foreground are typical Vine motifs. An account for the RASE show at Battersea in 1862 suggests that he was still executing small watercolour portraits at this date; a Ram is entered at only £2 and Sadler Pig

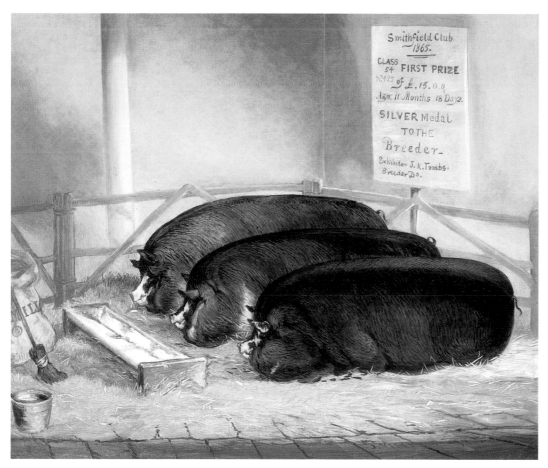

Colour Plate 128. *Three Berkshire pigs* by John Vine. Oil on canvas, 20 x 24in. (50.8 x 61cm).
Inscribed: *Smithfield Club, 1865, class 54, no 425. First prize of £15. 0 Age 11 months, 18 days. Silver medal to the breeder. Exhibited J K Tombs.*
John King Tombs of Langford in Lechdale, Gloucestershire, was a prominent breeder who commissioned several pictures of prize-winning animals. Despite his physical handicap Vine travelled all over the country visiting the agricultural shows where he would have met the artists W.H. Davis and Richard Whitford.

Iona Antiques

at £2.2s. Mr and Mrs Simpson, sketches for whose elaborate paintings appear in the book, were charged £58.6s. The prices of frames are also noted, a maple and gold frame costing £17 and a large gold frame £18.

While Vine appears to have painted very few human portraits during these years, an undated advertisement, probably from about 1860, describes him as 'J Vine Portrait and Animal Painter'. The remaining advertisement is worth reprinting.

J Vine
Portrait And Animal Painter
In gratefully acknowledging the very liberal and extensive patronage he has received for upwards of 30 years, begs to inform the Nobility, Gentry, Clergy and the public, that he continues to follow his profession in all its branches, with every improvement in the Art, at his residence Maldon road, COLCHESTER- N.B. Mr Vine attends any Commission throughout the Country Sporting Pictures. Frames of every description. Old Paintings cleaned and re-framed.

A *Gentleman Farmer with his Sheep* (Plate 64) shows Vine at his best. The painting is full of his characteristic details. The farmer has turned out in his smartest coat and top hat, even his buttons have been painted and an extensive landscape is suggested in the distance. When exerting himself for his best patrons, Vine's paintings still have a primitive quality, especially in the way he paints the figures. Although he was compared to W.H. Davis, he never achieved quite the same echelons of patronage as Davis with his more sophisticated London background was able to secure. His animals, especially his pigs, are full of character and his cattle seem to fix the viewer with a watchful eye. Anatomy was not his strongest point, although a drawing of a horse's skeleton in his sketchbook shows he was aware of its importance.

Edwin Frederick Holt was a more academic artist who turned to livestock and farming subjects in mid-career. Holt studied at the Royal Academy Schools and for a time had a studio

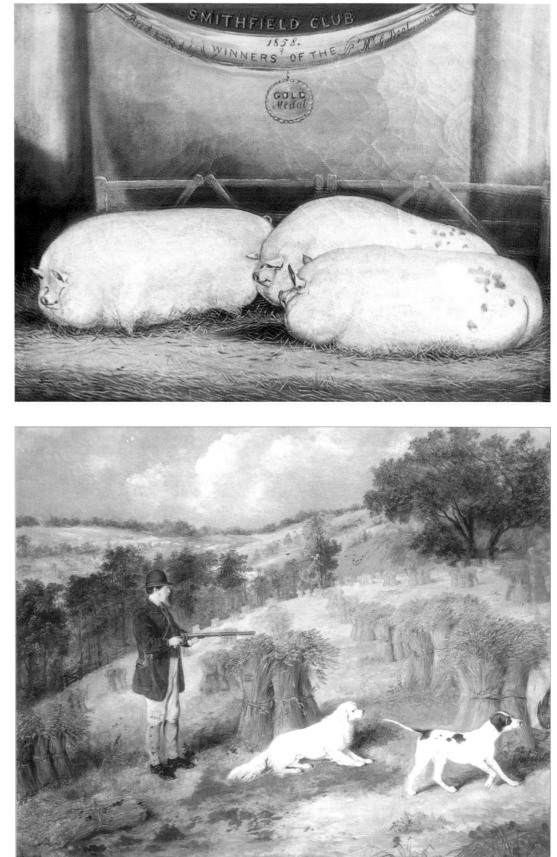

Colour Plate 129. *Three Prizewinning Pigs* by John Vine, 1858. Oil on canvas, 18 x 24in. (48.3 x 61cm). Bred and fed by Mr G. Beal, these pigs won a gold medal at the Smithfield Club Show in 1858. Vine acquired commissions from breeders all over the country by travelling to the different agricultural shows.

Private Collection

Plate 65. *A Sportsman with a Pointer and a Setter out Shooting* by Edwin Frederick Holt, 1865. Oil on canvas, 25 x 29½in. (63.5 x 74.9cm). Sporting and livestock painting was only a small part of Holt's *oeuvre*. He regularly exhibited complex narrative and mythological subjects at the Royal Academy.

Photograph Christie's Images

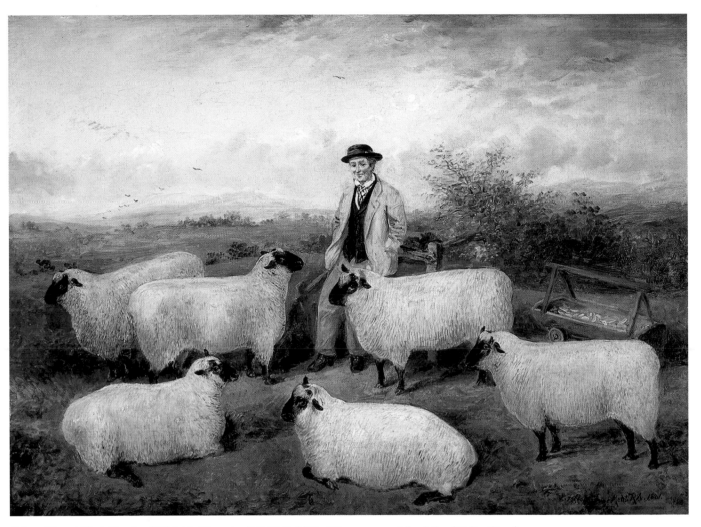

Colour Plate 130. *A Shepherd With his Sheep* by E.F. Holt, 1881. Oil on canvas, 18 x 24in. (45.7 x 61cm).
Holt may have taken up livestock painting to finance his peregrinations around the countryside.

Private Collection

in Camden Town, but lived most of his adult life in Dunstable. He was a promising young artist who in 1854 was awarded the Academy's silver medal for 'Painting from Life'. For three decades he exhibited a wide range of subject matter at the London Institutions including narrative, mythological and history subjects as well as portraits. Many of these are large scale compositions of complex figure groups with a rather ponderous and laboured subject matter. Holt also undertook sporting and animal commissions which he appears to have kept separate from his exhibition work and these, such as *A Sportsman with a Pointer and A Setter Shooting Pheasants in a Corn Field* (Plate 65), have more charm. Holt also executed a number of landscapes in the Dunstable region.

At some stage the artist went to Paris, returning with a French mistress with whom he toured England, Scotland and Wales for an undefined time before returning to his wife in Dunstable. He supported them both by his paint brush and during the 1880s and 1890s his paintings include subjects set in Wales and Scotland as well as rural scenes from all over England. His peregrinations about the countryside may well have drawn him to rural scenes and brought him into contact with farmers who wanted livestock portraits. A painting of Prize Suffolk sheep executed in 1887 (not illustrated) shows that he was attending an agricultural fair at this date. Holt's livestock paintings have considerable charm; he took care to compose attractive compositions and added interesting background details (Colour Plates 130 and Colour Plate

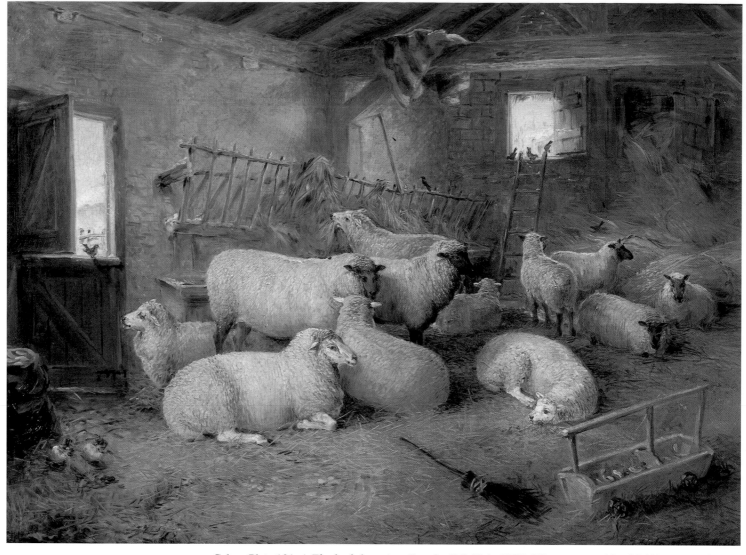

Colour Plate 131. *A Flock of sheep in a Barn* by E.F. Holt, 1887. Oil on canvas, 18 x 24 (45.7 x 61cm).
In his later work Holt adopts a more sentimental narrative approach typical of much of Victorian farm animal painting.
Private Collection

227). Around the late 1880s his style appears to change. His earlier rural scenes have a clarity based on carefully selected detail and a sense of real places and things. In his later work this gets swamped by indiscriminate detail and a Victorian sentimentality reminiscent of the late work of J.F. Herring Senior (Colour Plate 131).

Many other Victorian livestock painters were provincial artists for whom livestock painting was just one aspect of their stock in trade. The Newport artist James Flewitt Mullock established his reputation for animal painting through the forum of the Annual Tredegar Agricultural Show organised by the local landowner, Sir Charles Morgan. In 1836 Sir Charles commissioned J.H. Carter to paint the *Presentation of a Shorthorn Bull to King William IV by Sir Charles Morgan, 2nd Baronet of Tredegar* (Colour Plate 132), and this example may have acted as a stimulus to the show's wealthy patrons and competitors to commission further paintings. At the show's formal dinner in 1851, a toast was made to 'the health of Mr Mullock, the artist, by whose skill many of the finest beasts exhibited at the Tredegar Cattle Show were

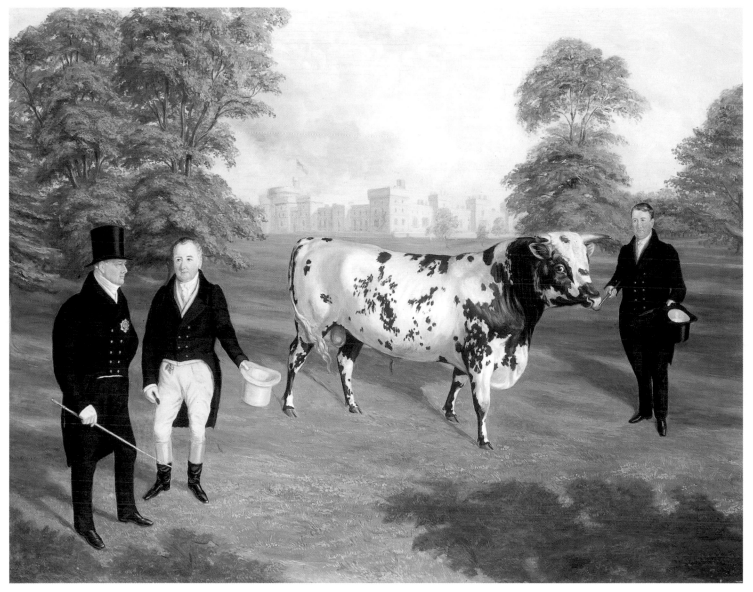

Colour Plate 132. *Sir Charles Morgan, Bt presenting his prize Shorthorn bull to King William IV in the grounds of Windsor Castle* by J.H. Carter, c.1836. Oil on canvas, 28 x 36in. (71 x 91.5cm).
A print after this work is inscribed: *Portrait of a Short-horned bull Bred by Sir Chas. Morgan Bart. of Tredegar in the county of Monmouth, presented to him by His Majesty William IV, April 1836. John Engal, who was bailiff to George III, George IV and William IV holds the bull.*
The king stands talking to Sir Charles Morgan on the left with Windsor Castle in the background. Carter (fl.1839-56) was an established portrait painter who exhibited regularly at the Royal Academy.

Courtesy Richard Green

perpetuated on the glowing canvas, and whose artistic ability had that day been called into requisition, to preserve in their remembrance the two wonderful animals exhibited by Mr. Homfray.'

Mullock's work is typical of many local artists. Largely self-taught, he executed topographical scenes, portraits and commemorative prints. The agricultural show offered a further outlet for his talents providing him with a steady stream of commissions for two decades. Many of his works were exhibited at the Newport Mechanics Institute which was

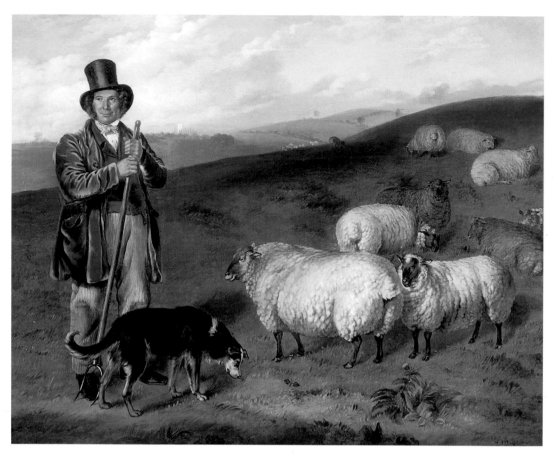

Colour Plate 133. *The Bailiff of St Julian's Farm with Ram Lambs, Southdown breed* by James Flewitt Mullock, 1845. Oil on canvas, 25 x 30in. (63.5 x 76.2cm).
Mullock was a local Welsh artist whose work depicts the community to which he belonged. Private Collection

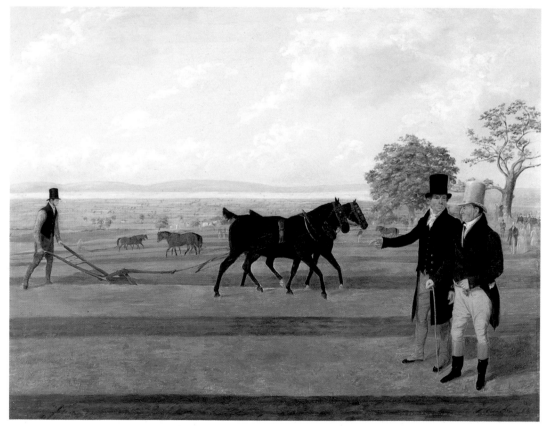

Colour Plate 134. *Sir Charles Morgan at the Castleton Ploughing Match* by James Flewitt Mullock, 1845. Oil on canvas, 25 x 29¾in. (63.5 x 75.5cm).
The placing of the figures on the right may well have been influenced by Carter's painting (Colour Plate 132).
Private Collection

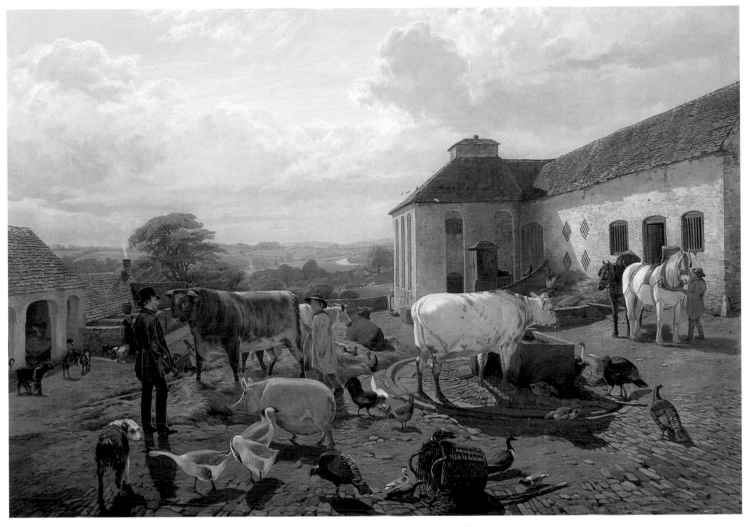

Colour Plate 135. *Capel Hanbury Leigh at the Home Farm, Pontypool*, unknown artist. Oil on canvas, 27½ x 39½in. (70 x 100cm).
Capel Hanbury Leigh was a neighbour of Sir Charles Morgan and a frequent exhibitor at the Annual Tredegar cattle show where he carried off many of the prizes. This painting is a marvellously detailed observation of the farm and its animals. The buildings are still standing. (See also Colour Plate 81.)

Sir Richard Hanbury-Tenison

dedicated to the educational reform of the working classes. Mullock's livestock paintings include Hereford and Glamorgan cows and a painting entitled the *Bailiff of St. Julian's Farm with Ram Lambs* (Colour Plate 133). These were bred by John Lloyd, proprietor of the King's Head Hotel, and typify his local circle of patronage.The silver goblet won by the rams at the 1845 show is still extant. Ploughing competitions were still popular and the Castleton Ploughing Club introduced an annual Castleton Ploughing Match in order to promote the latest machinery. Mullock's painting of the event (Colour Plate 134) records the visit of the elderly Sir Charles Morgan to watch the proceedings. Such paintings were a celebration of local life and events. They depict real people and animals about their business and have a freshness and vigour absent from much Victorian painting.

Over the border in Shropshire, William Gwynn of Ludlow began his career as a portrait painter and topographical artist before being commissioned to paint horses, dogs and prize cattle by several local landowners in the 1830s and '40s. Principal among his patrons was Mr

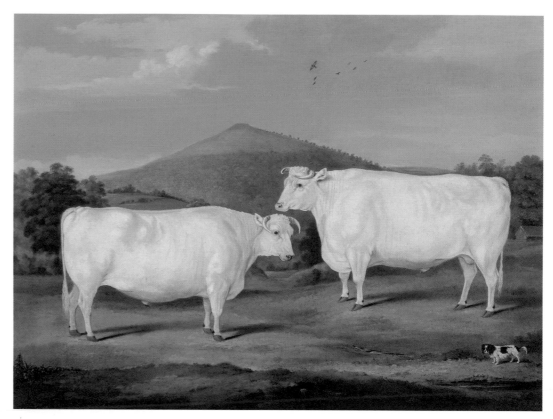

Colour Plate 136. *Twin Oxen* by William Gwynn, 1845. Oil on paper laid down on canvas, 30 x 39in. (76.2 x 99cm). Inscribed: *Bred and fed for J Ackers Esq, MP for Ludlow.*
Gwynn may have received some training and exhibited at the Academy. His detailed style is almost that of a miniaturist. Private Collection

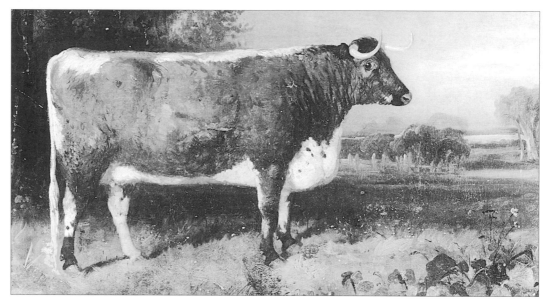

Plate 66. *A Longhorn cow* by Thomas Woodward, 1830. Oil on canvas, 12 x 22½in. (30.5 x 57cm).
Woodward executed only a few livestock portraits which form a contrast with his more sentimental genre scenes.

The National Trust, Chastleton House

J. Ackers, Member of Parliament for Ludlow, who lived at Prinknash Park, near Painswick in Gloucestershire, whose white oxen (Colour Plate 136) he recorded in a number of paintings. He executed cattle portraits for other local patrons, a painting of a Hereford with Ludlow Castle in the background is known, and there is print of a Shropshire pig after a painting by Gwynn (Colour Plate 137). He also executed sporting and equestrian scenes including views of Ludlow Racecourse and a portrait of Thomas George Henley, near Ludlow, with his race horse 'Little Thought of', published as an aquatint. In the late 1830s Gwynn painted a number of horses and dogs which may depict the countryside around Henley Hall.

His topographical scenes are executed with a delightful attention to detail. *North-east view*

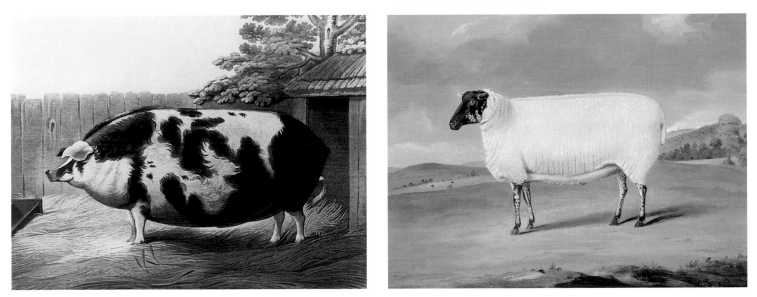

Colour Plate 137. *Shropshire Pig* after William Gwynn engraved by W. Wright, n.d. 10½ x 14in. (26.7 x 35.5cm).
Inscribed: *The portrait of a Shropshire pig. The property of Sir. Chas. Willm. Rouse Boughton, Bart. of Downton Hall, near Ludlow. Age 1 year & 10 months. Weight 33 score 15 lbs. W. Gwynn delt. W. Wright sculpt. Published by W. Gwynne, Corve Street, Ludlow* Rural History Centre. University of Reading

Colour Plate 138. *A prize ewe in a Landscape* by William Gwynn, 1842 . Oil on tin, 12 x 16in. (30.5 x 40.5cm). This may be an example of a Beulah Speckled face sheep. Its live weight was 206lb.
Collection of Mrs Robert F. Croll

of Ludlow (illustrated Lloyd and Klein, 1984) includes what is probably a self-portrait of the artist sketching with his wife in the foreground. He was evidently much in demand as a local portrait painter; a number of portraits survive in the Ludlow area, executed with the same naïve charm. His highly detailed style was also well suited to painting portrait miniatures. Nothing is known of his education; his father John is described as a labourer but listed as a tenant in a spacious timber-framed house in Corve Street, Ludlow, suggesting the family was reasonably prosperous. Gwynn spent several years in London, where his eldest son was born in 1812, and exhibited portraits at the Royal Academy between 1807 and 1817. He moved back to Ludlow in the 1830s continuing to paint mainly portraits, miniatures and equestrian scenes. His technique was excellent and he painted on a number of different materials including vellum, canvas, tin, mahogany or zinc panel. He had a fine sense of colour and his work survives in pristine condition.

There were several animal painters who worked in the Gloucestershire, Worcestershire area but there does not appear to have been any strong connection between them. Thomas Woodward was a friend of Landseer and like the young Landseer he spent his youth sketching farmyard animals. He was apprenticed to Abraham Cooper and lived for a time in London, but his indifferent health and fondness for hunting and the countryside probably drew him back to his native Worcestershire. Livestock painting did not form a very large part of Woodward's output which consisted more of sporting horse and dog portraits and rural genre scenes. His earliest exhibited work at the Academy, however, was a *Portrait of a Cow, the Property of — Booth Esq* suggesting livestock portraiture may have been a useful step towards establishing his career.

The Longhorn (Plate 66) is well painted and shows Woodward's feeling for landscape. He was a successful artist commissioned by Queen Victoria and Prince Albert to paint their horses during the 1840s; other patrons included the Duke of Montrose, the Duke of Newcastle and the Earl of Essex. His livestock paintings provide a contrast with his more sentimental rural genre scenes such as *Rural Courtship* (Plate 101), although the horses in this are very well

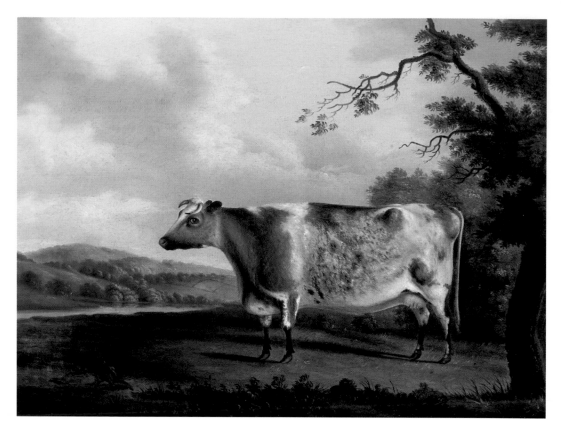

Colour Plate 139. *A Shorthorn bull from Lord Spencer's herd* by E.F. Welles. Oil on canvas, 20¼ x 24¼in. (51.4 x 61.5cm).
From the Collection at Althorp

observed. *Dumpling* is a portrait of his brother's cart-stallion (Plate 67). Despite its rather sketchy finish it is a frank portrait of an honest farm horse; the farmhouse can be seen tucked away in the distance.

E.F. Welles worked for a time in Worcester and may have known Woodward. By a coincidence both artists painted the same prize ox at the Smithfield Show in 1842. Welles was a Hereford breeder and executed four of the illustrations for the first Hereford herd book in 1846. He was clearly an artist of some stature for he painted cattle belonging to Lord Spencer at Althorp (Colour Plate 139) and Thomas Coke at Holkham. Welles exhibited regularly in London and in 1835 published a set of twenty-five etchings of sheep and cattle after his own work.

Another Gloucestershire artist was John Miles of Northleach. Details of his life have still to be researched but he signed his work Northleach and his painting of a Ploughing Match includes a view of Northleach with its church tower in the distance. He painted several portraits of prize animals, including *A Gloucester Old Spot Pig* (Colour Plate 140), as well as dog portraits. He must have had a lively imagination and specialised in anecdotal rural scenes such as an old cart-horse chasing his executioner

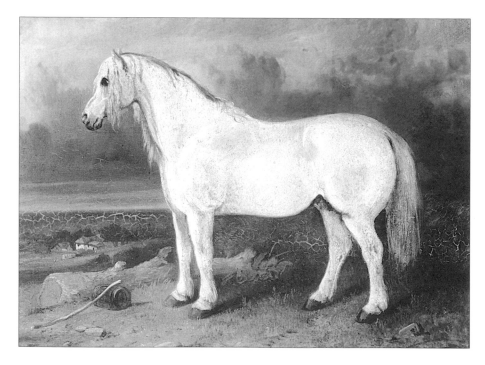

Plate 67. *Dumpling* by Thomas Woodward, 1843. Oil on canvas, 14¼ x 17¾in. (36 x 45cm). Private Collection

Colour Plate 140. *Gloucester Old Spot Pig* by John Miles, 1834. Oil on canvas, 21 x 27½in. (53.3 x 68.9cm).
Inscribed: *A Spot Pig Bred and fed by Wm. Painter of Northleach. aged 7 months.*
Courtesy Gloucester Folk Museum (Gloucester City Council)

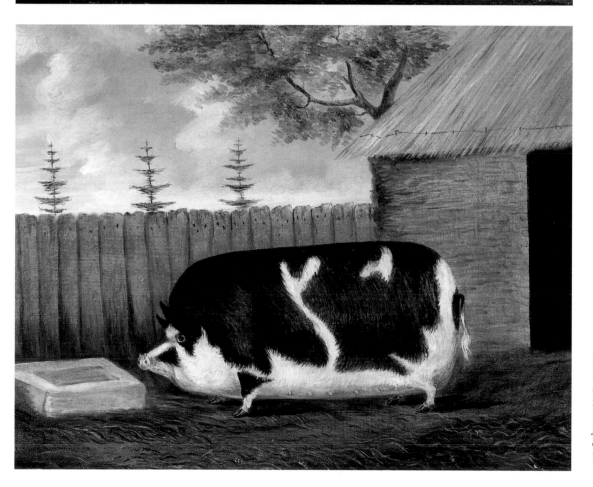

Colour Plate 141. *A Fat Pig* attributed to John Miles. Oil on canvas, 18 x 22in. (45.7 x 55.9cm).
Inscribed: *A Fat pig, bred and fed by Mr C Gillett of Sherborne, near Northleach and weighed score 38 and lbs 11.*
Private Collection

Colour Plate 142. *A Surprising Incident* by John Miles. Oil on canvas, 16¼ x 21¼in. (41 x 54cm).
Inscribed: *An instance never known before. On July 1811: A Butcher went to the seat of Thos. Willan Esq. at Farmington near Northleach, Gloucester to kill an Old Cart Horse After he had stuck the Horse, the man employed to hold it dropt the halter. The Horse immediately ran at the Butcher, who took to his heels, and after several turns in the field, they entered the rick-yard. The Butcher being an Old man and quite exhausted, fell between the Ricks. The Horse caught at him (but luckily missed) and fell to upon a mare. In a few minutes the man of Blood, assisted by a fear, crept softly away not to disturb the pleasuer till it was quite dead.*
The British Folk Art Collection, Peter Moore's Foundation

Opposite above. Colour Plate 143. *Naming the animals* by John Miles. Oil on canvas, 34½ x 47½in. (88 x 121 cm). Miles has attempted an extremely ambitious composition, way beyond the scope of most provincial painting. The subject must have fired his imagination; he has painstakingly depicted an incredible range of species which he could never have hoped to see.
Photograph courtesy of Sotheby's

Opposite below. Colour Plate 144. *A Farmer with his Cotswold Sheep* by James Loder, 1841. Oil on canvas, 23 x 30in. (58.5 x 76 cm).
Loder worked in the Bath area as a provincial sporting and animal painter.
Collection of Marlo Thomas and Phil Donahue

(Colour Plate 142) or an ox spit-roasted at a summer fair. Miles' most impressive work, of which he painted several versions, is his *Adam Naming the Birds and the Beasts* (Colour Plate 143). It may well have been based on a Flemish engraving of the subject but Miles made it peculiarly his own depicting the animals, birds and tiny beasts with charm and sympathy.

John Miles is typical of dozens of nineteenth-century provincial painters whose work is now scattered far and wide and whose lives and output remain to be documented. Their work varies in quality from artists like James Loder of Bath (Colour Plate 144) and G.B. Newmarch

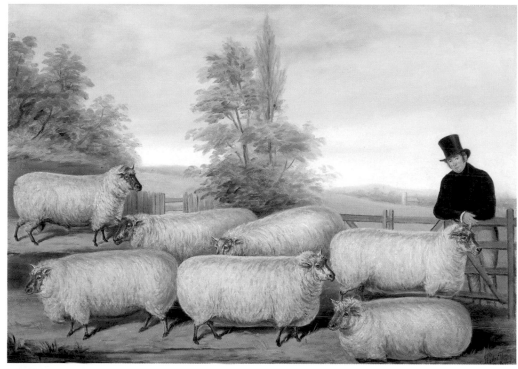

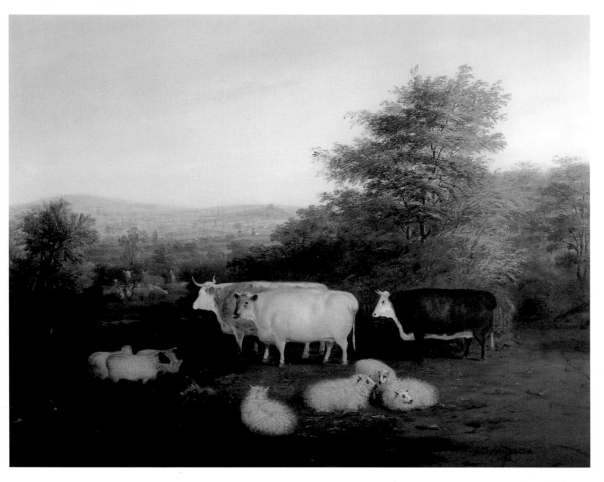

Colour Plate 145. *A pastoral scene with herdsman and dog* by G.B. Newmarch, 1855. Oil on canvas, 25 x 30in. (63.5 x 76cm).
Newmarch worked mainly in the north country and Scottish borders. His work has a detached naïve quality which places him with the earlier painters rather than his contemporary Victorian painters. Private Collection

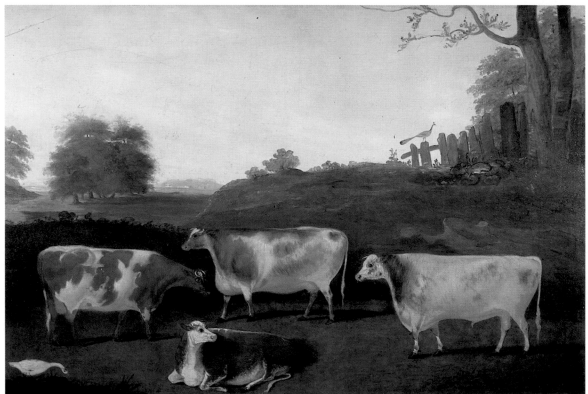

Colour Plate 146. *Four prize cattle in a landscape* by G.B. Newmarch, 1830. Oil on canvas, 28 x 41in. (71 x 104cm).
Collection of Judy and Joel Weiner

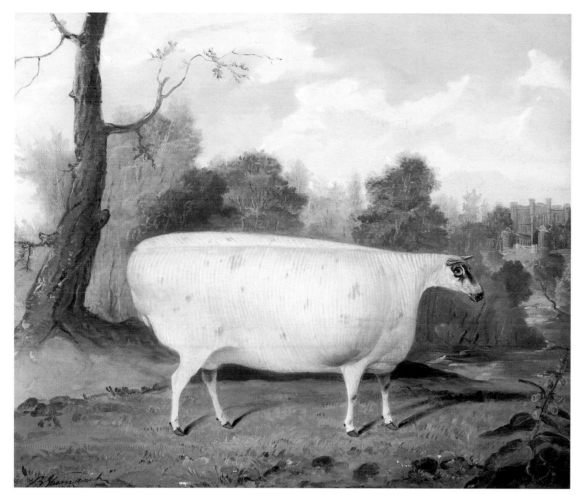

Colour Plate 147. *A Prize Ram* by G.B. Newmarch, 1835. Oil on canvas 16 x 20in. (40.5 x 51cm).
Private Collection

Colour Plate 148. *The Durham Steer* by Austin Neame of Canterbury. Oil on canvas, 23½ x 26in. (59.7 x 66cm).
Inscribed: *The Durham Steer, bred by Mr J Neame, of Selling, in the County of Kent which obtained a premium at the Kent and Canterbury Show Dec 14th, 1832.* Neame was a primitive artist from Canterbury specialising in animal portraits. The Neame family had lived in East Kent for centuries and are descended from John Neame, a tanner. Austin Neame was a cousin of Mr J. Neame of Selling. Iona Antiques

Colour Plate 149. *Prize Bullock with a boy* by I.H. Buckingham, 1857. Oil on canvas, 20 x 24in. (51 x 61cm). Private Collection
Co. Tipperary, Ireland

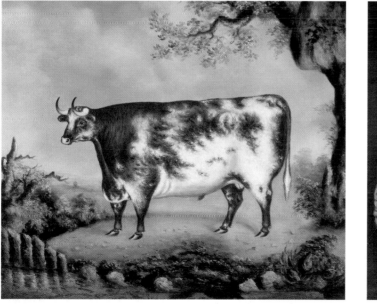

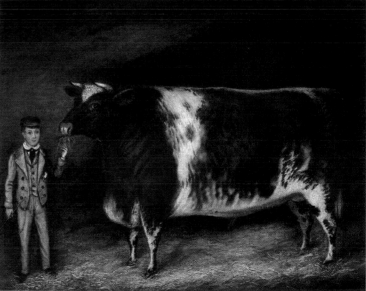

(Colour Plates 145, 146 and 147) who specialised in fine animal paintings to more primitive artists like Austin Neame of Canterbury (Colour Plate 148) and I.H. Buckingham (Colour Plate 149). Many of the images executed by primitive artists are unsigned. From a few that are, we

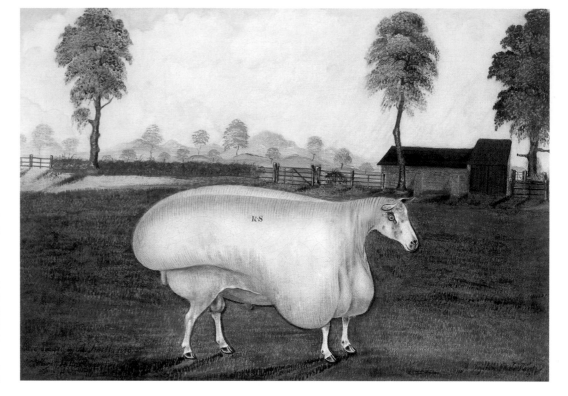

Colour Plate 150. *White Ram* by W. Bagshaw. Oil on canvas, 18 x 26¼in. (46 x 66.5cm).
Inscribed: *Bred and fed by R Smith, 1846 Weight 58 lb.*
The ram is branded R S for Robert Smith. Bagshaw was typical of the Victorian craftsmen for whom painting was a sideline. His ram is a deformed monstrosity but has a primitive impact almost heraldic in quality.

The British Folk Art Collection.
Peter Moores Foundation

know that the artists were sometimes employed in other professions with painting as a sideline. W. Bagshaw (Colour Plate 150) is listed in the Rugby directories as a plumber and glazier while John Whitehead (Colour Plate 151) was a licensed victualler at the Blue Bell in Moston, near Failsworth, Lancashire. Once photography and cheap mass-produced printed images were widely available the provincial public were less satisfied by the naïve images, with their lack of conventional space and proportion, produced by primitive painters. By the end of the

Plate 68. *Berkshire Pigs Advertising Thorley's Food,* lithograph by A.M. Gauci. Signed A.M Gauci, 1868, 24 St Stephen's Street, Tottenham Court Road, London. 12 x 19½in. (30.7 x 49.8cm).
Inscribed: *Berkshire pigs fed on food seasoned with Thorley's condiment. Age 9 months & 23 days. Bred and exhibited by John Treadwell, Esqr., of Upper Winchendon, Aylesbury, Bucks. 1st prize at Smithfield Club Show, 1867, Ist. at Aylesbury, and 1st. at Tring, the same year.*
Livestock painting was given an added impetus by food manufacturers requiring promotional material. Gauci designed a whole range of posters for Thorleys in the 1860s and '70s.

University of Reading, Rural History
Centre

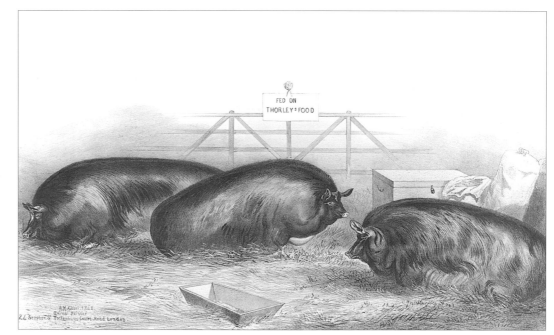

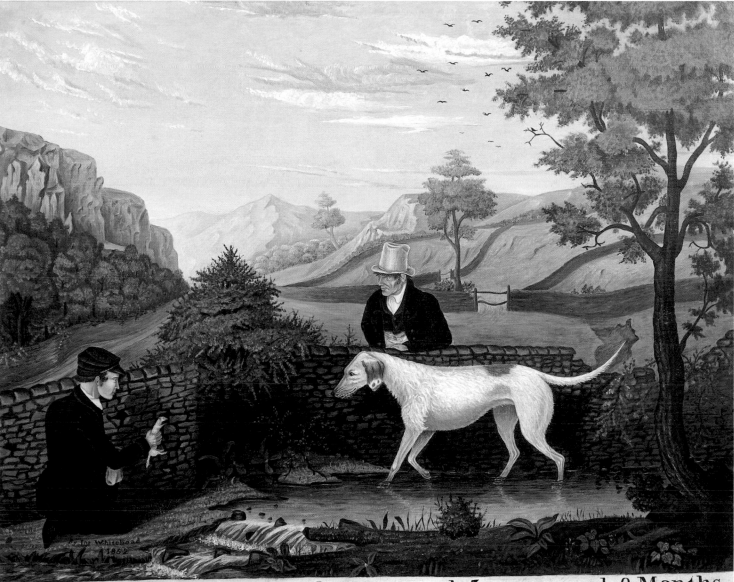

In Memory of NELL the rat-hunter, aged 3 years and 9 Months.

Colour Plate 151. *Nell, the Rat-hunter* by John Whitehead, 1852. Oil on canvas, 20½ x 25½in. (52 x 64.75cm).
Inscribed: *In memory of Nell the Rat-hunter Aged 3 years and 9 months.*
A Lancashire publican, Whitehead has produced a remarkable image of his local landscape.
The British Folk Art Collection. Peter Moores Foundation

nineteenth century, the tradition had almost died out. The genre was regarded as of no value and until its re-evaluation over the last thirty years was so neglected that sadly the vast majority of naïve painting has disappeared.

Photography did not have the dramatic impact on livestock portraiture one might have expected. Photographs of cattle from the Royal Herd are mentioned in Wallace's *Livestock* as early as the 1850s but these are an unusual exception. In 1877, the Queen began an album of hand-coloured photographs of her animals. Many of the photographs were taken by Hills and Sanders and coloured by Charles Burton Barber. Among the many dog portraits, her Suffolk stallion 'Renown', a Percheron horse and her Zulu cattle also appear (Colour Plate 152). Up

Plate 69. *Bovril Advertisement,* c.1885. Card advertisements started to appear around the middle of the last century and were extremely popular during the last two decades of that century. Similar advertisements were made in enamel for display outside and on tins and other forms of packaging. Card advertisements were used throughout the retail and manufacturing sector and would have been displayed in shops and company offices. After the late 1920s they were superseded by posters.

Beamish. North of England
Open Air Museum

to the 1890s, however, it was still more common to have prize animals painted than photographed. A clearly painted image could provide a more vivid and informative record of an animal than a hazy black and white photograph. Engravings and lithographs were used for newspapers and journals well into the 1890s. *The Agricultural Gazette* of 25 July 1874 discusses the relative merits of producing an engraving from a photograph or a painting (Plates 70 and 71). Two portraits of Mr Outhwaite's Shorthorn 'Royal Windsor' are published side by side, 'and we leave our readers to decide which is the truer and more life like'. The caption however suggests that, rather as in a botanical drawing, the engraving could actually provide more accurate information than the photograph. 'In the photograph of Royal Windsor the nose of the bull pulling against the ring is stretched, and thus in the engraving the portrait is a disfigurement of the animal at that point.' A letter from a reader published in the same issue

Plates 70 and 71. *Mr Outhwaite's 'Royal Windsor'* illustrated from a photograph and from a print in the *Agricultural Gazette* 25 July, 1874.
In the opinion of the editor the reproduction from the engraving produced a more accurate image of the bull.
Beamish. North of England Open Air Museum

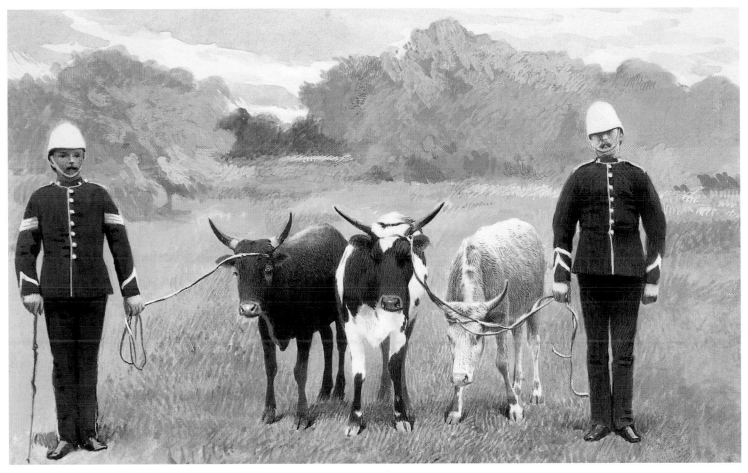

Colour Plate 152. *Zulu cattle from the Shaw Farm, Windsor,* photographed by Hills and Sanders, coloured by C. Burton Barber, c.1880. 3¾ x 5¾in. (9.5 x 14.5cm).
Inscribed: *Brought from Zulu land by Lord Wolsey and presented to the Queen by him April, 1880.*
Many artists and miniaturists were put out of work by the invention of photography. Hand colouring offered them an alternative means of employment. The Royal Collection © 1996 Her Majesty the Queen

gives us another indication why breeders continued to have their animals painted rather than photographed; the artist was kinder than the camera.

> I see that you wish to obtain the opinion of your readers upon your cuts of stock. If they are to be of any use, by all means let us have them as like the photo. as possible; never mind offending a few would be sellers, stick to the truth, to a hair. We can soon do the other thing for ourselves by going to the shop of some cattle food merchant, or by taking a brick and adding head and legs according to fancy, without you being at the expense of paying some enthusiastic artist for doing the same thing on paper'.

The reader goes on, 'I have often thought what a good thing the Smithfield Club could make by allowing some photographer the privilege of photographing the £100 winner. I should never leave the show without putting my name down for a copy.'

The Farmer's Magazine continued to publish engravings of animals rather than photographs until it ceased publication in 1881. This was obviously an important selling point as advertisements detailing the next print to be published appear in the *Mark Lane Express* during the 1930s. As photographic and tinting techniques improved, it was inevitable that photography would finally triumph. The *Livestock Journal* of 1891 includes three photographs for the six months from January to June. The majority of illustrations are still engravings and lithographs, many of them by the artist F. Babbage. Babbage continued to paint livestock portraits into the twentieth century and executed numerous illustrations for the *Livestock*

Plate 72. *Aberdeen-Angus Heifer Scottish Queen.*from a photograph by F. Babbage illustrated in the *Livestock Journal* 10 December 1897.
Inscribed: *The property of the Earl of Rosebery, K.G., Dalmeny Park, Edinburgh. Winner of Cup as best Cow or Heifer, and Reserve for Champion Prize, at the Smithfield Club Show.*
University of Reading. Rural History Centre

Plate 73. *Aberdeen-Angus steer Prince of Ethie* from a painting by F. Babbage, illustrated in the *Livestock Journal* 3 December 1897.
Inscribed: *The Property of Mr J. Douglas Fletcher, of Rosehaugh, Avoch, N.B. Reserve for Champion; Winner of President's Prize, and Messrs. Webbs Cup as Best Animal bred by exhibitor, Birmingham Fat Stock Show, 1897.*
University of Reading, Rural History Centre

Plate 74. *Mr Ernest Peacock From Garnthwaite with his Tup* photographed by Edward Albert Metcalfe c.1920. Photographers soon became adept at touching in to give the animals the best shape and proportions.

Beamish. North of England Open Air Museum

Journal, but from the late 1890s he undertook livestock photography as well as painting (Plates 72 and 73), demonstrating how improved photographic techniques gradually replaced painted portraits. Over the next few years the proportion of photographs used in the journal increased dramatically. *Country Life* commenced publication in 1897 and from the outset used only photographs of animals. Specialist photographers soon learnt how to 'improve' their photographs to produce the most flattering image (Plate 74). In Metcalfe's photograph taken in the 1930s he has touched in the backs of the sheep to make them appear flatter and straighter.

From the 1890s, the great age of livestock painting is over. Richard Whitford, the last of the important Victorian artists, died in 1890 and John Duvall, who was commissioned to paint a series of illustrations for the *Suffolk Stud Book* as late as 1888, died in 1892 (Colour Plate 153). However, the continuing limited demand for livestock painting, in particular for heavy horses

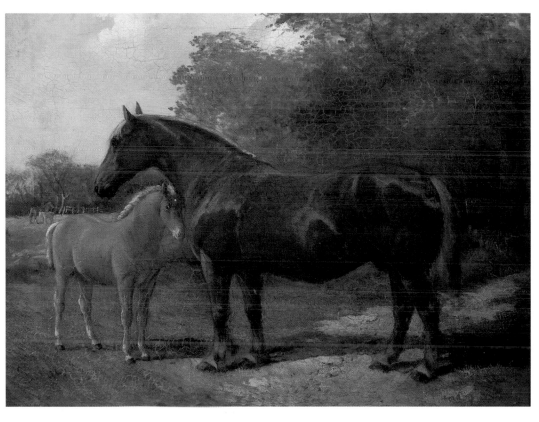

Colour Plate 153. *Scott and Vanity* by John Duvall. Oil on canvas, 16½ x 21½in. (42 x 54.5 cm).
Richard Garrett of Leiston had this picture painted two days before Scott foaled. He was so pleased with the foal 'Vanity' that her portrait was added to the painting when she was seven weeks old. Suffolk Horse Museum, Woodbridge, Suffolk

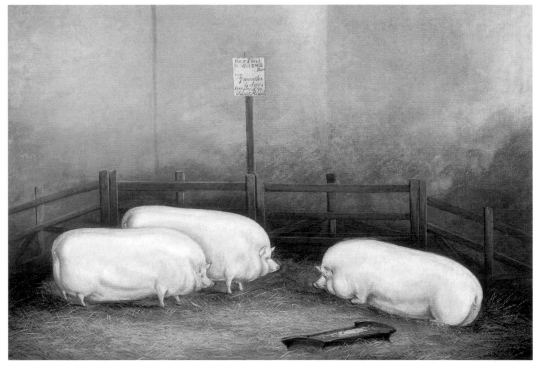

Colour Plate 154. *Three Middle White Pigs in a Pen* by James Clark, c.1860. Oil on canvas, 18 x 24in. (45.7 x 61cm). Inscribed: *Fed & bred by Sir J B Mill, Bart. Age 7 months 4 days. First Prize £10 silver medal.*
Several generations of the Clark family worked as animal painters. James appears to have been the eldest.
Private Collection

which fetched enormous prices early this century, kept the Clark family in business until the 1930s. Little is known about this family of sporting and animal painters which numbered some eight artists all working at the turn of the century. The eldest of them, James Clark senior, painted a variety of animal portraits from the 1860s to the 1890s (Colour Plate 154). He visited the agricultural shows and his paintings still have a nineteenth-century charm and quaintness

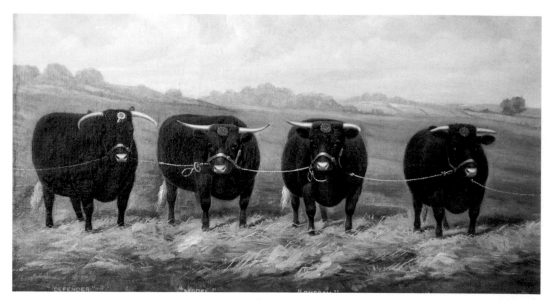

Colour Plate 155. *Defender, Model, Cherry and Coniger prize winners at Smithfield, 1935* by William Albert Clark, 1943. Oil on canvas, 15 x 24in. (38 x 61cm). Private Collection

which disappears in the work of the two elder members of the family, William Albert Clark (Colour Plate 155) and Albert Clark. Their portraits of Shire horses (Colour Plate 156) still appeal because they depict these faithful animals, no longer a part of our daily life. Their cattle portraits, however, lack the extraordinary proportions of their forebears and even the breeds are familiar – Guernseys, Jerseys and Friesians which by the 1930s were replacing the traditional British breeds. Painted with a Victorian realism, long outdated by the innovative techniques of the Impressionists, these later images have little artistic or historical interest.

The Modern British artist, Sir Alfred Munnings, provides a more interesting postscript. A contemporary of the Clarks, he had studied in Paris and was well aware of the artistic revolution wrought by the *plein-air* naturalism of the Impressionists. His fresh spontaneous approach, which captured the atmosphere of the racecourse or rural scene as much as the individual characteristics of the animals, brought a new dimension to animal portraiture. He was avidly taken up by the

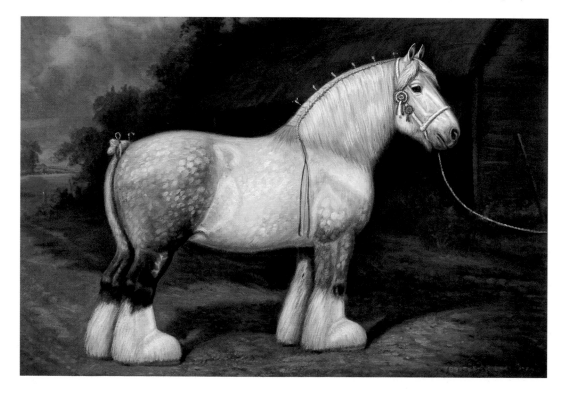

Colour Plate 156. *Shire horse, Erfyl Lady Grey* by William Albert Clark, 1928 Oil on canvas, 22 x 30in. (56 x 76 cm). The 21 Club, New York

Plate 75. *The Friesian Bull* by Sir Alfred Munnings, c.1920. Oil on canvas, 37½ x 50¾in. (95.3 x 129cm).
The bull is 'Ongar (imported) Vic Klaas', purchased in 1914 for 150 guineas by James Furze for his Ongar
herd. He was sold early in 1919 to Mr and Mrs Putnam for a high price. Putnam was a successful businessman
and a leading breeder in the 1920s. He paid very high prices to improve his Haydon herd in Buckinghamshire.
The 1920s were a boom period for the British Friesian. In 1911 the average price for a pedigree animal was
£20; in 1920 over 2,000 Friesians had changed hands for an average of £167.
 The Board of Trustees of the National Museums and Galleries on Merseyside (Lady Lever Art Gallery, Port Sunlight)

British racing and country house set. Like Sir Edwin Landseer, he gained a knighthood and was
offered the Presidency of the Royal Academy which he accepted in 1944. Munnings' *A Sow and
her Piglets* was painted while he was living in Cornwall in 1912. It depicts a long, lean White
Lop-Eared, vastly different in shape from the Victorian prize porkers. In terms of composition it
descends directly from nineteenth-century livestock portraiture, but what has interested the artist
is the changing colour of the animal's coat, wrought by the dappled sunlight filtering through the
woods, and the snuffling of the piglets as they root through the undergrowth.

The sight of a prize Friesian bull evoked a similar response. In Munnings' autobiography,
The Second Burst, he describes the incident:

> One morning we had the bull taken out. Seeing the heavy, slow-moving, black and white colossus
> led across the field was more than I could bear. The same afternoon, with the sun getting lower in
> the sky, I was at work on a large canvas. I still recall the picture of the placid docile beast passing
> by with low, ominous roaring – which was friendly talk – and slow, rhythmic movement, led by the
> attendant with a long pole fixed to a copper ring in its nose. Beyond as a background, the simple
> English land-scape – hedges, fields and hedgerows oaks, not yet hacked down.

The painting (Plate 75) was uncommissioned and took the artist a long time to sell. His
spontaneous appreciation of the magnificent beast provides a fitting epitaph to the artists who
150 years earlier were first called upon to record the novelty of the newly emerging breeds.

CHAPTER 4
Developments in Cattle Breeding

The Old English cow was neither a specialised milk nor meat producing animal as today. It had to provide milk and work as a beast of burden (for it was only in the late eighteenth century that horses began to replace teams of oxen in the plough). Only once it had come to the end of its life as a draught or milk-producing animal would it be fattened for slaughter. No attention was paid to breeding, and very little to the quality of feed. Cattle varied from region to region according to the local climate, terrain and fodder. They tended to be scraggy looking, big boned, long backed and wall sided. They took from four to six years fully to mature, needed long legs to roam far and wide for food, had to be strong enough to plough the heavy fields and tough and hardy to survive the winter months.

A wide range of types existed in the British Isles, but it was not until the nineteenth century that formal breeds with pedigrees and fixed characteristics were established. Scottish cattle included the Fife, Ayrshire, Galloway and shaggy Highland types. In the northern counties the roan Shorthorn and the wild white cattle of Chillingham (Colour Plate 157), by now one of the

Colour Plate 157. *Keepers Stalking the Wild Cattle at Chillingham Park* after J.W. Snow, lithographed by Hullmandel and Walton, c.1840. 21¾ x 27⅞in. (55 x 70.5cm).
The Chillingham cattle are reputed to be descendants of the wild cattle of the Romans. Their characteristic features – short white hair, black muzzle, white horns with black tips – have hardly altered over the centuries. White cattle once inhabited many of the parks of the British Isles but by the late 18th century they were almost extinct. Even so they were hunted for sport throughout the 19th century. See also Plate 12 and Colour Plate 101. University of Reading, Rural History Centre

Colour Plate 158. *The Holstein or Friesian Bull* by Thomas Weaver, 1806. Oil on canvas, 39 x 48¾in. (99 x 124cm).
Cattle from the Low Countries were among the first to be imported into the British Isles. They were used for crossing with native breeds on a limited basis and herds of Friesians did not arrive in Britain until after the First World War. The presence of red cattle, possibly Herefords, in the distance would suggest the Friesian bull was crossed with these. The famous Durham Ox was reputed to be bred from a black and white cow and Bewick's *History of Quadrupeds* includes an engraving of a Friesian. Photograph by courtesy of Frost and Reed Ltd.

few remaining wild herds in the country, were found. The Longhorn predominated in the Midlands, the Suffolk Dun in the county of its name, the Hereford with its distinctive white face in the West of England. In Wales the predominant colour by the eighteenth century was black, while in Sussex and Devon the cattle were a deep red.

Robert Bakewell started British farmers on the road to improvement which has led to today's intensive, highly specialised, farming industry. His principles underlie the entire development of British pedigree livestock which in turn gave rise to the tradition of farm animal portraiture. His techniques were applied to breeds all over the country and are therefore worth examining in some detail. Before Bakewell the only attempt to improve native British cattle had been the importation of 'pied' or broken colour cattle from Holland into Lincolnshire and Kent (Colour Plate 158).

Plate 76. *Longhorn Bull with Dishley Grange in the background* by John Boultbee. Oil on canvas, 17½ x 22½in. (44.5 x 57cm).

The painting, which still hangs at Calke Abbey, may have been acquired by Sir John Harpur Crewe (1814-1833). He bred Longhorns and was a great admirer of Bakewell's.

The National Trust, Calke Abbey.
NT Photo Library

These animals were larger and hardier and produced a higher quantity of milk; they also needed better food and care than the local breeds so standards of stockmanship were beginning to rise.

Bakewell selected a breed already well established in his own area, the Longhorn, and set out to breed an intensive meat-producing animal. He started with animals already improved with Dutch blood, purchasing two red and yellow heifers from a noted improver, Mr Webster of Canly near Coventry, and a bull from Westmorland. His improvements were based on the concept of selective in-breeding which followed a principle already established in the breeding of thoroughbred racehorses. He began his experiments in about 1760, going against the practice of the time which was to cross females of native stock with bulls of a different breed. No bull should be used on the same stock for more than three years as using the same line of parentage was believed to weaken the stock. Bakewell did the opposite; he bred not only from the same line but from the same parentage, putting mother to son, father to daughter and brother to sister. He believed there was only one best breed and by crossing it with others you adulterated it rather than improved it. We do not know exactly how his first improved Longhorns were bred. The details were probably kept secret because of the opposition he had to overcome. Such practices were considered immoral and contrary to the teachings of the church. One of his pupils, George Culley, wrote that 'some have imbibed the prejudices against Bakewell's breeding practice so far as to think it is irreligious.' Presumably, however, he began with animals as close to his ideal as he could find and bred them with similar animals to fix the characteristics he desired.

Bakewell had to overcome resistance to change not only in the way he bred his animals but in the way he fed and cared for them too. He established an extensive irrigation system and by flooding his meadows was able to obtain four cuts of grass a year. His neighbours actually believed that by flooding his grasslands he would poison his pasturage. He wintered his animals indoors, devising a special cattle shed which could house over 170 animals, and spread the resulting high quality manure on his fields to improve the winter fodder crops. Cattle are commonly depicted either in or beside a cowshed being fed on a diet of turnips or parsnips to indicate they have been reared in the new 'improved' manner. He showed an interest in his animals' welfare which was unusual for the time. William Marshall describes how his Longhorn bulls were so docile that they could be handled by children and one was even ridden (Colour Plate 159). In 1790 a visitor to Dishley noticed that one of his prize cows 'Old Comely at the age of 25 years, now lives in an asylum, a meadow full of keep, set apart to smooth her passage on earth, for in the slaughterhouse she is not to make her exit'.

Bakewell set out to change the prevailing characteristics of British cattle. He wanted an animal that was small boned because 'the smaller the bones the quicker it will fat', with the most weight in the valuable joints. He was focusing on an animal that would produce the most flesh on the least fodder in the shortest possible time and he was no longer interested either in milk production or draught power, believing 'all that is not beef is useless'. Arthur Young describes the ideal shape that Bakewell was aiming at:

…the belly, shoulder, neck, legs and head should be light; for if a beast has a disposition to fatten or be heavy in these it will be found a deduction from the more valuable points. It has been said, but improperly, that a barrel on four short sticks would represent the true form; but that shape swells at the top and bottom, whereas the back of a beast should be square, straight, and flat; or, if any rising, it should be from a disposition to fatten and swell about the rump and hip-bones.

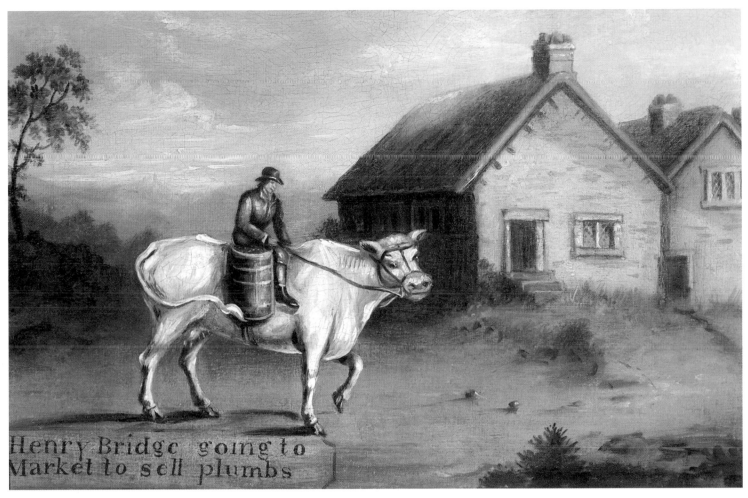

Colour Plate 159. *Henry Bridge Going to Market to sell Plumbs*, unknown artist, c.1820. Oil on canvas, 13 x 17in. (33 x 43cm).
Bakewell's bulls were so docile it was reputed that one was even ridden. This naïve painting is an extraordinary record of a farmer riding his cow to market to sell a basket of plums. Private Collection

Prize cattle paintings of the early nineteenth century fit this ideal (Colour Plates 161 to 164). The head is ridiculously small, the body cylindrical with a swelling rump and straight back and the short pin-like legs appear incapable of supporting the weight of these large beasts.

By Arthur Young's second visit to Dishley in 1785, Bakewell was breeding animals which had developed enormous masses of fat over the hip bones, around the tail head and on the ribs behind the shoulder. These animals appear disfigured and disgusting to us today and Boultbee's painting of a Longhorn at Calke Abbey (Plate 76) illustrates how far Bakewell's breeding experiments had distorted the shape of such animals. Conforming to Bakewell's idea, this animal is small boned, with small head and legs, a straight back, swelling rump and the most weight in the valuable joints. It also has the excessive deposits of fat around the hips and tail head for which Bakewell's animals were criticised. It is difficult to understand why such fat animals were desirable. They were not just objects of curiosity bred to fulfil the vanity of their owners. Fat was an important commodity just as it is in third world countries today where the hump of fat on the African cow is considered a delicacy. It was not uncommon to find as much as twelve inches of fat on the rib and nine inches on the rump (Colour Plate 160).

Colour Plate 160. *A Rib of Beef*, 19th century. Plaster model, 10 x 16 x 8in. (25 x 40.5 x 20.5cm).
The proportion of fat to meat on these chops would be totally unacceptable today.
 By kind permission of the Earl of Leicester and the Trustees of the Holkham Estate

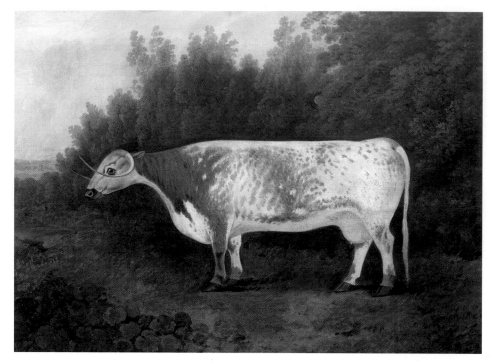

Colour Plate 161. *Spotted Nancy* by John Boultbee. Oil on canvas, 28 x 36in. (71.2 x 91.8cm).

The following group of Longhorns all come from Robert Fowler's herd at Little Rollright in Oxfordshire. Fowler was a close friend of Bakewell and developed his herd with the aid of Bakewell's breeding stock. He hired several bulls from Bakewell, including his famous bull 'Twopenny', and a bull called 'D', the grandson of 'Twopenny' who sired one of his most famous bulls, 'Shakespeare'. The dispersal of the Rollright herd in 1791 was the first cattle sale in the country where the animals had a documented pedigree. The prices fetched were roughly ten times greater than those for standard cattle. 'Spotted Nancy' sold for 80 guineas to J. Millington. Longhorns can vary enormously in colour but always have the characteristic white finching along their backs.

National Trust, Shugborough. NT Photo Library – John Hammond

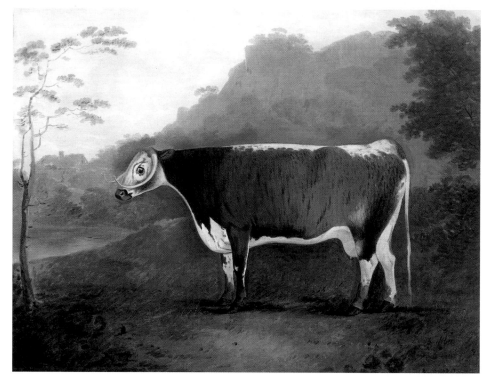

Colour Plate 162. *Brindled Beauty* by John Boultbee. Oil on canvas, 28 x 36in. (71x 91.8cm). 'Brindled Beauty' was by 'Shakespeare' out of 'Long Horn Beauty'. She was the star of Fowler's sale, selling for 260 guineas to Knowles and Co.

National Trust, Shugborough. NT Photo Library – John Hammond

Far more fat was eaten in the eighteenth and nineteenth centuries than today; it was an important source of carbohydrate. Bakewell's experiments were aimed at producing meat to feed the poorer urban working classes. So-called 'fat mutton' and 'fat beef' was a staple part of their diet. Fat mutton could be purchased for almost half the price of bacon and when salted and pickled for some time tasted very similar to it.. Fat was even more highly valued as a way of making tallow for candles and lamp oil. Wax candles cost three times the amount of tallow and only the very wealthy could afford them. The majority had to make do with candles made from a mixture of purified beef and mutton fat which tended to smoke and give off an evil

Colour Plate 163. *Garrick's Sister* by John Boultbee. Oil on canvas, 28 x 36in. (71 x 91.5cm).
She sold to Knowles and Co. for 115 guineas.
National Trust, Shugborough. NT Photo Library – John Hammond

Colour Plate 164. *Garrick* by John Boultbee. Oil on canvas, 24 x 30in. (61 x 76.1cm).
'Garrick' was the most expensive bull at the sale, fetching 205 guineas at five years old.
National Trust, Shugborough. NT Photo Library – John Hammond

smell. Tax records show that in the early nineteenth century more than a hundred times the weight of tallow candles was made than wax ones.

When you consider how limited communications were in the eighteenth century, Bakewell's experiments spread with astonishing quickness. He developed an animal that not only looked quite different but was ready for slaughtering within two years instead of five or six and could produce double the amount of meat of a nondescript cow. A comparison between the average weight of sheep and cattle sold at Smithfield market in 1710 and 1795, the year of Bakewell's death, reveals how effective his experiments were. In 1710 the average weight for beeves was

Colour Plate 165. *Two Longhorns with a Hereford*, unknown artist, c.1840. Oil on canvas, 20 x 28in. (57 x 71cm).

Hereford bulls were put to Longhorn cows to produce quality meat animals for the Fat Stock shows. The practice was more common among yeoman farmers than the aristocratic breeders. The long horns of the breed made it very difficult to winter them indoors and Bakewell tried to breed his animals with downward curving or bonnet-shaped horns to make them more manageable. Maximilian Von Hoote

Colour Plate 166. *Long-Horned Lancaster* after James Ward, unknown engraver, 1820. 6 x 8½in. (15 x 21.5cm). Inscribed: *Long-horned Lancaster Cow.*

This animal has very unusual horns which curve in opposite directions. One of the animals in the Calke Abbey herd had a horn which curved round and grew into its face. University of Reading, Rural History Centre

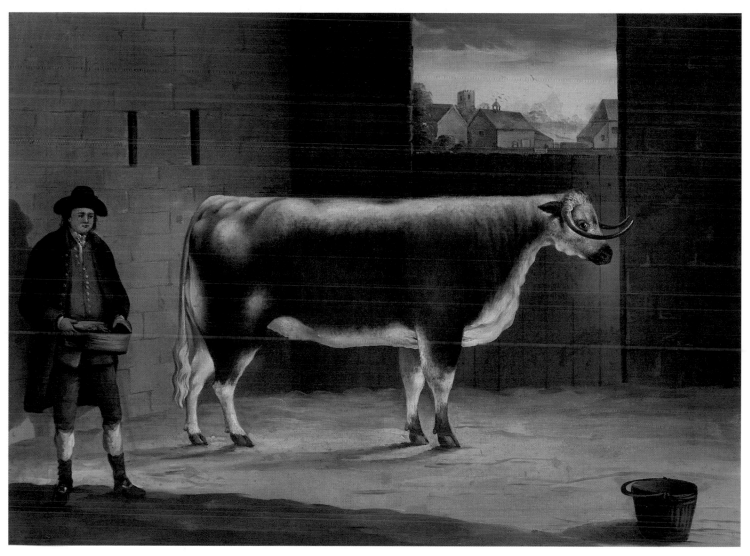

Colour Plate 167. *Portrait of a Longhorn with a Farmer at Croxall, Staffordshire*, unknown artist, c.1784. Oil on canvas, 16½ x 22½in. (42 x 57cm).
Inscribed on reverse: *The old buildings and Church at Croxhall, c.1790.*
This almost certainly represents an animal from Thomas Princep's herd at Croxhall (see Plate 15). One of the important early Longhorn breeders, Princep considered milk yield as important as aptitude to fatten. His animals showed the same disposition as Bakewell's to become over fat. Pitt commented that, 'Mr. Prinsep observes, the young stock are obliged to be almost starved by short pasturage otherwise they run fat and never stand the bull'. William Marshall visited him in 1784 and was extremely impressed by the quality of his animals. The herd was dispersed in 1811 and sixty-five cattle averaged the high price of 61 guineas each.

<div align="right">Collection of Mrs L. Gardoni de Tinoco, Mexico</div>

370lb., for calves 50lb., for sheep 28lb. and for lambs 18lb. In 1795 these figures had risen to 800lb. for beeves, 148lb. for calves, 80lb. for sheep and 50lb. for lambs.

Bakewell let out his bulls at five guineas a cow or 50 guineas for the season so that within a few decades most of the cattle in the Midland area, especially Leicestershire, Derbyshire and Staffordshire (Colour Plate 167), were of the improved Longhorn breed. Everyone from local farmers to leading landowners were fascinated by his experiments, recognising their important implications for the future of food production. On succeeding to his estates in 1776, Thomas Coke, later Earl of Leicester, invited Bakewell to come and advise him. Young tells us that he asked him how to judge cattle and Bakewell's reply reveals what a natural judge of livestock he was:

Plate 77. *Portrait of Charles and Robert Colling* after Thomas Weaver engraved by William Ward, 1825. 20¼ x 18½in. (51.5 x 47cm).
Inscribed: *Portraits of Robert & Charles Collings* [sic] *Esqrs. To the breeders and friends of the improved short horns, this print is respectfully dedicated by their very obliged & obedient humble servants Thomas Weaver and John Thompson.*
Charles and Robert Colling took up Bakewell's practices and pioneered the improved breed of Shorthorn on their respective farms near Darlington.

Lawes Agricultural Trust, Rothamsted Experimental Station

'Mr Coke, give me your hand and I will guide it!.' Bakewell thereupon took Coke's hand in his own and passing it over the cattle, taught him to judge the formation of a beast's flesh, its inclination in feeding and whether it possessed the proper qualities for fattening.

Bakewell understood the value of publicity, he kept an open house at Dishley where he entertained on a lavish scale and was visited by all the leading agriculturalists and landowners of the day. Here they were able to inspect his farm and stock as well as his rather gruesome museum of pickled joints and skeletons kept so he could compare one generation with another in depth of fat or fineness of bone. He also kept specimens of inferior breeds to widen his knowledge and show off the superior qualities of his own stock. When he fell into financial difficulties and was threatened with bankruptcy, a subscription list for voluntary contributions was opened, the list of subscribers reading like a *Who's Who* of the day.

During Bakewell's lifetime the improved Longhorn was the most fashionable breed of cattle in the country and Longhorns were frequently illustrated. Bakewell commissioned the well-established animal painter John Boultbee to paint his animals. One suspects that probably a great many more were painted than have survived. Not only would Bakewell have wanted images of the animals himself but they would have been eagerly sought after by his disciples and other aspiring breeders. Five versions as well as an engraving of his portrait by Boultbee (Colour Plate 1), which includes three Longhorns in the background, are still extant. One of these belonged to his friend and fellow Longhorn breeder Robert Fowler of Little Rollright, Oxfordshire. The Longhorn bull at Calke shows Dishley Grange in the background (Plate 76) and at Petworth House there is a painting by Boultbee of two Longhorns together with two new Leicester sheep, again with Dishley Grange in the background (Plate 20).

The most famous early Longhorn herd for which extensive illustrations survive was Robert Fowler's (d.1791) of Little Rollright in Oxfordshire. Bakewell and Fowler collaborated closely over a long period on the improvement and breeding of Longhorn cattle and some of Fowler's most successful stock, including his famous bull 'Shakespeare' and his cow 'Old Nell', were descended from Bakewell's bull 'Twopenny' whom he rented for the season. Some of these paintings can be traced directly back to Little Rollright and now hang in the Unit of Agricultural Economics, Oxford. Portraits of other cattle from the Rollright herd are now at Shugborough Park and give us a clear idea of what the improved Longhorn cattle looked like (Colour Plates 161 to 164). Longhorns are easily recognisable by the distinctive white streak running down their back and their downward curving horns, a feature bred into them by Bakewell as their original outward growing horns made it impossible to house them during the winter. According to Low, at the Eastern and Southern limits of England their horns frequently curved upwards and paintings of Longhorns with outward curving horns are not uncommon (Colour Plates 161 and 162). Despite their menacing looking horns, the Rollright cattle appear gentle and docile; the emphasis on fineness and lightness of bone makes the cows almost indistinguishable from the bulls and it is easy to believe contemporary stories of their placid natures.

The Rollright herd was the first pedigree herd to be dispersed at auction. The sale was held after Fowler's death on 29, 30 and 31 March 1791. The prices achieved were roughly ten times greater than the standard prices for cattle at that time, demonstrating how important the publicity attached to establishing pedigrees for the animals was. 'Shakespeare' was probably past his breeding prime by this time but three of his sons 'Garrick', 'Sultan' and 'Washington' fetched over 200 guineas each, while one of his daughters, 'Brindled Beauty', fetched £273. The average price was £85 per head. A note on the sale catalogue explains that another cow 'Old Nell' 'for the time she has bred, which has not been more than eight years, has made over

Plate 78. *The Lincolnshire Ox* by George Stubbs, engraved by George Townley Stubbs, 1791. 11½ x 18¾in. (29.5 x 47.5cm).
Inscribed: *To Sr. Joseph Banks Bart. President of the Royal Society. This print of the Lincolnshire ox, is humbly dedicated by his obedt. & devoted servt. Jno. Gibbons. This uncommon animal was fed (without oil cake) by Mr. John Gibbons, of Long Sutton in the county of Lincoln, and was carry'd to London in a machine, Feby. 1790, when he was exhibited by permission of his Royal Highness the Duke of Gloucester, at his riding house, in Hyde Park, and then removed to the Lyceum in the Strand, where the exhibition of him still continues, & where this print was subscrib'd to by a great number of noblemen and gentle men; all judges agree that the Lincolnshire ox, far exceeded any ever seen in size and fatness, being 19 hands in height & 3 feet 4 inches across the hips. A wager of £400 was offer'd that he would cut 9 10 11 & 12 inches thick of solid fat upon the rib if slaughter'd in the spring of 1790.*
Even as he was being exhibited the Lincolnshire Ox was becoming an anachronism as the old heavy Shorthorns were being crossed with the Colling brothers' improved animals. (See Colour Plate 50 for original.)
Courtesy of the O'Shea Gallery

1,000 guineas of herself and her stock, which was more than was ever made of any cow in the kingdom.' By way of comparison, the first recorded sale of Hereford cattle took place on 15 October 1795. The animals had no established pedigrees and the sale was not advertised beyond the county. Only twenty-seven cows and calves sold out of the forty-seven on offer. The average price was £15.6s. and the only bull in the catalogue was bought in.

Despite their initial popularity, the success of Bakewell's improved Longhorns was shortlived. Two of his pupils, Charles and Robert Colling (Plate 77), returned to their farms near Darlington and applied their new knowledge to the popular breed in that area; the Shorthorn soon overtook the Longhorn in national popularity. Bakewell had concentrated only on meat, neglecting milk yield. Subsequent Longhorn breeders took his principles too far and in their search for finer and finer bone, produced animals which were misshapen, grossly fat, weak in constitution and poor breeders. Shorthorns are believed to be descended from stock imported from the Low Countries. Their large size and ability to produce a high milk yield were inherited from their Dutch ancestry. The Collings refined the Shorthorn by selective inbreeding as well as very limited outcrossing with Scotch blood, producing an animal which proved to be far hardier, a better breeder, capable of a higher milk yield and of being fattened to even more immense proportions than the Longhorn. Without the long horns they were also much easier to manage, particularly during the winter months when the animals were housed indoors.

After about 1840 the Longhorn tended to be bred only by the more aristocratic landowners such as the Dukes of Buckingham at Stowe and the Harpur-Crewes at Calke Abbey who valued them as pedigree breeding animals and for their picturesque appearance, since with their long horns and shaggy winter coats they bore 'the character of a very old and original race about them'. Although portraits of Longhorns are less numerous after 1840 they continued to be exhibited and painted throughout the nineteenth century. At the dispersal sale of the famous Chapman herd in 1873 the walls of the dining room were hung with portraits of famous Longhorns dating back as far the Rollright herd. During the Second World War the number of Longhorn herds dwindled down to only two or three but the breed has happily been revived in numbers today. There are approaching three hundred herds and it is now a minority rather than a rare breed.

Throughout the nineteenth century, the Shorthorn, the Hereford and the Devon were the most popular cattle breeds, with the Shorthorn topping the list. One of the first animals to achieve notoriety was an unimproved Lincolnshire Shorthorn painted by Stubbs in 1791 (Plate 78 and Colour Plate 50). Bred by John Bough of Gedney near Holbeach in Lincolnshire, she was fed by John Gibbons who lived in the next parish of Long Sutton. She was 6ft.4in. tall and weighed 205 stone 7lb. She was fed on hay, not oilcake, and her owners attributed her

Colour Plate 168. *The Ketton Ox* by George Cuitt, c.1801. Oil on canvas, approx. 25 x 30in. (63.5 x 76cm). Cuitt was also commissioned to paint the Ketton or Durham Ox by Charles Colling before he sold him as an exhibition animal (see Colour Plate 12). He may well have painted other Shorthorns in his locality.

Rogers de Rin

enormous size to the habit of dipping her hay in water before eating it. However, even as she was being exhibited in London, the Lincolnshire Ox was becoming an anachronism. The heavy Shorthorns of Lincolnshire were being extensively crossed with improved cattle from Durham and Teesdale, reflecting the growing concern with quality of carcass rather than sheer size. It was with improved Shorthorns that the new breeders had the most spectacular successes. They fattened quickly, putting on flesh in the most desirable areas, and commanded fabulous prices. The largest animals weighed over 200 stone (a stone, however could vary from 8 to 14lb. so some of the weights quoted in contemporary sources can be misleading). There are six times as many prints of Shorthorns than of any other breed, and they become less frequent after about 1845.

The pedigree literature on Shorthorns is vast. They were the first breed to establish their own herd books, from 1822 (most other breeds did not do so until the 1870s, that for Longhorns did not appear until 1878), and the blood lines can be traced back to their original breeders, Charles and Robert Colling on their farms Ketton and Barmpton near Darlington. Confusingly, Shorthorns were also known as Holderness or Craven after districts in Yorkshire where the breed became established and Teeswater or Durham after the district where the Collings lived. They are distinguished by their short, stubby horns and vary in colour from white through roan to red, often with distinctive dappled markings like the 'Durham Ox' which belies their Dutch ancestry. The first cattle portrait to be commissioned by Charles Colling was probably the 'Ketton' or 'Durham Ox', painted by George Cuitt (Colour Plate 168) and engraved by Robert Pollard in 1801. The ox was got by Colling's bull 'Favourite' out of a black and white cow bought at Durham Fair. This is the same animal as the 'Durham Ox' whose portrait was published the following year by John Day to become the most famous cattle print of all time (see page 26) Colling received only £140 for him in 1801 when he sold him to Mr Bulmer. After touring him for four or five weeks Bulmer sold him to John Day for £250 and within a month Day was offered £2,000. Day, however, knew the animal's value lay in keeping him as an exhibition animal and toured him through England and Scotland for a further six years. Colling may appear to have been the loser financially but the publicity the animal gave to his Shorthorn herd was priceless.

The Collings were extremely astute and well aware of the publicity value of their animals. It is no coincidence that Colling chose the year 1810 to dispose of the famous Ketton herd. Agricultural prosperity was at its height, fuelled by the demand for home production as a result

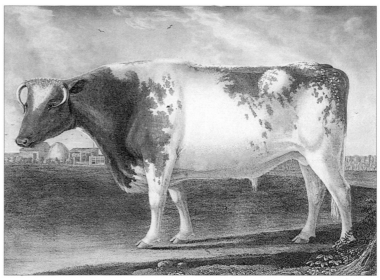

Colour Plate 169. *Comet* by Thomas Weaver, 1818. 28 x 32in. (71 x 81.5cm). 'Comet's' sire was 'Favourite' who also sired the Durham Ox and the 'White Heifer that Travelled'. He was got out of the heifer 'Young Phoenix' which 'Favourite' had himself got out of his own mother, the elder 'Phoenix'. 'Comet' was probably the most famous bull of the 19th century and sold for 1,000 guineas at the Collings sale, a record for its time. Shorthorns can vary enormously in colour and can be white, red or roan. 'Comet' was considered to be the finest of the Colling bulls. With his small head and legs he is dramatically different in shape from the unimproved Shorthorns. *Private Collection*

Plate 79. *The Howick Mottled Ox*, designed and engraved by J. Bailey, 1788. 11½ x 16¼in. (29.5 x 41.5cm).
Inscribed: *The Howlck motled* [sic] *ox, belonging to Sr. Henry Grey Bart. Bred & fed, at Howick, in the county of Northumberland, Weight: Two fore quarters, 80st. 7½lb; Hind do., 72 st. ½lb; Tallow 16 st.; Hide, 9st. 11 lb. NB 14 lb to the stone. Age: Seven years when killed at Alnwick 21 March 1787 by Mess Bolton & Embleton. Dimensions: Height at the crop, 5'10"; Do loins, 5'9¼", Do Breast from ground, 1'7"; Breadth at hips, 2'11"; Do at shoulders, 2'7"; Length from head to rump, 9'8"; Girt before shoulders, 9'11"; Do behind do, 9'8"; Do at the belly, 10'10"; Do at the loins, 9'10".*
Shorthorns predominated in the North of England. Even before the Colling brothers began their breeding experiments to improve carcass conformation they were renowned for their large size.
Lawes Agricultural Trust, Rothamsted Experimental Station

of the Napoleonic wars, and the Shorthorn's superior qualities were well established. The sale was so successful that Colling had catalogues printed after the event advertising the phenomenal prices. His prize bull 'Comet' (Colour Plate 169) sold for 1,000 guineas, making agricultural history. Compare this to Robert Fowler's sale of Longhorns twenty years earlier when his prize bull 'Garrick' fetched £215.5s. and his cow 'Brindled Beauty' £273. Cattle breeding had become very big business. Colling retired an extremely wealthy man having totalled £8,642.11s. from his two day sale. The consortium of five owners to whom 'Comet' was sold went on to make a handsome profit from letting him as a sire until his retirement. Colling was presented with a gold cup by the local farmers on his retirement in recognition of the work he had done to improve the value of their livestock.

'Comet' was considered to be a perfect specimen containing all the best blood lines. Garrard described him as of:

a shape now brought to a high state of perfection. A straight back; springing ribs, broad and flat loins; (consequently the hip bones, though broad, scarcely appear to project); a fine thin head; light neck, (not too long); deep in the brisket; broad in the chest; round in the barrel with fine bone; and so gimp or light in the belly, as in some instances, to appear high on the hind legs.

This is certainly a fairly accurate description of the animal as portrayed in Weaver's portrait. Even allowing for some artistic licence, the shape has changed dramatically from that of the 'Blackwell Ox' or the 'Howick Mottled Ox' (Plate 79), a print of an unimproved Teeswater Ox done thirty years earlier (Colour Plate 32). 'Comet' may have been regarded as a perfect specimen of breeding but with his tiny head and legs he has a very effete look about him, perhaps because he was the product of five generations of inbreeding in which brother was

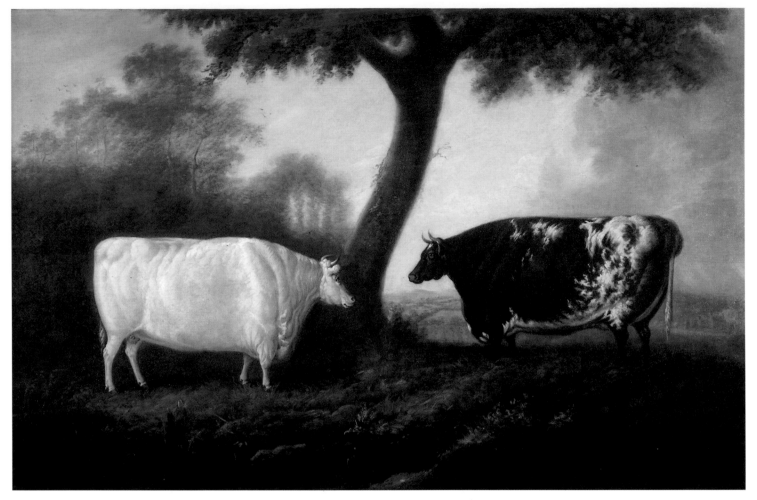

Colour Plate 170. *The White Heifer which Travelled and Red Rose* by Thomas Fairbairn Wilson, 1808. Oil on canvas, 32 x 48½in (81 x 123.5cm).
Inscribed: *The White Heifer which travelled and Red Rose 1st Prize. s & d N'Castle.*
Robert Colling of Barmpton was the brother of Charles at Ketton Hall. He was a noted stockman, breeding New Leicester sheep as well as cattle. There was a lot of cross-fertilisation between the Barmpton and the Ketton herds. Charles Colling was the more able marketeer of the two and illustrations of his animals are more common. 'The White Heifer which Travelled' and 'Red Rose' were two of Robert Collings most famous animals. From 'Red Rose' sprang 'Pilot', one of the most influential of the Booth (beef) herds as well as the Cambridge Roses developed in the Bates dairy herd. The Red Rose tribe were among the dairy Shorthorns exported to North America as early as the 1820s and they spread all over the world. Two sales, one in 1818 and one in 1820, dispersed the Barmpton herd producing an aggregate sum of £10, 126 14s 6d, an average of £94 12s 10d for 107 animals. Collection of the British Sporting Trust (donated by Stephen and Iona Joseph)

Opposite. Plate 80. *The Durham Bull, Favourite* after B. Taylor, engraved by Stadler, 1819. 17¾ x 25½in. (45 x 64.75cm).
Inscribed: *This portrait of the celebrated short horned Durham bull, Favourite, is, with permission respectfully dedicated to John Gill Esqr. of Hotton Hill, Leicestershire, by his most obedient servant Joseph Bott. Pedigree: Bred by John Gill Esqr. of Hotton Hill, Leicestershire; got by Mr. Wilkinson's bull, Favourite, bred by Mr.Weatherall, from his noted bull; which was by Mr. Charges old Grey bull, got by Mr. Charles Colling's Favourite, sire of the Durham ox, the White heifer, and of the celebrated bull, Comet, which was sold for 1000 guineas. He was killed on the 12th November 1818, by order of Mr Maide, the last proprietor, at the Bear and Ragged Staff, West Smithfield. His dimensions: Round the ancle, 10"; From point to point of shoulders, 4'8"; Round his front, 9'8"; Round his waist, 10'0"; And the length from the nose to the end of the tail was 13'6". Weight: Loose fat 25½ stone, eight pounds to the stone. His four quarters weighed 2018 lbs. viz. 252 st. 2 lbs.*
To emphasise his breeding the animal has been drawn with a view of Durham Cathedral in the background. The inscription reveals that 'Favourite' was a fifth generation descendant of Colling's bull 'Favourite'. It shows how widespread the influence of Colling's herd was by the 1820s. The print was published shortly before the first volume of the Shorthorn herd book in 1822 and every detail of the bull's pedigree is listed. This was the huge advantage the Shorthorn had over the Hereford and the Devon, they could trace their breeding back to the Colling herd which gave them added status and value.
Courtesy of the O'Shea Gallery

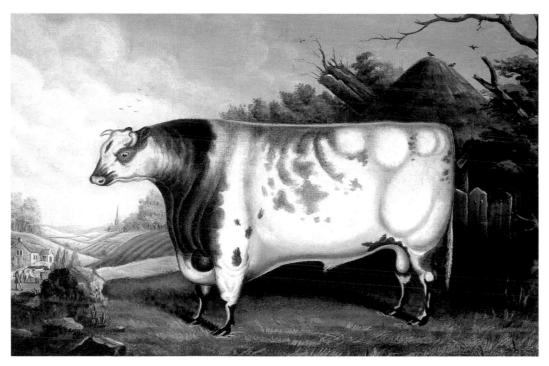

Colour Plate 171. *The Duke of Northumberland,* unknown artist after Henry Strafford, c.1840. Oil on canvas, 15 x 22in. (39 x 57cm).
Collection of Susie and Robert Zohman

bred to sister and mother to son. This selective breeding had ironed out all the fierce characteristics that appear in the wild bulls portrayed by Stubbs and James Ward and partly explains why such animals looked so curious.

'Comet' went on to found some of the most famous Shorthorn lines of cattle including the 'Duchess' line bred by Robert Bates. Bates' 'Duke of Northumberland' (Colour Plate 171) was descended from 'Duchess' and won first prize at the Royal Show in 1839. He was one of the first animals to travel by steam ship. Bates travelled all the way to London with him in a steam ship from Middlesbrough. On landing in London the poor animal slipped and lay perilously across the

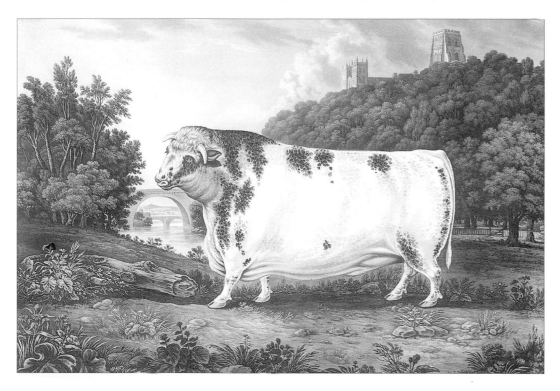

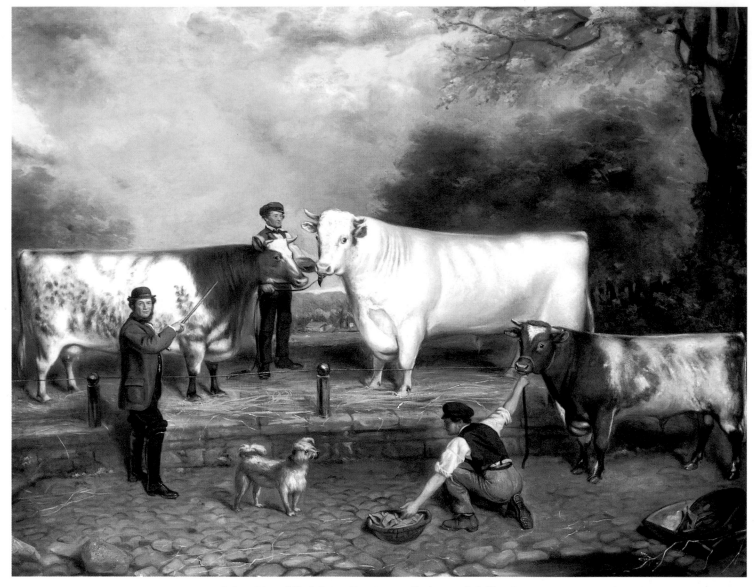

Colour Plate 172. *A Prize Shorthorn Bull, Cow and Calf with Farm Manager and Herdsmen,* unknown artist, c.1850. Oil on canvas, 36 x 46in. (91.5 x 117cm).
Pride of ownership is very obvious in this painting which may well show two generations of herdsmen and cattle. It also demonstrates the different colours of the Shorthorn breed. Maximilian Von Hoote

gangway. Bates kept him calm by patting his head and calling him 'poor boy'. On returning to Middlesbrough Bates vowed he would never travel by sea again. By the 1870s the Shorthorn was still the most valuable cattle in the world. The famous 'Duchess' line had almost died out in England but so great was the Shorthorn mania that British breeders travelled to America in 1873 to attend the sale of Senator Samuel's pedigree herd at Utica near New York and paid huge prices to reimport them. Determined that the famous 'Duchess' line should return to England, Mr R. Pawin Davies of Gloucestershire outbid breeders from all over the States and Canada to pay an astonishing $40,600 or £8,337 for a cow, 'Eighth Duchess of Geneva'.

Shorthorn herds spread from the North East all over England, their hardiness when crossed with local breeds making them especially suitable for the border areas of Scotland and England. Thomas Bates carried on the work of the Colling brothers and with stock from the Collings herd established the dairy strain of the Shorthorn in Northumberland which spread all over England and was exported to North America (Colour Plate 171) where it was well

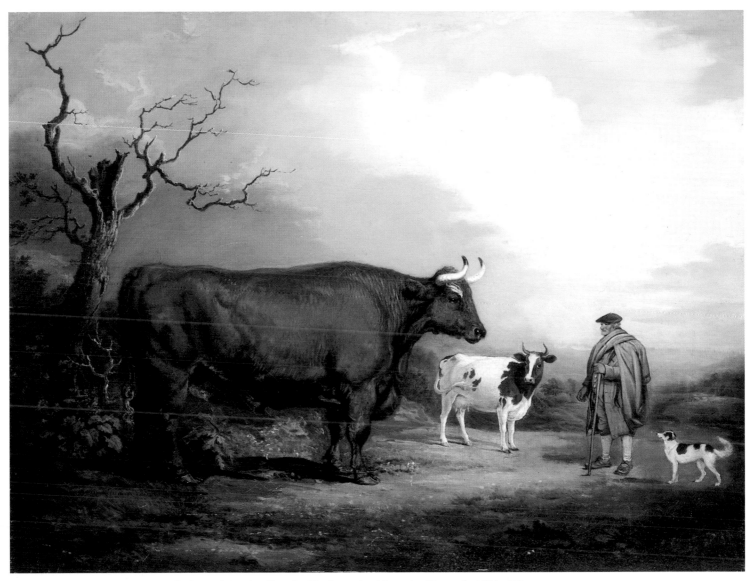

Colour Plate 173. *The Spottiswoode Ox with Mr Laidlaw the Herdsman* by Alexander Nasmyth, 1801. Oil on canvas, 27½ x 35½in (70 x 90cm)
This enormous ox was bred by John Spottiswoode in the county of Berwick. It measured 6ft.4in. at the shoulder and 12ft.4in. long from nose to rump. Its girth behind the shoulders was 10ft.2in. and breadth across the loins 3ft.1in. The ox was said to weigh 320 stone and is believed to have sold to Francis Dickson, flesher in Duns, for the immense sum of 200 guineas. It was exhibited for some time at Spottiswoode and afterwards sold for 400 guineas to become a travelling show animal. This is an early example of a Scottish animal being bred for beef for the English market. It shows breeding to type rather than indiscriminate stock breeding for market. Given the geographical proximity of Berwick to Darlington it is reasonable to assume the ox shows the influence of the Collings' herd of Shorthorns. Its quite unusual size and conformation is further emphasised by contrasting it with an Ayrshire, one of the smallest Scottish breeds, and the way in which it towers over the herdsman.

established by 1836. Thomas Booth of Killerby, Yorkshire, developed the beef strain of Shorthorn in the north of England which, however, was soon supplanted by the Scotch Shorthorn. George Coates of Driffield, Yorkshire, bred the famous bull 'Patriot' and established the breed's herdbook, the first in the country. Equipped with a capacious satchel containing writing materials and a portable desk, Coates travelled all through the Midlands and the North of England recording the pedigrees of all the animals he thought worthy of inclusion in *Coates' Shorthorn Herd Book*, first published in 1822.

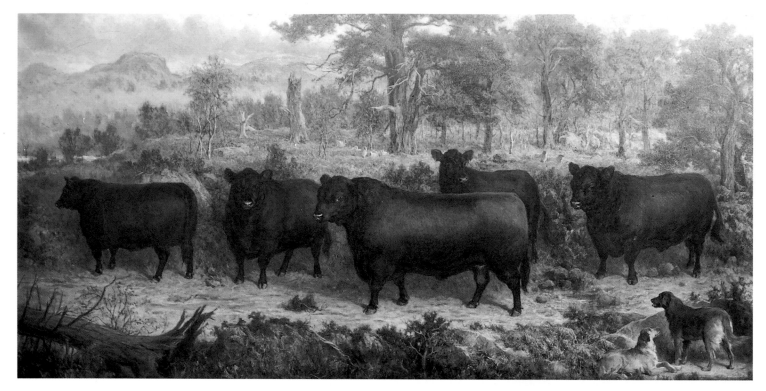

Colóur Plate 174. *Guisachan Cattle* by Gourlay Steell. Oil on canvas, 61 x 121in (155 x 306.5 cm).

Champion cattle from Lord Tweedmouth's Guisachan herd near Beauly, Invernesshire. The herd was founded in 1878 and dispersed fifteen years later. They are 'Field Marshall of Guisachan', 'Frailty' (a great breeding cow of her day), 'Cash' (her son who was Jubilee Champion and winner of the Queen's Gold Medal, Windsor 1889), 'Pride of Guisachan 20th' and 'Fame of Guisachan'.

The Royal Highland and Agricultural Society of Scotland

Colour Plate 175. *Champion Aberdeen Angus Heifer and Bullock* by R. Whitford, 1882. Oil on canvas, 20 x 30in (51 x 76cm).

These cattle belonged to Sir W.G. Gordon-Cumming, Bart. The heifer was best beast in the 1881 Smithfield Show and the bullock won a silver cup.

Theo Onisforou K.O.Angus Stud – Australia

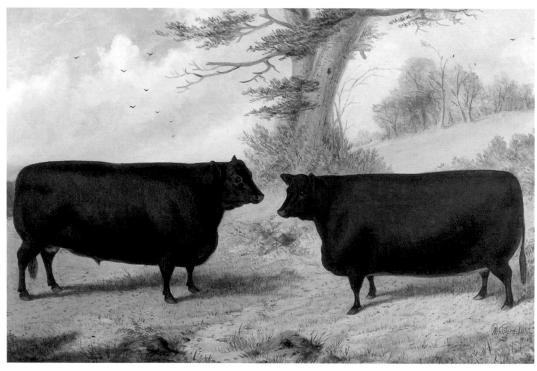

It was in Scotland that the breed really developed as a beef Shorthorn. The most famous Scottish breeder was Amos Cruickshank at Sittyton near Aberdeen who developed the beefing qualities of the breed to a very high degree. His herd was dispersed in 1889 and the success of the bull 'Field Marshall' in the Royal Herd at Windsor helped the Scotch Shorthorn establish itself with English breeders. It was Cruickshank's Scotch Shorthorn which influenced the development of the Aberdeen to produce the Aberdeen Angus, the source of most prime beef produced in Scotland (Colour Plates 174 and 175). The Aberdeen Angus is the most famous

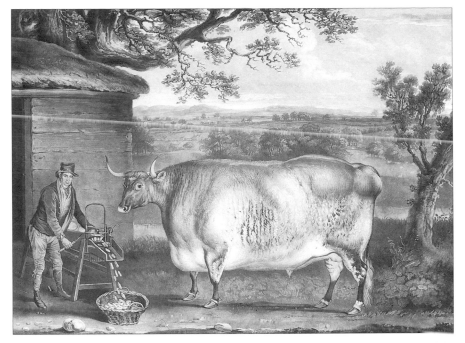

Plate 81. *The Newbus Ox,* a Shorthorn Highland Cross after Thomas Weaver, engraved by William Ward, 1812. 17¾ x 23¾in (45 x 60.5 cm).
Inscribed: *To the Right Honourable Lord Dundas, this plate of the Newbus ox, is with his Lordship's permission respectfully dedicated, by his Lordship's most humble and devoted servant, Geo. Byers. This ox was bred by William Hutchinson Esqr. of Egleston, near Barnard Castle. He was out of a Highland Scotch cow, which when fat and slaughtered weighed only 24 [sic] stone 10 lbs: (14 to the stone). His sire was a grandson of Old Favourite, belonging to Charles Colling Esqr. of Ketton, and he was fed by Thomas Wilkinson Esqr. of Newbus Grange, near Darlington, in the county of Durham.*
Here is a documented example of a Shorthorn from the Colling herd being used to improve Scotch cattle.
Courtesy of the O'Shea Gallery

Colour Plate 176. *Benjamin Tomkins (1745 1815), with Hereford Cattle and the Pyon Pumps near Hereford in the Background,* unknown artist, c.1790. 28 x 22in. (71 x 56cm).
Along with the Hewers, the Tullys, the Galliers and the Skyrmes, the Tomkins family was one of the most important early breeders to improve the quality of their stock. While the Hereford was grass fed the Shorthorn had the advantage of being able to winter indoors and fatten quickly on surplus grain which gave it an obvious advantage when supplying the London market.
The Hereford Cattle Society

Scottish breed and was first developed by Hugh Watson of Keillor in Angus from his father's 'best and blackest' cows of the local breed. The coming of the railways made possible the transportation of fresh meat and the breed developed to supply the London market. It also had good milking ability, unlike its main rival the Scotch Shorthorn which could be fattened more quickly but did not milk as well. The introduction of the Friesian early this century spelled disaster for the Shorthorn, once the toast of the land. Although not endangered, they are relatively rare today.

Fashion and marketing played an enormous part in the success of the Shorthorn. Elsewhere the development of local breeds depended largely on the interest of local landowners in improving them and their suitability in adapting to particular climates and terrains. Whereas the Hereford, the North Devon, the Sussex, the Ayrshire and the Galloway remained relatively important throughout the nineteenth century, other breeds such as the Suffolk Dun, the Fife and Glamorgan tragically became extinct. It was only a handful of dedicated breeders which prevented the Irish Moiled and the Gloucester from suffering a similar fate. When we turn to illustrations of these local breeds we are on much less firm ground. Not only are they far fewer in number but they seldom bear glowing legends depicting the animal's breed history. They were often painted by local artists for the enjoyment of farmers rather than as part of a highly developed marketing industry.

The Hereford was established as an improved beef breed by the Tomkins family (Colour Plate 176) and many others and after the Shorthorn was the most important beef animal in the nineteenth century. Not all the early Herefords were red with a white face; some had a mottled face while others varied in colour from silver through roan to deep red. Herefordshire offered

Colour Plate 177. *Prizefighter* by Thomas Weaver, 1801. Oil on canvas.

On 29 December 1800 'Prizefighter', a Hereford bred by Mr Gwilliam of Purslow, Shropshire and belonging to Mr Tench of Bromfield in Shropshire and a Leicestershire Longhorn belonging to Mr Knowles of Nailstone in Leicestershire were shown side by side at Shifnal in Shropshire for a wager of 100 guineas. The conditions were drawn up by Arthur Young and the Duke of Bedford appointed Mr E. Pester, a Somerset farmer, as the referee. Over 1,000 people assembled to see the animals despite the freezing December day. 'The decision was in favour of the Herefordshire bull; and it was the general opinion, that this animal was superior, both in the material points, and *very greatly* in the aggregate weight.' The bull was so notorious Weaver was commissioned to paint twelve portraits of him at five guineas each. At this date the bull does not have the white face which is now a fixed characteristic of the breed. The Tench Family

some of the best grazing in England. The Hereford fattened quickly on grass and was more acceptable to the London market than the Shorthorns of Scotland and the northern counties. It soon ousted the Longhorn from the West Midlands and at the first Smithfield Show, in 1799, three of the four prizes were won by Herefords. Mr Westcar, the famous breeder from Creslow in the Vale of Aylesbury, transported his animal to Smithfield on a barge via the Wendover and Grand Union canals. It was the first animal to make such a journey, it lost no weight and sold for £100. The breed became popular with gentlemen farmers in the West Midlands; the Duke of Bedford kept Herefords at Woburn and did a good deal to promote the breed. In Garrard's engraving of the *Woburn Sheepshearing* it is Mr Westcar's Oakley Hereford bull which occupies the centre of the painting while the Shorthorns are relegated to the background. When used as a crossing sire

Colour 178. *A Group of Herefords at the Court House* by A.M. Gauci. 30 x 48in. (76 x 122cm).

John Price of the Court House, Pembridge, took over his father's herd in 1867. His experience in Australia had taught him the importance of a rugged constitution, 'an ounce of hair being worth as much as a pound of flesh'. His animals were exported all over the world. Pictured here are 'Hotspur', 'Dowager' and her calf, 'Dark Rose' and the heifer 'Venus'. 'Hotspur' and his progeny won the group prize at the Bath and West Show at Brighton in 1885.

The Hereford Cattle Society

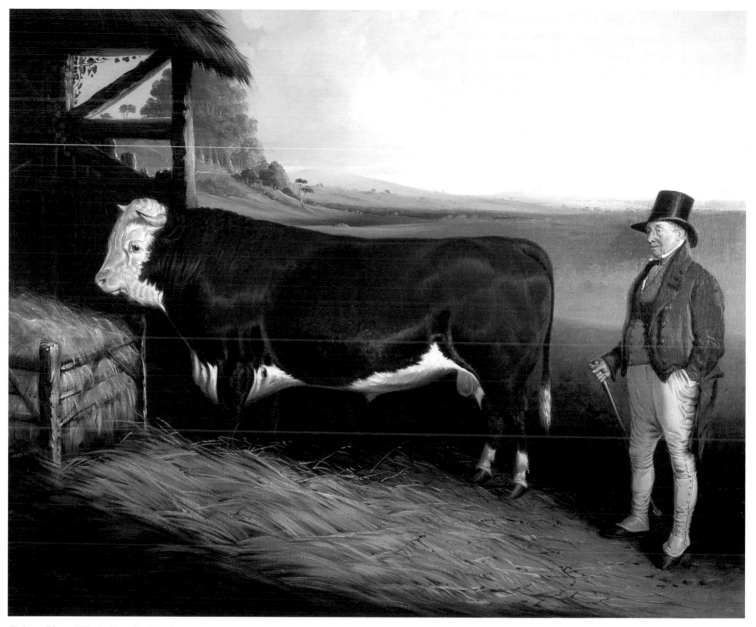

Colour Plate 179. *A Hereford with his owner* by Lucas Beattie, 1832. Oil on canvas, 25 x 30in. (63 x 76cm). Born in Wolverhampton, Beattie painted mainly equestrian portraits. Private Collection

Herefords confer their white face on their progeny so a Hereford descent is always clear. An illustration of a Hereford bull with two Longhorn cows reflects the practice of crossbreeding with Herefords to improve beef production from dual purpose breeds (Colour Plate 165).

Herefords never received the same publicity as Shorthorns. It was still a relatively isolated area of the country and the early breeders did not engage in publicity exploits touring prize beasts like the Colling brothers. Although they were well represented at the first Royal Show in 1839, they did not have an established herdbook until 1846 and many fashionable farmers preferred the Shorthorn breed with its well-established pedigree. The Shorthorn's adaptability to fatten in stall or yard on a small amount of food was an advantage over the grass-fed Hereford, although the Herefords had less far to travel to the London market. However, in the early nineteenth century Herefords carried off the majority of prizes at Smithfield. Between 1825 and 1845 Herefords claimed ninety-nine of the prizes against forty-five by Shorthorns, eight

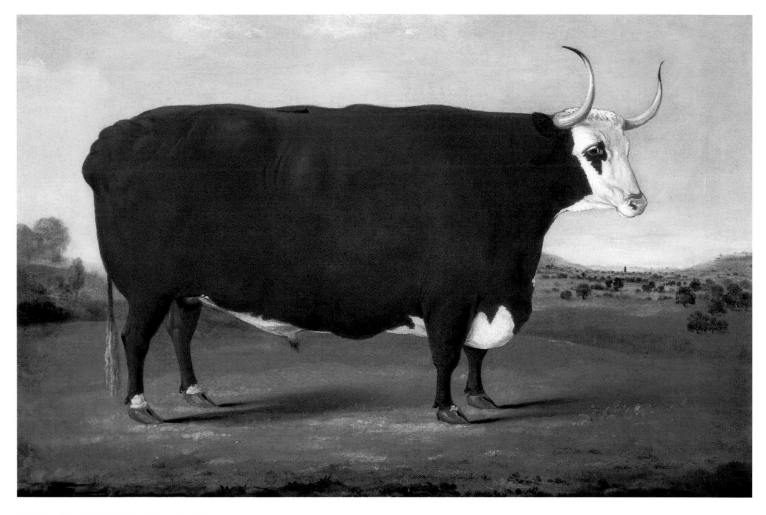

Colour Plate 180. *Mr Joseph Hall's Great Herefordshire Ox*, unknown artist, 1844. Oil on canvas, 17 x 24in (43 x 61cm).
The ox was fattened to the enormous weight of 450 stone which was presumably 8 and not 14lb. to the stone. The majority of giant oxen on public display were Shorthorns; it is unusual to find a Hereford being exhibited in this manner.

Iona Antiques

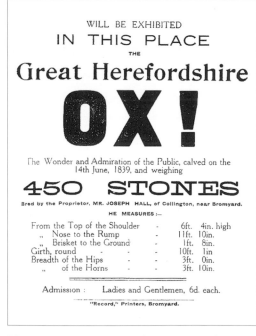

Plate 82. Poster advertising Mr Joseph Hall's Herefordshire Ox. *Iona Antiques*

by the Devons and seventeen by the 'Scotch etc', although it was the Shorthorn which regularly won the supreme championship, for which a gold medal was offered from 1830. Herefords, like Shorthorns were capable of growing to an enormous size. A Hereford ox, calved in 1839 and belonging to Mr Joseph Hall of Collington near Bromyard (Colour Plate 180), was exhibited to the public weighing 450 stone and measuring 6ft.4in. from the top of the shoulder. In the later nineteenth century Herefords were exported all over the world, especially to North America where they were used to upgrade the ranch herds. Here, the Hereford developed as a larger animal. While the Hereford Herd Book Society recognises the American Hereford as pure bred, the Rare Breeds Survival Trust does not. Twenty years ago the British Hereford was still a popular native breed but it fell out of fashion under competition from the new type from North America, which is not considered pure bred, and became almost extinct. After fifteen years of decline the British breed is again on the increase, especially appreciated on the basis of its beef quality and native adaptability and particularly valued as a beef crossing sire on Friesian-Holsteins.

The Devon red, also known as the 'Ruby Red', was another beef breed which

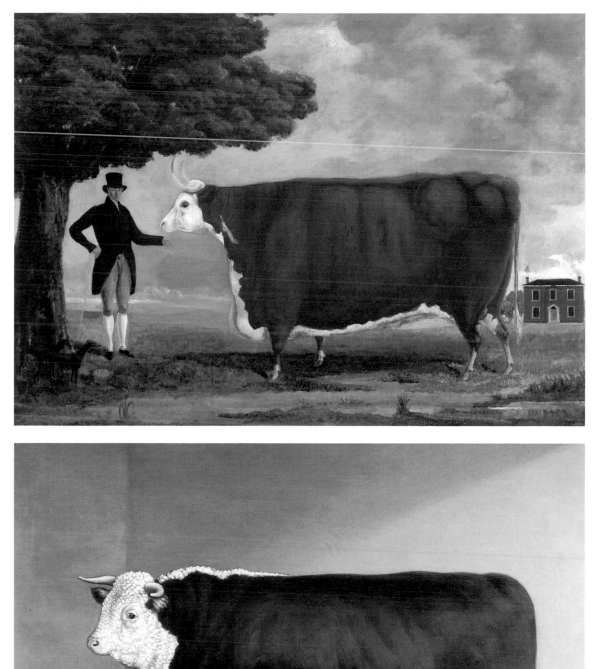

Colour Plate 181. *A Gentleman Farmer with his Prize Hereford Ox and Two Greyhounds*, unknown artist, c.1820. Oil on canvas, 26 x 35in. (66 x 89cm).
The gentleman looks ridiculously thin compared with his magnificent ox with its characteristic white face.
Private Collection

Colour Plate 182. *Prize Hereford Bull in a Byre* by H.J. Quintin, 1875. Oil on canvas, 23 x 30in. 58.5 x 76cm.
Although this animal is not identified, Quintin painted several Herefords belonging to the noted breeder Mr John Hewer of Hampton Lodge. The bull has been carefully prepared for show with its well groomed tail and face and gleaming coat.
Collection of Lady Southey

Colour Plate 183. *Sir Bartle Group,* lithograph by J. Ottoman, New York, 1866. 17¾ x 21⅜in. (45 x 55.5cm). Inscribed: *Sir Bartle V, Sir Bartle III, Sir Bartle II, Sir Bartle I, Sir Bartle IV, Sir Bartle Frere. Sir Bartle Group of yearling grade Hereford steers and their sire Sir Bartle Frere. Exhibited at the American Fat Stock Show, Chicago, 1885, Sir. Bartle 2nd, 4th and Ist won Ist 2nd and 3rd prizes as best yearlings, in a class of 30 Grade Yearling Steers of all breeds. The five steers won first Premium, and the marshall field special Prize, as the best fine yearlings in any breed in the show. Average age Nov. 1st 1885, 19 months, average weight 1450 pounds. J. Ottoman. Lith (Mayer, Menkel & Ottomann) Puck Building. NY. Copyrighted by Adams Earl, 1886. All Rights reserved. Copyright. With the compliments of Adams Earl Shadeland Farm, Lafayelle. Ind.*
'Sir Bartle Frere' was calved on 4 July 1880, bred by Mr T.W. Carnwadine, Stockton, Bury, Leominster. He was got by 'Lord Wilton', dam 'Tiny'. The first recorded export to America was two pairs of Herefords sent to the Hon. Henry Clay of Kentucky in 1817, but it was not until much later that they became established as a major beef animal in significant numbers. A ship containing Herefords was torpedoed in the Atlantic in 1940 and two of the animals managed to swim to Ireland, showing the enormous stamina of the breed. In the 1970s American Herefords were imported back into Britain. In America they had developed as a larger animal and were used to put size back into the remaining British Herefords, bringing them more into line with Continental breeds.

Courtesy of the O'Shea Gallery

held its own against the Shorthorn. The most famous herd was that of Francis Quartly, depicted as a prosperous landowner inspecting his cattle in Thomas Mogford's portrait of him (Colour Plate 184). Devons were excellent draught oxen as well as being excellent breeders and good dual purpose animals. They were reputed to be the speediest working oxen in England, able to plough an acre of heavy soil a day. Regional pride could have played a part in the popularity of the breed and Quartly was forced to pay high prices even early on to build up his herd. The Devon's popularity spread well beyond the county. Three of the country's most influential agriculturalists bred Devons: Thomas Coke (Plate 83), the Duke of Bedford (Colour Plate 70) and Lord Somerville. Not surprisingly, along with the Herefords, they dominated the prizes awarded at

Colour Plate 184. *Francis Quartly* by Thomas Mogford, 1850. Oil on canvas, approx. 54 x 42in. (137 x 107cm). This portrait was presented to Francis Quartly by public subscription in 1850 in recognition of his success as a Devon breeder. Quartly was the most important of the Devon breeders. He is shown by the side of his cow 'Cherry 66' while a calf licks his hand.

Marjorie Turner

Colour Plate 185. *Three Devon Cattle with a Farmer* by J. Loder, 1850. Oil on canvas, 22¾ x 29½in.(58 x 75cm). Known as 'Ruby Reds', Devons are a deep cherry red with medium sized horns and short legs. Like the Sussex, to whom they are related, they were valued as draught animals and were among the cattle taken to the New World by the Pilgrim Fathers.

Iona Antiques

Plate 83. *Thomas Coke with a North Devon Ox*, lithographed by W.H. Davis, n.d. 19 x 26in. (48 x 66cm). Inscribed: *Portrait of T.W. Coke Esqr. & Clerk Hilliard Esqr. with a North Devon Ox bred and fed at Holkham in Norfolk which was considered the most perfect animal of its kind.*
Coke recommended the Devon over any other breed describing them as 'cattle in which were blended the two qualifications of milkers and breeders'. They became fashionable with a number of aristocratic farmers.

University of Reading, Rural History Centre

the respective gatherings organised by these gentlemen. They became the favourite breed of Thomas Coke and therefore popular throughout East Anglia, ousting the local Suffolk and Norfolk cattle. At the meeting of the Norfolk Agricultural Society in 1811 he recommended them wholeheartedly as 'cattle, in which were blended the two qualifications as milkers and breeders'. Thomas Coke (Plate 83) is seen in a portrait by W.H. Davis inspecting a Devon ox. Coke carried out trials between two Devons and a Shorthorn. When killed the Devons weighed

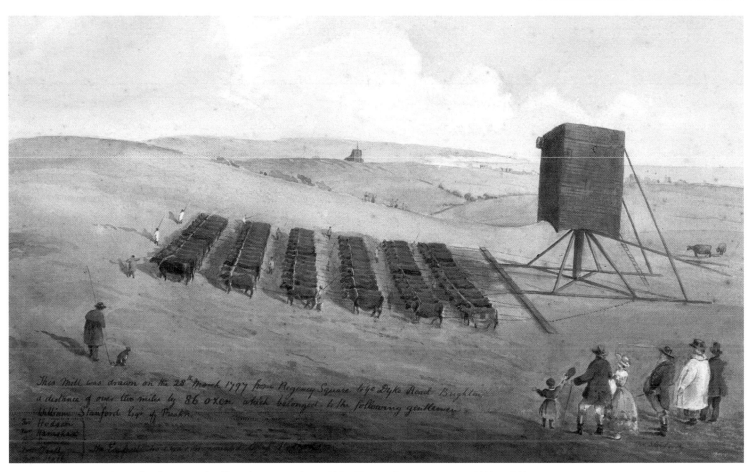

Colour Plate 186. *Oxen hauling Windmill,* unknown artist, 1797. Watercolour on paper, 13¼ x 20in. (33.8 x 51cm).

Inscribed: *This mill was drawn on the 28th March 1797 from Regency Square to Ye Duke Road, Brighton, a distance of over two miles by 86 oxen which belonged to the following gentlemen: William Stanford Esqr. of Preston Mr. Hodson Mr. Hamshare Mr. Scrase Mr. Trill Mr. Hall, the expedition was commanded by Tos. Hodson.* Mr Stanford is identified by inscription as the portly figure to the left of the man in a white smock. The following extract from *Bells Weekly Messenger* for April 9, 1997 records this incident: 'The following singular and extraordinary exploit was effected, in the presence of many thousand spectators on Tuesday last, by Mr Streeter, Miller at this place. – He removed his windmill *whole and literally as he worked her* with the help of 86 yoke of oxen, and a number of men, from the above place across the lains to a brow near Withdean, a distance of more than a mile, where he fixed her without the smallest accident. The above mill stood on the Westward of Brighton, very near the edge of the cliffs, and had long been complained of as a nuisance, which caused the removal. The neighbouring farmers accomadated him with their oxen for the purpose, gratis.'
Sussex oxen were famous for their pulling power and patient steadiness in the yoke.

Royal Pavilion Art Gallery and Museums, Brighton

140 stone and the Shorthorn only 110 although it had eaten more than the Devons.

After a drastic decline in numbers Devons are now on the increase with somewhere approaching 2,000 calves a year being born. Their increase is attributed to a growing consumer concern for prime quality beef and many of the Devons slaughtered each year find their way to local and specialist butchers. Early this century the Devon was exported all over the world and there are large numbers in North and South America, Australia and New Zealand.

Sussex cows were also red and related to the North Devons. They made fine draught oxen, were ideally suited for ploughing the heavy weald clay and are often painted in this occupation. A watercolour of 1797 shows eighty-six Sussex oxen yoked up to move the Dyke Road Mill (Colour Plate 186) a distance of over two miles from one part of Brighton to another. Draught oxen were not compatible with breeding premium beef since they needed strong forequarters to drag their loads and could not be rounded out in the hindquarters like the best beef animals.

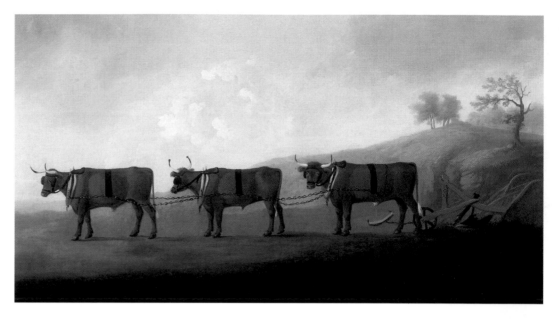

Colour Plate 187. *Three Oxen Yoked to a Plough* by Daniel Clowes, c.1800. Oil on canvas, 24 x 38in. (61 x 96cm). These red oxen could be Sussex or Devon; both breeds were highly esteemed in the plough. During the Middle Ages up to twelve oxen could be harnessed to the cumbersome ploughs. As improved lighter ploughs were developed this number was reduced and by the mid-18th century heavy horses were beginning to replace oxen and mixed teams were a common sight. Iona Antiques

Colour Plate 188. *Thomas Ellman of Beddington with Sussex Cattle outside Arundel Castle*, unknown artist, c.1840. Oil on canvas, 28 x 36in. (71 x 91cm). Thomas Ellman was the son of John Ellman, the famous breeder of Southdown sheep and Sussex cattle (see Plate 36). His animals were based on stock from his father's flocks and herds.
Rona Gallery. Bridgeman Art Library, London

John Ellman, the Southdown sheep breeder, was one of the first people to improve Susex cattle (Colour Plate 188). Another of the most famous Sussex herds was bred by Lord Egremont at Petworth House and there are still Sussex cattle in Petworth Park today. A painting by Boultbee at Petworth shows Sussex cattle and Southdown sheep grazing in the park in front of the house (Plate 20). Another leading improver was Edward Cane of Berwick, East Sussex. Although a good beef animal, the Sussex did not receive the same attention as other breeds and therefore lost out to them. It was only in the 1860s and '70s, when they had been replaced by farm horses, that they began to be bred for beef.

Colour Plate 189. *Ayrshire Heifer outside a Byre* by Samuel Spode, 1830. Oil on canvas, 25 x 30in. (63 x 76cm). The Ayrshire developed as a dairy breed when most of the improvements taking place were aimed at producing a more efficient beef animal. Unlike the Suffolk Dun, the most important dairy cow in England which sadly became extinct, the Ayrshire was in demand to supply the cheese making industry of South West Scotland. The picture shows the neat udder formation characteristic of the breed. Women did the milking which is why small teats were preferred.

Collection of Nigel Jones

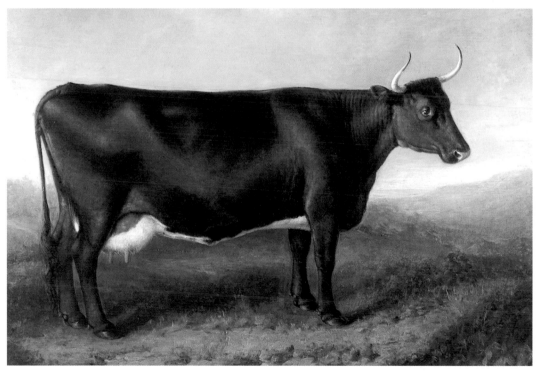

Colour Plate 190. *The Fife Cow* by William Shiels, c.1835. 51 x 63in. (130 x 160cm).
Once an important dairy cow of Lowland Scotland, like the Suffolk Dun the black Fifeshire breed is now extinct.

Trustees of the National Museums of Scotland

The Ayrshire (Colour Plate 189) was the only Scottish lowland cow able to hold its own as a successful dairy breed supplying the large populations of Glasgow, Greenoch and Paisley. Others such as the black Fifeshire (Colour Plate 190) are now extinct as, according to Low, the

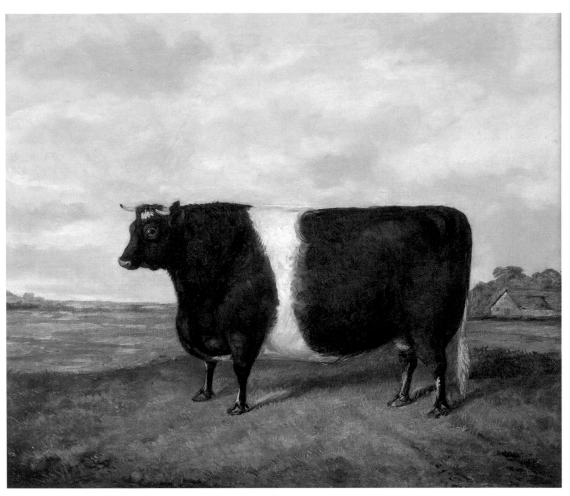

Colour Plate 191. *Belted Galloway,* artist unknown, c.1860. Oil on canvas, 21 x 23in. (53 x 58.5cm). Private Collection

Colour Plate 192. *Highland Steer* by Richard Whitford, 1872. Oil on canvas, 20 x 24in. (51 x 61cm). These hardy cattle were driven south for fattening and were a common sight throughout England. They were ousted by the demand for younger animals fattened on fodder crops close to the markets.　Private Collection

Colour Plate 193. *Highland Cattle in a Byre,* unknown artist, c.1850. Oil on canvas, 17 x 23in. (43 x 60cm).
Private Collection

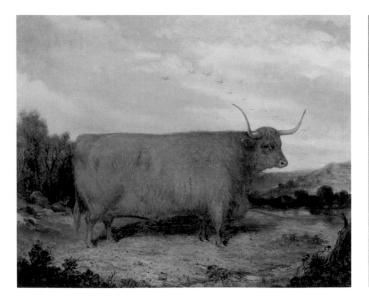

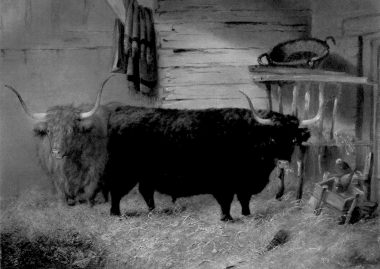

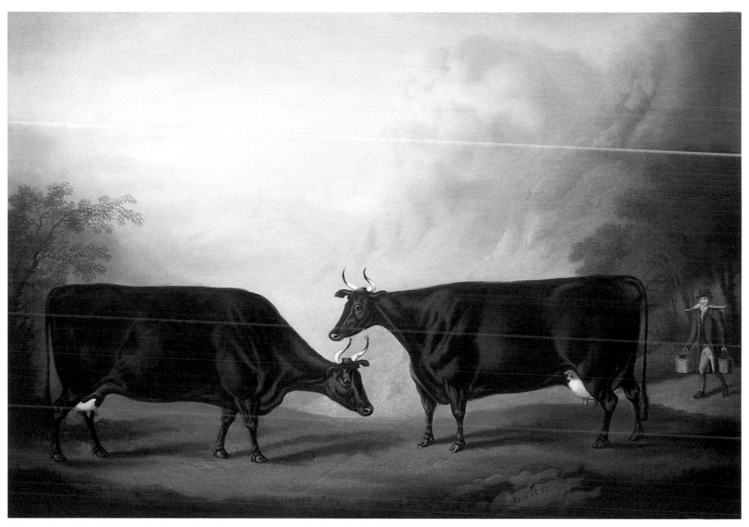

Colour Plate 194. *Welsh cattle Bethnal and Bran* by Daniel Clowes, 1824. 23½ x 33½in. (59.5 x 85.5cm).
Welsh cattle were extremely varied and the Welsh Black Cattle Society was not formed until 1883. The breed
combines milking ability, beef quality and hardiness to survive in inhospitable environs. Sir Robert Vaughan
(see Colour Plate 84), for whom these were painted, specialised in a dairy strain and a milkman with his churn
appears in the background. Private Collection

dairy in that area was merely 'an affair of the household'. The hardy Galloway (Colour Plate
191), Highland (Colour Plates 192 and 193), Shetland and Welsh Black (Colour Plate 194), all
of whom could survive without additional winter crops, flourished in the remoter regions of
Wales and Scotland.

Other breeds, however, were less fortunate. The red middle horned cattle of the west
including the Gloucester (Colour Plate 195) and Glamorgan (Colour Plates 196 and 197)
continued as fairly nondescript dual purpose cattle. They are easily recognisable by the
distinctive white stripe running down their back and hindquarters. They failed to compete with
the better milk-producing Shorthorns. By 1900 the Glamorgan was extinct while in 1985 the
Gloucestershire had dwindled in numbers to a few hundred. Illustrations of both breeds are
rare. The most famous Gloucester cow was 'Blossom' (Colour Plate 195), not because of her
size or weight (she appears to have been a fairly mangy looking animal), but for her part in the
development of preventive vaccination. Sarah Nelmes, a milkmaid, caught cowpox from
'Blossom'. Lymph from Sarah was transferred to James Phipps, an eight year old boy, by Dr
Edward Jenner of Berkeley and, as a result, James escaped the dreaded smallpox. Images of

Colour Plate 195. *Blossom, a Gloucester Cow* by Stephen Jenner. Oil on canvas, 16½ x 22in. (42 x 56cm).
'Blossom' became famous through her connection with Dr Edward Jenner who made a breakthrough in the development of vaccination by establishing that inoculation with cowpox could prevent a person from catching smallpox.

Jenner Museum, Berkeley, Gloucestershire

Colour Plate 196. *The Glamorganshire Fat Cow bred by William Powell of Margam* by James Flewitt Mullock, 1851. Oil on canvas, 18½ x 25¼in. (47 x 64cm).
The animal won first prize at the Tredegar Show in 1851. The breed was becoming rare by this time.

Private Collection

Colour Plate 197. *A Glamorgan Cow, Lilly,* unknown artist. Oil on copper. Inscribed: *Lilly, Bred & fed at Wallace, 1844.*
Lilly was bred by Thomas Thomas on the Wallace Farm, Ewenny in the Vale of Glamorgan. Animals from the herd won prizes at a show in Cowbridge in 1843 and 1844. From the late 1850s the herd was crossed with Herefords until by the 1880s no Glamorgan remained. The cow shows the red and white pied body, white top-line, all-white tail, and white under-line with medium, fine, upturned horns, all characteristic of the Glamorgan breed. The Glamorgan was very similar to the Gloucester in appearance. By 1900 it had become extinct, unable to compete with the dairy Shorthorn.

Whereabouts unknown. Photograph University of Reading, Rural History Centre

Glamorgan cattle are so rare that in 1933 when the breed had been extinct for thirty-three years a print of 'Lilly', an Old Glamorgan cow, was taken from a painting done in 1844 (Colour Plate 197).

Another breed now completely extinct is the Suffolk Dun (Colour Plate 198). Derided by Bakewell for its angular appearance, he commented that it would have looked better turned upside down. In 1846 the Suffolk and the Norfolk (Colour Plate 199) breeds were amalgamated to become the forerunner of the modern Red Poll (Colour Plate 200).

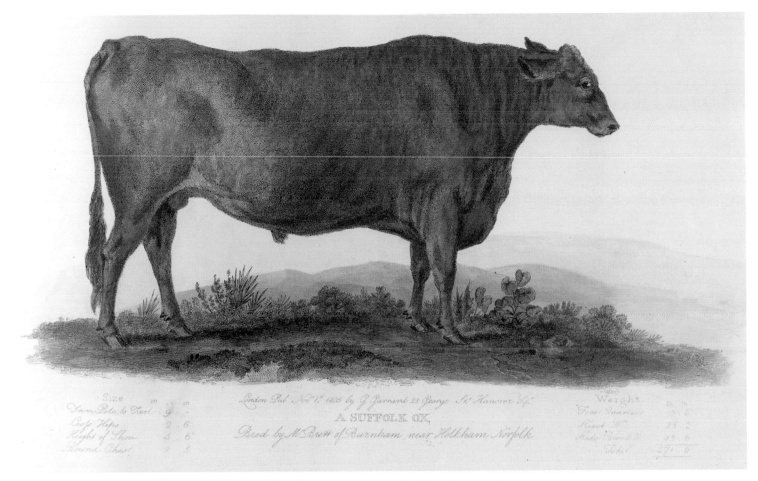

Colour Plate 198. *A Suffolk Ox* by George Garrard, 1805. Coloured engraving, 13 x 17in. (34 x 44cm).
Inscribed: *Bred by Mr Brett of Burnham near Holkham, Norfolk*

Size	Ft.	In.	Weight	St.	lb.
From Pole to tail	9	0	Forequarters	93	6
Cross hips	2	6	Hind "	35	2
Height of shoulder	5	6	Hide Blood	92	6
Round chest	8	5	Total	271	6

The Suffolk had excellent milking qualities. Historians have speculated that had it survived it could have assumed the role of the British Friesian. It was amalgamated with the Norfolk to form the Red Poll in 1846.

By kind permission of the Marquess of Tavistock and the Trustees of the Bedford Estates

Colour Plate 199. *Starling of the true Norfolk breed, in the 36th year of her age, the property of Charles Money Rainham,* unknown artist. 25 x 37in. (63 x 93.5cm).
Native Norfolk cattle were scorned by modern agriculturalists and became extinct. The Norfolk was the traditional beef breed and the Suffolk the dairy breed.

Private Collection

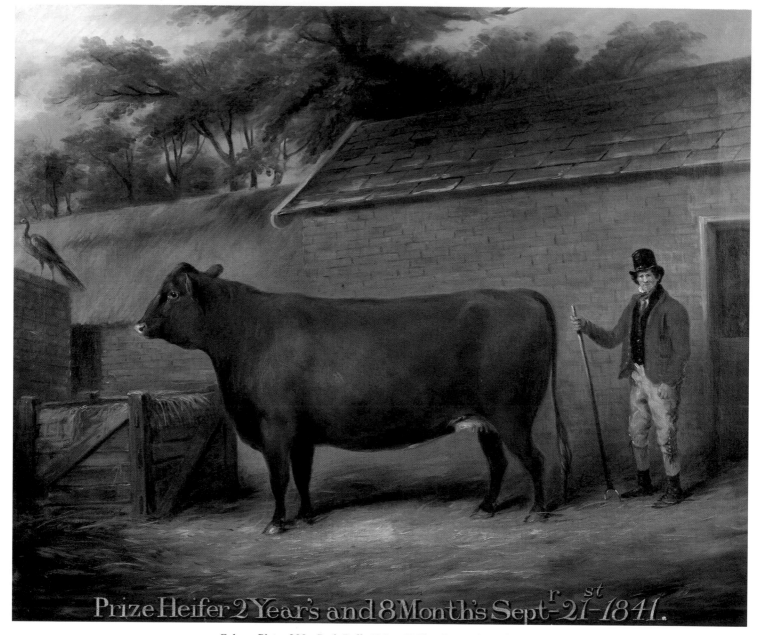

Prize Heifer 2 Year's and 8 Month's Sept.-21-1841.

Colour Plate 200. *Red Poll, Prize Heifer, 2 year's and 8 Months Septr-21 st- 1841,* unknown artist. 24½ x 29½in. (62 x 75cm).
The Norfolk and Suffolk breeds of cattle were formally amalgamated in 1846. This painting shows that even before this date there was little distinction between the breeds. The Red Poll Cattle Society, Woodbridge, Suffolk

Although the Suffolk was an excellent dairy cow and the Norfolk a beef animal, they were scorned by the modern agriculturalists, Arthur Young describing the breed as having 'no qualities sufficient to make it an object of particular attention.' Illustrations of both animals are extremely rare although the Norfolk achieved a certain degree of fame as the trademark for Coleman's mustard. The stuffed bull's head which served as the model for this survives mounted in the Coleman's mustard shop in Norwich.

A few breeds of cattle were imported into the British Isles. They had little effect on the development of native breeds and were treated more as fashionable curiosities. The Kerry and its miniature version the Dexter came from Ireland and the Alderney was the collective name given to Channel Island cattle (Colour Plates 201 and 202). Exotic species also arrived from

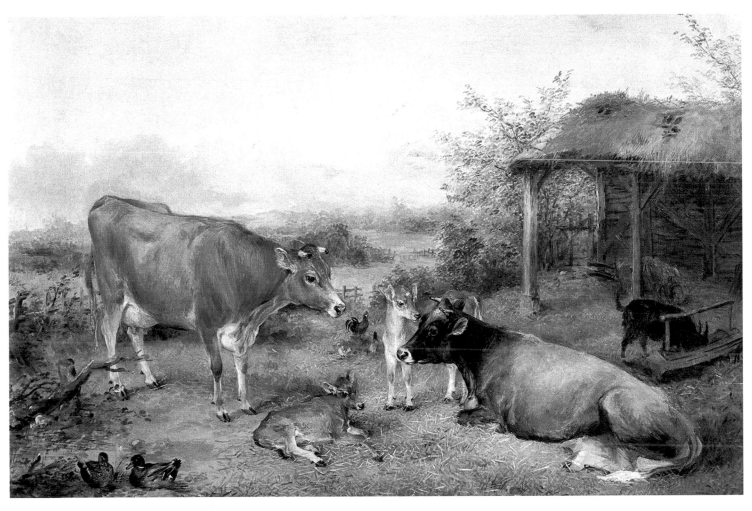

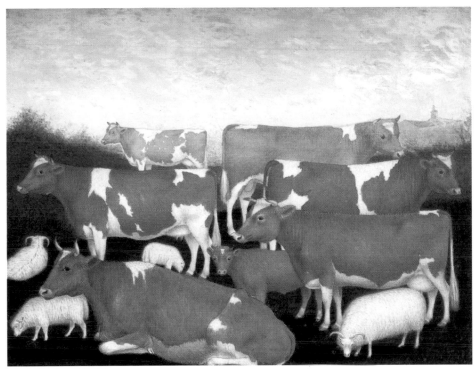

Colour Plate 201. *Jersey Cattle* by E.F. Holt, 1884. Oil on canvas, 17 x 24in. (43 x 61cm).
Alderney was the collective name given to Channel Island cattle. They were originally prized as decorative parkland cattle, only becoming an important dairy breed in this country at the turn of the century. *Private Collection*

Colour Plate 202. *Guernsey Cows with Sheep*, unknown artist, c.1850. Oil on canvas, 20½ x 26½in. (52 x 67.5 cm). Collection of Mr and Mrs Sol Magid

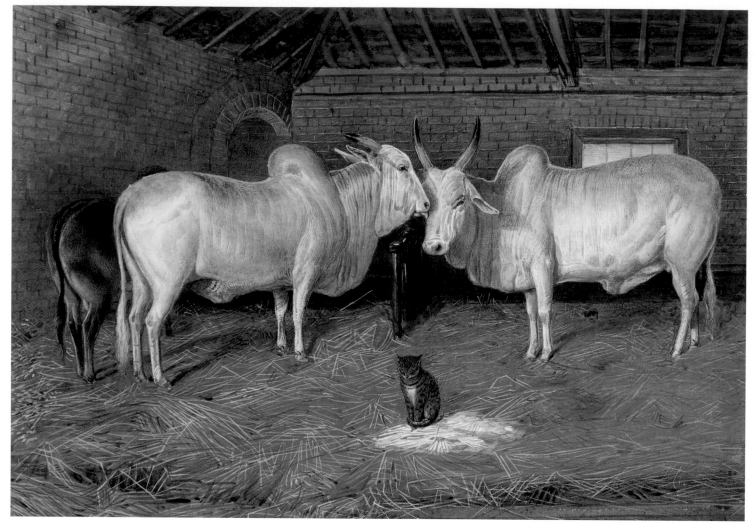

Colour Plate 203. Zebu Cows and Bull by F.W. Keyl, 1871. Watercolour on paper. 9 x 12½in. (23 x 31.5cm). Sent to Her Majesty in 1862 by the Maharajah of Mysore. Exotic animals were frequently exchanged as gifts. Among the most popular were Brahma cattle first imported in the late 18th century – see Colour Plate 21.

The Royal Collection © 1996 Her Majesty The Queen

India and the Far East (Colour Plate 203). These cattle were kept primarily by noblemen to decorate their country parks. Youatt comments that 'it is thought fashionable that the view from the breakfast or drawing-room of the house should present an Alderney cow or two grazing at a little distance'. He explains that the animals were popular partly for the richness of their milk but more for their diminutive size. It was only later in the century that the Alderney or Jersey and Guernsey cattle, often crossed with native breeds, became properly established as dairy herds in the gentle climate of the South West. Gujarat and Ceylon bulls were kept at Woburn and Lord Salisbury owned a Bengal bull. Youatt explains how the Earl of Fitzwilliam (Colour Plate 21) owned a herd of Indian cattle and that even if any attempt was made to crossbreed 'it would be a matter of zoological curiosity rather than of practicality'.

This century native British breeds have suffered a drastic decline in numbers at the expense of competition from imported foreign breeds. Today it is the boring but reliable black and white Friesian-Holstein (Colour Plate 204) with its high milk yield which makes up ninety per cent of the British dairy herd, the remainder being comprised of dairy Shorthorn, Ayrshire, Jersey and Guernsey cattle, although in some cases these are declining rapidly and becoming seriously endangered. Although black and white cattle were imported from the Continent in the eighteenth century and some may even have been crossed into the Shorthorns, it was not until the early twentieth century that they began to be imported in large numbers from the

Colour Plate 204. *A Study of Leevwarden Holland with Friesian Cattle in the Foreground,* unknown artist, c.1850. Oil on canvas, 17 x 23½in. (43 x 60cm).
Imported in large numbers early this century, the Friesian, here seen in its native habitat, makes up 90% of the British dairy herd.
<div align="right">Private Collection</div>

Netherlands. The Friesian's high milk yield quickly supplanted the native British breeds because it was the more viable commercial animal. The majority of the British beef herd is now comprised of the large Continental breeds such as the Charolais imported from France in the 1960s, followed by the Limousin and Simmental from France and Germany and Switzerland respectively in 1970. All the native beef breeds are now minority breeds in this country, many of them adulterated by crossing with foreign breeds.

Contemporary cattle portraits show us the extraordinary variety and quality of our native breeds in the nineteenth century. Many of those discussed in this chapter are either extinct or rare breeds such as the Longhorn, Shorthorn, White Park, Red Poll, Dexter, Kerry and Gloucester. The picture, however is not entirely gloomy. The Rare Breeds Survival Trust was founded in 1973 and together with a group of dedicated breeders has worked hard to preserve the numbers of native British breeds of cattle, sheep, pigs, goats, horses and poultry. Over the last ten years these have almost all shown a steady increase in numbers. There is a growing understanding among breeders, farmers and consumers that percentages, yields and maximum return for money are not the only things that matter. The unique qualities of these breeds which make them ideally suited to specific habitats and systems of farming, as well as their genetic importance, are gradually becoming appreciated, but there is still a long way to go.

Colour Plate 205. *A farmer with his flock of sheep and Sheepdog,* unknown artist, c.1840. Oil on canvas, 30 x 36in. (76 x 91.5cm).
Flocks of sheep grazed in remote and inaccessible parts of the country. The shepherd's life was hard and lonely, often his dog was his only companion. The dog appears to be similar to today's Border Collie while the sheep resemble North Country Cheviots, a breed specially adapted to a hardy life on the hills of the Scottish borders.
Collection of Mr and Mrs David A. George

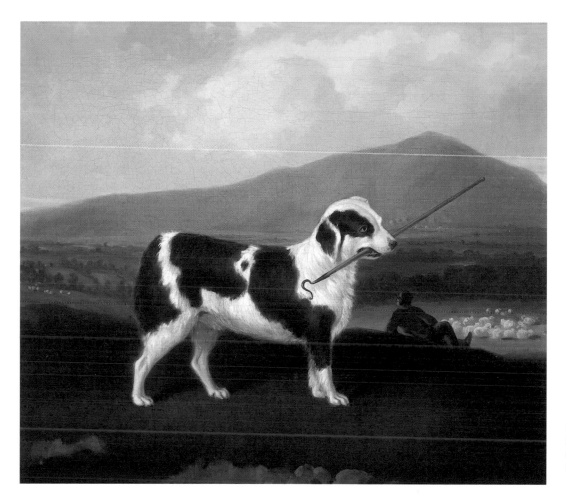

Colour Plate 206. *Sheepdog carrying his Shepherd's Crook,* unknown artist, c.1840. Oil on canvas, 15¼ x 18¾in. (39 x 47.5cm).

Chrisse Schafferhans, Vienna, Austria

CHAPTER 5
Developments in Sheep Breeding

Like cattle, the earliest recorded breeds of sheep were associated with their counties of origin and carried county names. Due to the very varied geographical conditions, over sixty localised types of sheep could be found in eighteenth-century Britain. They differed enormously in appearance and characteristics, reflecting the land and climate from which they originated. In the Outer Hebrides the sheep were multi-horned and dark brown or black; a similar sheep, the Manx Loghtan, grazed on the Isle of Man. These and the hardy, fine-woolled Shetland and Orkney (Colour Plate 207) sheep may be descended from animals brought by the Vikings. The Scottish Dunface (Colour Plate 209), now extinct, was a common sight in central Scotland; Cheviot and Scottish Blackface were found in the Borders. Moving down to the Lake District were the Herdwick (Colour Plate 210), made famous by Beatrix Potter, the Swaledale and the now almost extinct Whitefaced Woodland. In the Midlands grazed the flocks of Lincolns, Leicesters and Cotswolds descended from the great monastic long-wool flocks. The Southwest of England and Southern Midlands were covered with fertile heath sheep, white faced and long legged. In Dorset the Dorset Horn could lamb twice yearly, and a multitude of types flourished in the Welsh uplands and on the moors of Devon and Cornwall.

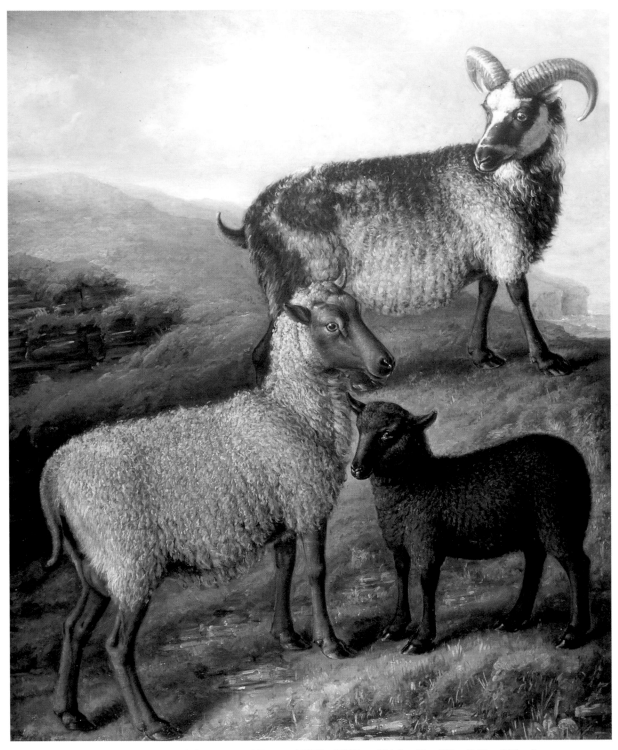

Colour Plate 207. *Orkney Ram and Ewe,* c.1835 by William Shiels. 60 x 50in. (152 x 127cm).
Over sixty varieties of sheep flourished in eighteenth century Britain. They varied according to the terrain from the hardy highland breeds to the larger, plump breeds of the lowlands.

Since the Middle Ages, Britain had grown wealthy on the profits of the wool trade. Sheep were bred for their wool first; they were also a valuable source of milk, particularly in areas which were too poor to support a cow. Meat was a tertiary consideration and no attempt was

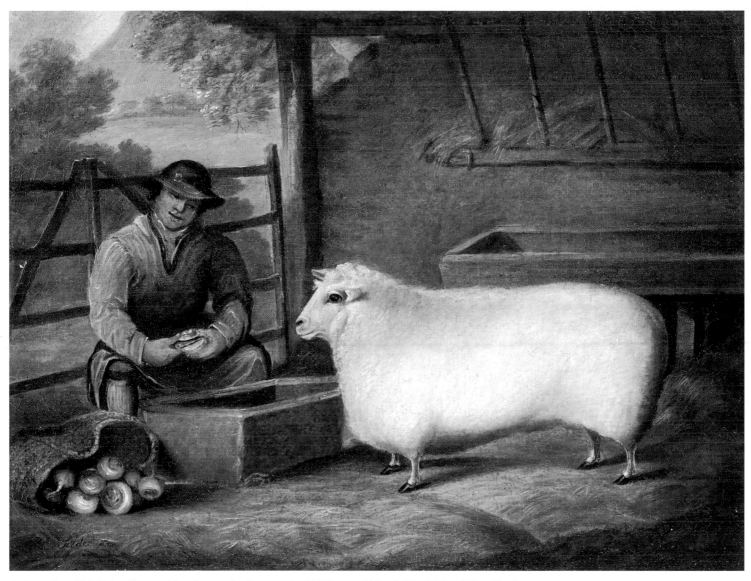

Colour Plate 208. *Prize Sheep with a farmer feeding turnips* by Thomas Alder. 15¾ x 21¼in. (40 x 54cm). Improved fodder crops enabled sheep to be given additional food during the winter months when pasture was poor. This allowed the young sheep to be fattened for slaughter much quicker. Clifford Ellison

made to fatten sheep or improve their quality of carcass; they were still lean, large boned, scraggy looking animals with long legs to roam in search of fodder. They were slaughtered only when they were no longer useful as breeding, milking or wool-producing animals. Sheep from each area produced their own specialised type of cloth. In the Midlands, the lustre wool of the Leicester and Lincoln made Kersey cloth; the rye growing area round Leominster in Herefordshire bred the finest woolled sheep, the Ryeland, whose wool was so valuable it was known as 'Lemster Ore', and in the Cotswolds, the soft fine wool of its sheep was made into a light serge fabric which was in demand all over the world.

By the later seventeenth century, the cloth trade was beginning to falter, cheap wool was being imported from abroad and towns were growing and changing. The country was turning from a subsistence economy into one in which large amounts of food were needed to feed the urban working classes. Just as he had experimented with Longhorn cattle to breed a more effective meat-producing animal, Robert Bakewell turned to the long-woolled Leicester sheep to produce an improved mutton animal. From the mid-eighteenth century new breeds began to emerge but it

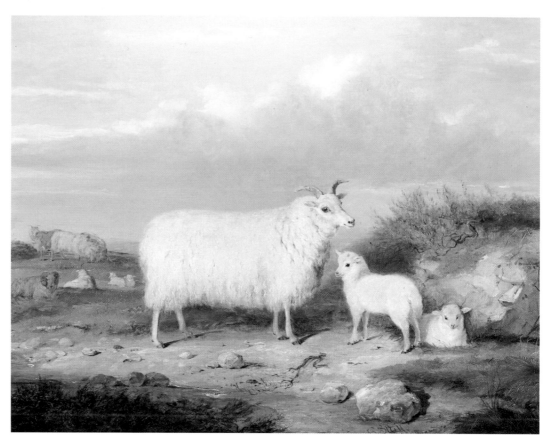

Colour Plate 209. *Brae Moray Ewe* by Gourlay Steell, 1845. Oil on canvas, 27 x 35in. (68.5 x 89cm).
The property of Alexander Forbes, Esq., of Boyndlie, Fraserburgh. Now extinct, the Scottish Dunface was once a common sight in Scotland.

Royal Highland and Agricultural Society

was not until the late nineteenth century that formal associations were established, fixing the characteristics of named breeds. The Dishley Leicesters spread all over the country. Their descendants, the Bluefaced Leicesters, are still the preferred sires for crossing on the pure hill breeds to produce the half-bred ewes which dominate the lowland farms.

Bakewell built on the pioneering work of breeders like Joseph Allom of Clifton, Nottinghamshire. He selected the large Leicester sheep (Colour Plate 211), crossing it with the similar looking Lincoln, and then fixed his chosen characteristics by inbreeding. He is believed to have worked in secret for ten years before allowing his results to be publicised. As with his work on Longhorns, Bakewell was aiming at the perfect butcher's animal. This was early maturing with a barrel-shaped body, short legs and small head and bones. His friend George Culley described the New Leicester as surpassing all other breeds in its ability to fatten and the return given for the amount of food consumed. He goes on to describe 'The fine lively eyes, clean head, straight, broad flat back, the barrel-like form of the body, fine small bones, thin pelt and inclination to early maturity'. Bakewell's sheep were ready for slaughter after two years as opposed to three or four and his most famous ram was named 'Two Pounder' because it had such a small head and round body that it resembled the shape of a cannon barrel. There is a marvellous painting of 'Two Pounder' by J. Digby Curtis in the Unit of Agricultural Economics, Oxford (not illustrated). In contrast, an Old Leicester ram seen by William Marshall at the Leicester Ram Show in 1784 was described as 'the lowest form of degeneracy. A naturalist would have found some difficulty in classing him and seeing him on a mountain might have deemed him a cross between a sheep and a goat.' The old Leicester had a large frame, heavy bone, and long, thick legs which culminated in large splayed feet. Its body was sharp and angular and did not improve even with good pasture.

The New Leicesters are the most commonly reproduced sheep until the mid-nineteenth century. In contemporary paintings they appear as rather pathetic animals, the Bessie Bunter of the school playground. They are so fat they can scarcely walk and their ridiculously short legs brought their stomachs so close to the ground it became difficult for the lambs to suckle. Their tiny heads

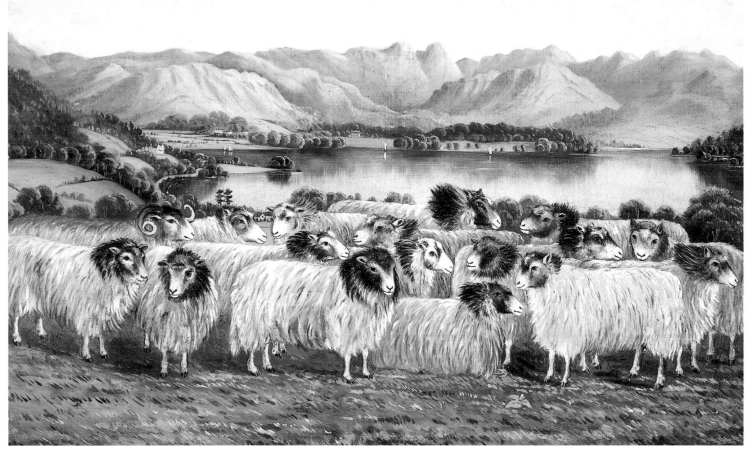

Colour Plate 210. *A flock of Herdwick sheep at Windermere seen from Low Wood* by Taylor Longmire of Ambleside, c.1870. Oil on canvas, 17½ x 25½in. (44.5 x 65cm).
The Herdwick is one of the few white face hill sheep which still flourishes. The breed was championed by Beatrix Potter and is now farmed on the extensive landholdings of the National Trust in the Lake District. Taylor Longmire was born in the Lake District. He studied under Mr Howe and lived at Ambleside.
Reproduction Courtesy of the National Trust

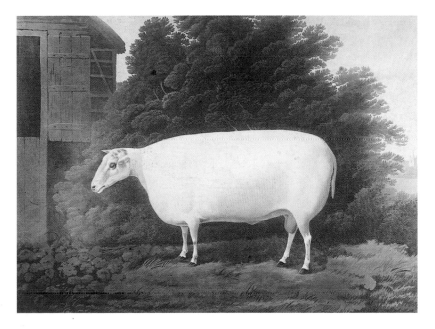

Colour Plate 211. *A New Leicester Ram* by John Boultbee, engraved by Francis Jukes, 1802. 17 x 22½in. (43 x 57cm).
Inscribed: *Portrait of a two-year-old ram, of the New Leicestershire kind; – bred by Mr. Honeyborn of Dishley.*
Mr Honeyborn was Robert Bakewell's nephew who inherited his farm at Dishley Grange but failed to make much of a success of it. Boultbee has made this ram appear enormous by isolating it in the centre of the painting. It shows the small head, short legs and barrel-shaped body Bakewell was aiming at.
Lawes Agricultural Trust, Rothamsted Experimental Station

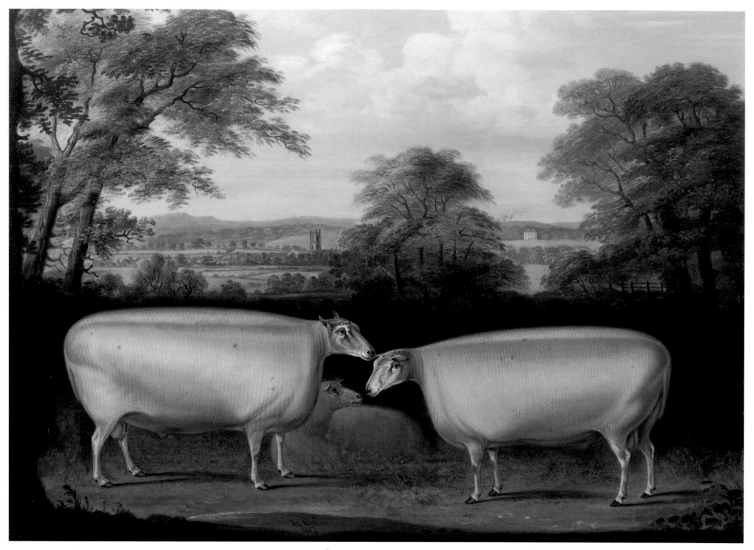

Colour Plate 212. *Three Shorn Leicester Rams* by E. Brown, 1837, Oil on canvas, 24 x 31in (61 x 78.7cm). Sheep are often portrayed shorn to show off their carcass size and shape. This accentuated the smallness of the New Leicester's head in proportion to its body. Edward Brown worked in Warwickshire and Coventry painting sporting and livestock portraits for local patrons. Maximilian Von Hoote

protrude from their enormous bodies in a way that makes them look not just docile but quite stupid (Colour Plate 212). Intensively reared on the finest pasture, supplemented by root crops, they look incapable of walking up a hill, let alone being herded by a sheep dog. Even allowing for the fact that their coats were fluffed up and teased out before painting (Colour Plate 213) and artistic licence which straightened a back here and rounded out a belly there, there is no question that the animals really did look like this. Marshall describes seeing two and three year old wethers so fat they were hardly able to run 'and whose fat lay so much about the bone, it seemed ready to be shook from the ribs at the smallest agitation'. Compare George Garrard's model of the *Old Lincoln Ewe* (Plate 84) with that of a *New Leicester Ewe* (Plate 85). The old breed has a head in proportion to its body, its stomach is a comfortable distance from the ground and it appears capable of bearing its own weight. By comparison the Leicester looks as if it is about to tip forward it is so heavy in the forequarters, its monstrous body looks bloated and swollen, it seems to have no shoulders, the tiny legs just disappear into the barrel-shaped body and the head is ridiculously out of proportion to the rest of the body. Sheep were not exhibited as curiosities in the same way as cattle but it was not uncommon for them to be as much as 6ft. in girth and weigh over thirty stone.

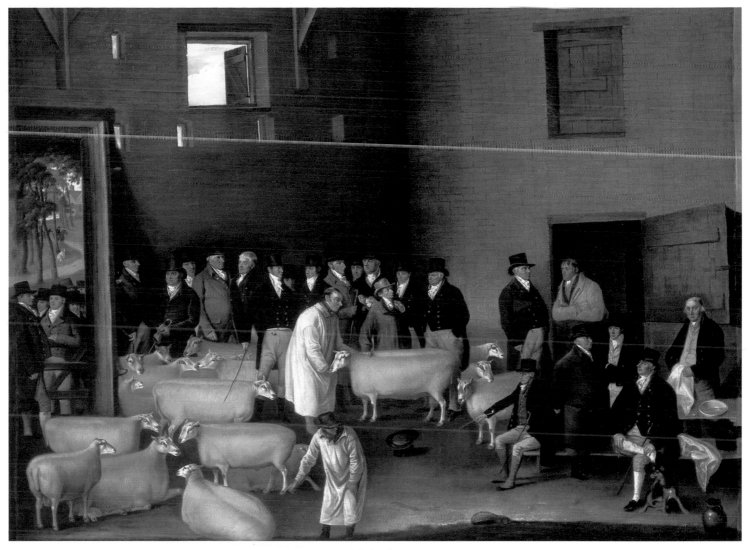

Colour Plate 216. *Thomas Morris's Ram Letting* by Thomas Weaver, 1810. Oil on canvas, 40½ x 50¾in. (103 x 129cm).
Thomas Morris farmed at Barton-on-Humber, in Lincolnshire. Ram-lettings similar to those instigated by Robert Bakewell were held all over the country.

work predated Mendel's by nearly a century but was remarkable for its scientific soundness. Bakewell let his customers value the rams as they thought fit and bid a fair price. In this way it was impossible for the high prices paid to give offence. The money earned through ram letting was phenomenal. In 1786 by letting twenty rams he made 1,000 guineas, in 1789 he earned 1,200 for letting three brothers and 2,000 for seven other rams. His top ram 'Two-Pounder' was said to have earned more than 1,200 guineas in one year. It was estimated that the total made in 1789 by Bakewell and six or seven other prominent Midland breeders was £10,000.

Weaver's painting of 1810 shows a private ram letting in process. The scene has been traditionally believed to represent Robert Bakewell's ram letting in the Great Barn at Dishley (Colour Plate 216). However, the painting is dated fifteen years after Bakewell's death and none of the figures has been satisfactorily identified. A key originally published in the *Catalogue of the F. Ambrose Collection of Sporting Art* is now thought to be erroneous. Bakewell's barn was far more likely to have been a stone and timber construction, not brick as represented in the painting, as indeed it appears in the background of the portrait of Robert Bakewell on his cob. He also made a practice of showing his rams separately to the annoyance of the other breeders as it made

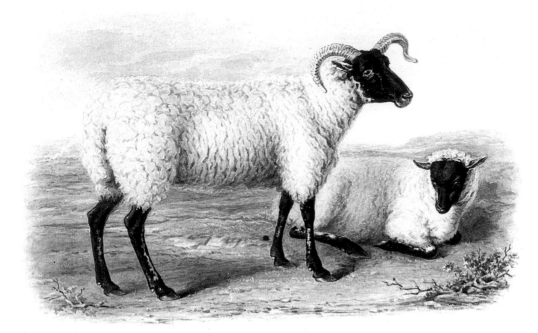

Colour Plate 215. *Old Norfolk Ewe,* c.1840. Watercolour on paper, 10¾ x 14¼in. (27.3 x 36cm).
Inscribed: *The old Norfolk breed ewe 3 years old the property of Mr Brown Norton descended from the flock of Mr Turner.*
This may be one of William Nicholson's drawings from Shiels' original oil paintings from which the lithographs for *The Breeds of Domestic Animals of the British Islands* were made. The Norfolk breed was well known for its high quality mutton. However, it fell from fashion, was extensively crossed with other breeds and by 1845 the pure Norfolk had become extremely rare.
Lawes Agricultural Trust. Rothamsted Experimental Station

The joint was 17 lb in weight, at my desire the fat which dripped in cooking was measured and it amounted to between 2 and 3 quarts, besides which the serving dish was a bog of loose, oily fat, huge deep flakes of it remained to garnish that which we called, by courtesy, lean, being itself also thoroughly interleaved and impregnated. It struck me forcibly that an addition of a reasonable quantity of bone, and exchange of 7 or 8 lbs of fat for lean meat, would have contributed much to the actual value and good character of the joint. Little of it was eaten at our table, and I have reason to believe not much more at other tables.

Despite the opposition of traditional farmers, the New Leicester was taken up by the progressive agriculturalists to become the most fashionable breed by the 1780s. Bakewell's calculated practice of ram letting ensured that by the end of the century they had interbred throughout the country. Because of their inherent drawbacks and their need for such high quality pastures, they were used to improve other breeds passing on their large size and early maturing qualities rather than actually replacing them. It was their excessive fatness and a change in taste from fat to leaner meat in the mid-nineteenth century which led to their fall from favour. Ram letting had originated in Lincolnshire, but it was Bakewell who popularised it. From 8 June until Michaelmas private shows were held by the principal breeders. They kept open house, entertaining lavishly and only once the rams had been shown privately and the top breeders had selected the finest stock were they taken to the public shows. Before Bakewell these shows had merely been a means of selling rams, but he turned ram letting into a serious business and of course the high prices bid ensured a degree of publicity which promoted the new breed even more.

In 1783 Bakewell established the Dishley Society, whose members were a select group of New Leicester breeders. The bulk of its members were farmers and landowners from the East Midlands but, to show how widespread Bakewell's influence was, among its members were the Duke of Bedford, the Marquess of Buckingham, Lord Egremont and Thomas Coke, all of whom established flocks of New Leicesters. Ostensibly it was to protect the purity of the new breed, but in fact it created a monopoly to further their interests. Rule number eight stated that 'Mr Bakewell engages not to let any ram for less than 50 guineas to any person residing within 100 miles of Dishley', while number nine ensured that 'No member shall let a ram to any person residing within 30 miles of Leicester and, not being a member of the society, who shall have hired a ram of Mr Bakewell during the preceding season'. To widen the choice for further selection, Bakewell developed a system of progeny testing. The carefully controlled use of his sires on other farmers' flocks and herds gave him a much wider range of genetic material to improve his breeds. His

Plate 84. *Old Lincoln Ewe* by George Garrard, c.1800. Plaster model. The Natural History Museum, London

Plate 85. *New Leicester Ewe* by George Garrard, 1810. Plaster model.
This is the only model in the Natural History Museum which is inscribed on the back *Fat Leicestershire Ewe, G.Garrard, May 31st, 1810.*
A comparison of these two models demonstrates how enormously Bakewell had altered carcass size and conformation in the development of the New Leicester. The Natural History Museum, London

against Bakewell's. In the same letter he describes Bakewell's animals as 'without size, without length and without wool'. Bakewell, on the other hand, considered the Lincoln to have a 'barrowful of garbage for mutton' and he bought 'an outstandingly ugly' Lincoln sheep and kept it at Dishley to set off his New Leicesters. Even before his death, Bakewell's sheep were being criticised for their poor milk production, loss of wool, their poor performance as breeders and the excessively fine grazing they required. Even Arthur Young, one of Bakewell's most fervent admirers, who felt Bakewell's sheep to be superior to any other breed, had doubts about the quality of the meat. 'Norfolk, Southdown and Mountain mutton are beyond all question finer flavoured; and if I kept a stock of Mr Bakewell's sheep, I should at the same time have some others, as a man keeps deer for his table without any idea of any profit attending them'. Likewise Thomas Coke sold Dishley Leicester meat at 5d. a lb. to the poor while eating the much leaner mutton of the local Norfolk sheep (Colour Plate 215).

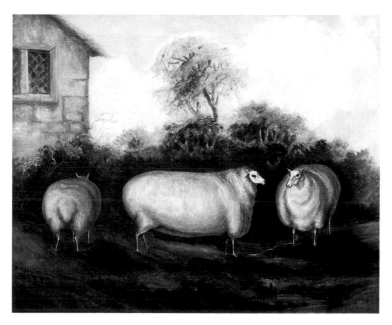

Bakewell was going for quantity of carcass rather than quality, producing meat with an enormous amount of fat. His sheep were especially full in the forequarters, instead of the hind legs and saddles where the best cuts of meat come from, with huge lumps of fat on the ribs behind the shoulders. In 1783 James Bolton of Alnwick recorded that his three-year-old wether of the Dishley breed had 7⅛in. of fat on the ribs and a back like the fattest bacon hog. It has to be remembered he was producing meat for the working classes and fat mutton was much cheaper than lean. In 1809 Pitt reported a remark made by Bakewell to a gentleman who was complaining 'That his mutton was so fat that he could not eat it'. 'Sir,' he replied, 'I do not breed sheep for gentlemen but for the public.' John Lawrence, writing in 1805, describes eating such a leg of prize mutton:

Colour Plate 214. *Three Fat New Leicester Sheep in a Landscape* by C.W. Jacques, 1833. Oil on canvas 22 x 26in. (56 x 66cm).
The New Leicester produced meat with an enormous quantity of fat. It was especially full in the forequarters instead of the hind legs and saddle where the best cuts lay. (For other illustrations of New Leicesters see also Colour Plates 63-67 and 78.) Private Collection

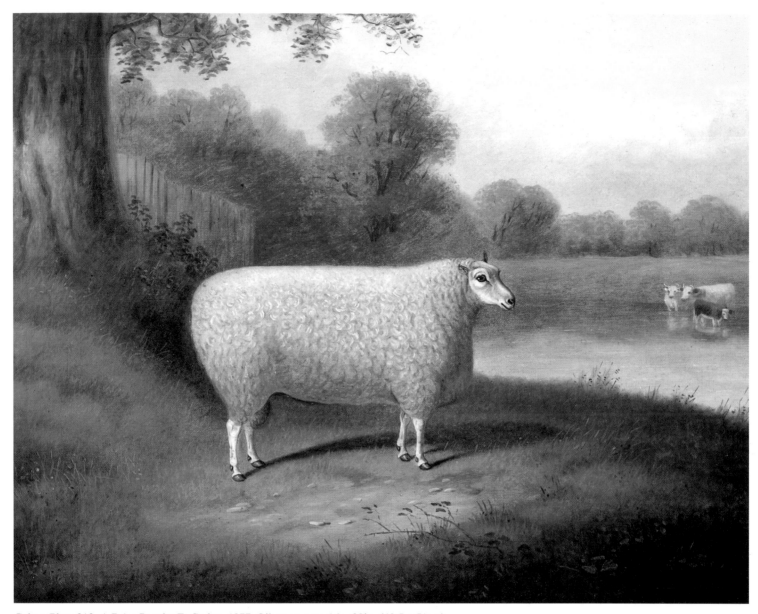

Colour Plate 213. *A Prize Ram* by E. Corbet, 1877. Oil on canvas, 16 x 20in. (40.5 x 51cm).
Before being painted or exhibited the coats of sheep were teased and fluffed out to produce the perfectly rounded proportions of this animal. Corbet was a prolific sporting and animal artist. He contributed many of the illustrations to the *Farmers' Magazine* series. From the collection of John and Carter Schwonke

Bakewell manipulated breeds, sacrificing much of their charm and suppressing their natural tendencies, to breed a production line animal. His rams were so over fed before the ram shows that they had to be let down on poor pasture before they could be any use as they were too fat to tup the ewes. Although he treated his animals kindly and did everything to ensure their comfort, washing their fleeces until they were snow white and sending his prize rams out in two-wheeled sprung carriages, this did not stop him from making sure that some of the ewes he sold for slaughter were infected with liver fluke – something he could easily have prevented – so that his competitors could not breed from them.

Bakewell encountered considerable opposition from the traditional breeders, among them Charles Chaplin, a breeder of the Old Lincoln. The two exchanged ferocious letters in the local newspaper, Chaplin accusing Bakewell 'of meanly sneaking into my pastures at Wrangle' to examine some of his rams before one of the Lincolnshire sheep fairs where they were to be judged

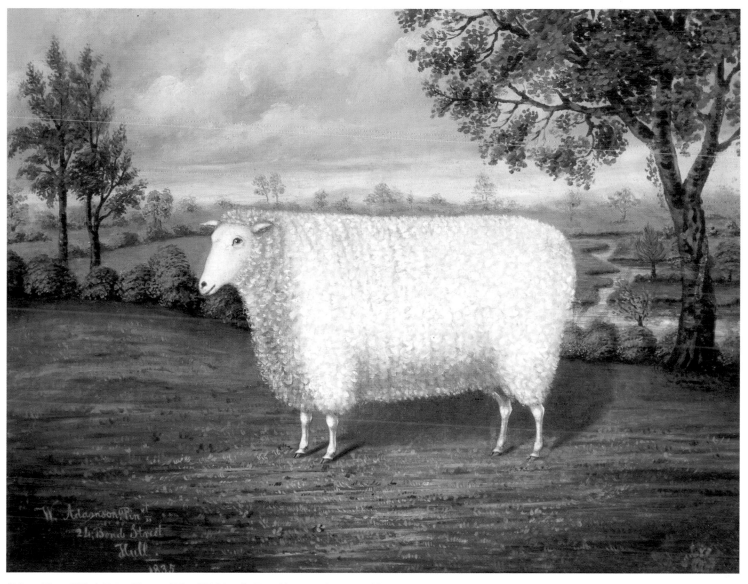

Colour Plate 217. *A Prize Sheep of The Old Lincoln Breed* by W. Adamson, 1835.
Inscribed: *W. Adamson Pinxt. 24 Bond Street, Hull. 1835.*
The thick curly fleece of the Old Lincoln with its excellent wool quality can be clearly seen. After crossing with
New Leicester and Merino rams, the Improved Lincoln became a successful mutton-producing sheep quite similar
to the New Leicester. The fine quality of its long-woolled fleece suffered but was suitable for the carpet making
and worsted industry. Private Collection. Bridgeman Art Library, London

it very difficult to compare one with another. The painting can now be conclusively identified as
representing a ram letting at Thomas Morris' farm at Barton-on-Humber. Frank Weaver's article
published in the *Shrewsbury Chronicle* in 1907 gives us the following crucial information:

> In 1809 he paints a portrait, large size, of the short-horned bull, Patriot, for Thomas Morris of
> Barton-on-Humber, and portraits of Mr. Morris's father and mother. In 1810 he paints a portrait of
> this same Thomas Morris, and begins upon a group of Mr Morris's Sheep Show. He gives the names
> of 27 gentlemen in the group and introduces 14 Leicester tups.

Tantalisingly, Frank Weaver does not record the names of those present. Until Weaver's original
diaries are located it will not be possible to identify the figures. The breeders present are a mix-
ture of gentry and farming types and several other characters are crowding around the gate to be
let in. A shepherd is showing one particular ram while the others jostle for space in the barn.

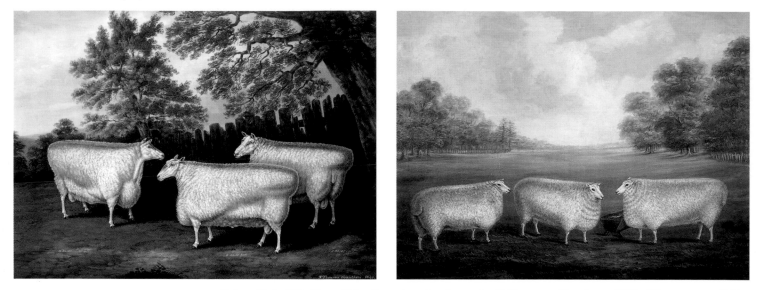

Colour Plate 218. *Three Prize Rams in a Landscape* by T. Yeomans, Grantham, 1841. Oil on canvas, 27½ x 36in (70 x 91.5cm).
Inscribed *2,3 and 5 shear.*
The inscription refers to the number of shearings or age of the animals. A great deal of money and prestige was tied up in breeding the finest rams. Bakewell instigated the policy of ram letting which not only gave him a valuable income but enabled him to monitor the effect of his sires on other farmers' flocks. The annual ram sales continued to be the most important events on sheep farms throughout the 19th century.

Maximilian Von Hoote

Colour Plate 219. *Three Prize Sheep* by J. Flege, 1859. Oil on canvas, 21 x 26in. (53 x 66cm).

Collection of Michael and Ann Judd

Plate 86. *Cotswold Sheep at the International Cattle Show at Poissy, 1862.* Engraving from the *Illustrated London News.* 7 x 10in. (18 x 25cm).
Inscribed: *One of Mr Thomas West's Prize of Honour Cotswolds. One of M. de Lalouel de Sourdeval's Prize of Honour Berrichon-Cotswold-Berrichons.*
These sheep have been sheared for showing but a sample of wool has been left to show length and quality of fleece. Courtesy of Lyn Gibbings

Competition from the New Leicesters made the Old Leicester and Lincoln virtually extinct, but while the new breed flourished on the rich parkland of the gentlemen's estates, they were unsuited to upland areas and therefore did not replace the many varieties of hill and mountain

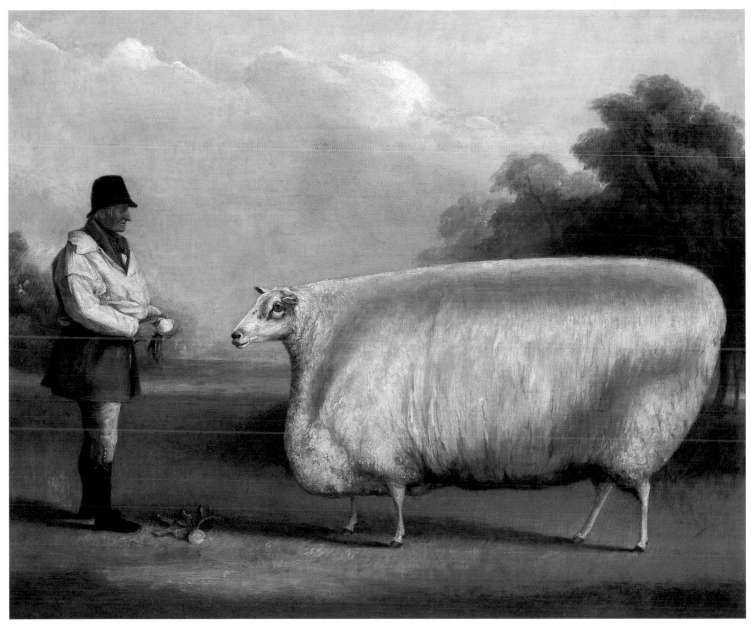

Colour Plate 220. *Prize Sheep Being fed Turnips* by W.H. Davis, 1838. Oil on canvas, 21½ x 26½in. (55 x 67cm). Museum of Lincolnshire Life, Lincolnshire County Council

sheep. Animal portraiture follows fashion, so it is very rare to find illustrations of the hill and mountain breeds. The New Leicester, however, was used to improve both Lowland and Upland breeds. The Cotswold, the great wool sheep of Medieval England, is another breed which, crossed with the New Leicester, became an important and large meat producing animal capable of going to a weight of 90lb. a quarter and selling for up to 210 guineas. Cotswolds are easy to recognise; they have an extremely long and shaggy coat and, although they are usually portrayed shorn, they have a curly top knot which falls over their face which is not clipped when the rest of the sheep is shorn, giving buyers the opportunity to assess the quality of the wool even after shearing. Illustrations of them are fairly common. According to local tradition, the Cotswold shepherds were buried with a lock of sheep's hair placed on their coffins to explain their absence from church on Sundays. The Cotswolds breeders of the mid-nineteenth century, the Lane and Garne

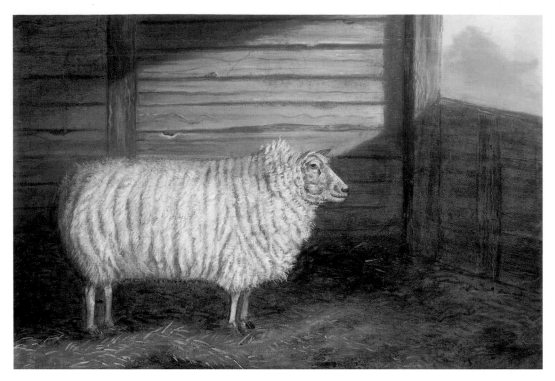

Colour Plate 221. *A Prize Sheep in a Barn,* unknown artist, c.1850. Oil on canvas, 11 x 14½in (28 x 37cm).
The sheep's coat has been teased out and groomed into an elaborate pattern to show it off to its best advantage. All sorts of tricks were practised on sheep to improve their chances at the agricultural shows; teeth were filed to make the animals seem younger and their coats were artificially sheared to make them appear more symmetrical.

Maximilian Von Hoote

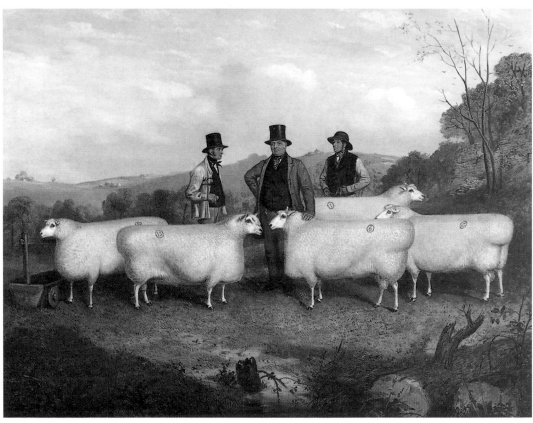

Colour Plate 222. *Robert Lane, his foreman, Mr Day, Shepherd and Five Prize Cotswold Rams* by Richard Whitford, 1861. Oil on canvas, 35½ x 45½in. (90 x 116cm).
Robert Lane was the brother of William Lane of Broadfield Farm; he farmed at Crickley Barrow, near Northleach. The rams depicted fetched an average of 100 guineas apiece. No. 13 fetched 120gns. and No. 6 100gns. This portrait is typical of several paintings by Whitford depicting the Garne and Lane families on their Cotswold farms. (See Colour Plate 121.) Private Collection

families (Colour Plates 121, 222, 223 and 224), carried off most of the prizes at the agricultural shows and held annual ram sales which lasted for several weeks and were great social as well as business events. Their flocks were immortalised by the Gloucestershire artist, Richard Whitford, and the paintings would have been displayed at the annual ram sales. The Garne family continued

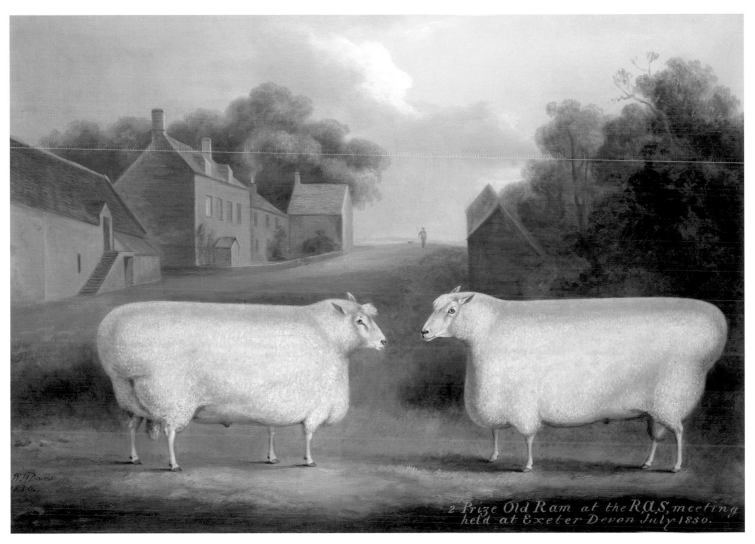

Colour Plate 223. *William Lane's Cotswold Rams* by W.H. Davis, 1850. Oil on canvas, 22 x 30½in. (56 x 77.5cm). Inscribed: *2 Prize Old Rams at the R.A.S. Meeting held at Devon July 1850.*
See also Colour Plate 121. William Lane's farm, Broadfield Farm, Northleach, can be seen in the distance.

Maximilian Von Hoote

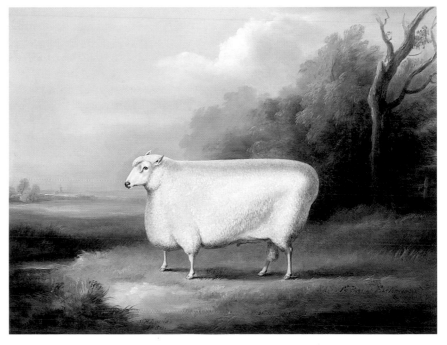

Colour Plate 224. *William Garne's Champion Cotswold Ram* by W.H. Davis, 1850. Oil on canvas, 27 x 20½in. (68.5 x 42cm).
William Garne farmed at Blackpitts Farm, Aldsworth. He was the first of the Garne family to export sheep, sending them to America in 1832. He showed at the RASE every year from 1849 taking first prize in 1849, 1850, 1851 and 1852. This ram won at the Exeter Show of 1850.

Richard Garne

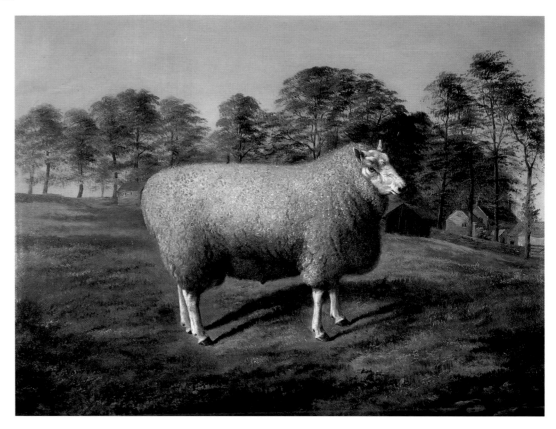

Colour Plate 225. *North Country Cheviot Ram* by B.C. Norton, 1865. Oil on canvas, 20 x 26in. (51 x 66 cm). Crossed with New Leicester blood, the Cheviot became a larger sheep with more wool but the fleece quality suffered.
From the Collection of Delsa and Rob Ham

to farm Cotswolds when all around them the breed was being abandoned. After the Second World War, Will Garne of Green Farm was the only farmer left with a pedigree herd of Cotswolds and it is thanks to him that the breed has survived today.

New Leicester blood was less successfully introduced into another long-wool breed, the Romney Marsh. The sheep became too delicate for the husbandry system of the Marsh and farmers began to breed back to type. With the Ryeland, New Leicester blood had the sad effect of increasing the carcass size and raising the weight of clip while tragically coarsening the fleece of England's finest wool sheep. Crossed with the Cheviot (Colour Plates 225 and 226) and the Blackface (Colour Plates 227 and 228) in the Borders, the New Leicester blood produced an improved sheep with a larger carcass and more wool, although again at the expense of quality. The Cheviot had lost so much of its hardiness that whole flocks were wiped out in the severe winters of the 1870s. Likewise the improved Shetland was unable to withstand the inclement weather and the famous soft Shetland fleece coarsened, causing breeders to revert back to type.

In the more rigorous climate of Northern England a separate, hardier breed, the Border Leicester, developed. Bakewell's friends Mathew and George Culley moved to Fenton in Northumberland, working with Bakewell's New Leicester, and produced a new improved sheep which became known as the Border Leicester. Bewick's engravings of the Improved and Unimproved Teeswater (Plates 87 and 88) represent the Old Teeswater and the New Border Leicester and show how

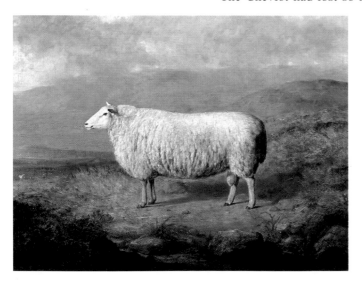

Colour Plate 226. *Cheviot Tup* by Gourlay Steell. Oil on canvas, 27¾ x 33¾in. (70.5 x 85.5cm).
Bred by Messrs. Young & Craig, Bighouse, Sutherlandshire. The tup was aged three years and five months at the Society's General Show at Aberdeen in October 1840 when he gained first prize in his class.
Royal Highland and Agricultural Society, Ingliston

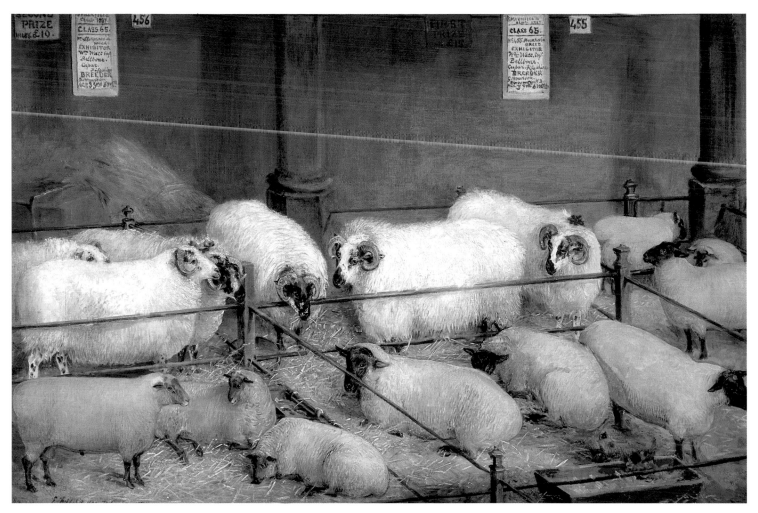

Colour Plate 227. *Scottish Blackface Sheep at Smithfield* by E.F. Holt, 1887. Oil on canvas, 16 x 24in. (40.5 x 61cm). Inscribed: *Second prize No. 486 £10 Smithfield Club 1887 Class 65 No 456 Mountain breed. Exhibitor Wm Watt Esq, Bell Brae, Cupar, Fifeshire. Breeder Geo Blair, Age 3 yrs and 6 mths. First Prize No.455 Mountain Breed. Exhibitor Wm Watt Esq, Bell Brae, Cupar, Fifeshire.* Iona Antiques

Plate 87. *Tees-Water Old or Unimproved Breed* by Thomas Bewick from *A General History of Quadrupeds* first published in 1790. Woodcut, approx. 2¼ x 3¼in. (5.75 x 8.25cm).

Beamish: The North of England Open Air Museum

Plate 88. *Tees-Water Improved Breed* by Thomas Bewick from *A General History of Quadrupeds* first published in 1790. Woodcut, approx. 2¼ x 3¼in. (5.75 x 8.25cm).

Bewick's illustrations show how the Border Leicester changed as a result of crossing with the New Leicester.

Beamish: The North of England Open Air Museum

Colour Plate 228. *A Scottish Blackface Ram in a Landscape* by W. Luker, 1845. Oil on canvas, 20 x 24in. (51 x 61cm).
After crossing with the New Leicester, the Scottish Blackface became a larger sheep providing more meat.
Private Collection

Colour Plate 229. *Southdown Tup bred by the Duke of Richmond* by Gourlay Steell, 1843. Oil on canvas, 27 x 35in. (68.5 x 89cm).
The animal won first prize in his class at the Society's General Show at Dundee in 1843.
Royal Highland and Agricultural Society of Scotland

dramatically the animal changed. The old Teeswater became extinct although its special wool quality remained in the new breed. The Culleys formed a society similar to Bakewell's and were soon in competition with it, hiring rams to many of Bakewell's breeders. The wethers fattened quickly and the ewes produced fine early maturing lambs. Although the Border Leicester supplanted the Old Teeswater, many farmers remained faithful to the local Cheviot and Black-faced breeds which had been improved by crossing with New Leicester blood.

In the long term, however, it was the Southdown which proved to be even more influential than the New Leicester as Britain's major mutton producing sheep. Between them the New Leicester and the Southdown dominated sheep breeding until well into the nineteenth century. Up to 1860 no other breed figured in the Supreme awards at Smithfield. Unlike the Leicester, with all its inherent defects, the Southdown by the 1830s was already a sheep of great intrinsic butcher's merit, which explains its ascendancy. From the 1780s John Ellman of Glynde near Lewes devoted about fifty years to the improvement of this breed. His results were not as spectacular as Bakewell's and little is known about his methods. He did not cross-breed but is believed to have mated ewes with undesirable characteristics to rams selected to correct this weakness. He produced a small, fast-growing sheep of good quality meat which was ideal for the butcher, but hardier than Bakewell's New Leicesters. The Southdown was able to fatten well on the relatively poor downland pastures without additional feeding. Ellman was a modest man, the son of a farmer, who rose to considerable fame. The Southdown, like the New Leicester, became a fashionable breed and was soon found stocking the estates of gentlemen farmers. Lord Somerville and the Duke of Bedford were regular visitors to the farm at Glynde and George III invited Ellman to visit him on his farm at Kew. Lord Egremont, Thomas Coke (Plate 89) and the Dukes of Bedford and Grafton all established flocks of Southdowns. Later in the mid-century the Duke of Richmond entered the arena with his home-bred flock at Goodwood (Colour Plate 229). Coke described the poor, scrawny, Norfolk sheep, whose fleece had once made Norfolk rich, as a 'vile degenerate breed'. Coke obtained his first Southdowns from Ellman in 1791 or '92 and through the influence of his annual clippings when his rams were available for hire the Southdown

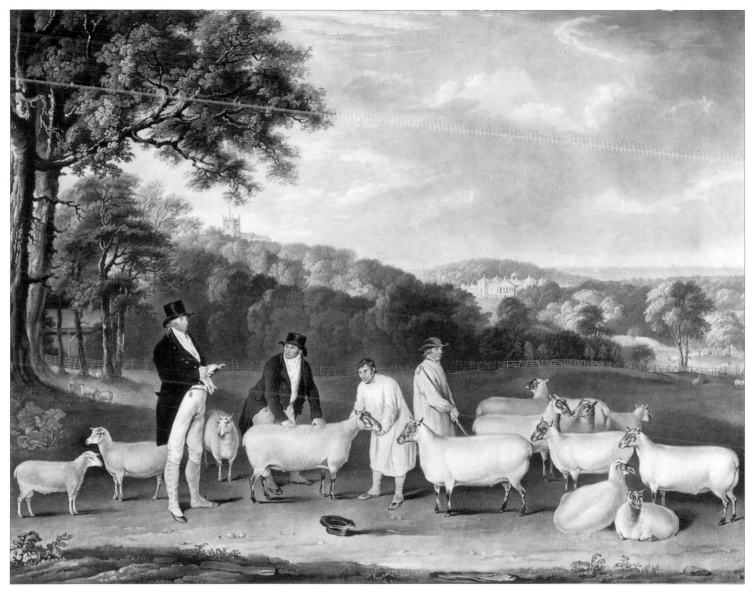

Plate 89. *Thomas William Coke and his Southdown sheep* after Thomas Weaver, engraved by William Ward, 1808. 21 x 29in. (53 x 74cm).
Inscribed: *Portrait of Thomas William Coke Esqr. M. P. for Norfolk, inspecting some of his South-down sheep, with Mr. Walton and the Holkham shepherds. To the Right Honble. the Lord Viscount Anson, this plate is respectfully inscribed by his Lordship's much obliged and very obedient servant, Thos. Weaver.* (Arms of the 2nd Viscount Anson.)
A note in Weaver's diary for 15 August 1809 reads, 'From 15th August to 10th October engaged delivering my publication of T.W. Coke, Esq. Cleared, after paying all expences of publication, £500.'

<div align="right">Courtesy of the O'Shea Gallery</div>

became established as a popular breed in East Anglia. By 1816 there were over 2,000 on his farm and he was said to be most persuasive in 'encouraging' his tenants to farm Southdowns.

In Weaver's painting (Colour Plate 11 and Plate 89) Coke can be seen inspecting his Southdown sheep, apparently entering records into a notebook. The sheep are a good deal smaller and leaner than the New Leicesters and have black faces and legs which represent the halfway house between the ancient Sussex breed and the present small compact sheep which appear white faced as the faces are now covered with woolly hair. The Southdown rapidly became the premier sheep of the English downlands; at Lewes Fair in 1793, 30,000 Southdown sheep were sold. Jonas Webb of Babraham, near Cambridge was another Southdown

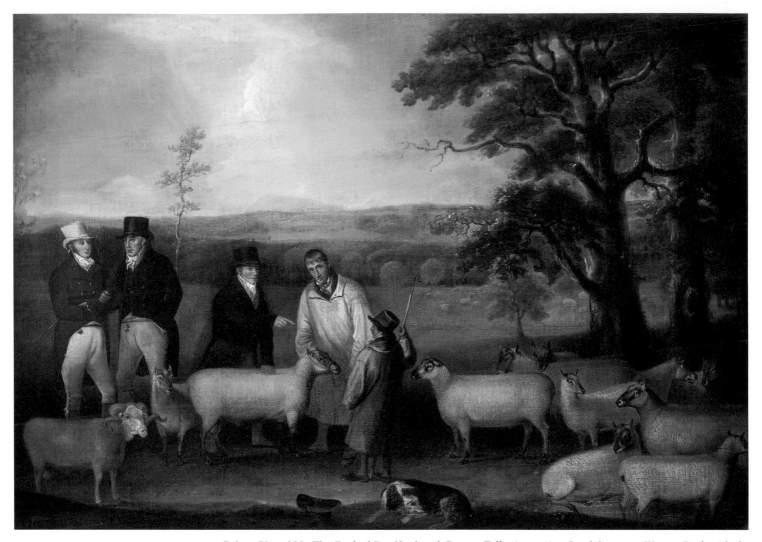

Colour Plate 230. *The Earl of Bradford and George Tollet inspecting Southdowns at Weston Park with the agent, the shepherd and his lad* by Thomas Weaver, 1812. 27½ x 35½in. (70 x 90cm).
The sheep here have the black faces of the Southdown. The painting is described in Weaver's diaries as 'Large group, containing a portrait of Earl Bradford, Geo. Tollet Esq., shepherd and Southdown sheep for Earl of Bradford. Private Collection

breeder (Colour Plate 231). His father had experimented in Norfolk by improving the native sheep with Southdown crosses and Sussex stock was used to establish Babraham's flock. There was great competition between the Sussex and Cambridge breeders, the Sussex men declaring 'they could get as good legs of mutton as Webb did but the Babraham shoulder was beyond them'. More than 2,000 people attended Webb's ram lettings. When he sold his flock in 1861 so great was his reputation that sales were made to farmers in America, Canada, South America, New Zealand, Australia and many European countries.

By judicious crossing, the Southdown transformed all the local rather nondescript Down breeds into far more productive mutton animals and established many new breeds in the early nineteenth century. These were shown by proud owners at the now booming local agricultural shows where they gathered most of the prizes and were duly painted. It is very difficult to distinguish one Downland breed from another. One of the most successful was the Shropshire (Colour Plates 232 and 233) with its black face and legs, although the early Southdowns also had dark legs and faces. The Shropshire was improved by crossing with both Southdowns and New Leicesters. At the Royal Show at Salisbury in 1857, a Shropshire carried off first prize and in 1860 at Canterbury they were awarded their own class. By 1822 when the Flock Book was

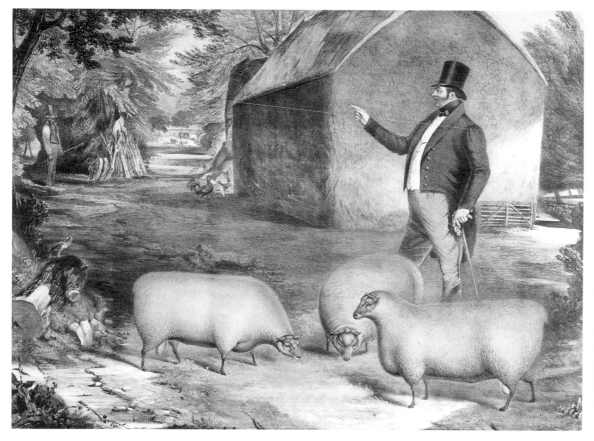

Colour Plate 231. *Jonas Webb and his three Rams* painted and lithographed by J.W. Giles, 1842. Oil on canvas, 16 x 22in. (40.5 x 56cm).

Inscribed: *To the Rt. Honble. Lord Braybrooke, president and member of the Saffron Walden Agricultural Society and Southdown breeders generally, this print of Mr. Jonas Webb, of Babraham, and his three rams, which gained the first prizes at Liverpool 1841, is, with permission, most respectfully dedicated, by their obliged servant, J W. Giles. Clumber, Liverpool Woburn.*

Jonas Webb is shown here with three rams of the Clumber, Liverpool and Woburn breeds. Giles was an Aberdeen sporting artist who moved to London c.1830. He executed many livestock portaits and lithographs.

Lawes Agricultural Trust. Rothamsted Experimental Station

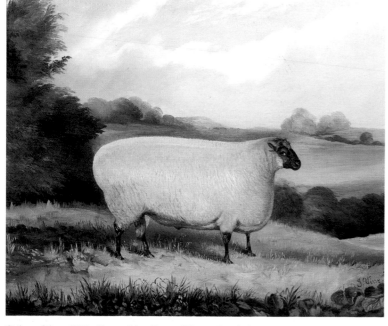

Colour Plate 232. *Shropshire Ram, 'Young Buckskin'* by John Vine, 1859. Oil on millboard, 18 x 24in. (45.75 x 61cm).
Inscribed: *The prize Shropshire Down Ram 'Young Buckskin' aged 2 years, 3 months & 3 weeks; bred by Mr George Adney of Harley, Nr Much Wenlock, Salop. Sire: Buckskin no. 773. He took 3rd Prize of any other age at the RASE, Warwick in 1859.*
Iona Antiques

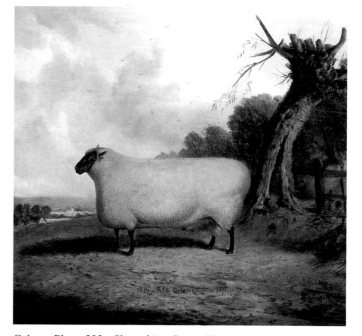

Colour Plate 233. *Shropshire Ram, Hampton Hero* by Richard Whitford, 1871. Oil on canvas, 20 x 24in. (51 x 61cm).
Bred by Charles Byrd of Lillywood, Stafford, the ram won first prize at the RAS show at Wolverhampton in 1871. The Shropshire, with its black legs and face, was one of the most successful Down breeds to be improved by crossing with the Southdown.

Collection of Mr and Mrs Gary Edwards

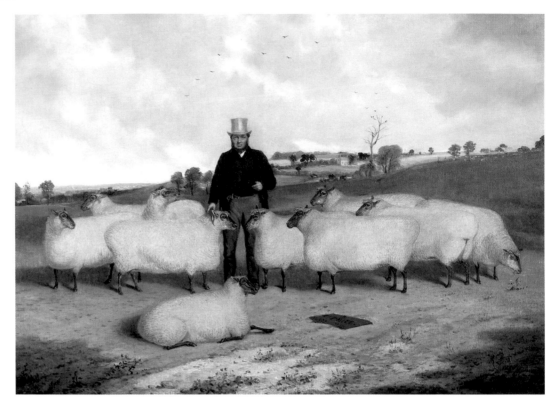

Colour Plate 234. *John Treadwell and his Oxford Down Sheep at Nether Winchendon* by Richard Whitford, 1870. Oil on canvas, 27½ x 35in. (70 x 89cm). By the mid-19th century the Oxford Down was beginning to make inroads on the Cotswold as a meat-producing sheep in the Oxfordshire area.

Buckingham County Museum

established (the first in Britain) they were in existence as prime meat producing animals all over Britain. By the mid-nineteenth century, the improved Oxford Down (Colour Plate 234), the largest of the Down breeds, was beginning to compete with the Cotswold as a meat producing animal in Oxfordshire. In Norfolk the old lean horned Norfolk sheep virtually disappeared after crossing with the Southdown, Old Wiltshire Horn and Lincoln to produce a new breed, the black-faced Suffolk (Colour Plate 235). The Southdown was also adopted by fashionable farmers in Wiltshire, Hampshire and Berkshire replacing the Old Hampshire, Wiltshire Horn and Berkshire Nott. The New Hampshire became a rapid growing, dark faced, hornless animal capable of producing good quality lambs for the butcher. With the introduction of artificial manure and new forage crops it made sense for farmers to sell meat as lambs rather than mutton. In 1802 the Smithfield Show introduced a class for shearlings but it took some time for breeders to accept the concept of fat lamb production. The wether lambs of these fast maturing Down sheep, however, could be sold the following autumn. The Dorset Down was born from a mixture of local sheep, Southdown and Hampshire, and in the West Midlands an admixture of Southdown blood established the Shropshire Down, Kerry Hill, Clun and Radnor out of the complex mass of the sheep breeds of Staffordshire, Radnor and Montgomery.

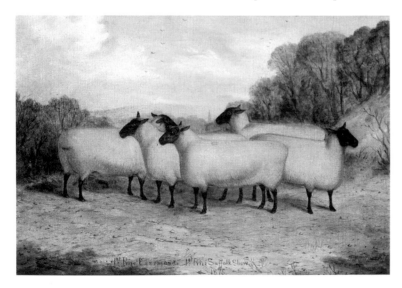

Colour Plate 235. *Five Prize Sheep* by Richard Whitford, 1875. Oil on canvas, 16 x 20in. (40.5 x 51cm).
Inscribed: *1st Prize Suffolk Show 1875.*
These sheep closely resemble the black-faced Suffolk which emerged from crossing the Old Norfolk breed with the Southdown and others to produce a better meat-producing sheep. The new breed was first recognised at the Suffolk Agricultural Association's Show in 1859. Flocks of Suffolks were established in Scotland, Ireland and Wales and by the 1890s they were being exported to Europe, Russia, North and South America. The Suffolk ram was especially valued as a terminal sire on hill breeds Collection of Mrs L. Gardoni de Tinoco, Mexico

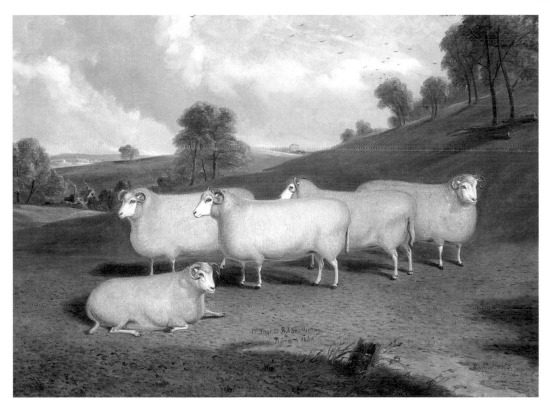

Colour Plate 236. *Five Dorset Horn Sheep* by Richard Whitford, 1865. Oil on canvas, 21 x 27in. (53.5 x 68.5cm). Inscribed: *1st Prize at RAS's meeting Plymouth, 1865. T. Danger Esq. Stile, Bridgewater. He won the Somerset & Dorset Horn Class for the best five sheep in a pen at the meeting at Plymouth in 1865.*
The Dorset Horn was unique in being able to lamb out of season and up until the mid-19th century supplied the London Christmas lamb market. It was one of the few Lowland breeds to remain uninfluenced by either the Southdown or the New Leicester.

Iona Antiques

Although sheep breeding never attracted the same publicity as cattle, for a time in the eighteenth and early nineteenth century it became extremely fashionable. Gentlemen kept primitive sheep like the spotted horned Jacob and the multi-horned Hebridean in their parklands as curiosities. Along with their Old Masters, Canalettos and Antique sculptures, exotic sheep from Spain and Portugal made up part of the baggage accumulated on the 'Grand Tour'. They were, however, even more interested in the way breeds could be manipulated to produce handsome profits and there was scarcely a gentleman's flock without a strong dash of Southdown or New Leicester blood. Events like the Holkham, begun in 1778, and Woburn, begun in 1797, Sheep-shearings, and later the local Agricultural Society shows fostered a keen sense of experimentation and competition amongst the sheep breeders and encouraged them to change and improve their breeds. The Duke of Bedford offered a prize of fifty guineas to the flock owner who spent the most in buying Leicester or Southdown stock while at the 1801 Bath and West Show a prize of twenty-nine guineas was awarded 'To the Stock Farmer who shall have bred and kept... the greatest number and most profitable sort of sheep in proportion to the size of his farm, in consequence of his having changed his flock from what had usually been kept... in the neighbourhood'. It was won by a Mr Duke who had substituted Southdowns for Wiltshires twelve years before and handsomely increased his annual profits.

The publicity attached to George III's interest in sheep must have been one of the greatest fillip's to the breeders. Both Bakewell and Ellman were summoned to meet him when no doubt he discussed his attempts at breeding Merino sheep. George III was convinced these fine woolled Spanish sheep could be successfully introduced to England. The first Merinos to arrive in England were a gift to Sir

Plate 90. *Model of a Merino Ram* by George Garrard, c.1800. Plaster.
The fine long horns and heavy neck are typical of the Merino breed.
The Natural History Museum, London

Joseph Banks from a French scientist in 1785. With the help of Banks, George III established a flock of Merinos on his Marsh Gate Farm at Kew. He started with stock smuggled from Spain, as the export of Merino sheep was forbidden until the late eighteenth century, but in October 1791 received a gift of four rams and thirty-six ewes from the prize Negretti flock of the Count and Countess de Campo di Alange, one of the most famous flocks known to the European wool trade. He went to considerable personal expense to try to establish the breed in England; he had cloth woven from the wool to convince manufacturers of its quality and gave away many of his rams and ewes to interested agriculturalists such as John Ellman, Lord Somerville, Thomas Coke and Arthur Young. In 1807 he obtained a flock of 2,000 from Spain which were distributed throughout the country. Arguments as to the relative merits of the New Leicester, Southdown and Merino raged in the agricultural press as native breeders feared competition from the foreign imports. While no one doubted the superior quality of their wool they were felt to be indifferent feeders, producing poor quality mutton. For the dinner at his annual show in 1811, Lord Somerville served mutton from his merino flock, commenting as he left; 'As I have seen none of you carried out in consequence of eating Merino Mutton, show how by your cheering, that it doesn't disagree with you.'

Lord Western, the Essex breeder who established the Essex pig, formed a society to promote Merinos in 1811. The society held an annual show which followed on from Lord Somerville's in March. By careful crossing with Southdowns, Western, Coke and other breeders produced a good mutton-bearing carcass with plenty of wool, achieving, in the words of Sir Joseph Banks, 'A fine fleece on a fat carcase'. It became fashionable to have a flock of Merinos in the park; their status was similar to that of the imported Alderney cattle. There was also an added element of excitement since the Merinos had for so long been jealously guarded by the Spanish as a monopoly. Attempts to cross the Merino with British breeds, particularly the fine woolled Ryeland, failed. Perhaps it was the damp British climate which caused the Merino wool to become coarse and lank, but the breed never established itself in Britain despite its success abroad, particularly in Australia and New Zealand.

Sheep are the most difficult animals to identify in contemporary portraits because of the way the breeds changed in appearance as they evolved and the subtle nuances which distinguish one breed from another. Between them the Southdown and the New Leicester modified the vast majority of breeds in the country rather than merely replacing them. They fulfilled the need of the time – to produce a quickly maturing mutton sheep – and both of these breeds and the improved offspring they spawned through cross-breeding were widely exhibited and painted. In retrospect they were only part of the answer, for in breeds such as the Shetland and Romney Marsh they upset the complex genetic structure which had evolved over centuries to produce a sheep ideally suited to that particular environment. British sheep have fortunately not suffered the same fate as cattle in competition from foreign imports. On the contrary it is British sheep which form the basis of some of the largest

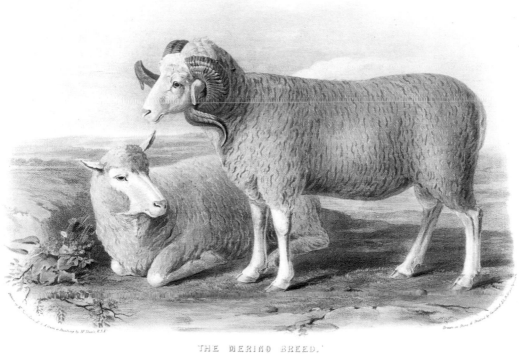

THE MERINO BREED.
Ram & Ewe, bred by Mr Benett, of Pyt House, Wiltshire M.P.

PROFESSOR LOW'S ILLUSTRATIONS OF THE BREEDS OF THE DOMESTIC ANIMALS

Colour Plate 237. *Merino Ram and Ewe* by William Nicholson after William Shiels, 1841. Lithograph from *Breeds of the Domestic Animals* by David Low, 9 x 15in. (23 x 39cm). Bred by Thos. Benett, Pyt House, Wiltshire. Courtesy of the O'Shea Gallery

flocks now farmed in Australia, New Zealand and South America. Some of the old breeds such as the Old Lincoln, Old Leicester and Scottish Dunface are extinct. Several breeds, among them the Portland, Manx Loghtan, Cotswold, Whitefaced Woodland, Leicester Longwool, Shropshire and Oxford Down are now rare breeds but, like cattle, have shown a considerable increase in the last ten years. Including imported foreign breeds and rare breeds there are still more than eighty breeds of sheep in Britain. These flocks, in many cases altered beyond recognition, are the descendants of Bakewell's and Ellman's experiments. The top-hatted breeders strutting before their flocks of fat New Leicesters and Southdowns are not just ridiculous curiosities. They are a unique breeding record and the sheep are the ancestors of the sheep farmed so intensively today. In Australia it is the Border Leicester crossed again with the Merino which makes up seventy-five per cent of the sixteen million prime lambs slaughtered in each year.

Colour Plates 238 and 239. *A Pair of Sheep Dogs*, unknown artist, 19th century. Oil on canvas, 24 x 28¾in.(61 x 73cm).
These dogs of indeterminate breeds were typical of the sheepdogs of the period.
Devonshire Collection, Chatsworth. Reproduced by permission of the Chatsworth Settlement Trustees

227

Above. Colour Plate 240. *A prize sow outside a Sty*, unknown artist, c.1830. Oil on panel, 5½ x 7in. (14 x 18cm).
Collection of Mr and Mrs Paul R. Greenwood

Right. Colour Plate 241. *A prize sow with a farmer outside a sty*, unknown artist, c.1820. Oil on panel, 5½ x 6½in. (14 x 16.5cm).
Pigs of seemingly incredible proportions were commonly painted during the 19th century. For cottagers and smallholders the pig at the bottom of the garden was a vital source of winter food. All that mattered was its weight and fatness; breed and type had no bearing on the value of such animals. 'A Good fat pig to last him all the year' was the philosophy behind the feeding of the family pig, while William Cobbett commented, 'If a pig can walk two hundred yards he is not fat'.
Collection of Mrs John Rowlinson

Opposite, below. Colour Plate 242. *A Prize sow outside a sty* by R. Woodrouffe, 1839. Oil on millboard, 8 x 12in. (20 x 30.5cm).
Collection of the Kanter Foundation

228

OLD ENGLISH BREED.

Old English Sow from the midland Counties

Colour Plate 243. *Old English Pig* after William Shiels, drawn by William Nicholson, 1842. Lithograph from *The Breeds of the Domestic Animals* by David Low, 9 x 15in. (23 x 38cm). Inscribed: *Old English Sow from the Midland Counties.*

Shiels has depicted a typical Old English pig with a long snout, lop ears and fairly long legs. Its shape was to alter dramatically once it began to be crossed with imported oriental pigs in the mid-19th century

Courtesy of the O'Shea Gallery

CHAPTER 6
Developments in Pig Breeding

Pigs never received the same attention from livestock improvers as other animals. Up to the mid-nineteenth century they were not taken seriously as a commercial meat producing animal and the National Pig Breeders Association was formed only in 1884. This is why pig portraits are the most charming, idiosyncratic and most popular of all the animal paintings.

Breeders were not trying to breed true to type but experimenting to produce ever fatter and more distinctive pigs. Shape, colour and fatness were more important than meat production. These paintings were not commissioned by aristocratic and ambitious farmers to establish the specific characteristic of a new breed, so painters had a much greater degree of artistic licence. Very few of the animals can be identified, often even the breed cannot be ascertained. Pig prints are not at all common which indicates there was not a very wide popular interest in the subject and even these, with lengthy descriptions, seldom mention a specific breed.

By the eighteenth century an Old English pig (Colour Plate 243) had developed which was quite different from the Medieval pig. The latter was descended from the wild boar and was small with prick ears, a long body and bristles along the spine. They were more docile than the wild boar (the last of which was killed by James I in Windsor Forest in 1617)

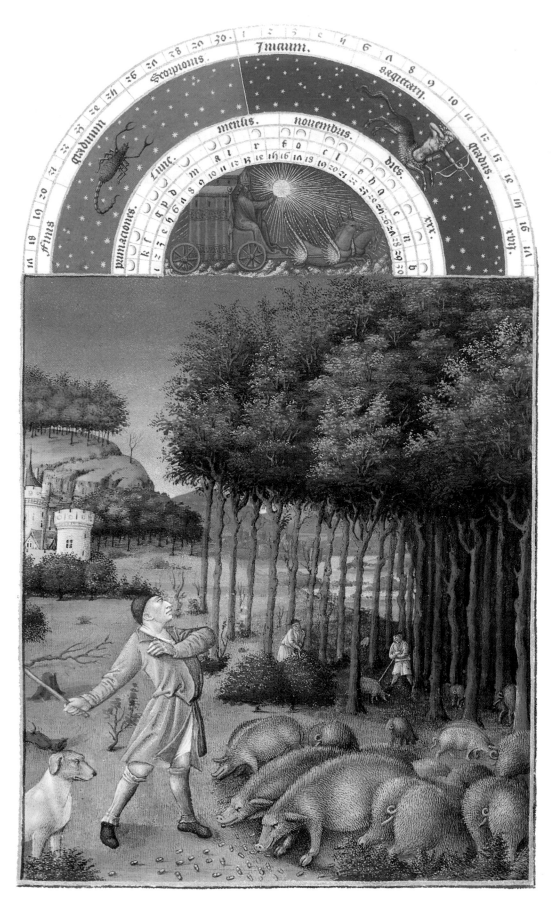

Colour Plate 244. November from *Les Très Riches Heures du Duc de Berry* by the Limbourg Brothers, c.1416. Watercolour and gold leaf on vellum, folio size 11½ x 8¼in. (29 x 21cm).
The swine are being driven into the acorn forest for the pannage season. They are small and prick eared with a long bristly body, typical of the medieval pig which resembled its ancestor, the wild boar. The swineherd is preparing to hurl his stick at the oak tree; at his feet the pigs are eating the fallen acorns, watched by a dog. Giraudon: Paris

230

Colour Plate 246. *A Gloucester Old Spot Sow with Six Piglets* by C. Jones, 1857. Oil on millboard 6 x 9in. (15.2 x 23cm).
The offspring of this sow vary enormously in colour from almost no dark spots to being covered in them.
Collection of Mr and Mrs William C Morris

and were kept in herds tended by swineherds. They ranged semi-wild through the woods and forests feeding on acorns, roots and beech nuts during the so-called pannage season which ran from midsummer to November after which they were moved to grassland (Colour Plate 244). This type was by now confined to the Highlands and Islands of Scotland and a much larger breed with a long snout and long lop ears was found throughout the rest of England. Its origins are unknown and it varied enormously in colour and conformation from one area of the country to another. The Hampshire pig still had prick ears but a rounder less bristly body and shorter legs. The Gloucester Old Spot (Colour Plates 245 and 246), also known as the 'Orchard Pig' as it was fed on windfalls and the dairy waste from this milk-producing area, is one of the earliest breeds. Northamptonshire and Leicestershire were other great pig producing areas where there were quantities of beans and pulses to fatten them. White pigs were the preferred colour. Pink pigs were distrusted as they were believed to be

Colour Plate 245 (detail). *Gloucester Old Spot* by G. Sebright, 1841. Oil on canvas, 13½ x 15¼in. (34.3 x 38.7cm).
The Old Spot is the ideal smallholder's pig and flourishes in non-intensive systems of farming. The breed originated in the Severn valley where they fed on the surplus whey from cheesemaking, cleared up the cider windfalls in the autumn and the residues of pulp from the cider press.
Iona Antiques

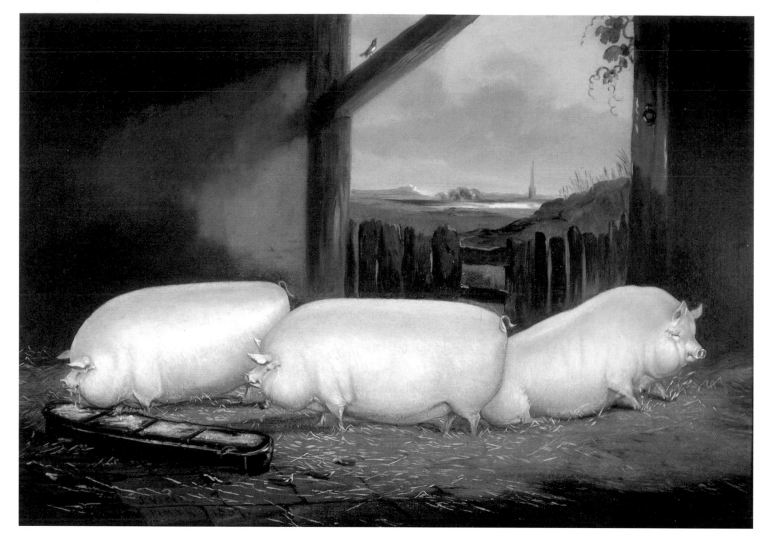

susceptible to measles, a common skin disease akin to the human type which was highly contagious. Black were unpopular as the meat had a tendency to dress blue.

In the Middle Ages pigs had been a mainstay of agriculture, but deforestation, the planting of arable crops and the much higher commercial value of sheep all contributed to their change in

Colour Plate 247. *Three middle white Sows in a sty* by J. Vine, 1857. Oil on millboard, 19½ x 25½in. (49.5 x 65cm).
The Middle White claimed descent from the large, slow maturing pigs of Yorkshire, Lincolnshire and Leicestershire.

Collection of Paul Junger Witt and Susan Harris

Plate 91. *Mr William White's Hog,* unknown artist. Etching, 1798. 7 x 10in. (18 x 25.5cm).
Inscribed: *This hog the property of Mr William White of Kingston Surrey was killed 28 March 1798. 4 ft. high. 8 ft. 9 long. 9ft. 2 girt. 5 inches thick of fat all over. 2½ years old. 49 score 6 lb. weight. 70 sto. [sic] 6 lb at 14 lb to ye stone. 123 sto [sic] 2 lb. (at) 8 lb to ye stone. It was generally allowed that this pigg [sic] would have fatted nearly as much again.*
This is one of the earliest dated pig prints. They are extremely rare compared with the large numbers of prints made of celebrated cattle at this date. If the inscription is to be believed this was a pig of truly monstrous proportions, it was nearly 9ft. long and weighed over 70 stone.

Rural History Centre. University of Reading

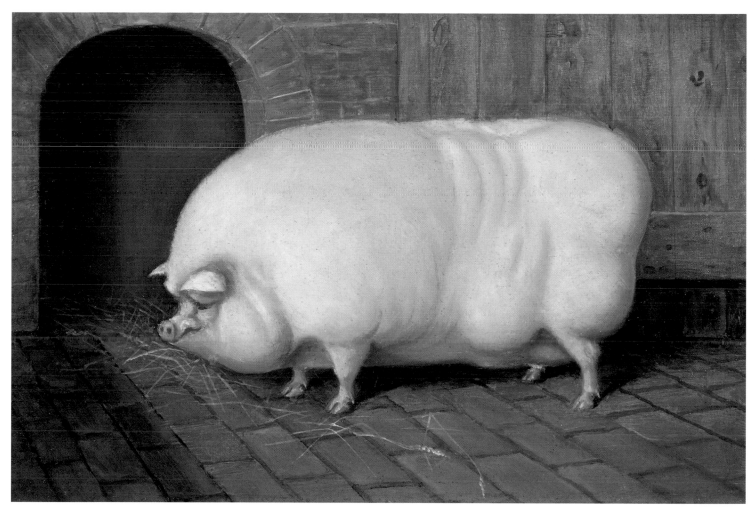

status. Their primary source of food was removed and their long rooting snouts caused untold damage in the fields now planted with arable crops. They could no longer roam semi-wild but had to be kept in sties and fed on expensive crops so that by the eighteenth century they were principally a cottager's animal fed on waste products. It was only profitable to keep large numbers of pigs in areas where there was a surplus of pulses and cereals or waste products created from the dairy or brewing industry. They were considered of such lowly status by agriculturalists and breeders that in 1776 John Mills wrote:

> Of all the quadrupeds that we know, at least certainly of all those that come under the husbandman's care, the Hog appears to be the foulest, the most brutish, and the most apt to commit waste wherever it goes. The defects of its figure seem to

Colour Plate 248. *A Prize Sow Outside a Sty,* unknown artist, c.1840. Oil on millboard, 8½ x 12½in. (21.5 x 32cm).
Fat was as important as meat. It had dozens of household uses as well as being an important source of carbohydrate. Animals like these with their bulging lumps of fat seem hideously deformed today but were common in the 19th century.
Collection of Mr and Mrs Douglas McCallum

Colour Plate 249. *Prize Boar in a Sty,* unknown artist, initialled T.W., c.1810. Oil on canvas, 20 x 24in. (51 x 61cm).
Inscribed on reverse: *Bred by Mr A Morris, Bucks 2 Years Old. Weight 40 score 2 lbs.*
Collection of Andrew Thomas

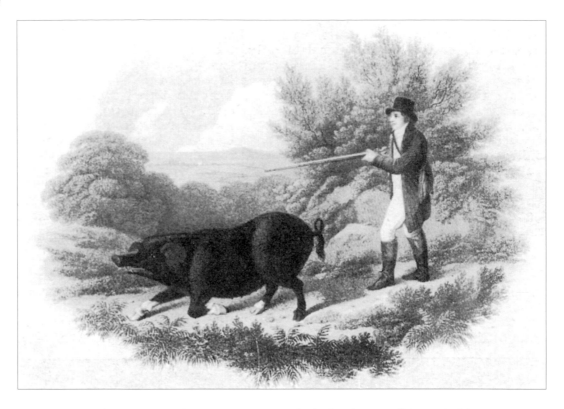

Plate 92. *Slut, The Gun-Pig in Action.* Reproduced from *Country Life* 9 October 1969. Pigs are well known for their intelligence and sense of smell. They are famous as truffle hunters but were also trained to hunt game.

influence its dispositions: all its ways are gross, all its inclinations are filthy, and all its sensations concentrate in a furious lust, and so eager a gluttony, that it devours indiscriminately whatever comes in its way.

On the other hand smallholders and cottagers probably became extremely fond of their friend grunting away at the bottom of the garden, referred to as 'the gentleman that pays the rent'. The pig was a vital source of food; slaughtered at Christmas when fresh food was scarce, the family would still be living off the salted bacon and sausages until spring came. As people migrated from the country to towns, the pig came with them and they were frequently let loose in the towns to scavenge during the day. They were not just a source of food but provided sport and amusement with annual pig races through the streets. In his *Rural Sports*, Daniel records an eccentric farmer who drove into town in a carriage drawn by 'four large hogs'. After making a tour of the marketplace they were taken into a stable and rewarded with a trough full of beans and swill while the farmer executed his business before returning to drive them home. Penant, during his tour of Scotland in 1771-75, said in parts of Murrayshire it was not uncommon to see a cow, a sow and two young horses all yoked together in a plough and 'the sow was the best drawer of the four'. Pigs are famous as truffle hunters but they were also used to hunt game.

The most famous gun-pig was 'Slut' (Plate 92), a black sow born in the New Forest in the early nineteenth century. The property of a gamekeeper, within a fortnight she could point and retrieve as well as any dog. Her sense of smell was remarkable, she could point a partridge from forty yards and her pace when working was described as a steady controlled trot. She was not a favourite with the gun dogs who 'dropped their sterns and showed symptoms of jealousy'. 'Slut' was only one of several sporting pigs. The barbaric custom of disabling the dogs of commoners by cutting three claws of their right foot so they would be unable to hunt and poach meant that pigs were used instead, the added advantage being that they would arouse no suspicion. The print of 'Slut' shows her standing with her foreleg bent, as if pointing like a spaniel.

It was the arrival of exotic foreign pigs from far flung corners of the Empire in the mid-eighteenth century which really drew the breeders' attention to the improvement of the Old English pig. They arrived from China, Siam (Colour Plate 250) and Naples and contemporary accounts even describe varieties from Turkey, Africa and Malta, as well as Wild Jamaican, Otaheitan, German, Barbadian and Indian jungle pigs. These pigs were small and round with

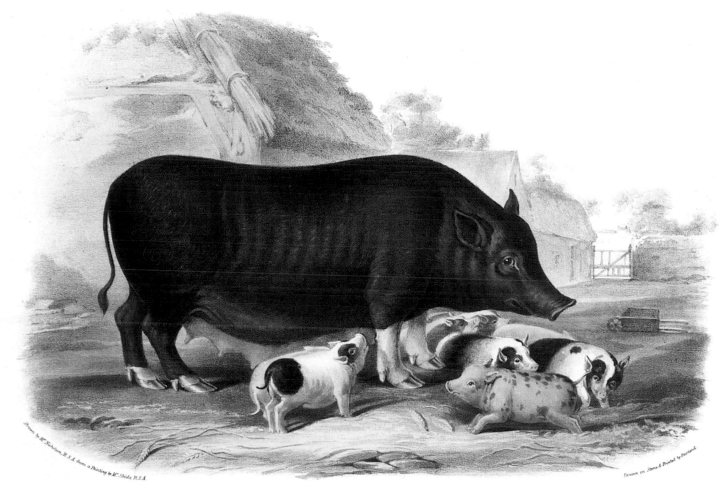

Colour Plate 250. *Siamese pig with her litter* after William Shiels, drawn by William Nicholson, 1840. Lithograph from *The Breeds of Domestic Animals* by David Low, 9 x 15in. (23 x 38cm).
Pigs first began to be imported from the Far East in the mid-18th century. This animal came from Singapore. They were dramatically different in appearance from the old English pig, small with prick ears and a dished face. This sow has been crossed with a half-bred Chinese male and the mixed parentage has given an enormous diversity of colour in the offspring. Imported oriental pigs were crossed with almost every type of British pig but specific breeds did not emerge until the mid-19th century. Courtesy of the O' Shea Gallery

prick ears, a dished face, downy coat and a tendency to fatten early in life. They had been bred to produce a large quantity of meat in a short time. In China pigs were very highly valued and were carried from place to place in cradles slung on poles; model pigs are even found buried with the dead. In contrast the Old English pig took two years to reach maturity and was therefore an unprofitable feeder. Its large body size meant there was a high proportion of bone to meat.

These more quickly maturing exotic breeds were crossed with almost every type of Old English pig and it is impossible to trace the emergence of specific breeds until the mid-nineteenth century. There is almost no documentary evidence relating to cross-breeding or improving during this period. Pigs are prolific breeders, producing a new litter every six months and another generation within a year. Youatt estimated that within ten years, ten sows and their offspring could produce 39,062,500 pigs. At the whim of the individual breeder they could be moulded into innumerable shapes and colours. In 1793 Boys remarked on his tour of Kent that 'no two pigs are the same', and John Farley, describing the pigs of Derbyshire in 1817, mentions that they are 'a complete mix of colour and types in this county as elsewhere'. Local county names, such as Berkshire, continued to be used, but these are confusing since they can relate either to a generic type or to completely different looking pigs from the same area. Every county had its own type – there were Nazeby Hogs, Cumberland Hogs, the

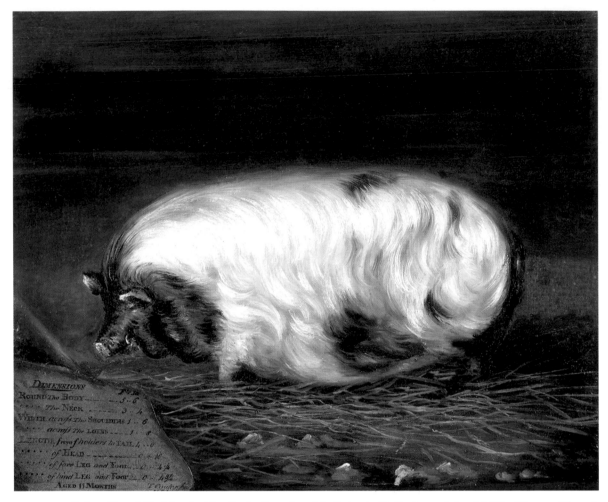

Colour Plate 251. *Lincolnshire Curly Coat* signed indistinctly T. Coulas and dated 1821. Oil on millboard, 14½ x 17¾in. (37 x 45cm).
Inscribed:

Round the Body	*5 6*
" "	*3 4*
Width across the shoulders	*1 6*
loins	*1 8*
Length from Shoulders to tail	*4 0*
of head	*0 10*
of fore leg & foot	*0 4¼*
of hind leg & foot	*0 4¼*
Aged 11 months	

Every county had a different breed of pig. One of the most unusual was the Lincolnshire with its long curly coat.
Maximilian Von Hoote

Lincolnshire with its curly coat (Colour Plate 251), while in the Orkney and Shetland Islands the tiny pigs still ran semi-wild scavenging along the sea-shore and their bristles were woven into ropes by the islanders.

The general trend during this period, however, was towards a more profitable, smaller boned, quicker maturing animal. Garrard's model (Plate 93) shows the dramatic change in shape from the rangy Old English pig with its long snout to the much smaller dish-faced, prick-eared, half-bred English and Siamese sow. One of the few recorded attempts to improve pigs was made by Robert Bakewell, but it is not known whether he used exotic breeds. Marshall considers that his policy was the only example of improvement of swine by inbreeding but later writers tend to believe he did cross-breed. It would appear his attempts were not entirely successful and while they were lighter boned and fattened easily they were defective in a number of other ways,

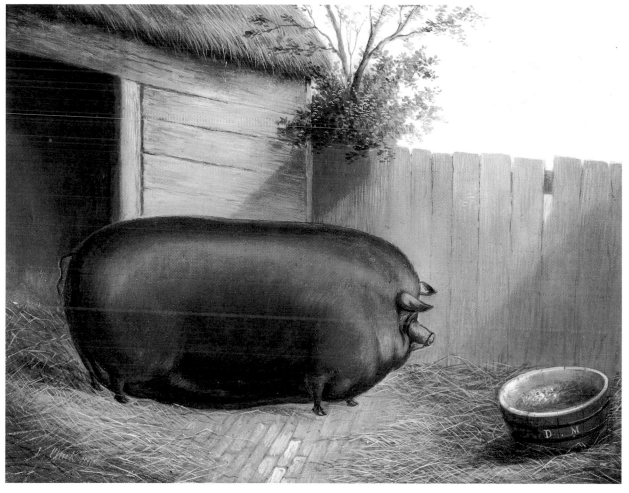

Colour Plate 252. *Old fashioned, Chinese breed Sow* by James Clark Senior, c.1870. Oil on canvas, 14 x 18in. (35.5 x 45.7cm).
This is the sort of imported Chinese animal which was used to cross with the Berkshire.
<div align="right">Private Collection</div>

Plate 93. Models of Pigs by George Garrard, c.1800. Plaster.
Garrard's models show on the left a wild boar, in the centre an Old English boar and on the left a half-bred Siamese and English sow. The half-breed shows a dramatic change in shape to a small round bellied animal with prick ears and a dish face.
<div align="right">The Natural History Museum</div>

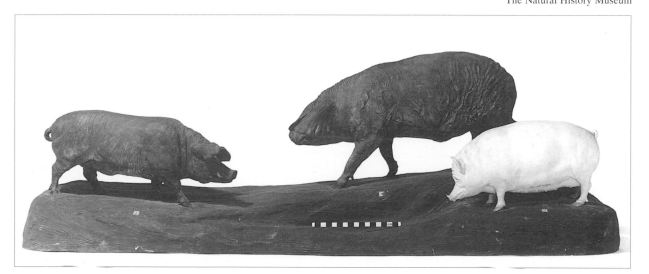

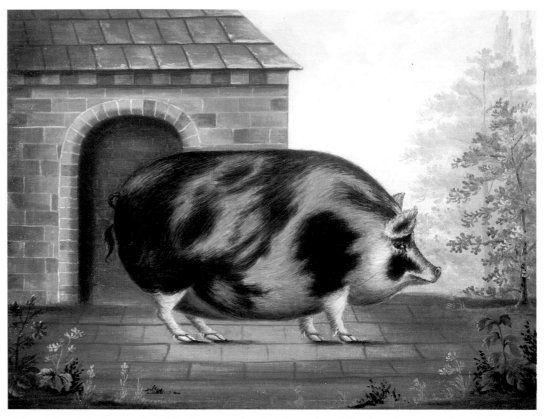

Colour Plate 253. *A prize Berkshire Sow outside a brick sty,* signed Heath, painter Knowle, c.1850. Oil on canvas, 14 x 18in (35.5 x 45.7cm).
Early Berkshires varied in colour from black, black-red and white and red with black spots. (See also Colour Plate 91). Iona Antiques

Colour Plate 254. *'Highclere', a Berkshire Sow* by Richard Whitford, 1884. Oil on canvas, 16 x 20in. (40.5 x 51cm).
The British Berkshire Society was founded in 1884 and the breed is now black, prick eared with white markings on its feet, nose and tail. 'Highclere' is shown here with her prize-winning rosette Iona Antiques

Colour Plate 255. *A prize Berkshire* by W. Luker, 1882. Oil on canvas, 15 x 18in. (38 x 46cm).
Maximilian Von Hoote

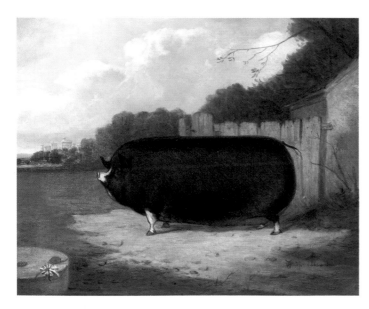

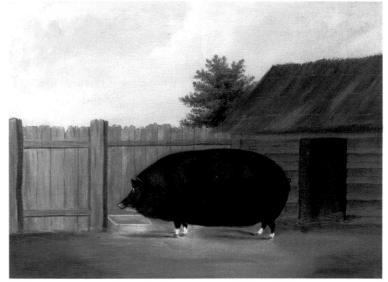

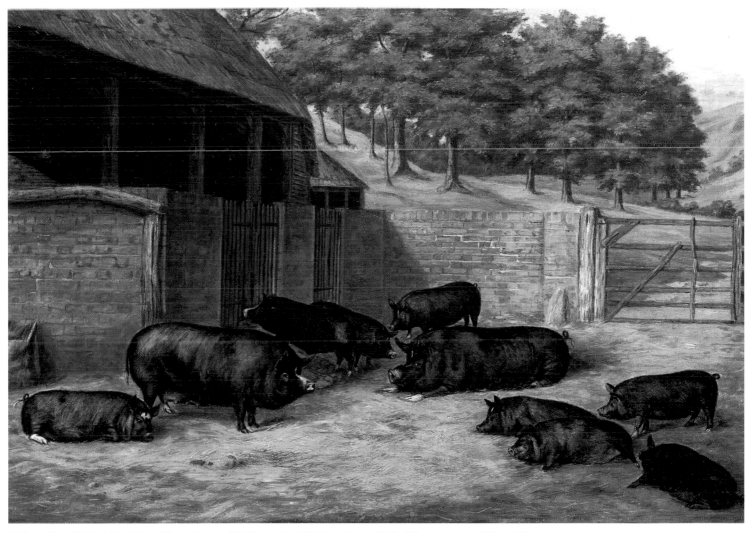

Colour Plate 256. *A Berkshire Hog, Sow and 8 Piglets* by H.J. Brooks, c.1880. Oil on canvas, 18½ x 26in. (47 x 66cm). Collection of Mrs. Robert F. Croll

Marshall describing them as 'rickety' and 'fools', and they were poor breeders.

The most successful of the improved breeds was the Berkshire crossed with Chinese and Neapolitan pigs. Its close proximity to London made it the ideal animal for fattening on the waste products of the large London breweries. In 1794, 9,000 pigs were fattened from the waste products of breweries in Vauxhall, Battersea and Clapham and, although pigs came from all over the country to supply this burgeoning industry, the Berkshire was the preferred breed. We have no accurate idea of its appearance at this time. It is variously described as black, black and white, and red with black spots and animals ranging from a red Indian jungle pig to a wild boar have all been associated with its improvement (Colour Plates 91 and 253). The Berkshire, like the Essex, attracted some distinguished breeders and until the turn of the nineteenth century carried off nearly all the prizes at the Smithfield Show. From 1889 to 1893 Berkshires won the prize for the best pen of pigs in the show. Notable breeders included the Duke of Hamilton and the Duke of York. Lord Barrington's herd was extremely influential in the 1920s and it was Mr Heber Humfrey, a leading breeder, who helped found the British Berkshire Society in 1884 (Colour Plates 254 to 256). Today it is black, prick-eared, with white markings on the feet, nose and tail.

By the mid-nineteenth century pigs were being broadly classified into large and small breeds. The large breeds were predominantly white, based on the native Yorkshire, Lincoln-

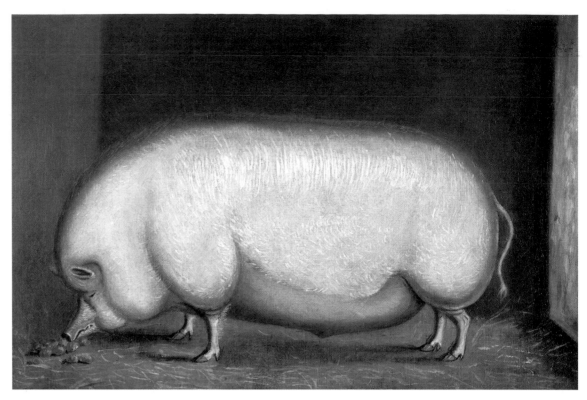

Colour Plate 257. *A Prize boar eating turnips in a sty,* unknown artist, c.1840. Oil on canvas, 12 x 17in. (30.5 x 43cm).
This large boar with its dish face, long back and prick ears is typical of the smaller Yorkshire pigs.
Collection of Benjamin Jacobson

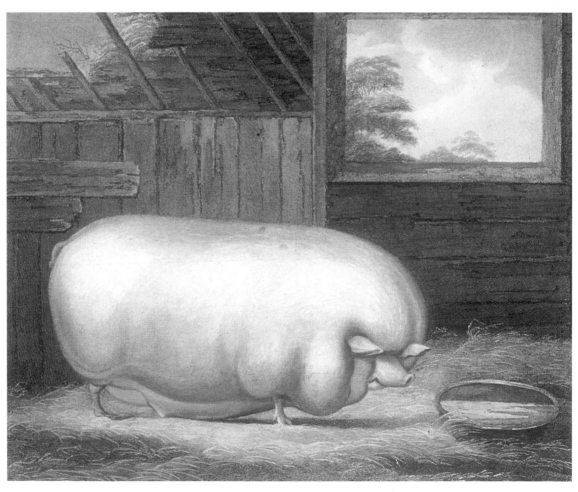

Colour Plate 258. *This remarkable animal* after B. Gale, engraved by J. Whessell, 1808. 16 x 19¼in. (40.5 x 49cm).
Inscribed: *This remarkable animal (now two years and a half old) was bred by Mr. Gardiner, of Elsham Hall, Lincolnshire. Its length 70 inches, heigth [sic] 28¼, width across the shoulders 28, girth 84, circumference of its neck 62½ inches, & supposed by judges to weigh 50 stone.*
Lawes Agricultural Trust. Rothamsted Experimental Station

240

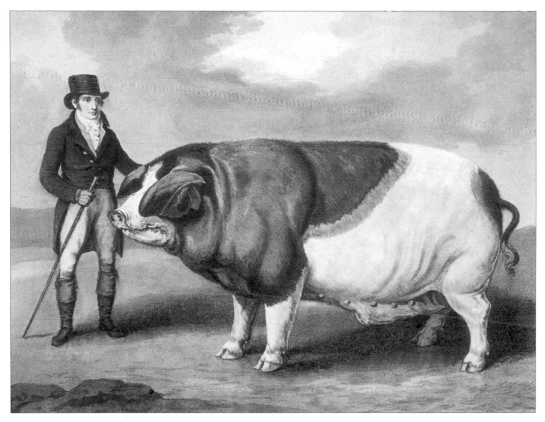

Plate 94. *The Yorkshire Hog engraved by R. Pollard, 1809. 17 x 20½in. (43 x 52cm).*
Inscribed: *The Yorkshire hog, to Coln. Thomas Charles Beaumont Esqr. M.P. This specimen of an improved breed of this useful animal was bred by Benjn. Rowley of Red House near Doncaster & fed by Josh. Hudson on the estate of Col. Beaumont of Bretton Hall to whom this print is respectfully inscribed by his obedt. humble servant Joseph Hudson. This stupendious creature for height & length far exceeds any of this species ever yet seen measuring 9'10" long 8' round the body stands 12½ hands high 4 years old & weighs 1344 lbs. or 160 stone 8 lb to the stone or 96 stone 14 lb to the stone & would feed to a much greater weight were he not raised up so often to exhibit his stature. He has been view'd by the Agricultural Society & the best judges with astonishement & excited the public curiosity so much that the proprietor for admittion money to see him in 3 years has received near 3,000 pounds !!!*
The Yorkshire hog was one of the most famous of the large, slow maturing strains to come out of Yorkshire, Lincolnshire and Lancashire. The very large prize-winning pigs were of a maturity not seen today but a good Yorkshire pig could attain 250lb. in seven months. These huge animals could hardly stand and drew enormous crowds when they were exhibited.

Lawes Agricultural Trust. Rothamsted Experimental Station

Plate 95. Poster advertising J. Marsh's Great Novelty Pig. University of Reading, Rural History Centre

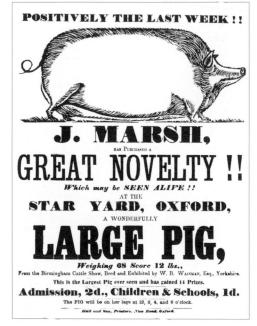

shire (Colour Plate 258) and Lancashire types but improved by imported varieties, and were the forebears of the Large White. This type also included the White Leicester, Hampshire, Cheshire, Rudgewick and Northampton. They were slower maturing but grew to enormous sizes and were more suited to the production of bacon. With the fashion for enormous animals still raging, they were fed to immense sizes and there were lucrative profits to be made from their exhibition. As one contemporary observer noted, 'nothing draws such a crowd of Yorkshire folk as a monster pig show'. The most famous was the Yorkshire Hog (Plate 94) which was 9ft.10in. long, 8ft. in circumference and weighed 1,344 lb. or 96 stone. The pig proved such an attraction that its owner Joseph Hudson received nearly £3,000 in admission money over three years. Another enormous Yorkshire pig bred by W.B. Wainman Esq. weighed 68 score 12lb., that is 1,372lb. or 98 stone, and was exhibited all round the country (Plate 95), admission 2d., 1d. for children and schools. These unfortunate animals found it

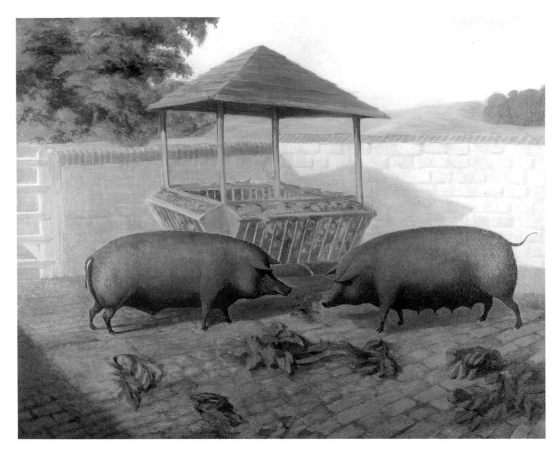

Colour Plate 259. *A Neapolitan boar and sow,* unknown artist, 1834. Oil on canvas, 21 x 26in. (53.5 x 66cm).
Lord Western began experimenting with imported Neapolitans, crossing them with the local Essex pig in the late 18th century. The principal role of the Neapolitan on both the Essex and the Berkshire seems to have been to reduce the size of the big strain to provide a middle sized bacon pig.

Maximilian Von Hoote

Plate 96. *The Cup Pen of Pigs* engraved by E Hacker, 1874. 6 x 9in. (15.3 x 23cm).
Inscribed: *at the Smithfield Club Show, 1873, The property of Mr C M Niven of Perrysfield, Godstone, Surrey.*
These pigs were entered in Class XLVI Pigs of any Black breed, above 12, and not exceeding 18 months old. They are described in the catalogue as no. 454 Charles Mc Niven, of Perrysfield, Oxted, Godstone, Surrey 17 months 23 Days, improved Dorset, bred by exhibitor, fed on barley and maize meal and Thorleys food. They won First Prize of £10 and Silver Medal to Breeder and Silver Cup, value £20, to the Exhibitor, for best pen of Pigs, in any of the Classes. Small pigs with their huge mounds of flesh were in danger of suffocating while they slept so wooden pillows were placed under their noses.

Collection of Andrew Thomas

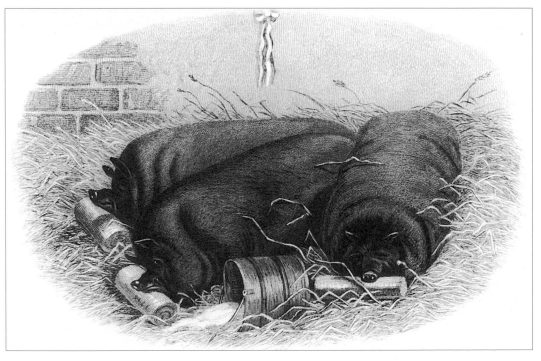

extremely difficult to stand; getting them on to their feet was quite an undertaking and they were frequently supported by props. Wainman's pig was to be on her feet for the assembled spectators at twelve, two, four and six o'clock, while Hudson announced that his Yorkshire hog 'would feed to a greater weight were he not raised up so often to exhibit his stature'. Breeders

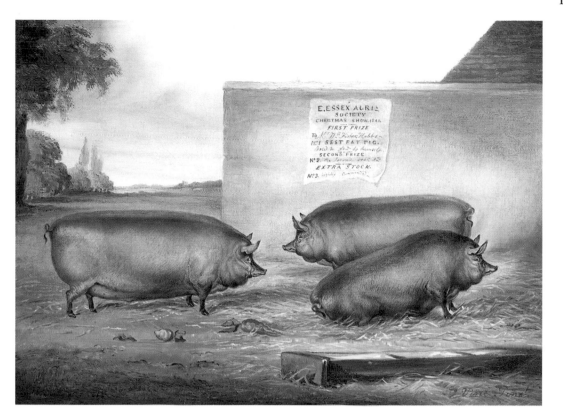

Colour Plate 260. *Three Essex Pigs* by John Vine, c.1841. Oil on canvas., 11 x 13½in. (28 x 34.3cm).
Inscribed: *E. Essex Agri. Society Christmas Show 1841. First Prize to Mr Wm Fisher Hobbs, No. 1 Best Fat Pig Bred and fed by himself. Second Prize No.2 The second best ditto. Extra Stock. NB Highly recommended.*
Maximilian Von Hoote

like Joseph Tuley of Keighley in Yorkshire and Samuel Wiley of Brandsby had by the mid-century concentrated on producing a more refined and more useful meat-producing animal than these mammoth Yorkshire pigs which became the ancestor of the Small White. They cross-bred local stock with Bakewell's improved Leicester pigs. These improved Yorkshires are considered to be the ancestor of today's Large White.

The smaller breeds were based almost entirely on the Chinese or Neapolitan varieties and included the improved Essex Black, the Coleshill White, the Cumberland White and the improved Suffolk. Lord Western was another of the few aristocrats to be interested in pig farming. He imported Neapolitans, crossing them with the local Essex and probably introducing Berkshire blood to produce the Essex half-black, the ancestor of the Essex saddleback (Colour Plate 261). His work was continued by another Essex breeder, William Fisher Hobbs, who made the small black Essex pig famous (Colour Plate 260). Both breeders patronised the local artist John Vine of Colchester who recorded many of their animals. While still in his teens Landseer also painted animal portraits for Lord Western and his painting of *A British Boar* (Colour Plate 98) is the property of Lord Western and may be an early example of an Essex Saddleback. The small pigs fattened much sooner than the larger more slowly maturing strains and, although they did not achieve the same weight, were just as fat. With their huge mounds of flesh they frequently suffocated while they slept and pig men had to place wooden pillows under their snouts to help them breathe (Plate 96). An interesting

Colour Plate 261. *A Hog of Lord Western's Improved Neapolitan Breed* by R. Farmer, 1848. Oil on canvas, 12 x 16in. (30.5 x 40.5cm).
Inscribed: *A Bacon hog weighing 27 st, 3 lbs of Lord Western's Improved Neapolitan, bred and fatted by C Steward, killed 1848, painted from nature by R. Farmer. 1848.*
Lord Western's House, Felix Hall near Kelvedon, Essex can be seen in the background.
Private Collection

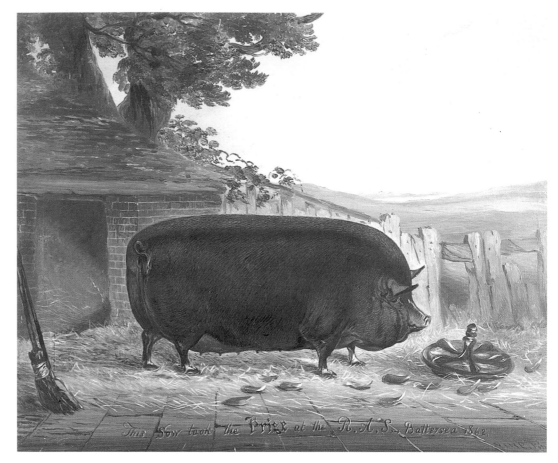

Colour Plate 262. *Improved Suffolk Pig* by John Vine, 1862. Oil on canvas, 20 x 24in. (51 x 61cm).

Inscribed: *This sow took the prize at the RAS Battersea, 1862.*

There were a number of prizes given for pigs in 1862, but the most likely one was £10 given to the breeder of 'Negress 11', an improved Suffolk, aged 1 year, 1 month and 8 days. She was bred by George Mumford Sexton of Wherstead Hall, Ipswich, Suffolk. The name Suffolk by this time was becoming associated with a small black improved breed being developed in East Anglia. Classifying early pig breeds is extremely confusing as a county can give its name to types entirely different in appearance.

Alistair Sampson Antiques Ltd.

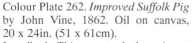

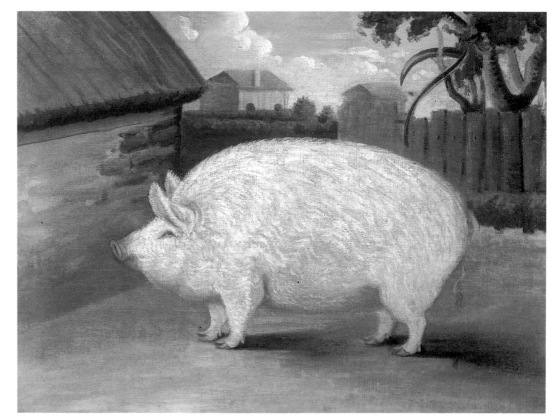

Colour Plate 263. *A Prize sow outside a sty,* unknown artist, c.1840. Oil on canvas, 15 x 20¾in. (38 x 52.7cm).

Maximilian Von Hoote

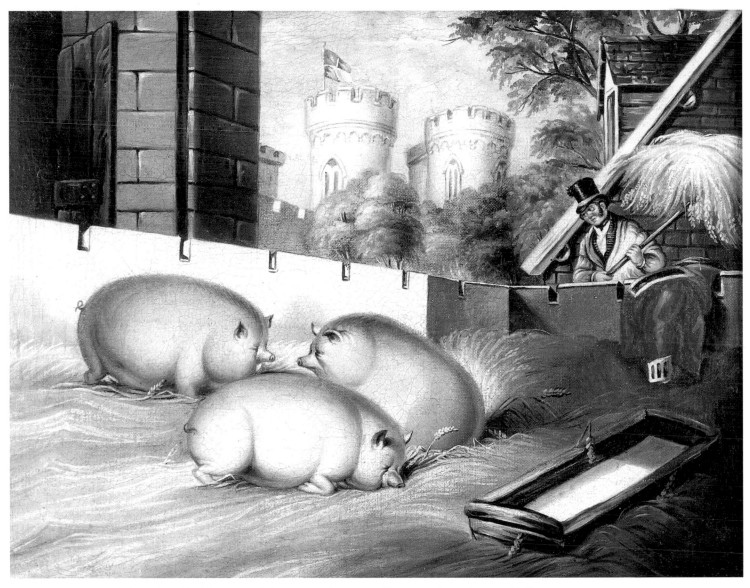

Colour Plate 264. *Suffolk and Bedfordshire Pigs belonging to the Prince Consort, a*rtist unknown, 1844.
9 x 11¾in. (23 x 30 cm).
There is a print of this painting in the Rothamsted Collection after J.W. Giles, lithographed by Dean & Co,
and inscribed: *Three 25 week old Suffolk and Bedfordshire pigs, bred by His Royal Highness Prince Albert,*
which gained the second prize of £5 at the Smithfield Show, 1844. Fed on milk, barley-meal and pea-meal.
Prince Albert kept black Berkshire pigs on the Shaw Farm but was more famous for his white 'Windsor' pigs
which carried off numerous prizes. Maximilian Von Hoote

painting (Colour Plate 264) of 1844 shows very fat Suffolk pigs with a view of Windsor castle
in the background; Prince Albert is throwing a pitchfork of straw into the sty. The pigs look
extremely clean and cosy on thcir deep bed of straw and had just won second prize at the 1844
Smithfield Show. Known as Windsor pigs, this breed of white pig was based on stock from
Colonel Lucie, Mr Wiley of Yorkshire and Mr Brown of Cumberland. They were white
Suffolks crossed with Berkshires and Chinese.

The fashion for very fat animals was not helpful in establishing the British pig industry
abroad. The importance of fat as a source of energy essential for the harsh physical life of
labourers had long been recognised. In 1794 Abraham and William Driver had described a
pickling process in which all lean and bone was removed and the remaining fat (between four

Colour Plate 265. *A Prize Sow by a Trough,* unknown artist, c.1840. Oil on canvas, 9 x 11in. (23 x 28cm).　　Private Collection

Colour Plate 267. *A Large Black Boar,* unknown artist, c.1840. Oil on millboard, 5 x 7in. (12.7 x 17.8cm).　　Collection of Tatjana T. Former MD

and six inches thick) was salted down and given to labourers. The fattest hogs were also laid down in pickling brine to be fed to ploughmen. The gentry, however, preferred smaller animals of more succulent roasting pork and certainly by the mid-century a reaction against excess fat had set in. The London market was demanding smaller animals weighing between 40 and 70lb., especially for cured pork. The fatter pigs tended to be processed into sausages. Youatt explains how 'A premium would be far better bestowed upon the most useful and profitable animal – the one most likely to make good bacon or pork, than on those huge masses of obesity

Colour Plate 266. *A Prize sow by a trough,* unknown artist, c.1840. 14 x 17½in. (35.5 x 44.5cm).
Throughout the 19th century enormously fat pigs which defied any breed classification continued to be popular despite the growing criticism that such animals were inferior as breeding animals and unsuitable as meat carcasses.　　Private Collection

Colour Plate 268. *The Spherical Pig* by S. Stringar, 1792. Oil on canvas. 11½ x 14in. (29 x 35.5cm).
Reproduced as an engraving in Pitt's survey of Staffordshire, the pig had a live weight of 802lb. and was killed at the age of two and a half years.

Private Collection

whose superabundance of fat is fit for little else but the melting pot.'

There was a growing distinction between the type of pig suitable for the meat market and those favoured by the breeders. In 1871 Samuel Sydney advised foreign buyers that there were good pigs to be found but not in the show rings where all you see are 'snow-white bladders of lard'. It was the distorted prize animals which were painted, not the average suckling pig or bacon hog, which is why the pig portraits which have come down to us appear to be so extraordinary. By the1870s extremely fat pigs were not even desirable in the show ring, as judges became aware of their inherent defects. Contemporary reports comment on their unsuitability as meat carcasses, their inferior qualities as breeding animals and the debilitating effects such an excess of fat produced on these wretched animals. 'It is painful to see prostrate masses of fat grunting and sweating under a weary life in the heat… the time has come to put a check on the unlimited exhibition of animals that plainly can not be in a fit state for breeding' (Derby Agricultural Show 1881).

Chinese pigs proved too delicate for the British climate; they were also poor breeders. These factors, combined with the worst effects of inbreeding, had an increasingly detrimental effect on British pigs. The British bacon trade consequently came under pressure from imported meat, particularly from Denmark. By the end of the nineteenth century, most of these smaller breeds descended from Chinese stock, which are so delightfully and humorously captured in the paintings of the time, had disappeared.

A fashion developed in the mid-nineteenth century for fancy breeds named after a place or owner. Particular points were developed purely for the show ring, without any thought to increasing meat production. As Sydney Sanders commented in 1890, 'fashionable pigs are so unfortunately often bred solely for their aptitude to fatten or some fancy points which have little or no commercial value.' The Black Dorset, the Coleshill, Cleveland, Crinkhill, Middlesex and Devon all came and went during these years. They enjoyed initial popularity in the show ring, only to be found wanting in the long term. Although a pig class had been

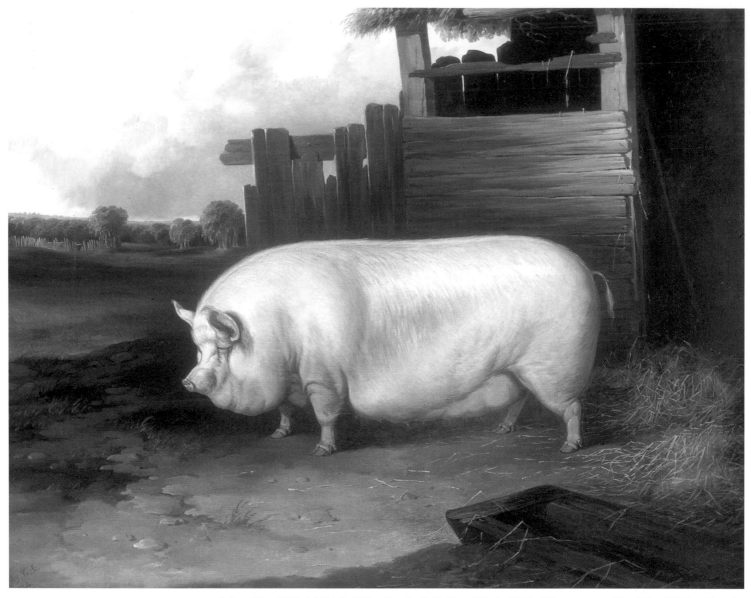

Colour Plate 269. *A Middle White Sow* by J. Dalby of York, 1844. Oil on canvas, 19 x 24in. (48.3 x 61 cm)
Collection of Mr and Mrs William C. Morris

introduced to the Smithfield Show as early as 1805, the first pig to win a championship gold medal was the Earl of Radnor's home-bred Coleshill as late as 1846.

It was criticism from American buyers that the popular large and middle white breeds which were being exported all over the world were not breeding true to type which at last convinced the breeders that some attempt should be made to rationalise the multitude of different pig breeds. In 1884 the National Pig Breeders Association was formed and from this time on recognised breeds were established. However, their ancestry is so complex and confused it is not worth trying to trace them here. The fullest account of the evolution of pig breeds is given by Julian Wiseman in his *History of the British Pig,* 1986. The new breeds being registered tended to be of the larger bacon type which had not been popular during the era of extremely fat pork animals. Breeds under the association's aegis from the beginning were the Large, Middle and Small Whites or Yorkshires and the Small Black, although the last two mentioned were soon no longer recorded. Like the Berkshire, the Large and Middle White (Colour Plates 269 to 273) have had a tremendous influence on the world's pig population. In the 1860s there

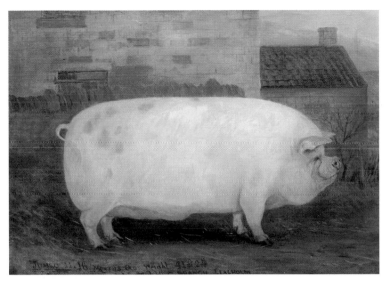

Colour Plate 270. *Jumbo* by W. Henderson, 1886. Oil on canvas, 18 x 25in. (45.7 x 63.5).
Inscribed: *Jumbo II. 16 months old. Weight 41 stone 2 lb. Bred by J. Young, Newholm. Fed by G.Branch Leaholm. Winner of 4 prizes.*
Collection of Christopher Davenport Jones

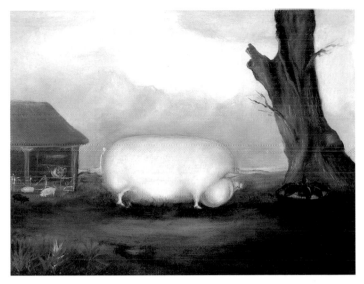

Colour Plate 271. *A Prize White Middle White Sow,* unknown artist, c.1850. Oil on canvas 13½ x 18in. (34 x 45.7cm).
Collection of Mr and Mrs Douglas McCallum

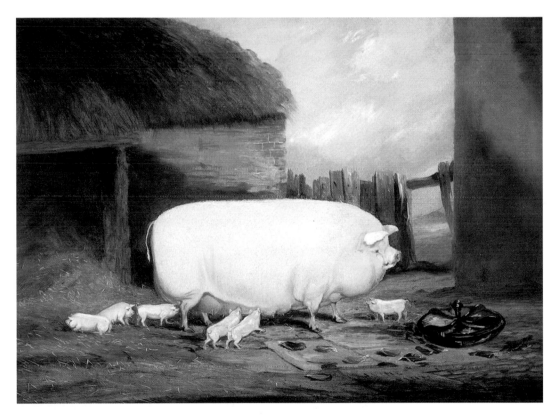

Colour Plate 272. *A Middle White Sow with Six Piglets* by J. Vine, c.1870. Oil on millboard, 19½ x 25½in. (49.5 x 64.8cm).
The Large, Middle and Small White were among the first breeds to be registered by the National Pig Breeders Association in 1884 after criticism from American buyers that they were not breeding true to type. Descended from the large slow maturing pigs of Yorkshire and Lancashire, they have been exported all over the world.
Collection of Mr and Mrs Edd Stepp

had been no breed distinctions for pigs at Smithfield; by the 1890s the modern pattern of pig breeds had emerged with classes for Berkshires, Small, Middle and Large Whites, Blacks, and Tamworths.

All of the breeds being registered had existed for many years in a variety of different forms and of course do not date from their time of formal registration. A herd book for the Lincolnshire Curly Coat, now extinct, was established in 1908 and the Gloucester Old Spot

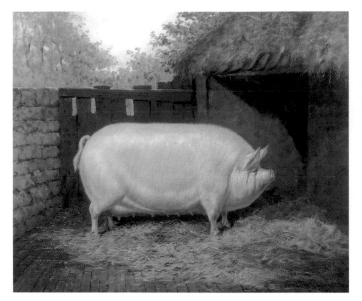

Colour Plate 273. *Peterboro Queen 1V* by Frederick Albert Clark, 1905. Oil on canvas, 20 x 24in. (51 x 61 cm).
This champion Middle White was the winner of seven first prizes, three second and two silver medals. She was bred by T Henson.
Collection of Ms Madge de Wycke, Shropshire

Colour Plate 274. *Two Gloucester Old Spot Pigs,* unknown artist, c.1850. Oil on canvas, 10 x 12in. (25.4 x 30.5cm)
The Gloucester Old Spot was not formally registered as a breed until 1914.
Private Collection

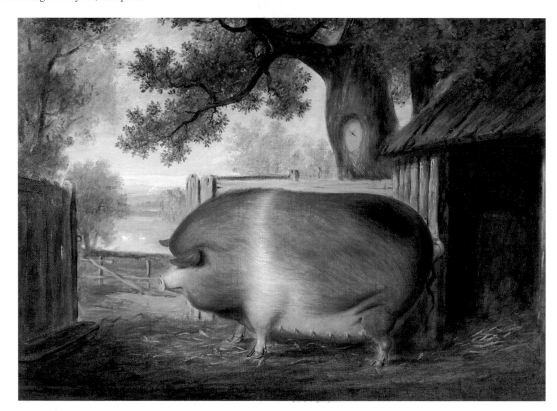

Colour Plate 275 *Saddle back sow* by J.M. Dacre, 1835. Oil on canvas, 19 x 24in. (48.3 x 61cm).
Maximilian Von Hoote

(Colour Plate 274) in 1914. The Large Black was registered in 1889, the Sheeted Essex and Wessex Saddlebacks (Colour Plate 275) in 1918 and the Welsh in 1921. The distinctive red Tamworth (Colour Plate 276), closely related to the Old Berkshire which along with the Gloucester Old Spot was one of the few breeds to escape improvement by crossing with Chinese blood, came back into favour in the later nineteenth century when excessively fat pigs were no longer desirable, and by 1909 the breed was fixed in form and colour. Other breeds

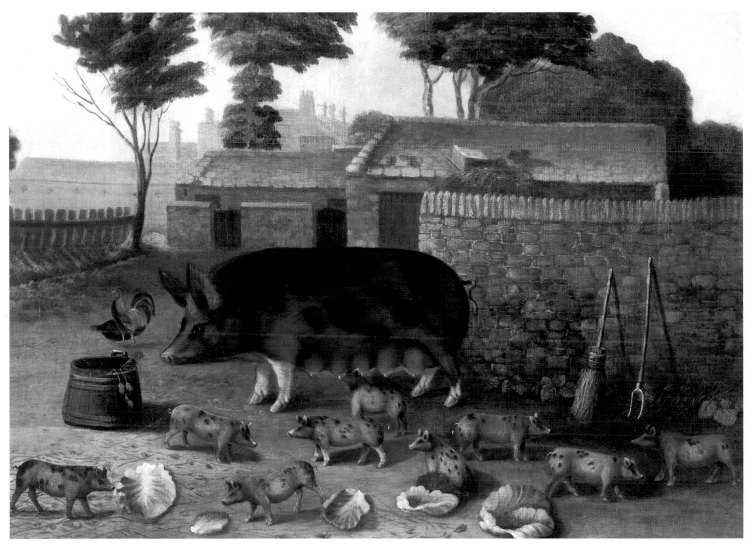

Colour Plate 276. *A Tamworth Cross with her Piglets,* unknown artist, c.1860. Oil on canvas, 27 x 36in (68.5 x 91.5cm).
Along with the Gloucester Old Spot, the Tamworth is one of the few British breeds to escape improvement by crossing with Chinese blood. Collection of William and Jacqueline Maritz

remained popular locally even though formal breed societies were not established. These included the Yorkshire Blue and White, the Oxford Sandy and Black and the Dorset Gold Tip, all of which are now extinct although the fate of the Oxford Sandy and Black is debatable as breeders claim present-day pigs of this type can trace their ancestry to the early years of this century.

Today the mainstream British pig industry is entirely dependent on hybrids developed from the Welsh, the Scandinavian Landrace and the Large White. The origins of the Welsh are obscure but it is closely related to the Large and Small White. The Scandinavian Landrace was developed by Danish pig improvers early this century. Modern pigs bear little resemblance to round, chubby pig portraits of the nineteenth century, being long animals, often with an extra rib bred into their backs, covered by the thinnest layer of fat with their weight concentrated in their valuable back hams. Even today pig farmers do not stick to pure breeds as the qualities found within a particular strain of pigs are more important than the characteristics of the overall breed. Whereas in the nineteenth century breeders were concerned with shape, size and colour to the detriment of meat, breeders today concentrate on developing hybrids from selected individuals producing the most ideal animal to suit a particular system of farming and a highly specialised meat market.

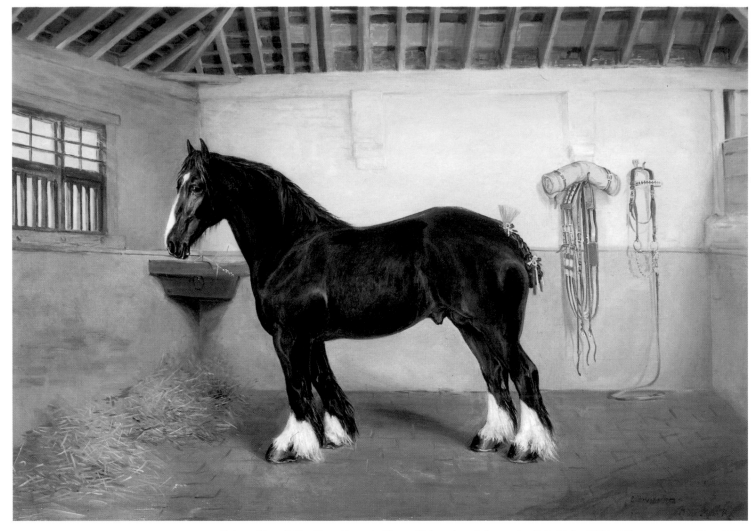

Colour Plate 277. *King Cosy, 3 Years Old a plough horse* by E.F. Holt, 1892. Oil on canvas, 20 x 30in. (51 x 76cm).
Iona Antiques

Colour Plate 278. *A Prize Shire horse with his owner,* unknown artist. Oil on canvas, 31 x 40¾in. (79 x 103.5cm).
Private Collection

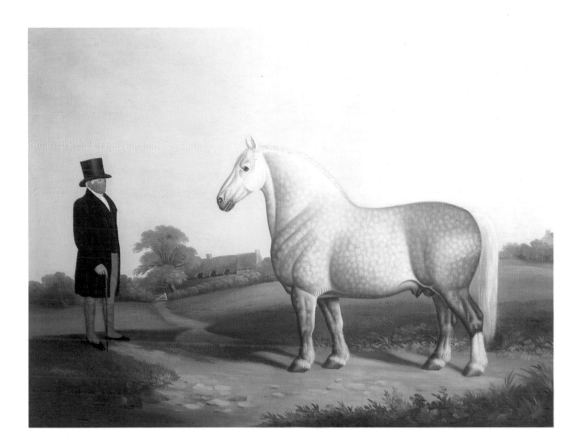

CHAPTER 7
Developments in Heavy Horse Breeding

It took several hundred years for the farm horse to establish its superiority over the oxen in the plough only to be ignominiously supplanted by the arrival of the tractor. Throughout the nineteenth century, however, British heavy horses were the most desirable in the world. They were bred with as much interest and enthusiasm as prize cattle, competing in the show ring alongside other farm livestock. With the establishment of the English Cart-horse Society in 1878, the list of successful breeders included Edward VII, and the Dukes of Devonshire, Westminster and Bedford and the most famous stallions established blood lines that have continued to the present day. No account of farm animals would be complete without a brief mention of the gentle giants who ploughed the land, drilled the seed and hauled home the harvest.

There is no account of horses being used on the farm before the arrival of William the Conqueror whose mounted army defeated the Saxon foot soldiers. The Norman battle horses were drawn from German and Spanish stock and were far superior to native British breeds. They were graded by size, the finest and strongest being reserved for knights and only the very meanest were put to work on the land. By the early twelfth century horses were being yoked in tandem with oxen. They were thick bodied animals but as yet with none of the pulling strength of the later heavy horses. Oxen were still the preferred animal; they pulled more steadily, cost less to feed and were hardier and less prone to sickness. Once past work, the oxen could also provide a valuable hide and carcass.

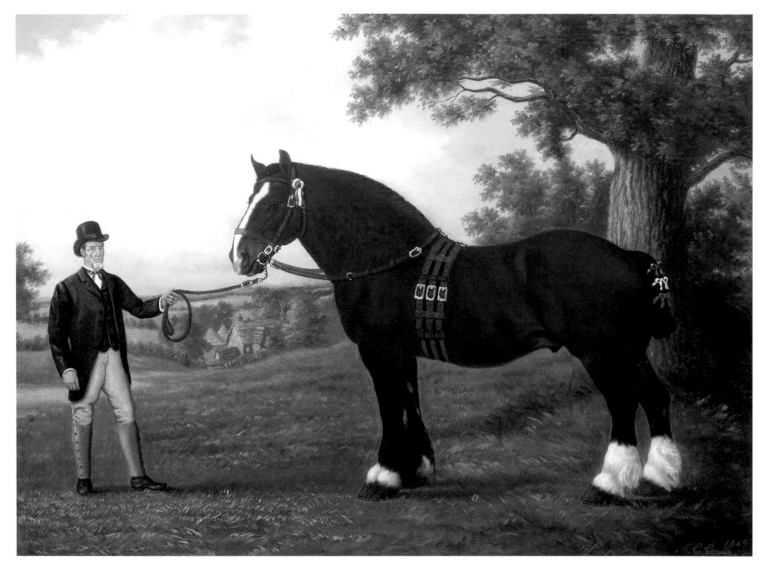

Colour Plate 279. *Thomas Hillman with his Cart Stallion* by A.E. Evans, 1869. Oil on canvas, 30 x 40in. (76 x 101.5cm). Britain led the way in heavy horse breeding throughout the nineteenth century and British horses were the most desirable in the world. Their improvement was assisted by the forming of local societies which controlled the hiring of stallions and the establishment of classes for horses at the agricultural shows. Private Collection

Plate 97. *Tanfield Ploughman*, unknown artist. Oil on canvas, 7½ x 15¼in. (19 x 39cm).
Horses replaced oxen in the plough earlier in England than other European countries. This left farmers free to concentrate on cattle as beef rather than draught animals.
 Beamish. The North of England Open Air Museum

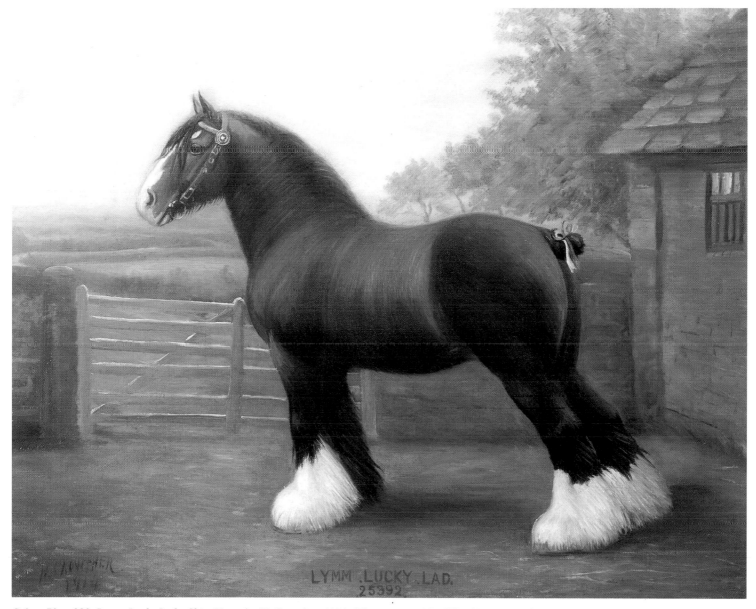

Colour Plate 280. *Lymm Lucky Lad a Shire Horse* by H. Crowther, 1914. Oil on canvas, 16 x 20in. (40.5 x 51cm).
He was bred in 1906 by James Gould of Model Farm, Lymm, Cheshire and won 6th prize at the London Shire
Horse Breed Show as a yearling. Horses were specially turned out for the show ring. Once it began to be bred
as a show horse the Shire was criticised for excessive feathering on its legs which made it impractical as a
workhorse. Collection of Judith Jahnke

Massive horses were needed to carry the medieval knights into battle, since their iron plate-
armour which replaced chain-mail could weigh up to 400lb. Several of the early English kings
imported stallions from Flanders and the Low Countries so that by the time of the Wars of the
Roses the English war-horse was superior to any in Europe and the finest animals were
swallowed up by the army. The age of gunpowder and firearms demanded a lighter swifter
horse for carrying cavalry but by the reign of Queen Elizabeth carriages had been invented.
The roads of the time were little more than tracks, rutted and potholed, inches deep in mud in
the winter, and horses of enormous strength were required to pull the carriages along them. It
was not until the end of the Civil War that any but the poorest quality animals were available
for farm work, the best horses all going to serve in the army or as carriage horses.

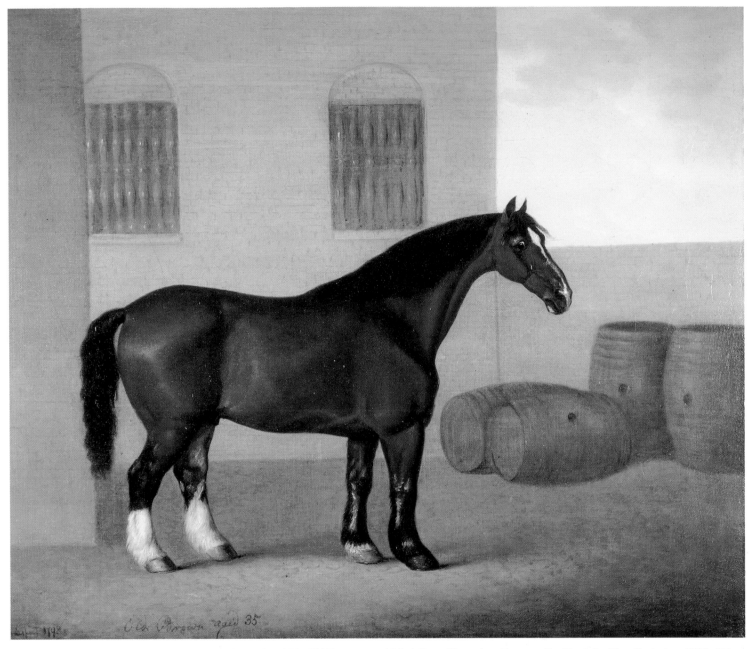

Colour Plate 281. *Old Brown, aged 35, A Dray Horse in a Brewery Yard* by John Nost Sartorius, 1798. Oil on canvas , 17 x 21in. (43 x 53.3cm).
This is an early example of a portrait of cart-horse which later became known as the 'Shire' breed. Before the mid-19th century there was enormous demand for workhorses, both in the towns and on the land. Breeding was fairly indiscriminate with the majority of stallions being gelded to make workhorses. The horses were worked extremely hard and this horse appears in amazing condition for its age. Most town horses were useless by the age of twenty. Collection of the Reverend and Mrs Frank T. Mohr

Thomas Coke was one of the first to realise the potential of the farm horse. He demonstrated that two horses and a single man could plough more quickly and efficiently than six oxen driven by a man and a boy and the newly drained fenland was laid out in areas fitted to working horses rather than ox teams. Ploughing matches, in which teams of oxen competed against horses and later on different teams of horses against one another, became fashionable (Plates 99 and 100). George III was a keen participant, pitting his plough horses against Lord Somerville's.

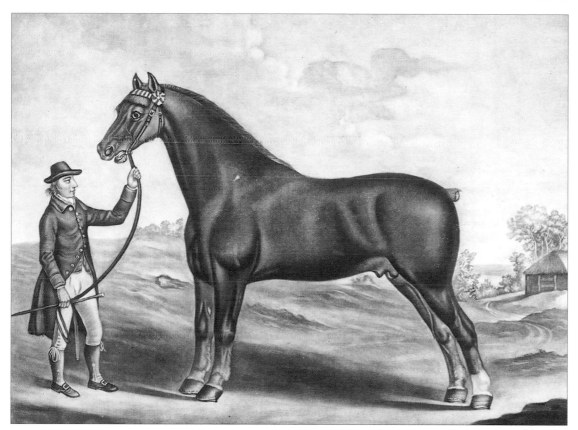

Plate 98 *Plough Boy, a Suffolk cart horse* after Francis Sartorius, engraved by W. Pyott, c.1800. 15½ x 20½in. (39.4 x 52cm). Inscribed: *Plough Boy, a true bred Suffolk cart horse five years old; the property of Mr.Steele, of Sutton, in Surry.*

Lawes Agricultural Trust, Rothhamsted Experimental Station

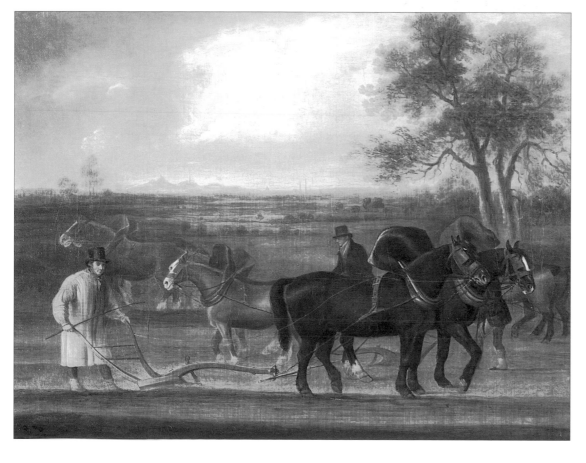

Plate 99. *A Ploughing Match by Thomas Weaver*, 1813. Oil on canvas, 28 x 36in. (71.2 x 91.4cm). A note in Weaver's diary reads, 'Group Ploughing match, won by Earl Bradford against Sir W.W. Wynne Bart. Rd Lyster Esq., – Owen Esq (45gns) for the Earl of Bradford.

Weston Park Foundation. Photograph Courtauld Institute of Art

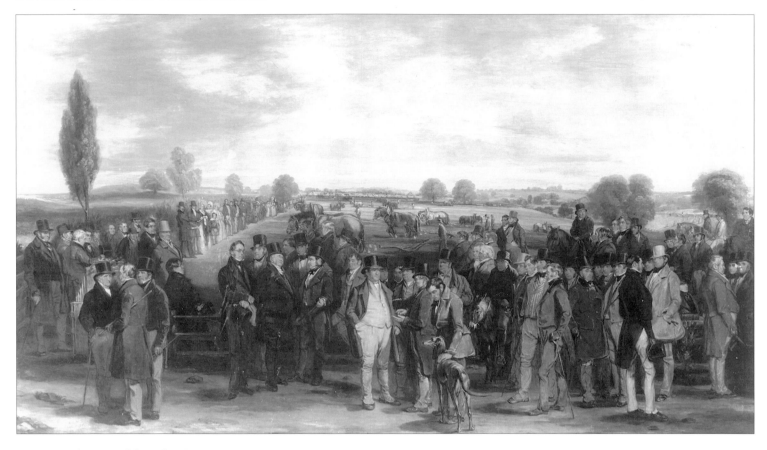

Plate 100. *The Groundslow Ploughing Match* by Richard Ansdell, 1840. Oil on canvas, 30¾ x 53in. (78.1 x 135cm). The spectators include the Duke of Sutherland and other members of the gentry and aristocracy.

The Tate Gallery, London

Plate 101. *Rural Courtship* by Thomas Woodward, 1836. Oil on canvas, 24½ x 29½in. (62.2 x 75cm).
Teams of plough horses were a popular subject for rural genre painting throughout the Victorian era. This is a rather contrived and sentimental example of Woodward's work, but the horses are very well depicted.

Private Collection

Colour Plate 282. *A Dray Horse*, unknown artist, c.1880. Oil on canvas, 22 x 30in. (56 x 76cm).
Dray horses were often dressed in elaborately decorated harnesses. Smartly turned out haulage carts were an important source of advertising for businessmen. The significance of the anchors on this harness is not known.
Collection of Johnny Mengers

A whole way of life grew up around the teams of plough horses. The ploughman rose at 4.00 am to feed the horses before they turned out to plough at 6.30 so that two hours could elapse to give them plenty of time for digestion. The horses did not eat again until they returned to the stable at 2.30 p.m. At 8.0 p.m the horses were turned out for the night into a well littered straw yard. The horses on the big estates were kept in immaculate condition and beautifully turned out each day. There was a fixed order of precedence among the horsemen and their teams, the head man always leading the way out and back.

In addition, heavy horses were needed for haulage in the towns and local business began to take pride in well turned out dray horses. Until the First World War there were only three main breeds of heavy horse in Britain, the Suffolk, the Shire and the Clydesdale. It was soldiers returning from the battle front who first introduced the Continental breeds, the Percheron, Belgian and Ardennes.

Colour Plate 283. *Shire Horse belonging to John Moon* by J. Mortimer. Oil on canvas, 21½ x 29in. (54.5 x 73.5cm).
John Moon ran a large hay and corn business near Cardiff. He kept to quality horses as an advertisement for his business and exhibited at many of the local shows, travelling as far as the Bath and West Show.

Avon Antiques

Plate 102. *A View from the East End of the Brewery, Chiswell Street, 1st January 1792* after George Garrard. Engraving, 22 x 30in. (56 x 76cm).
Before the age of motor vehicles horses had to do all the haulage work in towns as well as on the land. Certain breweries such as Young & Co in Wandsworth still keep up the tradition of teams of immaculately turned out Shire horses for local deliveries.

Whitbread Archive Collection

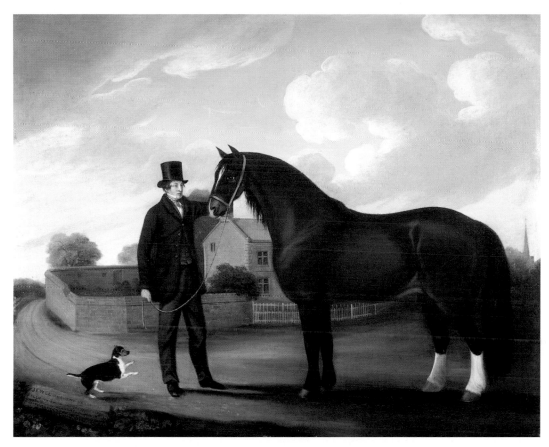

Colour Plate 284. *Jewel The Shire Horse* signed Cox. Oil on millboard 26 x 31in, (66 x 78.75cm).
Inscribed : *Jewel, the 2 Year Old Filly to which the Society's Prize of £10 was awarded at the R A S held at Northampton, July 1847.*
Jewel was a two year old filly owned by a Mr William Barns of Byfield, Northampton. Private Collection

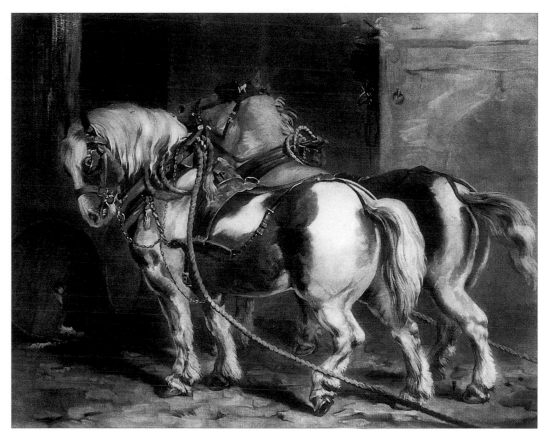

Plate 104. *Pirate and Outlaw* after J.C. Zeitter engraved by J. Egan, c.1818. 11¾ x 15in. (30 x 38cm).
Inscribed: *Pirate & Outlaw. Engraved by J. Egan from a picture by J.C. Zeitter, in the possession of Mr Andrew McCallan to whom this plate is respectfully inscribed.*
According to the Rothamsted catalogue the two Shire dray horses belonged to Reid's Brewery.
 Lawes Agricultural Trust. Rothamsted Experimental Station

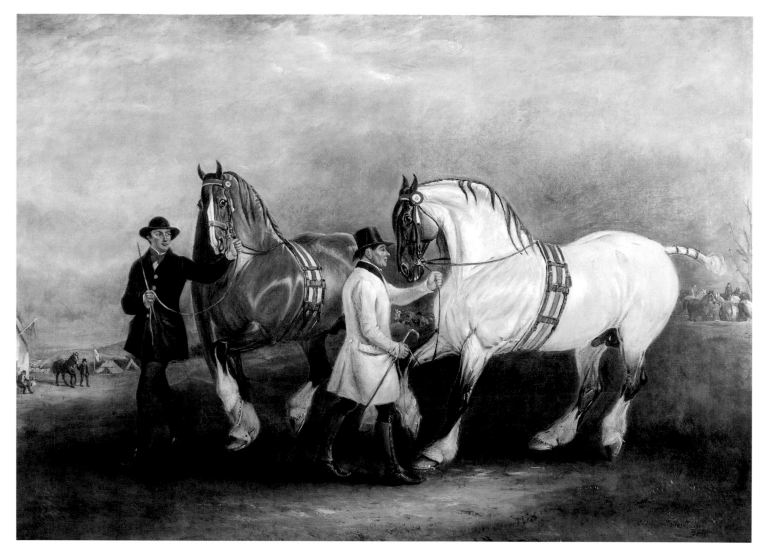

Colour Plate 285. *Carthorses* by John Ferneley, 1856.
Oil on canvas, 41 x 58in. (104 x 147.3cm).
Heavy horses are an unusual subject matter for
Ferneley. Leicester Museums and Arts & Records Service

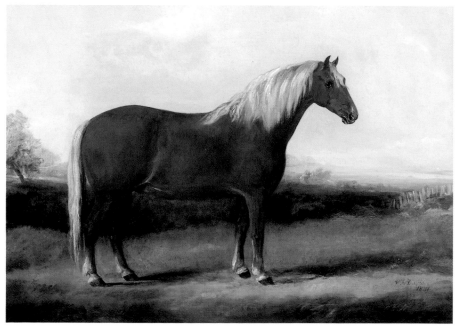

Colour Plate 286. *Suffolk Stallion* by W.H Davis,
c.1850. Oil on canvas, 22½ x 25½in. (57 x 64.75cm).
 Suffolk Horse Museum, Woodbridge, Suffolk

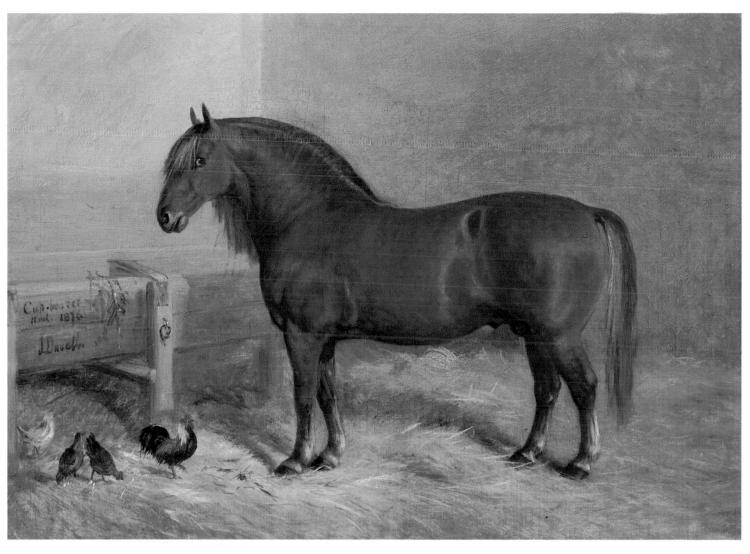

Colour Plate 287. *Suffolk Stallion Cup Bearer II* by John Duvall, 1876. Oil on canvas, 16½ x 21½in.(42 x 54.5cm).
Duvall lived in Ipswich and specialised in painting horses. He was employed by Herman Biddell, the first Secretary of the Suffolk Horse Society, to illustrate volume I of the Suffolk Stud Book published in 1880.　　　　Suffolk Horse Museum, Woodbridge, Suffolk

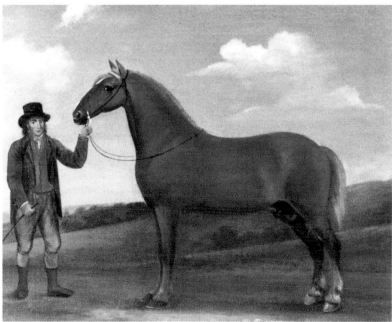

Colour Plate 288. *A Farmhand holding a Suffolk Stallion*, unknown artist, c.1840. Oil on canvas, 23 x 27in. (58.5 x 68.5cm).
The Suffolk is distinguished by its 'chesnut' or 'sorrel' colour. It was the earliest regional breed of horse to become established and began to be improved in the late 18th century by Coke of Norfolk.
Collection of Mrs Pat Coombes

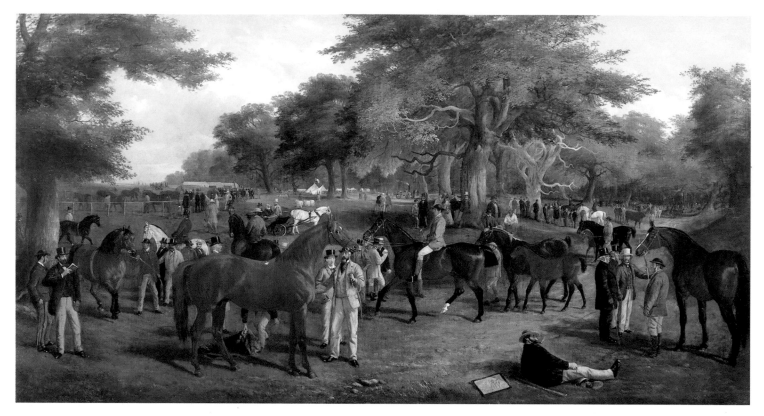

Colour Plate 289. *The Suffolk Horse Show in Christchurch Park* by John Duvall, 1869. Oil on canvas, 32½ x 60in. (82.5 x 152.5 cm).
The painting was commissioned by Colonel Barlow who is seen with his prize-winning Suffolk 'Dalesman' in the foreground. Barlow owned a racing stable and stud at The Shrubbery, Hasketon, Suffolk. Other local breeders can be seen in the painting and John Duvall, the artist, is lying on the ground in the foreground with a sketch of a man on a horse. Ipswich Borough Museums and Galleries

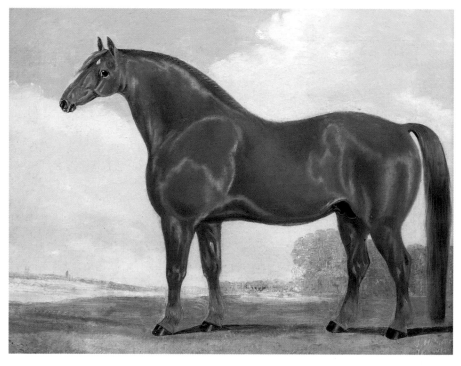

Colour Plate 290. *A Suffolk Stallion* by John R. Hobart. Oil on canvas, 14 x 16½in. (35.5 x 42cm).
Hobart lived in Ipswich and was the first official Suffolk Horse Society artist.

Suffolk Horse Museum, Woodbridge, Suffolk

Coke was fortunate in that the Suffolk horse was one of the few established local breeds and provided ideal material for improvement. It has changed little in appearance since the eighteenth century and was already established as chesnut (the T is left out) or 'sorrel' in colour. Smaller than the Shire, it stands between sixteen and seventeen hands high. Its low set shoulders enable it to throw all its weight into the collar, its barrel-like belly, which earned it

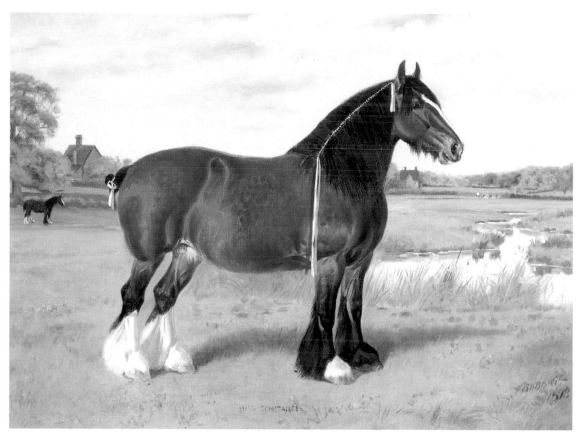

Colour Plates 291 and 292. A pair of Prize Suffolk horses, 'Miss Constance' and 'Childwick Victoria', by F. Babbage, 1898. Oil on canvas, 12 x 16in. (30.5 x 40.6cm).

Babbage continued painting livestock and in particular heavy horses well into the 19th century. The demand for horse painting seems to have continued after livestock painting was beginning to be replaced by photography. Both these horses were bred on the Childwickbury Estate near St Albans by Sir J. Blundell Maple, Bart, M.P.

Private Collection

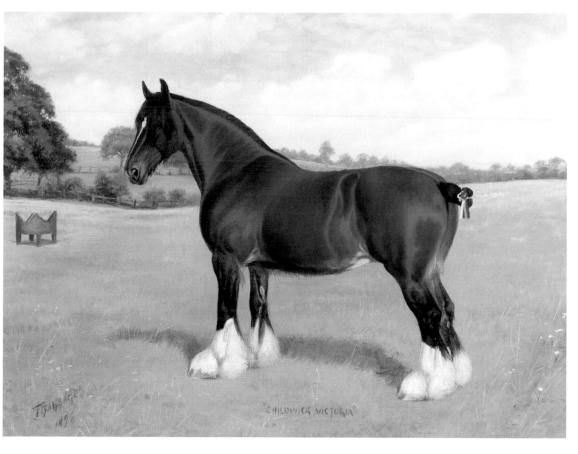

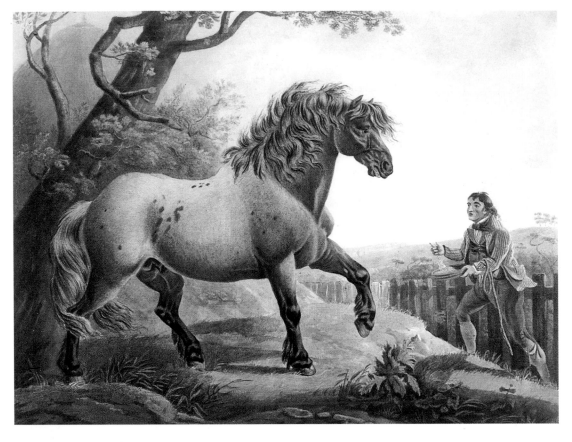

Colour Plate 293. *Elephant, A Cart-horse* after C. Catton engraved by Robt Dodd, 1793. 15½ x 20in. (39.4 x 51cm).

Inscribed: *Portrait of Elephant a cart-horse 4 yrs: old, the property of Thomas Alsop Esqr, of Marylebone. Elephant is supposed to be one of the most boney horses and of the greatest bulk for his length in this kingdom. His height 16 hands 1 inch; Length sideways from shoulder to buttock 6 feet 2 inches: Length of the back from shoulder to tail 4 feet, Breadth of chest 2 feet, Breadth behind 2 feet 6 inches, Girt round his body 8 feet, Girt round the neck 6 feet 10 inches, Girt of his arm 2 feet; Girt on the knee joint 1 foot 4½ inches, Depth of his shoulder 2 feet 7½ inches.*

Lawes Agricultural Trust. Rothamsted Experimental Station

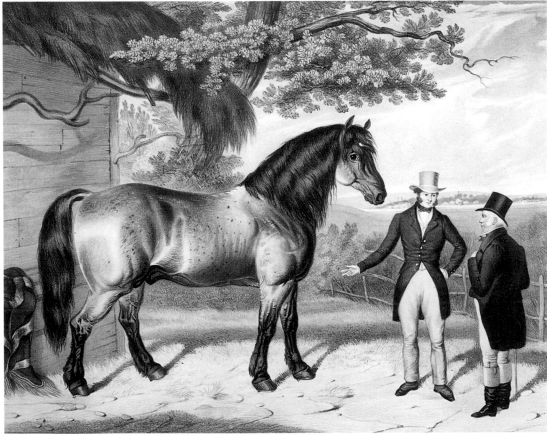

Colour Plate 294. *Farmer's Glory, The Surry Champion* after W. Wombill, lithographed by J.W. Giles. 1844. 13¾ x 17¼in. (35 x 44cm).

Inscribed: *Farmer's Glory, the Surry Champion. Bred in 1838, stands 17 hands high, got by Elephant, dam by Mr. Pearce's Old Punch. – 1841. Farmer's Glory obtained three prizes from the Surry Agricultural Association. & is considered by judges to be the best horse now travelling. The property of Mr. Wm. Coleman, Cheam, Surry.*

Lawes Agricultural Trust. Rothamsted Experimental Station

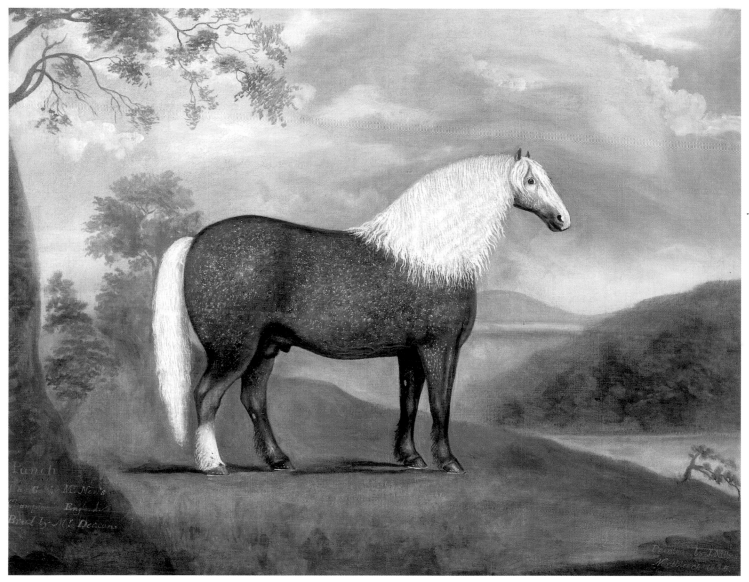

Colour Plate 295. *'Punch', A Grey cart-stallion* by J. Miles of Northleach, 1835. Oil on canvas, 25 x 31in. (63.5 x 79cm).
Inscribed: *Punch was got by Mr New's Champion of England bred by Mr Deacon.*
Shires can be black, grey or chestnut in colour. The development of the breed was not formally coordinated until the foundation of the English Cart-Horse Society (later renamed the Shire Horse Society) in 1878.

Private Collection

the nick-name of 'Suffolk Punch', meant it could carry food for longer than other breeds. Suffolks could work a day which began at 6.0 am, finishing at 2.30. Young calls them 'one of the greatest curiosities of the county'. They take the shape of 'a true round barrel, remarkably short and the legs the same: and lower over the forehand than in any part of the back, which they reckon here a point of consequence.' They have the longest history of all the breeds and can be traced back to a stallion foaled at Woodbridge in 1768, the so called 'Horse of Ufford', which was advertised in a local newspaper of 1773:

light chestnut horse full 15½ hands, five years old, to get good stock for coach or road, which said horse is the property of Thomas Crisp of Ufford.

The Suffolk was the only well-established regional breed in the late seventeenth century.

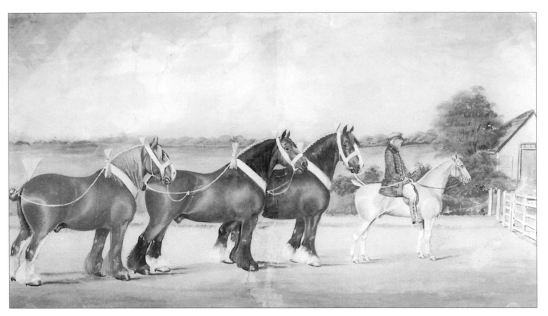

Plate 105. *The Horse Dealer* by H.W. Standing, 1908 Watercolour, 14½ x 25in. (37 x 64cm).

Collection of John Gall and Rosy Allan

Throughout the rest of the country farm horses did not conform to any particular type except that black was a common colour. Several breeders attempted to improve the local horses by crossing them with imported Friesland and Zeeland blood. Lord Chesterfield sent six Zeeland mares back to his estate at Bretby in Derbyshire and the Earl of Huntingdon brought home 'a set of coach horses from the Continent' to mate with local mares. Robert Bakewell travelled through Holland to purchase West Friesland mares which he put to his own Leicestershire stallion in-breeding to fix his desired characteristics (Colour Plate 297). The horse which finally developed from this medley of experiments is the Shire horse, named after the Shire counties of the Midlands, although this name did not stick until late in the nineteenth century (Plates 106 and 107). The largest of the draught horses, they stand between sixteen and eighteen hands high with a coarse, heavy head and short strong body. They can be black, grey or chestnut in colour with white socks and spectacular feathering on the legs.

Plates 106 and 107. *The Common Cart-Horse, The Improved Cart-Horse* by Thomas Bewick from a *History of Quadrupeds* first published in 1790. Woodcuts, approx. 2¼ x 3¼in. (5.75 x 8.25cm).
Bewick's woodcut shows how the improved cart-horse developed with a much fuller heavier chest and shoulders, straight back and stronger, more compact legs. There is no sign of the feathering which becomes such a feature of Shire horses in the mid-nineteenth century. Beamish: The North of England Open Air Museum

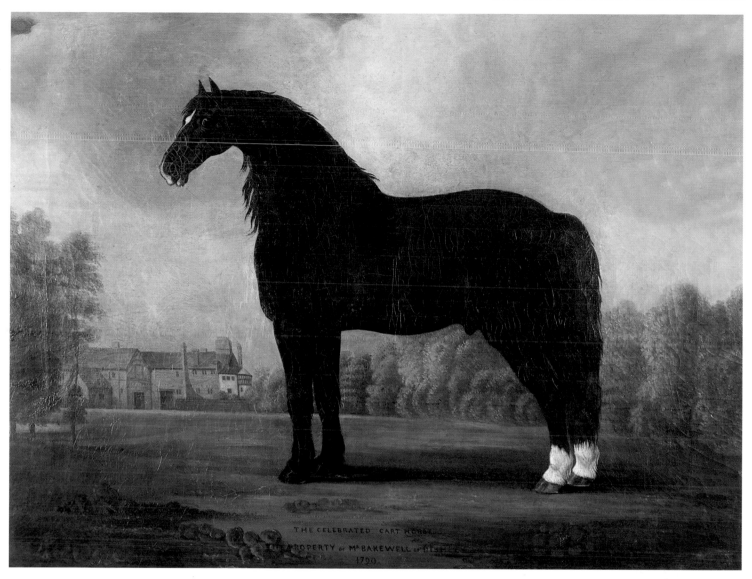

Colour Plate 297. *Robert Bakewell's Black Cart-Horse Stallion* attributed to John Boultbee. Oil on canvas 25 x 30in. (63.5 x 76.2cm).
Inscribed: *The Celebrated Carthorse. Property of Mr Bakewell of Dishley, 1790.*
An engraving after this painting in the Rothamsted Collection is given to John Boultbee, engraved by F. Jukes, 1791. Inscribed: *Portrait of a horse, six years old. The property of Mr Bakewell of Dishley.*
Bakewell imported mares from Holland to improve his Leicestershire cart-horses and had a considerable influence on the development of the Shire horse. When Shiels painted an 'Old English Black Horse Stallion' for his *Breeds of Domestic Animals* he chose a stallion belonging to Mr Broomes of Ormiston, Derby from a mare of the 'Dishley Breed'. Private Collection

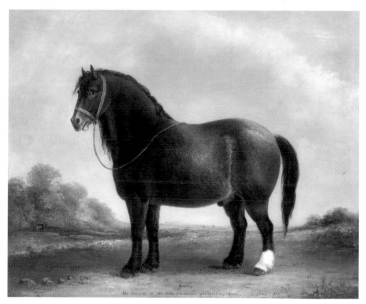

Colour Plate 296. *Bowler, A Shire Horse* by J. Hutchings, 1857. Oil on canvas, 25 x 30in. (63.5 x 76.2cm).
Inscribed: *Bowler, The property of Mr John Checkley, Biddlesden, Bucks.*
 Private Collection

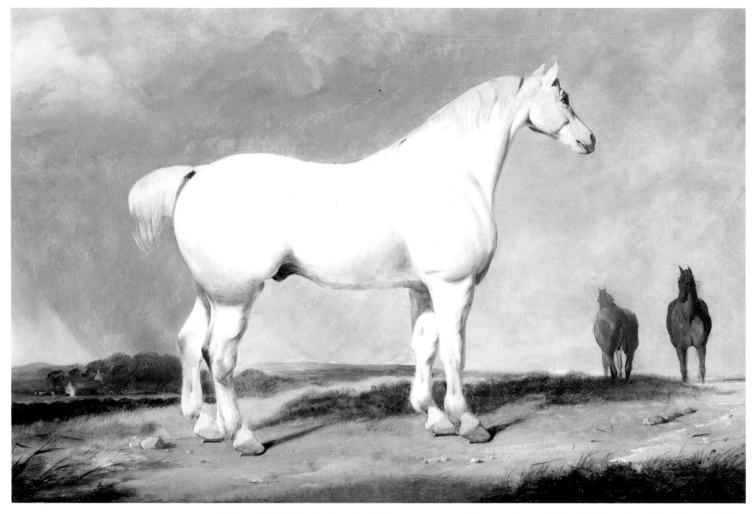

Colour Plate 298. *Clydesdale Gelding, property of Messrs Hervey & Co Edinburgh* by John Sheriff. 15¾ x 23½in. (40 x 60cm).
Clydesdales vary enormously in colour. They often have white socks and it can be difficult to distinguish them from Shires. Royal Highland and Agricultural Society of Scotland

In Scotland the Clydesdale emerged from a similar mix of native and imported stock and its development parallels that of the Shire horse. Tradition has it that some of the Clydesdale blood comes from the defeated English war-horses left floundering in the mud after the Battle of Bannockburn. There were certainly successive imports of both English and Flemish horses into Scotland and by the eighteenth century a recognised breed of heavy horse had developed on the upper Clydesdale in Lanarkshire. They were further improved by crossing with improved English Shires, by breeders such as the Duke of Hamilton who acquired one of Bakewell's black horses. The Clydesdale Stud Book was established in 1878 and in the late nineteenth century the blood of three famous stallions predominated, 'Prince of Wales', 'Darnley' and 'Baron's Pride'. Clydesdale horses were bred for work on farms throughout Scotland and the northern counties of England. Like the Shire they can be be bay, black, brown or roan in colour with white socks and are as tall as the Shires.

As with sheep and cattle, stallions were let to farmers or a group of farmers for the season. Some breeders kept their most valuable stallions at home and the mares were sent in for mating. Travelling stallions also moved around the country at prearranged stopping points. Contemporary advertisements show what an exhausting schedule was arranged for them; the stallions were expected to perform at two different venues every day of the week and one wonders how high their success rate was.

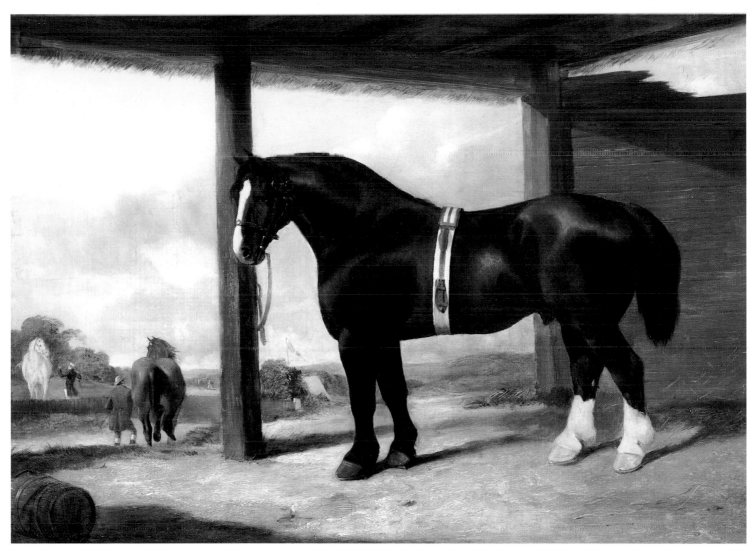

Colour Plate 299. *Clydesdale Stallion property of Mr James Steedman, Boghall, Midlothian* by John Sheriff. Oil on canvas, 15¼ x 21½in. (38.7 x54.5cm).
Like the Shire, the Clydesdale developed from crossing local horses with Flemish imports.

Royal Highland and Agricultural Society of Scotland

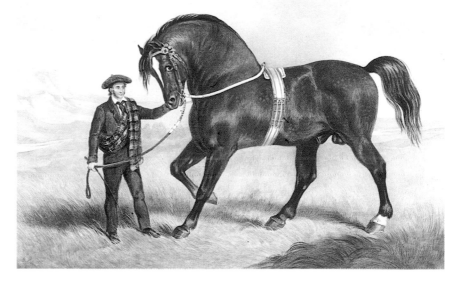

Colour Plate 300. *Lofty, A Clydesdale Stallion* after S.E. Jones, lithographed by T. Fairland. 15½ x 20in. (39.4 x 50.8cm).
Inscribed: *Lofty. A Clydesdale - the property of Benjamin Boyd Esqr. Lofty has gained five of the highest premiums awarded by the agricultural societies in the south of Scotland (Sire, the celebrated Clyde;) was bred by Mr Dove of Faulfar Mains, Ayrshire, from his well known brown mare, which took three premiums in that county. Dam by Old Briton, grandam by Old Ploughboy.*

Lawes Agricultural Trust. Rothamsted Experimental Station

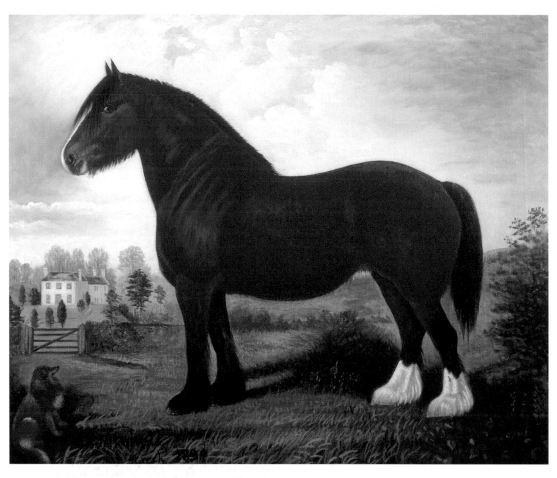

Colour Plate 301. *Old Darling of Gartland, A Clydesdale Horse* by E. Mitchell, 1890. Oil on canvas, 25 x 30in. (63.5 x 76.2cm).
'Old Darling' was bred by Mrs M'Crea, of Half Mark, Leswalt, Stranraer.

Collection of the Reverend and Mrs Frank T. Mohr

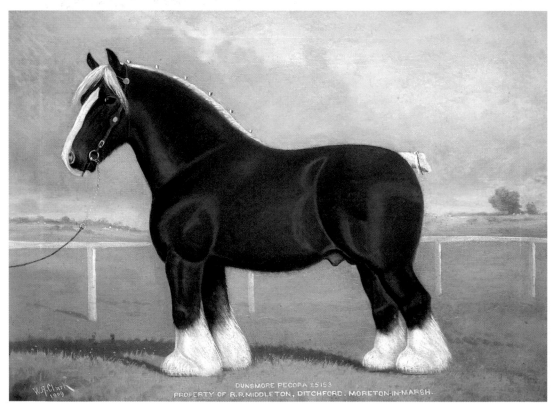

Colour Plate 302. *Dunsmore Pecora 25153, the property of R P Middleton, Ditchford, Moreton-in-Marsh* by W.A. Clark, 1909. Oil on canvas, 17½ x 23¾in. (44.5 x 60.5cm).
One of 'Dunsmore Pecora's' foals, 'Dunsmore Girl' was purchased by the Duke of Devonshire in 1909.

Devonshire Collection, Chatsworth. Reproduced by Permission of the Chatsworth Settlement Trustees

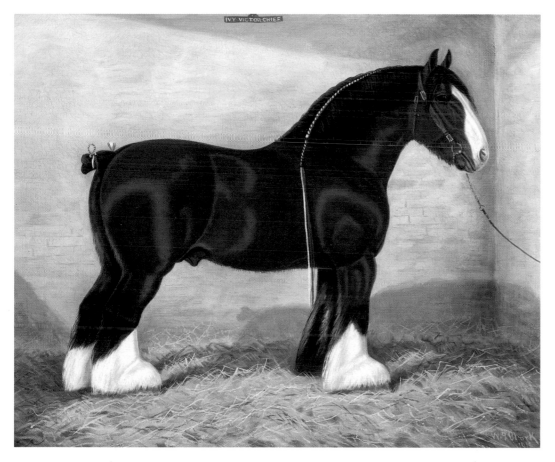

Colour Plate 303. *Ivy Victor Chief, A Shire Horse* by W.A. Clark, 1914. Oil on canvas, 20 x 24in. (51 x 61cm). Inscribed: *Ivy victor chief. This Shire horse was bred in 1906 by the Executors of Philo L Mills, an American Millionaire of Nottingham, & sold to H H Smith Carington, President of the Shire Horse Society, who exhibited him at seven of the Society's London Shows, gaining 1st prize in 1914.*
The Clark family continued painting prize-winning shires well into the 20th century. These massive, thickset Shires with their white feathered socks are typical of the breed as it developed as a show animal in the later 19th century.

Although well established as a workhorse, breeding of heavy horses as prize animals did not become fashionable until the mid-nineteenth century. Demand for workhorses both for farms and for haulage in the towns was high and relatively uncritical and the majority of foals were gelded and reared as workhorses rather than stallions. Lord Ellesmere and other enthusiasts founded the English Cart-horse Society of Great Britain in 1878, renamed the Shire Horse Society in 1884. Societies were formed to control the hiring of stallions, and from now on prizes were

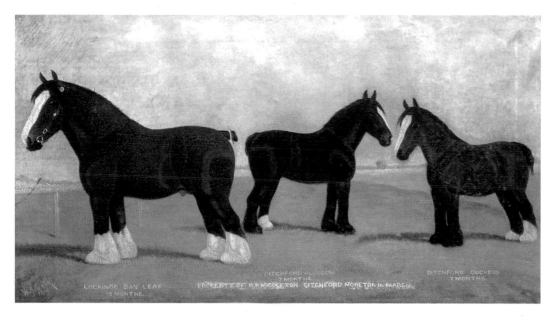

Colour Plate 304. *Lockinge Bay Leaf 18 months, Ditchford Blossom 7 months, Ditchford Duchess 7 months Property of R P Middleton, Ditchford, Moreton-in-Marsh* by W.A. Clark, 1909. Oil on canvas 15¼ x 32in. (38.5 x 81.5 cm).

273

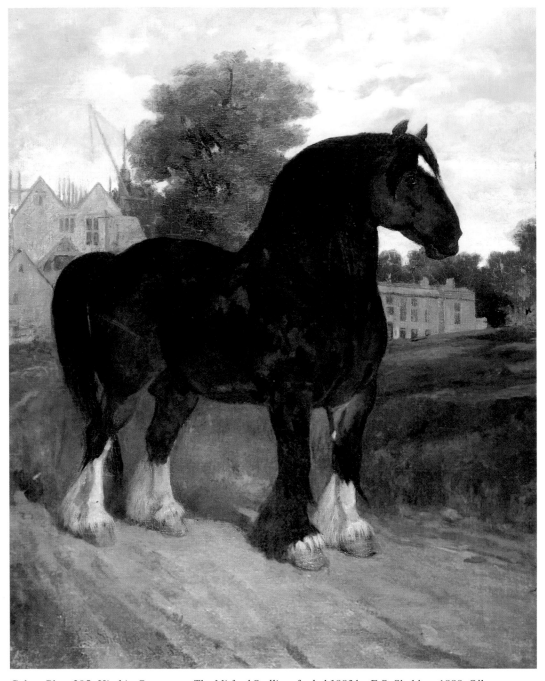

Colour Plate 305. *Hitchin Conqueror, The Mitford Stallion, foaled 1883* by E.S. Sheldon, 1888. Oil on canvas, 25¾ x 20¾in. (65.5 x 53 cm).
The Duchess of Devonshire's father, Lord Redesdale, had a famous stud at Batsford in Gloucestershire which can be seen in the background.

offered for horses at the agricultural shows, and cart-horse parades became annual events. Horses could be compared and judged and the best points were fixed by the breed societies. All three breeds reached standards of excellence with enormous demand coming from the United States for the best horses. They fetched extremely high prices with prominent breeders holding their own sales. In February 1885 over 2,000 people travelled to Sir Walter Gilbey's sale at Elsenham where an average price of £172 was paid. A record price reached was 4,100 guineas paid for a dark brown two-year-old, 'Champion's Goalkeeper', at the dispersal sale of

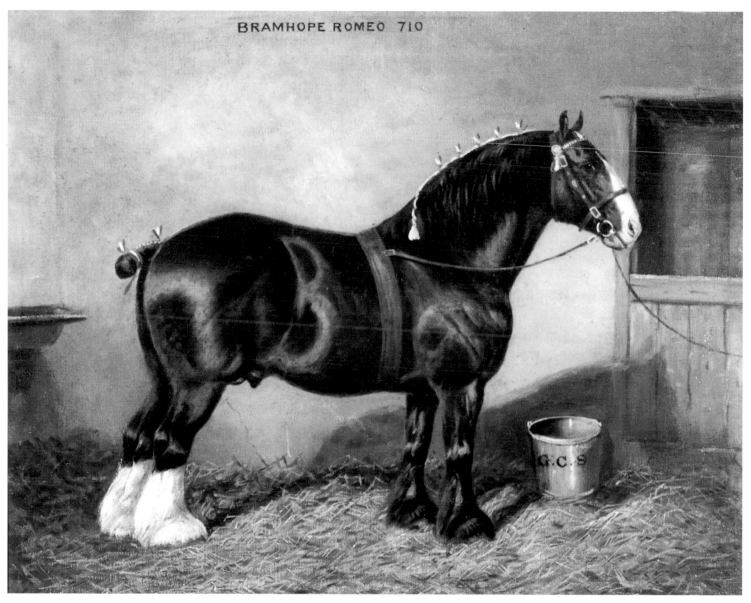

BRAMHOPE ROMEO 710

Colour Plate 306. *A Shire Stallion Bramhope Romeo* by Albert Clark, c.1910. Oil on canvas, 20 x 24in. (51 x 61cm).

'Bramhope Romeo', foaled in 1906, was one of many Shires exported to the USA and Canada. He was imported in 1909 by Robert Burgess and Son of Wenova, Illinois, and resold to Messrs. Colquhoun and Beattie of Brandon, Manitoba, in Canada. The painting has a Canadian provenance and shows the horse as a mature stallion, which raises the interesting question – did Albert Clark travel to Canada to paint him?

Private Collection

Lord Rothschild's Tring Stud in 1915. Forty-seven animals made an average of over £564.

World World War I dealt a mortal blow to the heavy horse; more than a third of the country's horses were requisitioned and half a million died alongside a million men in the terrible battles of the Marne, Mons and Ypres. Worse was to follow. By 1921 when the next generation of horses, bred under the instigation of the government's Heavy Horse Breeding scheme were ready for work, they were already being challenged by the tractor. Farm horses played a valiant part in the Second World War, this time at home, cultivating the two million extra acres needed to feed the population. After the war numbers dwindled so drastically they were in danger of vanishing. Today all three breeds are safe, the greatest threat being the continuing export of the best breeding stock to America.

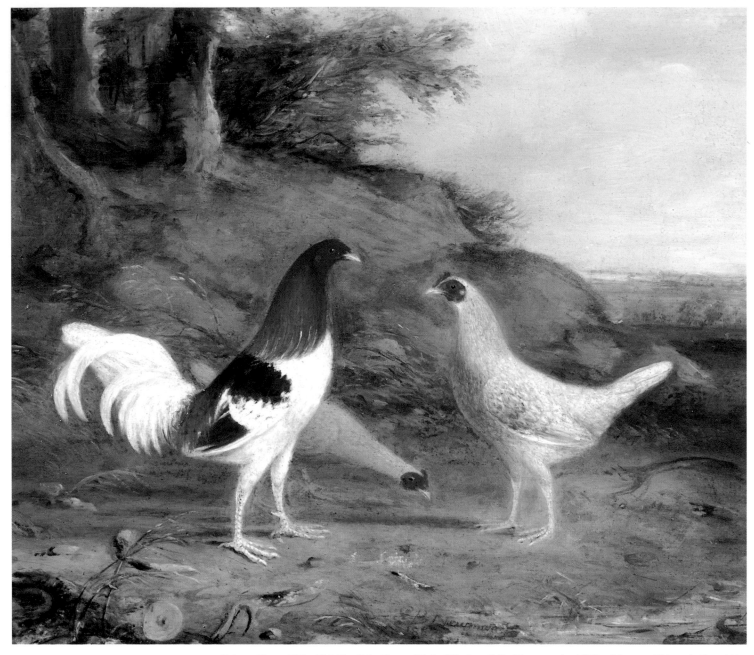

Colour Plate 307. *Old English Game Birds Pile* by G.B. Newmarch, 1857. Oil on millboard, 9 x 11in. (23 x 28cm).
Domestic fowl are all believed to have descended from the jungle fowl. The English Game Bird was the most common indigenous poultry. The sport of cockfighting, which had existed since Roman times, had an important influence on the game bird's development. Until the mid-19th century no one paid much attention to methods of poultry keeping and the birds were left to scavenge a living. Private Collection

Colour Plate 308. *An Old English Game Cock Golden Duckwing with a dead Chicken at its feet,* unknown artist, c.1830. Oil on millboard, 11 x 13in. (28 x 33cm).
Cocks are extremely aggressive and will fight to the death. Private Collection

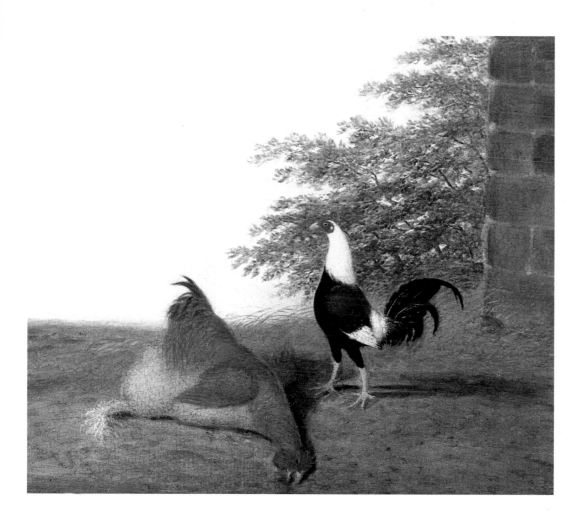

CHAPTER 8
Developments in Poultry Breeding

Poultry breeding was one aspect of the farmyard where commercial incentive played little part in the development of breeds until after the First World War. Hens still scavenged a living from the farmyard and were kept to provide the family with eggs and meat. In the mid-nineteenth century, following the arrival of exotic species from the Far East, 'fancy breeding' became a popular pastime. These foreign breeds were encouraged for their appearance and glorious plumage rather than for their egg laying or carcass qualities. Specimen birds were seized off the returning ships almost before they had time to dock. Birds were bred for their fancy points and their owners competed avidly at shows up and down the country. The first poultry show was held at the Zoological Gardens, London, in 1845 and several of the birds exhibited were depicted in the *Illustrated London News*.

Until the arrival of these exotic species, little attention had been paid to breeding poultry, the only exception being the fighting cock. The barbarous sport of cockfighting, known in Britain since at least Roman times, was not outlawed until 1849 and lingered on longest in the north-west where illegal fights still take place today. Naturally aggressive, a cock will fight to the death and the use of steel and silver spurs made the sport extremely cruel (Colour Plate 308). Illustrations of fighting cocks date from long before fancy breeding really got under way.

Colour Plates 309 and 310. *A Pair of Modern Game Cocks trimmed and Spurred* by Hilton Pratt, c.1850. Oil on canvas 10 x 12in. (25.4 x 30.5cm). Cockfighting was made illegal in 1849 but fights continued to take place long after this, especially in the North West of England. Private Collection

Colour Plate 311. *Modern Game Birds Golden Duckwing* by W. Hollingworth, c.1830. Oil on canvas, 19 x 31in. (48.25 x 78.75).
Crossed with Malay game, the Old English game cock developed into a much taller bird with shorter tail feathers. Compare this modern Game bird with Colour Plates 308 and 313.
Collection of Mr and Mrs Gary Gross

Although cockfighting certainly did not end overnight (Colour Plates 309 and 310), many breeders turned their attention to exhibiting their birds in poultry shows. The old English game cock was crossed with Malay game for greater size and developed into the much taller elegant Modern Game bird with its shorter tail feathers which was bred purely for exhibition purposes (Colour Plate 311).

Colour Plate 312. *Old English Game Cock Black Red and Clay Hen in a Chicken Run* by J.S. Howson, 1910. Oil on millboard, 18½ x 23½in. (47 x 59.7cm).

It was not until the mid-19th century that hens began to be kept in proper poultry yards. As a result, their laying ability increased which led to the establishment of the first commercial poultry farms.

Collection of Richard P. O'Loughlin, Ft. Lauderdale, Florida

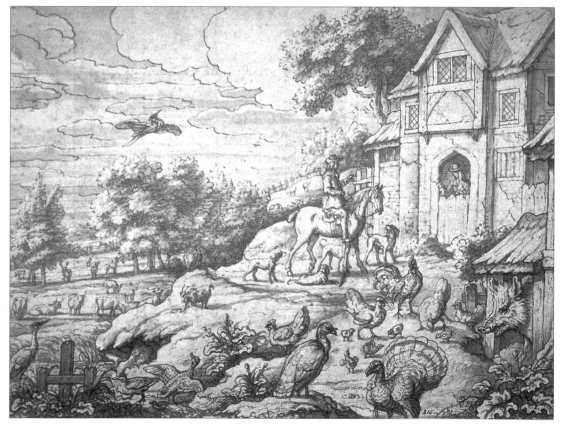

Plate 108. *Farmyard Sketch* by Francis Barlow (1626-1702). Pen and ink on paper,

Barlow was the earliest British artist to show an interest in domestic livestock and farmyard scenes. This sketch shows the haphazard manner in which poultry was reared. Turkeys, ducks, geese and all types of 'barn yard fowl' all ranged freely about the farmyard. (See also Colour Plate 18.

By courtesy of the Board of the Trustees of the Victoria & Albert Museum. Bridgeman Art Library, London

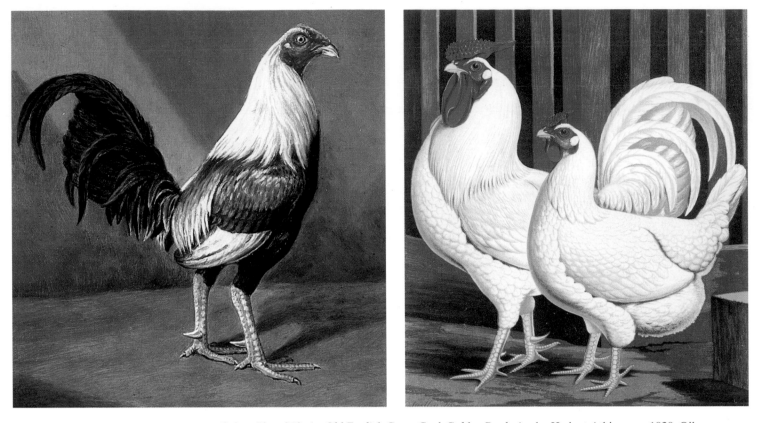

Colour Plate 313. *An Old English Game Cock Golden Duckwing* by Herbert Atkinson, c.1920. Oil on canvas, 14 x 12in. (35.5 x 30.5cm).
Once cockfighting became illegal, prize cocks were bred for exhibition purposes. Despite the appearance of the Modern Game Cock the Old English type did not diminish in popularity. Atkinson was a world authority on cockfighting and one of the original founders of the Old English Game Club in 1885. He was born at Wallingford, where his father was a doctor, and specialised almost entirely in poultry scenes.
Collection of Mr W.C. Stevens, Melbourne, Australia

Colour Plate 314. *Miss Fairhurst's Pair of White Dorkings* by Ludlow, c.1890. Chromolithograph from *Cassell's Poultry Book,* 8¼ x 6¼in. (21 x 16cm).
Inscribed: *First Prize at Colchester 1873. Besides other prizes separately.*
Dorking fowl were fattened for the London market providing plump, white fleshed birds. A.J. Ludlow, who undertook the illustrations for *Cassell's Poultry Book,* was well known as a painter of pigeon- and cock-fighting portraits. Works by him appear as illustrations to the *Fanciers Gazette* Courtesy of the O'Shea Gallery

All domestic fowl are believed to be descended from the jungle fowl of India and South East Asia. They were a motley bunch known as 'barn door fowls' or 'dung-hill fowl' ranging loose around the farmyard. In poorer areas they were brought inside at night to sleep beside the fire. By the early nineteenth century a few breeds of poultry had become identified and were well established. In Scotland there was the Scots Grey, found on almost every lowland farm. It was a cuckoo-patterned grey hen which laid white-shelled eggs. Its cousin, the Scots Dumpy, had much shorter legs and was bred in the Highlands.

The London market preferred white hens and the white Dorking fowl (Colour Plate 314) with its red comb, capable of being fattened into a plump table bird, developed in the Weald of Sussex. This was one area of the country where birds were raised and fattened on a mixture of stone-ground oats and milk to supply the London market. Old Sussex or Kent fowls, similar to the Dorking, were bred in other parts of the South and Lincolnshire. In Devon and Cornwall the Cornish game fowl was created from the Old English game bird and the Aseel. It had a yellow, richer, flavoured flesh and was taken to America. Poultry raising was a sideline to the main business of farming; while a few birds may have been fattened and taken to market, it

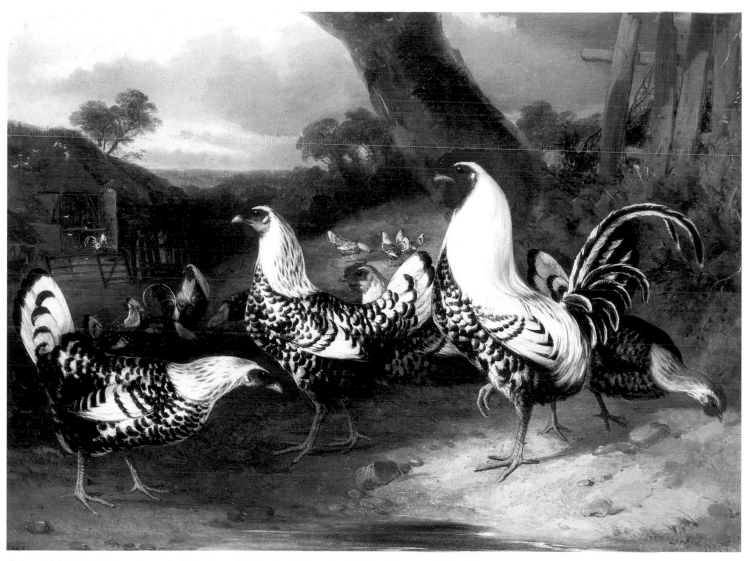

Colour Plate 315. *A Silver Spangled Hamburg Cockerel and Hens* by William Shayer, c.1850. Oil on canvas. The Hamburg was largely a home-grown bird from Yorkshire and Lancashire. There were many different varieties.

Spink and Son Ltd. Bridgeman Art Library, London

was not taken seriously as a commercial enterprise.

The north of England had a long established tradition of fancy breeding encouraged by the migration of country people to the towns during the Industrial Revolution. Unable to keep live-stock in their backyards, they could keep hens and chickens and local, low key, poultry competitions began. Hamburgs, Redcaps and Pheasant Fowl masquerading under a variety of names were all kept in the north; they were all good layers and somewhat pheasantlike in appearance. Birds from Holland contributed to the make-up of the Hamburg (Colour Plate 315) but it was principally a home-grown bird, most of its blood coming from Lancashire and Yorkshire hens. The spangled and black varieties were also known as Gold, Silver and Black Pheasants, Lancashire Silver Moonies and Yorkshire pheasants. Larger and more gamey than the Hamburg was the Derbyshire Redcap, so called after its rosette of comb wattles that resembled a cloth cap.

The fashion for poultry paintings obviously coincided with the arrival of exotic species from abroad and keen competition among breeders. Brightly coloured and highly feathered with their idiosyncratic combs and wattles, these fowl were a very jolly addition to the Victorian

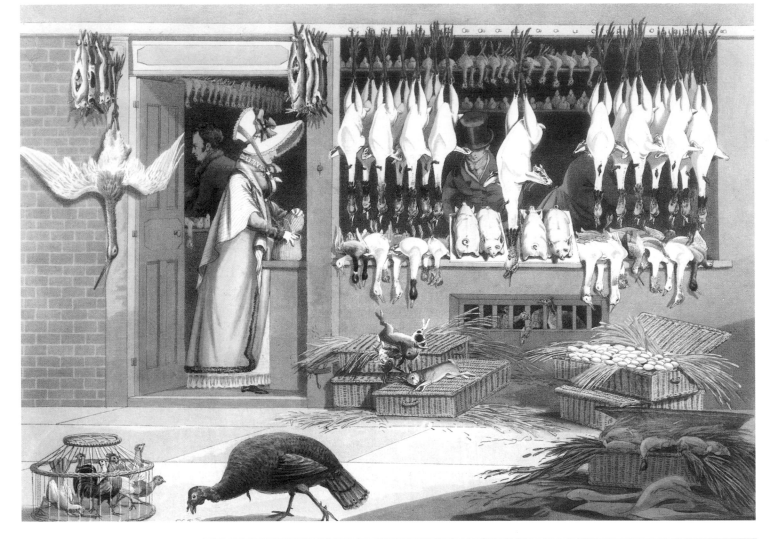

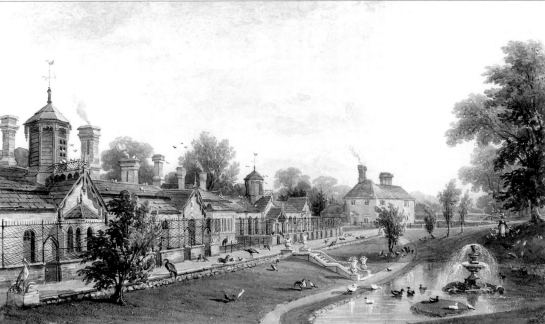

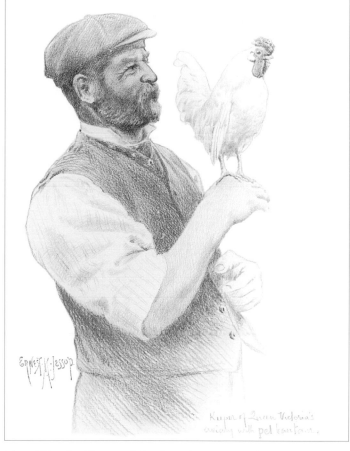

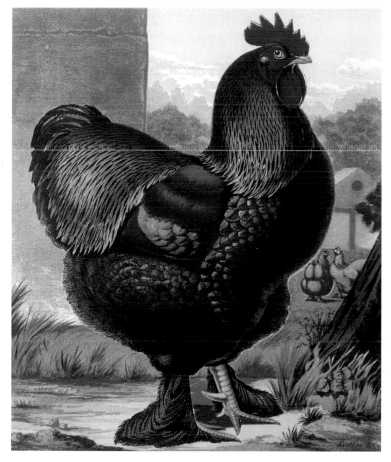

Plate 110. *The Keeper of the Queen's Aviary with a pet Bantam* by Ernest M. Jessop. Pencil on paper, 12 x 7¾in. (30.5 x 20 cm).
The keeper is looking at the Bantam with enormous affection. Queen Victoria was deeply interested in poultry keeping. She and Prince Albert were presented with numerous exotic fowls, many of which were exhibited. The Royal Collection © 1996 Her Majesty The Queen

Colour Plate 317. *Partridge Cochin Cock* by Ludlow, c.1890. Chromolithograph from *Cassell's Poultry Book*, 8¼ x 6¾in. (21 x 17cm).
Inscribed: *Mr E. Tudman's Partridge Cochin Cock 'Talbot'. First Prize at Birmingham, 1870 & Kendal 1871.*
The arrival of exotic species from abroad fostered keen competition among breeders. The first poultry show was held in 1845.
Courtesy of the O'Shea Gallery

farmyard and were splendidly captured by contemporary painters. None of the pure breeds had a significant commercial future and, although scarce, they have nearly all survived, thanks to the enthusiasm of breeders who organised themselves along formal lines with the establishment of the Poultry Breeders Club in 1877. Queen Victoria headed the fashion, building a magnificent poultry house in Windsor Great Park (Plates 109 and 110). She exhibited her heavily feathered Cochin fowl (Colour Plates 317 and 318), newly arrived from Shanghai, at the Royal Dublin show of 1846, causing a sensation. Their exotic looks coupled with their ability to lay brown eggs in winter meant they were 'vaunted to the skies as the best, the most prolific, and handsomest bird that was ever seen'. Also from the Far East came the

Colour Plate 316. *The Poultry Shop* by James Pollard, 1822. Coloured aquatint, 8¾ x 11¾in. (22.5 x 30cm)
A very wide range of poultry and game was available in the London markets. Birds were transported live in wicker baskets and kept alive in the shops for several days. Courtesy of the O'Shea Gallery

Plate 109. *The Aviary and Poultry Farm* by C.R. Stanley, 1845. Watercolour on paper, 11¼ x 16in. (25.8 x 41cm).
The Queen's new aviary and fowl house in Windsor Park designed by Messrs Bedborough & Jenner of Windsor was completed in the summer of 1844. The Royal Collection © 1996 Her Majesty The Queen

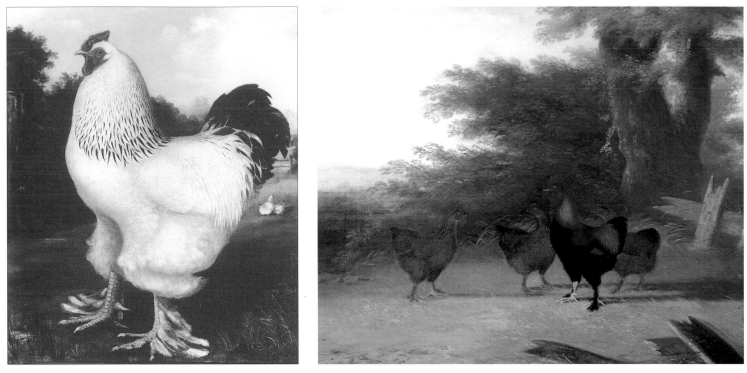

Plate 111. *A Prize Bramah Cockerel* by E.J. Aston, 1875. Oil on canvas, 27 x 22in. (68.5 x 56cm).
The first Brahmas to arrive in England were presented to Queen Victoria in 1852 by an American breeder, George Burnham. Private Collection

Colour Plate 318. *A Cochin Cock with Three Hens* by G.B. Newmarch, 1858. Oil on canvas, 20 x 24in. (51 x 61cm).
These are very early examples of the Cochin breed first introduced to Britain in 1845. Private Collection

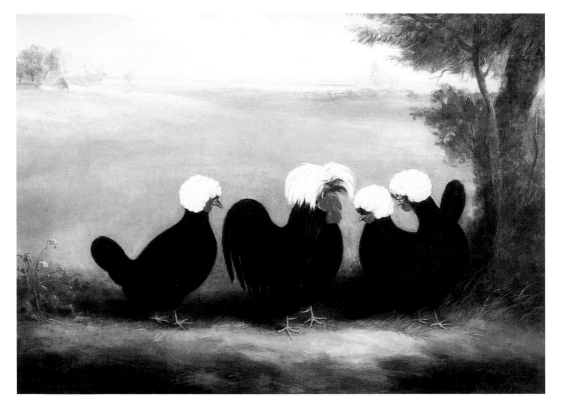

Colour Plate 319. *A Polish cock with Three Hens* by W.H. Davis, 1853. Oil on canvas, 18 x 24in. (45.7 x 61cm). Polish fowl are easily recognised by their white crest feathers resembling a bath hat. Dillingham & Co., San Francisco

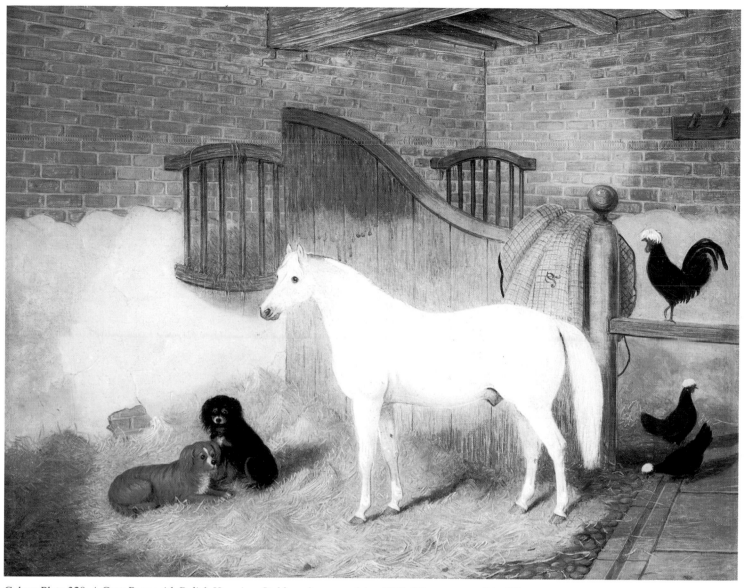

Colour Plate 320. *A Grey Pony with Polish Hens in a Stable,* unknown artist, c.1870. Oil on canvas, 17 x 21in. (43 x 53.3cm).

Private Collection

Brahma (Plate 111), silvery white and black and shaped like a tea cosy. It was imported into America and developed in Connecticut. The first birds to arrive in England were sent by an American breeder, George P. Burnham. Determined to make as big a sensation as possible, he had the case painted in purple and gold and addressed to Her Majesty Victoria, Queen of Great Britain. Sure enough, the *Illustrated London News* reported their arrival. The brilliant, black, white or blue Langshan came from north of the Yangtze Kiang River in China and the fierce looking black and red Malay from Malaysia. The Silkie, with its silky, almost woolly feathering, although originating in Asia, had been known in Europe since at least the sixteenth century. Its broodiness makes it a favourite with gamekeepers for hatching pheasant and partridge eggs.

A whole range of fowl also arrived from Europe, one of the most curious being the Poland (Colour Plates 319 and 320), a black fowl with its flurry of white crest feathers resembling a bath hat. There is little evidence to connect them with Poland and they appear to have been imported chiefly from Holland. Clearly related to the Poland, the Sultan came to Britain from Turkey and the Leghorn from Italy was exported to America and played an important part in establishing many of the later breeds including the Rhode Island Red. Other European breeds included the

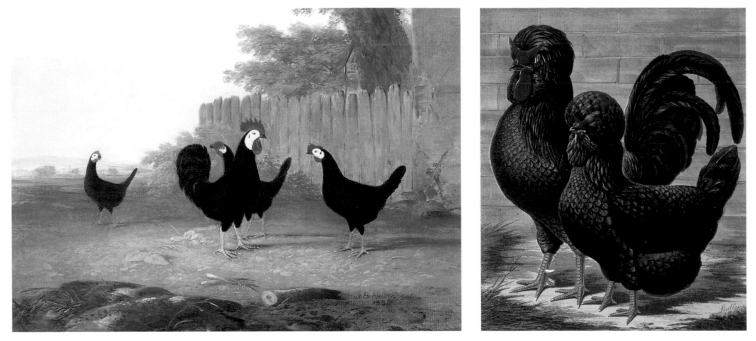

Colour Plate 321. *Whiteface Spanish Cock with Three hens* by G.B. Newmarch, 1857. Oil on canvas, 20 x 24½in. (51 x 62.2cm).
The Spanish with its huge white face first appeared in Britain in the 1750s. Collection of Mrs Robert Francis

Colour Plate 322. *Pair of Houdan's* by Ludlow, c.1890. Chromolithograph from *Cassell's Poultry Book*, 8¼ x 6¾in. (21 x 17cm).
Inscribed: *Mr Robt. B. Wood's Pair of Houdan's 'Young Champion' and 'Lady'. The cock took First Prize at Birmingham Crystal Palace & Manchester 1870. Besides Numerous other Prizes in Company.*
Courtesy of the O'Shea Gallery

Black Spanish with its enormous white face, the smaller rounder Minorcan and the finely marked, greyish white Andalusian. From France came the Houdan (Colour Plate 322) and Crêve-Coeur (Colour Plate 323). The only breed to be imported from Holland was the Campine. Bantams, the majority of them diminutive replicas of the true breeds bred by selecting the smallest examples and inbreeding them, also became fashionable (Colour Plate 324).

Inevitably the chicken craze was relatively shortlived. Bred too much for their fancy points, many of the new species were soon found wanting. Monstrous combs could flop over blinding the chickens and causing brain damage by the pressure they put on the head. The Cochin fell out of favour when it became evident it laid only a few small eggs and the flesh of the older birds was tough and stringy. In a different climate and terrain many of the foreign breeds failed to show the characteristics which had favoured them in their country of origin and soon fell from fashion. None the less, interest in poultry keeping had now been stimulated and breeders began to wonder how they could develop more productive fowl.

In the later nineteenth century there was a reaction to breeding birds for the

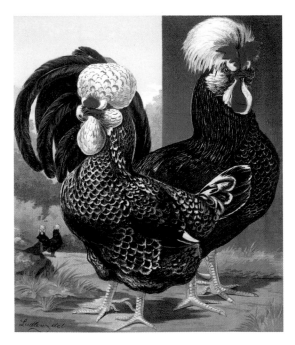

Colour Plate 323. *Pair of Crêve-Coeurs* by Ludlow, c.1890. Chromolithograph from *Cassell's Poultry Book*, 8¼ x 6¾in. (21 x 17cm).
Inscribed: *Mr R.B. Wood's Pair of Crêve-Coeurs 1st Prizes at Wolverhampton, Birmingham, (Summer Show). Spalding & Chesterfield, 1872.*
The Houdan and the Crêve-Coeur were just two of the many European breeds which arrived in Britain in the mid-19th century. Courtesy of the O'Shea Gallery

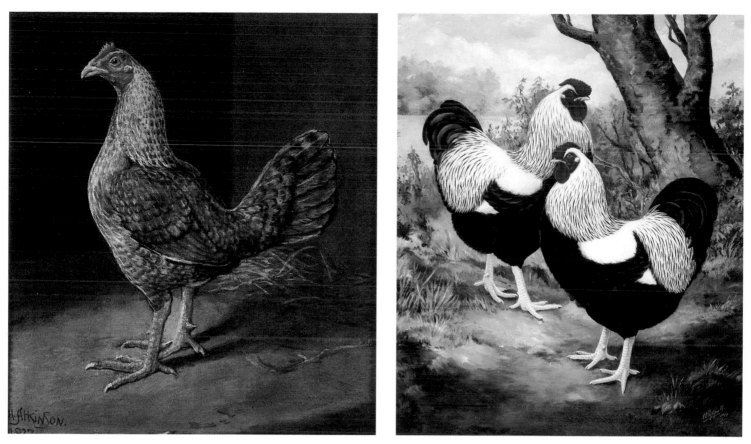

Colour Plate 324. *A Creel Old English Game Bantam Hen* by H. Atkinson, 1927. Oil on canvas, 4 x 12in. (35.5 x 30.5cm).
Bantams, diminutive replicas of the true breeds, were highly fashionable with the Victorians.Private Collection

Colour Plate 325. *Two Silver Wyandotte Cockerelles* by Wippell, 1908. Oil on canvas, 20 x 24in. (51 x 61cm). The Wyandotte was one of several hybrids bred in America and valued for its commercial rather than its exhibition characteristics. Iona Antiques

show ring. The British now wanted birds with good egg-laying ability, plump breasted on a fine-boned, lightly feathered frame which matured early. Poultry breeders in North America had already begun to cross-breed Old English fowl with the newly imported strains. By careful selection, they had produced a group of breeds which became the mainstay of the poultry industry for the next eighty years. British breeders therefore looked to America to find strains which had not been spoilt by the show ring. The new hybrids included the Rhode Island Red, the breed kept by everyone in their backyard during the last war, the Wyandotte (Colour Plate 325), the Plymouth Rock and in England William Cook launched the Buff Orpington breed in 1894. He was an astute publicist and the breed was soon highly in demand. Many of these late nineteenth century birds played an important part in the development of today's hybrids who eke out such a miserable existence in their intensive battery units.

Other farmyard poultry – geese, ducks and turkeys – did not become popular as show animals and were therefore never painted in the same way as cocks and hens. In the eighteenth century there was a flourishing goose industry in East Anglia, the geese travelling on foot, their feet protected from the wear of the road by walking through a mixture of sawdust, tar and sand. The draining of the Fens destroyed the goose's natural habitat and from then on they were kept only in small numbers by cottagers and farmers. Even so, attempts were made to improve the native English goose. The Toulouse goose was imported from France, the Emden from Germany and the first Chinese geese to arrive in Britain were said to have hatched on a ship travelling from China in 1848. The most popular goose today is a Toulouse-Emden cross while

Colour Plate 326. Detail from *Capel Hanbury Leigh at the Home Farm, Pontypool Park* (see Colour Plate 135).
Geese and turkeys ranged at large in the farmyard alongside other types of poultry. They never became fashionable as exhibition birds and were reared only for the table. Sir Richard Hanbury-Tenison

the Old English survives in breeds such as the Pilgrim, said to have been taken to America by the Pilgrim fathers in 1620.

With the exception of the South American Muscovy, all domestic ducks are descended from the Mallard. A specialised duck industry developed around the Vale of Aylesbury in the eighteenth century. The white Aylesbury is a prolific layer, has light bones and matures early. In other parts of the country farmyard ducks were a motley coloured collection made up of brown and green mallards and the English white. In the nineteenth century came an influx of exotic ducks, the white duck with its canary yellow tinge from Peking in 1872, the agile Runner duck from India, and crested ducks from Bali and Holland. Pure bred ducks are now extremely rare; most commercial ducks are hybrids and include some Pekin in their make-up.

Turkeys were imported to England from their native Central and South America in the sixteenth century. They soon became popular and the first birds to be bred were bronze, like their wild ancestors. The domesticated birds were re-exported to America. By the eighteenth century East Anglia was the main turkey farming area and these black turkeys, shod with leather boots, were driven to London in their thousands each autumn. The Victorians demanded ever fatter turkeys for their groaning Christmas tables and turned to America to improve the breed. Here the wild bronze turkey had been crossed with the Mexican black and was known as the bronze. A cross between the bronze, the black Norfolk and a grey turkey from southern Ireland produced the Cambridge bronze which for over one hundred years was the favourite commercial breed. Other birds were introduced from America to try and breed ever fatter turkeys. The largest turkey on record weighed 78lb.11¼oz. In the 1960s the commercial breeders switched to white turkeys and the bronze almost became extinct.

BIBLIOGRAPHY

For bibliographic details on the artists consult:

Bolach, D.H. *A Record of the Rothamsted Collection of Prints.* Harpenden,1958.

Harris, Paul and Halsby, Julian. *A Dictionary of Scottish Painters 1600-1960.* Edinburgh, 1990.

Mitchell, Sally. *The Dictionary of British Equestrian Artists.* Woodbridge, 1985.

Wingfield, Mary Ann. *A Dictionary of Sporting Artists, 1650-1990.* Woodbridge, 1992.

Wood, Christopher. *The Dictionary of Victorian Painters, 1837-1901.* Woodbridge, 1971.

Wood, J.C. *A Dictionary of British Animal Painters.* Leigh-on-Sea, 1973.

Artists: General

Ayres, James. *British Folk Art.* London, 1977.

Ayres, James. *English Naïve Painting 1750-1900.* London, 1980.

Barrell, John. *The Darkside of the Landscape, The Rural Poor in English painting, 1730-1840.* Cambridge, 1980.

Boase, T.S.R. *English Art 1800-1870.* Oxford, 1959.

Cameron, A.D. *The Man Who Loved to Draw Horses: James Howe 1780-1836.* Aberdeen, 1986.

Campbell, Colin. 'Awesome Aspect.' *Country Life.* 29 June, 1989 pp. 204-5. Thomas Bewick's commission for the Wild Bull of Chillingham.

Deuchar, Stephen. *Sporting art in Eighteenth Century England.* New Haven, Conn. London, 1988.

Egerton, Judy. *British Sporting and Animal Paintings 1655-1867 in the Paul Mellon Collection.* London, 1978.

Gilbey, Sir Walter. *Animal Painters of England From the Year 1650. A brief history of their lives and works.* Vols I and II London, 1900. Vol III London, 1911.

Grant, M.H.A. *A Chronological History of the Old English Landscape Painters (in oils) from the XVIth Century to the XIXth Century.* Leigh-on-Sea, 1957-61.

Graves, Algernon. *The Royal Academy of Arts: A Complete Dictionary of Contributors. London 1769-1904,* 8 vols 1905-6, repr. 1970.

Graves, Algernon. *The British Institution (1806-67). A Complete Dictionary of Contributors.* London, 1908, repr. 1969.

Graves, Algernon. *A Century of Loan Exhibitions, 1813-1912,* 5 vols. London, 1913-15, repr. 1971.

Jackson, Christine E. *Bird Painting: The Eighteenth Century.* Woodbridge, 1994.

Johnson, Jane (compl.). *Works Exhibited at the Royal Society of British Artists 1824-1893 and The New English Art Club, 1888-1917.* Woodbridge, 1975.

Kavanagh, Amanda. 'Prize Pedigree Portraits.' *Antique Collector*, July 1986, pp. 34-41.

Low, David. *The Breeds of the Domestic Animals of the British Isles.* London, 1842.

Marillier, H.C. *The Liverpool School of painters: An Account of the Liverpool Academy, from 1810-1867.* London, 1904.

Millar, Delia. 'We Agriculturalists of England. Farm Animals of Queen Victoria and Prince Albert.' *Country Life*, 26 June, 1986, pp. 1824-6.

Millar, Delia. *The Victorian Watercolours in the Collection of Her Majesty the Queen.* London, 1995

Millar, Oliver. *The Victorian Pictures in the Collection of Her Majesty the Queen.* Cambridge, 1992.

Neve, Christopher. 'The Englishness of Sporting Art, paintings at Cottesbrooke Hall Northants in the collection of Major Sir Reginald and Lady Macdonald Buchanan.' *Country Life Annual* 1968.

Pavière, Sydney. *A dictionary of British Sporting painters.* Leigh-on-Sea, 1965.

Rosenthal, Michael. *British Landscape Painting.* Oxford, 1982.

Siltzer, Frank. *The Story of British Sporting Prints.* London, 1929.

Sparrow, Walter Shaw. 'British Farm Animals in Prints and Paintings.' *Walker's Quarterly,* 1932.

Sparrow, Walter Shaw. *British Sporting Artists.* Second edition, London, 1965.

Taylor, Basil. *Animal Painting in England from Barlow to Landseer.* Harmondsworth, 1955.

Titley, Norah M. (compl.). *A Bibliography of British Sporting Artists.* London: for the British Sporting Art Trust [1984].

Walker, Stella. A. *Sporting Art: England 1700-1900.* New York, 1972.

Waterhouse, Ellis. *Painting in Britain 1530-1790.* London, 1953.

Wilder, F.L. *English Sporting Prints.* London, 1974.

Wood, Christopher. *Paradise Lost, Paintings of English Country Life and Landscape (1850-1914).* London, 1988.

Artists: Monographs

Ayrton, Michael McInnes. 'William Henry Davis: Livestock Portrait Painter, 1783-1864.' *Antique Collecting*, January, 1982. pp. 15-17.

Beasley, Edwin R. *Edwin Frederick Holt: Victorian Artist of Dunstable.* [Publication details unknown]

Beckett, Oliver. 'James Ward, A Flawed Genius.' British Sporting Art Trust Essay, 1985.

Bewick, Thomas. *General History of Quadrupeds.* Newcastle Upon Tyne, 1790

Bewick, Thomas. *A Memoir of Thomas Bewick written by himself.* Newcastle upon Tyne, 1862.

Boughton, P.J. *The Clowes Family of Chester Sporting Artists.* Chester: Grosvenor Museum, 1985.

Clutton-Brock, J. 'The Models of Livestock made by George Garrard (1760-1862) that are in the British Museum (Natural History).' *Agricultural History Review* Vol 24, 1976, pp. 18-29

Clutton-Brock, J, 'George Garrard's Models of Sheep.' *Textile History* Vol 10, 1979, pp. 203-206.

Cooper, Thomas Sidney R.A. *My Life.* London, 1891.

Deuchar, Stephen: 'The Chequered Career of George Garrard.' *Antique Collector*, April, 1984. pp. 50-55

Fletcher, E. (Ed.). *Conversations of James Northcote R A with James Ward on Art and Artists.* Edited and arranged from the MSS and notebooks of James Ward by E Fletcher. London, 1901.

Frankau, Julia. *Eighteenth century Artists and Engravers. William Ward, ARA, James Ward, RA. Their Lives and Works.* London, 1904.

Fussell, G.E. *James Ward RA Animal Painter (1769-1859) and his England.* London,1974.

Garrard, George. *A Description of the different varieties of oxen common in the British Isles with [coloured] engravings: being an accompaniment to a set of models of the improved breeds of cattle, executed by G.G, etc..* London, 1800-1815.

Graham-Stewart, C.W. *Thomas Woodward.* Published privately, 1989.

Graves, Algernon. *Catalogue of the works of Sir Edwin Landseer.* London, 1875

Grundy, C. Reginald. J*ames Ward, R A His Life and Works.* London, 1909.

Gurnhey Benham, W. *John Vine of Colchester (1808-1867). A Remarkable Armless Artist.* Colchester, 1931.

Hampton, J.F. 'Portrait of a Painter'. *Shropshire Magazine,* May 1968, pp. 32-33. [Describes Weaver's hunting scene of John Corbet at Sudborne Castle and his paintings at Shugborough.]

Hatcher, Jane. *George Cuitt the elder (1743-1818).* Tennants Auctioneers, Leyburn, 1992.

Johnson, John (ed.). *Memoirs of the Life and Writings of William Hayley.* London, 1823. [Refers to John Boultbee at Petworth.]

Lloyd, David & Klein, Peter. *Ludlow: A Historic Town in Words and Pictures.* Chichester, 1984. [Biography of William Gwynn.]

Moore, C.N. 'Daniel Clowes and Sporting Art.' *Antique Collector*, February, 1987, pp. 52-60.

Nygreen Edward J. T*he Art of James Ward, RA 1769-1859.* Yale University Ph. D dissertation, Ann Arbor, 1976.

Paget, Guy. *The Melton Mowbray of John Ferneley.* Leicester, 1931.

Paisey, Mrs Robin. 'John Ferneley Animal Portrait Painter.' *The Antique Collector*, May, 1983, pp. 70-75.

Sartin, Stephen. *Thomas Sidney Cooper.* Leigh-on-Sea, 1976.

Scantlebury, Hugh. 'No Obstaclé to Talent.' *Country Life*, April 9, 1992. The life and works of John Vine. pp. 40-41.

Sheldon, Andrew. 'Gross Beasts A Speciality.' *Country Life*, 8 November, 1990, pp. 108-9. [The life and works of Richard Whitford.]

Shropshire Artists: Thomas Weaver 1772-1844. *Shropshire Magazine,* April 1954, p. 18.

Sparrow, Walter Shaw. 'Charles Towne.' *Connoisseur*, May, June, July and August, 1930. pp. (respectively 286-93; 370-60; 9-16; 90-97.

Sparrow, Walter Shaw. 'John Boultbee: Sporting Painter.' *Connoisseur*, March 1933. pp. 148-159

Sparrow, Walter Shaw. 'Thomas Weaver of Shropshire A Yeomanist in Paint.' *Connoisseur,* December, 1934. pp. 386-391.

Stewart, Brian. *Thomas Sidney Cooper of Canterbury.* Rainham, Kent, 1983.

Taylor, Basil. *Stubbs.* London, 1971.

Walker Stella A. *John Ferneley and His Sporting World (1782-1864).* British Sporting Art Trust, 1982

Walker Stella A. 'Abraham Cooper: An Animal Artist of 100 yrs ago.' *Country Life.* 19 December 1968. pp 1652.

Weaver, Frank. 'Thomas Weaver: Extracts from the Diary of a Shropshire Artist, from 1797 to 1833 by his Grandson, Frank Weaver,' *Shrewsbury Chronicle.* Part I 7 June 1907, Part II 14 June 1907.

Artists: Exhibition Catalogues

An Exhibition of Old Prints and Paintings of Prize Cattle, Sheep & C. London: Walker's Galleries, 1932. Introd. Lord Northbrook.

A Second Exhibition of Old Prints and Paintings of Prize Cattle, Sheep, Pigs & C. London: Walker's Galleries, 1934. Introd. Lord Northbrook.

Exhibition of Pictures of Agricultural and Sporting Interest. Lincoln: Usher Art Gallery, 1947.

James Ward. London: Arts Council. 1960. Introd. Denis Farr.

George Garrard 1760-1826. Bedford: Cecil Higgins Museum, 1961. Introd. E. Croft-Murray

Portraits of Animals: A Catalogue of the Nineteenth Century Paintings and Prints of Farm Livestock. University of Reading, Museum of English Rural Life, 1964. Introd. Andrew Jewell. Note on the prints Michael L. Twyman.

An Exhibition of Cattle and Sheep Paintings 1750-1850. Woodstock: Oxford City and County Museum, 1971. Introd. Robert Trow-Smith.

A Loan Exhibition of the Works of Thomas Woodward 1801-1852. London: Spink & Son, 1972. Introd. Basil Taylor.

British Sporting Painting 1656-1850. London: Arts Council, 1974. Introd. Oliver Millar.

Paintings of Longhorn Cattle. Shugborough: Staffordshire County Museum, 1977. Introd. Alan Cheese.

The Danson collection of paintings by Charles Towne. Liverpool, Walker Art Gallery, 1977.

James Ward's Gordale Scar An Essay in the Sublime. London: Tate Gallery, 1982. Introd. Edward Nygreen.

Sir Edwin Landseer. London: Tate Gallery, 1982. Introd. Richard Ormond.

Paintings, Politics and Porter: Samuel Whitbred II (1764-1815) and British Sporting Art. Museum of London, 1984. Introd. Stephen Deuchar.

George Stubbs 1724-1806. London: Tate Gallery, 1984. Introd. Judy Egerton.

Richard Ansdell R.A (1815-1885), A Centenary Exhibition. London: Malcom Innes Gallery & Richard Green Gallery, 1985.

William Gwynn of Ludlow 1782-c.1861, Tenth Anniversary Exhibition. Cirencester: William Marler Gallery, 1985. Introd. William Marler.

The Pasture in Print: Prize Livestock Prints. London: The Schuster Gallery, 1988.

This Land is Our Land. London: Mall Galleries, 1989. Introd. Demelza Spargo.

Fat of the Land. Lincoln: Usher Art Gallery, 1989.

The Art of American Livestock Breeding. Pittsboro: American Minor Breeds Conservancy, Box 477, 1991. Introd. John Dawes.

James Ward R.A. 1769-1859. Cambridge: Fitzwilliam Museum, 1992. Introd. Jane Munro

The British Folk Art Collection. London: Peter Moores Foundation, 1993. Introd. Lynne Green.

James Flewitt Mullock: Art and Society in Newport and the Victorian Achievement. Newport Museum and Art Gallery, 1993. Introd. John Wilson with Roger Cucksey.

Mountain, Meadow, Moss and Moor. Joseph Denovan Adam, RSA, RSW (1841-1896). Stirling: Smith Art Gallery and Museum, 1996. Introd. Maria Devaney.

English Naïve Paintings from the Collection of Mr and Mrs Andras Kalman. London Crane Kalman Gallery [not dated].

A Century of Farming in Paintings and Prints. London: The Parker Gallery [not dated].

Agriculture

Alderson, Lawrence with the Rare Breeds Survival Trust. *The Chance to Survive.* Revised Edition, Yelvertoft Manor, Northamptonshire, 1989.

Batty, Dr J. *Lewis Wright's Poultry.* Hindhead, 1983.

Bell, Thomas. *The History of Improved Short-horn or Durham Cattle and of the Kirklevington Herd from the notes of the Late Thomas Bates.* Newcastle-Upon-Tyne, 1871.

Burt, N. *Delineation of Curious Foreign Beasts and Birds in their Natural Colours which are to be seen alive at The Great Room over Exeter Change in the Strand.* London, 1791. [Description of the Lincolnshire Ox.]

Carter, Harold Burnell. *Her Majesty's Spanish Flock. Sir Joseph Banks and the Merinos of George III.* Sydney 1964.

Chivers, Keith. *The Shire Horse, a History of the Breed, the society and the Men.* London, 1988.

Clutton-Brock, J. 'British Cattle in the 18th Century.' *Ark* Vol 9, 1982 pp. 55-59.

Comben, Norman. 'The Durham Ox', *Veterinary History,* New Series, Vol I Number 2, Winter 1997/80, pp. 38-46.

Day, John. *An Account of the Late Extraordinary Durham Ox with remarks on the great advantage to be derived by the breeder and the public from the encouragement of such a breed.* London, 1807.

Garne, Richard. *Cotswold Yeoman and Sheep.* London, 1984.

Gilbey, Sir Walter. *Concise History of the Shire Horse.* London, 1889.

Gilbey, Sir Walter. *Farm Stock of Old.* London, 1910.

Gilbey, Sir Walter. *The Royal Family and Farming George III to George IV.* London, 1911.

Goddard, Nicholas. 'The Development and Influence of Agricultural Periodicals and Newspapers 1780-1800.' *The Agricultural Review,* Vol 31, 1983. p.116-131.

Goddard, Nicholas, *Harvests of Change: The Royal Agricultural Society of England 1838-1988.* London, 1988.

Hall, Stephen J.G. & Clutton-Brock, Juliet. *Two Hundred Years of British Farm Livestock.* London, 1989.

Hart, Edward. *The Heavy Horse.* Haverfordwest, 1979.

Harris, Helen. 'Pioneer of Britain's Livestock. Robert Bakewell (1725-1795).' *Country Life,* 26 June, 1975

Harris, Mary Corbett. 'The white Cattle of Wales. '*Country Life* 10 April, 1975, pp. 931-2.

Heath Agnew, E. *A History of Hereford Cattle and their Breeders.* London, 1983.

Hill, Robin. *Shropshire Sheep: A History.* Shropshire County Museum Service, 1984.

Hughes, D. Wyn. 'Remembering a Bovine Wonder. The Durham Ox.' *Country Life.* 24 July, 1980. pp. 331-334.

Jones, John L. 'When Pigs were too Fat to Walk.' *Country Life.* 4 December, 1969. pp. 1472-1476.

Le Marchant, Sir Denis. *Memoirs of John Charles Viscount Althorp, third Earl Spencer.* London, 1876.

Mingay, G.E. (ed.). *Arthur Young and his Times.* London, 1975.

Morton, J. C. *The Prince Consort's Farms.* London, 1863.

Pawson, H C. *Robert Bakewell. Pioneer Livestock Breeder.* London, 1957.

Porter, Valerie. *The Southdown Sheep.* Singleton, 1991.

Rare Breeds Facts and Figures. Kenilworth 1994.

Ritvo, Harriet. *The Animal Estate. The English and Other Creatures in the Victorian Age.* Cambridge, Massachusetts, London, England, 1987.

Sinclair, James. History of Shorthorn Cattle. London, 1907.

Stanley, Pat. Robert Bakewell and the Longhorn Breed of Cattle. Ipswich, 1995.

Stirling, A.M.W. *Coke of Norfolk and his Friends.* London, New York, 1908.

Trow-Smith, R.A. *History of British Livestock Husbandry.* London 2 vols, 1959.

Trow-Smith, Robert. *History of the Royal Smithfield Club.* Bath, 1979.

Urguhart, Judy. *Animals on the Farm, their history from the earliest times to the present day.* London, Sydney, 1983.

Wiseman, Julian. *The History of the British Pig.* London, 1986.

Youatt, William. *Cattle; their breeds, Management and Diseases.* London, 1835.

Youatt, William. *Sheep, their breeds, Management and Diseases.* London, 1837.

Youatt William. *The Pig: A Treatise on the Breeds, Management, Feeding and Medical Treatment of Swine.* London, 1847.

INDEX OF ARTISTS

Page references in bold type refer to illustrations and captions

INDEX OF BREEDS

Page references in bold type refer to illustrations and captions

GENERAL INDEX

Page references in bold type refer to illustrations and captions